Edward Lucie-Smith
was born in 1933 in Kingston, Jamaica,
and in 1946 came to England. He was educated at King's
School, Canterbury, and Merton College, Oxford, where he
read History. Well known as a poet, novelist, biographer,
broadcaster and critic, he is the author of numerous books –
among them *Furniture: A Concise History*, *Sexuality in Western
Art*, *Symbolist Art* and *Movements in Art Since 1945* (all in the
World of Art series). He contributes frequent newspaper
articles on the art-market and collecting.

WORLD OF ART

This famous series
provides the widest available
range of illustrated books on art in all its aspects.
If you would like to receive a complete list
of titles in print please write to:
THAMES AND HUDSON
30 Bloomsbury Street, London WC1B 3QP
In the United States please write to:
THAMES AND HUDSON INC.
500 Fifth Avenue, New York, New York 10110

Printed in Slovenia

The Thames and Hudson Dictionary of

ART TERMS

Edward Lucie-Smith

375 illustrations

THAMES AND HUDSON

For Susan Benn,
who began this project with me.

© *1984 Thames and Hudson Ltd, London*

First published in the United States in 1984 by
Thames and Hudson Inc., 500 Fifth Avenue,
New York, New York 10110
First paperback edition 1988
Reprinted 1993

Library of Congress Catalog Card Number 83-51331

Printed and bound in Slovenia

Contents

Preface:
How to Use This Book

This dictionary is designed to serve as a field-guide to the arts. It is compact, because our experience of the arts is gained in so many places – in exhibitions, in museums, touring with a guide-book – and no one wants to travel with a reference library. It is also comprehensive, because neither in real life nor in books are the various arts neatly segregated. More than 2000 entries therefore define and explain terms from painting, sculpture, architecture, the decorative and applied arts, and the graphic arts, together with techniques of photography.

Even in large dictionaries of the English language, many of the entries included here are not defined adequately, if at all, either because they refer to foreign terms or because artists, like other specialists, have their own uses for familiar words. In the **fine arts**, the rich polyglot terminology of painting and sculpture covers the materials and physical structure of works of art, and also artistic tendencies, phases and movements, many of them confusingly similar and others in need of a fresh non-partisan definition. I also provide a **comprehensive architectural vocabulary**, together with the essentials of the language of **furniture, ceramics, glass, enamel, jewellery, metal-work and textiles**. Where a word has several senses, varying according to context or to the particular art form being discussed, I have given all the meanings which apply to the visual arts and have distinguished them clearly from each other.

Our generation travels more extensively and has access to more historical information than any previous one, and is perhaps better equipped than any other to appreciate the art of remote and alien cultures. This has led to an increasing need for a dictionary which includes **non-Western terminology**, and it therefore seems to me natural to cover the basic vocabulary of the arts of India, China, Japan, Malaysia, Oceania, Africa and pre-Columbian America. The **chronological spectrum** is equally wide: under 'C', for example, we find both conceptual art, one of the most esoteric new means of expression, and Cycladic art, one of the earliest forms, dating from four or five millennia ago. The **Table of Dynasties** at the end of the book facilitates the chronological identification of the various phases of Japanese, Chinese, Egyptian, Greek and Indian art.

Above all, the aim has been to fit the book to **contemporary approaches to art**. Our view of art is broader than it has ever been, and our vocabulary for dealing with it has grown more complex and seems sometimes to burst the confines of normal English usage. The criterion for inclusion has not been my approval of a particular usage, but the fact that it exists and is not self-explanatory.

Art is by its very nature visual, and this is a dictionary which uses numerous **illustrations and diagrams** as well as words. As far as possible, they serve as definitions in their own right – especially where, as in the explanation of a style, the nuances of a term cannot be fully characterized in words. A series of special **composite diagrams** covers more than a quarter of the entries, and provides a particularly comprehensive treatment of architectural terms. These diagrams will be found under the following entries:

arch	machicolation
basilica	moulding
brickwork	netsuke
capital	orders of architecture
classical temple	pedestal
column	projection
dome	rood-screen
door	roof
entablature	stonework
Gothic cathedral	vault
Greek Orthodox church	window
Greek vases	

Composite entries, listed below, bring together definitions of various types of object or technique in order to aid comparison and subsequent recognition:

arch	perspective
brickwork	projection
capital	relief
column	roof
dome	stonework
door	tracery
enamel	vault
moulding	window
orders of architecture	

I have made the individual entries self-sufficient as far as possible, but, in order to achieve the widest coverage of terms, a system of **cross-references** is used. They are given in SMALL CAPITALS, with an **asterisk** ★ if the reference is to an illustration. Indicating that the reader will be able to enhance his or her knowledge of a subject by consulting connected entries, these references

are also a clear demonstration that the book assumes no previous specialized knowledge and will, I hope, encourage the pleasant habit of following up a subject from one entry to another.

The entries to which the reader will find cross-references fall into the following categories: important art movements such as Surrealism or periods such as the Renaissance, where the reader will find a synopsis of background information enabling him or her to form a wider picture of the art of the time; influences on particular styles; types of building where architectural features may be found; techniques used in styles of painting; wider classifications which include the object or style defined; other styles with which a movement has close links; other words with which terms are often confused; and periods which immediately precede or follow a phase of art or architecture.

With this dictionary at hand, the reader should be able to puzzle out any art text, however technical, and the collector or exhibition-goer should feel at ease with any auction or museum catalogue, no matter how recondite.

ELS

Abbreviations

Chi.	Chinese	lit.	literally
fr.	from	Jap.	Japanese
Fr.	French	pl.	plural
Ger.	German	sing.	singular
Gk	Greek	Skr.	Sanskrit
It.	Italian	Sp.	Spanish
Lat.	Latin		

A

abacus In architecture, the uppermost part of a CAPITAL. (ENTABLATURE,★ ORDERS OF ARCHITECTURE.★)

abbozzo (It. 'sketch, outline') Underpainting in MONOCHROME, used to indicate the general composition of a picture before its final colouring.

absidiole See APSIDIOLE.

abstract art Art which is either completely non-REPRESENTATIONAL, or which converts forms observed in reality into patterns which are read by the spectator primarily as independent relationships, rather than with reference to the original source.

Abstract Expressionism The consciously American style of art which emerged in New York during the 1940s and remained dominant until the late 1950s. It was essentially an amalgam of ideas borrowed from SURREALISM (most of whose leaders lived in exile in the US during the war years) and more strictly American concepts about the importance of the pioneering individual, particularly in the liberation of art from tradition. Abstract Expressionism was neither fully ABSTRACT nor wholly EXPRESSIONIST. It borrowed the Surrealist technique of AUTOMATISM and carried it to new extremes as a way of generating images, and at the same time explored CUBIST ideas about 'shallow space'. It is less a recognizable style than a common approach to the problem of making art, but typical Abstract Expressionist works do generally fit into one of two categories: 'calligraphic', with freely scribbled marks covering the whole surface, or 'iconic', where the composition is dominated by a single, usually centralized, form. Jackson Pollock's DRIP PAINTINGS would be typical examples of the first category, while Mark Rothko's late canvases are equally typical specimens of the second. The style as a whole is more loosely termed Action Painting. See also TACHISME.

Abstract Illusionism A tendency in American ABSTRACT painting of the late 1960s and 1970s in which forms and brush-strokes, normally experienced by the spectator as things lying flat on the canvas, are separated from it by various illusory devices (cast shadows, etc.), so

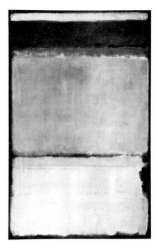

Iconic **Abstract Expressionism:** *Mark Rothko's* Number 10, *1950.*

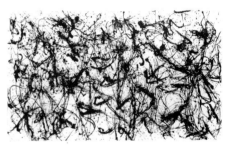

Calligraphic **Abstract Expressionism:** *Jackson Pollock's drip painting* Number Thirty Two, *1950.*

Abstract Illusionism: *Jack Lembeck's* Star Wars II, *1978.*

9

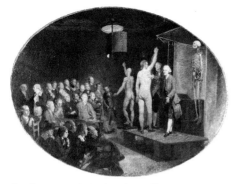

Academy: *a painting by John Zoffany, c. 1775, of a lecture at the Royal Academy, London, by William Hunter, Professor of Anatomy.*

that they seem to float in front of the PICTURE-PLANE. The term was first used *c.* 1967.

Abstract Image painting The type of ABSTRACT EXPRESSIONISM which makes its effect purely through the use of colour and FORM, with no emphasis on brush-strokes or other marks.

Abstraction Lyrique (Fr. 'Lyrical Abstraction') European equivalent of American ABSTRACT EXPRESSIONISM, particularly associated with the CALLIGRAPHIC PAINTING of Georges Mathieu, from the late 1940s onwards.

Abstraction-Création (Fr.) Name adopted by a large group of ABSTRACT artists formed in Paris in 1931, under the leadership of Auguste Herbin and Georges Vantongerloo. Open to artists of all tendencies, it was the chief rallying point of Paris-based abstract art during the 1930s.

academic art Art created according to the prescriptions of the official ACADEMIES of painting and sculpture which flourished in Europe from the 17th to the 19th c.

academy An institution whose origins lie in the many associations formed during the RENAISSANCE as a revolt against the medieval GUILD system, with the aim of establishing painters and sculptors, hitherto regarded simply as artisans, as highly educated professionals equipped with a comprehensive theory of art as well as with technical skill. Academies gradually evolved so that by the 18th c. they offered a complete education to the aspiring artist, based on CLASSICAL standards.

academy figure A painting or drawing of the male or female nude executed not as an end in itself but as part of the whole process of study, as taught in an ACADEMY of art.

acanthus An architectural ornament derived from the stiff, prickly leaves of the Mediterranean plant *Acanthus spinosus*. It is used as part of the capitals of the Corinthian and Composite ORDERS OF ARCHITECTURE. ★

accidental colour The optical illusion caused by staring at a strongly coloured area, then transferring one's gaze to a white or neutral ground. The COMPLEMENTARY of the colour one has been gazing at momentarily appears. Thus if one has been gazing at an area of bright orange, one will see a corresponding patch of green.

accidental light In painting, any source of light which is not sunlight, e.g. candle-light, moonlight.

accidental points In PERSPECTIVE, additional vanishing points which do not fall on the horizon line.

Achaean art Art produced by the Achaeans, peoples of eastern and southern Greece, during the period 2000–*c.* 1100 BC.

Achaemenian art Art created under the influence of the Achaemenids, who were the dominant people in Persia and the Near East from 550 to 330 BC. It often shows the impact of older styles, such as that of the Assyrians, who had ruled in the same territories.

acheiropoeitos (Gk 'made without hands') Any sacred image, pagan or Christian, which is believed to have been created without human intervention.

acrolithes (Gk 'high stones') Ancient Greek statues in primitive style, with wooden bodies but stone limbs and heads.

acropolis (Gk 'high city') The citadel of an Ancient Greek city, enclosing a royal palace or a group of temples, or both.

acrosolium (Lat.) A niche for a tomb, for example in an EARLY CHRISTIAN CATACOMB.

acroteria (Gk sing. **acroterion**) The small PLINTHS, and the statues or carved ornaments they support if any, at the apex and the two ends of a PEDIMENT. (CLASSICAL TEMPLE, portico.★)

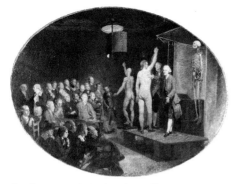

acrylic paint An EMULSION paint using a synthetic MEDIUM, acrylic resin, now frequently used by artists as a quicker-drying substitute for true OIL PAINT.

'**action**' Term used from *c.* 1960 to describe a tightly or loosely structured sequence or combination of physical movements, sounds, manipulations of materials, interactions with space and time, etc., not necessarily taking place in one particular setting, and presented as a work of art either directly or through documentation. The 'action' is a development of the HAPPENING but is less specifically theatrical. For example, an artist such as Richard Long walking a given number of miles per day along a specified route, and documenting the result with lines drawn on a map and with a camera is first performing, then recording, an artistic 'action'.

Action Painting See ABSTRACT EXPRESSIONISM.

adhocism Term coined by the architectural historian Charles Jencks to describe design which comes about, not by formulating new solutions to problems but by combining pre-existing elements to achieve a new result. The elements chosen need not necessarily have been designed for the use to which the adhoc designer puts them. A classic example is the stool designed by Nathan Silver which consists of a metal tractor seat mounted on four wheels taken from a baby carriage.

adobe (Sp.) Sun-baked clay, i.e. unfired brick.

advancing colour A strongly SATURATED warm colour (red, orange, yellow, etc.), which seems to lie in front of the PICTURE-PLANE. The opposite of a retreating colour.

aedicule (fr. Lat. *aediculum*, 'miniature house') 1. A niche for a statue, framed by COLUMNS supporting an ENTABLATURE and PEDIMENT. 2. A window framed in the same way.

Aegean art The art of a number of early cultures located around the Aegean Sea, among them the CYCLADIC, MINOAN and MYCENAEAN civilizations. Aegean art spans the period *c.* 3000–*c.* 1400 BC.

Aeropittura (It. 'air painting') A late development of Italian FUTURISM. The painters associated with it tried to depict the sensations induced by contemporary technology, especially the aeroplane. In 1929 F.T. Marinetti, the founder of Futurism, published a manifesto under this title.

aesthete 1. Specifically, an adherent of the AESTHETIC MOVEMENT in the late 19th c. 2. More generally, someone who puts artistic sensibility first in his or her life.

aesthetic A coherent system of criteria, which can be purely visual, moral or social, or any combination of these, used for evaluating works of art – e.g. 'the craft aesthetic' applied to the products of the ARTS AND CRAFTS MOVEMENT.

Aesthetic Movement An English artistic movement, influenced by the doctrine of 'ART FOR ART'S SAKE' as put forward by both French and English writers – first in France by Gautier and Baudelaire, later in England by Pater and Wilde. It reached a climax with the opening of the Grosvenor Gallery in London in 1877, and the two painters most closely associated with it were Whistler and Burne-Jones. Through the latter, it also came to be seen as a continuation of PRE-RAPHAELITISM. With its preference for what was suggestive and evocative rather than what was specific, anecdotal or didactic, the Aesthetic Movement can also be seen as the English offshoot of Continental SYMBOLISM. Because it denied any moral value in art, it was also popularly confused with the DECADENT MOVEMENT. Its chief long-term impact was in reforming and simplifying household decoration, and on the DECORATIVE ARTS in general rather than on painting.

Aestheticism A theory of art, first formulated in the 18th c. by Immanuel Kant, which maintains that the philosophy of art is separate from any other form of philosophy and that art can be judged only by its own standards. The concept was revived in France in the 1840s by Baudelaire and Gautier as 'L'Art pour l'Art' (see ART FOR ART'S SAKE). It achieved its greatest influence in Britain in the late 19th c. with the AESTHETIC MOVEMENT.

aesthetics The philosophy of the beautiful in art. The term was first used in the mid 18th c. by the German philosopher Alexander Gottlieb Baumgarten (1714–62), and was later taken up by Kant in his theory of AESTHETICISM.

Afro-Portuguese ivories Ivory objects in hybrid styles, chiefly salt-cellars and hunting horns, carved in Africa in the 16th c. for export to Europe.

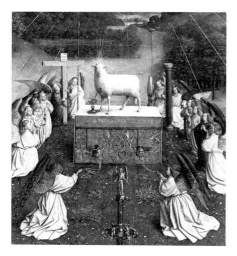

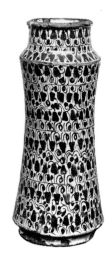

(Left) The **Agnus Dei** *from Jan and Hubert van Eyck's* Adoration of the Lamb, *1432 (detail from an altarpiece at St Bavon, Ghent).*

(Right) Hispano-Moresque earthenware **albarello.**

after___ 1. When applied to a reproductive medium such as ENGRAVING, indicates that the name it precedes is that of the artist who created the original design, but who was not responsible for engraving the PLATE from which the PRINT was made. 2. When applied to a painting or drawing, indicates a copy or reproduction by a hand other than the artist named.

aggry, aggri A bead made of canes of glass fused together. The composite cane is cut into sections, and the ends of these sections are cut obliquely to show a zig-zag pattern. Such beads were made in Europe for export to Africa, where many have since been found.

Agnus Dei (Lat. 'Lamb of God') Christ symbolically represented as a lamb with NIMBUS, cross (or 'red-cross' flag) and CHALICE.

agora (Gk) The Greek equivalent of a FORUM.

airbrushing A method of painting by means of a small, finely controllable mechanical paint-sprayer. The method was first used in the GRAPHIC and COMMERCIAL ARTS to achieve a smooth, impersonal finish, and was later adopted by certain practitioners of the FINE ARTS, especially those affiliated to POP ART and SUPER REALISM.

aisle (Fr. 'wing') In a BASILICA★ or other church, the space between the COLUMNS of the NAVE and the side wall. (GOTHIC CATHEDRAL.★)

ajouré (Fr. 'openwork') (Used especially of metalwork.) Pierced or perforated in elaborate patterns.

alabastron (Gk 'alabaster') In Ancient Greece and Alexandria, a small POTTERY or GLASS bottle, usually cylindrical, with LUG HANDLES, rounded at the bottom (to be rested on a tripod), and a mouth consisting of a flat disk and a small central hole. It was used for ointment, perfume or oil. (GREEK VASES.★)

albarello (It. 'pot, jar, phial') A cylindrical, slightly waisted drug jar with a flanged neck to which a paper or PARCHMENT cover could be tied. The shape seems to have originated in Persia in the 12th c., and became popular first in Spain in the 15th c. and then throughout Europe.

albumen print A photographic PRINT made on paper coated with albumen (white of egg) and salt, sensitized before use with a solution of silver nitrate. The process was introduced in 1850 by Niépce de St Victor in France, and was popular throughout the second half of the 19th c.

Alienated Art Synonym of ART AUTRE.

all'antica (It. 'after the antique') A work of art *all'antica* is one based on a CLASSICAL model.

alla prima (It. 'at first') A method of painting a picture in one layer of PIGMENT, usually on a white GROUND, without the use of underpainting, GLAZE or retouching.

allegory A work of art which represents some abstract quality or idea, either by means of a single object or figure, or by grouping objects and figures together, frequently in an un-

realistic way. In RENAISSANCE art, allegories make frequent allusions both to scripture and to Greek and Roman legends and literature.

all-over paintings Paintings, usually ABSTRACT, and dating from the years since the Second World War, which have no central focus or dominant area of interest.

alloy 1. A mixture of different metals without chemical combination. 2. The level of purity in gold or silver (e.g. a gold alloy can be anything less than 24 carat, which is pure gold).

altarpiece A devotional work of art placed on, above or behind the altar in a Christian church. It can be painted or sculpted, and may represent an episode from scripture, a sacred personage, or some episode in the life of a saint. Many altarpieces contain multiple scenes and are hinged so that these can be concealed or revealed according to the occasion. See also PREDELLA, REREDOS.

alto rilievo See RELIEF.

amalgam 1. A non-chemical combination of two or more substances. 2. An ALLOY of mercury and another metal, e.g. gold (for gilding PORCELAIN and GLASS) or tin (for backing mirrors).

Amarna art The phase of Ancient Egyptian New Kingdom art of the time of the 'heretic pharaoh' Akhenaten (c. 1375 BC), who moved his capital to the site now known as Tel-el-Amarna. Amarna art combines extremes of REALISM with extremes of MANNERISM.

ambo (Gk 'rim') A raised stand or pulpit in an EARLY CHRISTIAN church on which the Bible is placed during the reading of the Gospel and the Epistle. Frequently two are used, one on the south side of the NAVE for the Gospel, and one on the north side for the Epistle.

ambrotype An early photographic process designed to produce a cheap imitation of a DAGUERROTYPE. A glass negative was first bleached, then laid against a black background to give a positive image. The technique was first published in 1831, and patented by the American James Cutting in 1854.

ambulatory 1. In a large church or cathedral, the passageway behind the high altar and around an APSE. (GOTHIC CATHEDRAL, plan.★) 2. More generally, a place for walking, usually one which is covered over.

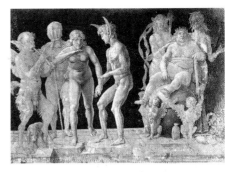

Allegory of Vice and Virtue in a drawing by Andrea Mantegna (c. 1490). The figures include, from left to right, Lust (the satyr playing a pipe), Virtue (the woman about to fall into the abyss), Folly holding her hand and Ignorance (the fat woman sitting on the globe).

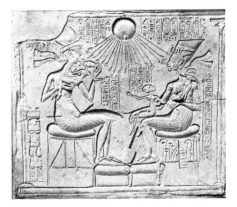

Amarna art: *a relief of Amenophis IV, Queen Nefertari and three of their children being blessed by the sun's rays, 14th c. BC. Note the use of simultaneous representation in the faces and shoulders.*

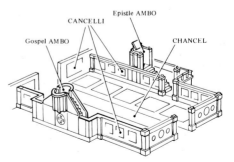

*The double **ambo** in the church of San Clemente, Rome, AD 514–23.*

13

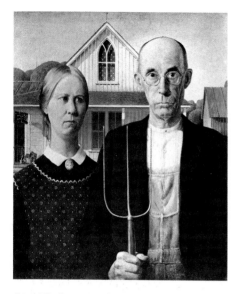

Grant Wood's painting, American Gothic, *1930, which gave its name to this type of* **American Scene Painting**.

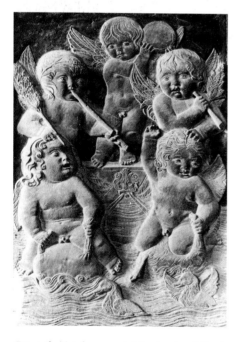

Group of mid 15th-c. **amorini** *by Agostino di Duccio from the Tempio Malatestiano, Rimini.*

American Gothic The more gaunt and awkward aspects of AMERICAN SCENE PAINTING, as typified by artists such as Grant Wood, one of whose paintings bears this title.

American Scene Painting American FIGURATIVE painting of the 1920s and 1930s, committed to a realistic depiction of contemporary American life, mostly small-town and rural rather than big-city subjects. It found much of its subject-matter in the rural Mid West.

amorino (It. 'little cupid') Chubby naked winged boy, used in European DECORATIVE ART from the RENAISSANCE onwards. The type derives from Greek and Roman representations of the love-god Eros/Cupid but is interpreted in a Christian context as a child-angel. See also PUTTO.

amphitheatre 1. A circular or oval building with rising tiers of seats around a central space. 2. The gallery (usually curved) in a conventional theatre.

amphora (Lat., fr. Gk) Ancient Greek jar, used for storage, and sometimes as a decanter, for oil or wine, with an egg-shaped body and two handles on either side of a short neck. It was sometimes made without a foot so that it could be stuck upright into sand or soft ground. (GREEK VASES.★)

amphoriskos (Gk) A miniature AMPHORA, usually of POTTERY or GLASS, and used in ancient times as a container for unguent or perfumed oil.

ampulla (Lat. 'flask') 1. In Greek and Roman times, a miniature AMPHORA, usually with a tall neck and one or two loop handles, attached to the shoulder of the vessel and just below the rim. It can be of POTTERY, GLASS or other materials. 2. In a Christian context, the miniature flask, usually made of clay, which was used by pilgrims to carry away lamp-oil from a martyr's shrine. 3. A similarly shaped vessel, made of precious materials, used from the Middle Ages onwards to hold the sacred oil for coronation ceremonies.

an hua (Chi. 'secret') Decoration incised in PORCELAIN or painted upon it in fine white SLIP under the GLAZE. It appears only when the piece is held to the light.

anaglyph 1. See RELIEF. 2. In photography, a stereoscopic image made by superimposing images in COMPLEMENTARY COLOURS.

anamorphosis A painting, drawing or PRINT which seems distorted when looked at from a frontal position, but which, when looked at from a viewpoint to one side, or in a curved mirror, resumes normal proportions.

anastasis A depiction, common in BYZANTINE art, of the resurrection of the Old Testament saints (which takes place during the HARROWING OF HELL).

ancona An early type of Italian ALTARPIECE, without folding wings but made up of numerous painted panels.

Angevin Gothic A type of GOTHIC architecture with characteristic dropped ARCHES, particularly associated with the rule of the English Plantagenet kings in Aquitaine (1154–1453).

animal interlace Ornament which consists of stylized and intertwined representations of animals. It is typical of BARBARIAN ART, both Celtic and Germanic. Synonym: lacertine. (CARPET PAGE.★)

Animal Style A distinctive style of ornament which flourished among the mounted nomads of Europe and Central Asia, from Hungary to the Gobi Desert. It is first met with among the Scythians of the 6th c. BC. Animals, often intertwined in combat, are used to create linear patterns. Often one animal will grow out of another, or be contained within another. It occurs typically in metalwork.

Animaliers (Fr.) A group of sculptors (most of them French) who in the 19th c. specialized in making small-scale representations of wild and domestic animals.

ankh The Ancient Egyptian hieroglyph representing the word 'life'. It is shaped like a TAU CROSS with a loop at the top. (CARTOUCHE.★)

annealing A process by which metal and GLASS, having become hard and brittle during working, are softened and made workable by heating until cherry red, then cooling (slowly in the case of glass, and either rapidly – by quenching in water – or slowly in the case of metals).

annular 1. Ring-like. 2. Composed of ring-like sections.

annulet, annulus (Lat. *annulus*, 'ring', pl. **annuli**) One of several small ring MOULDINGS at the top of a Doric COLUMN. (ORDERS OF ARCHITECTURE.★)

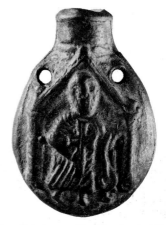

Christian pilgrim's **ampulla** *with a figure of St Peter. Smyrna, 6th c. AD.*

Detail of an **anamorphosis** *by Hans Holbein the Younger:* Jean de Dinteville and Georges de Selve *('The Ambassadors'), 1533. If the lower left-hand corner of the page is held up to the eye, the hidden image will appear.*

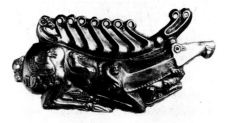

Scythian **Animal-Style** *plaque, in gold repoussé, 5th-4th c. BC.*

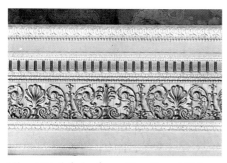

(*Above*) *Detail of a door frame at Syon House, Middlesex, designed by Robert Adam (1728–92), showing two* **anthemions** *on either side of a palmette.*

(*Right*) *Portico in* **antis**.

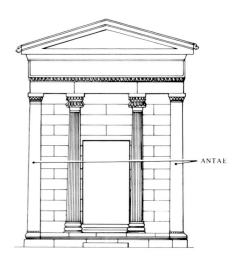

ANTAE

anonimo (It. 'anonymous') 1. Any Italian artist whose identity is unknown. 2. Any anonymous Italian writer; in the field of art one who serves as an art-historical source, e.g. the Anonimo Morelliano.

antae (Lat., sing. **anta**) See ANTIS, IN.

antechamber Synonym of VESTIBULE.

antechurch An addition to a church extending the NAVE westwards by several BAYS. It is generally the full width of the main building.

antefix (fr. Lat. *antefixa*, 'fastened in front') An ornament first used in CLASSICAL architecture to conceal the ends of the roof-tiles and protect the rafters of a temple. It was subsequently adopted for the decoration of NEO-CLASSICAL, REGENCY and EMPIRE furniture. (ENTABLATURE.★)

antependium (Lat. 'hung in front') An ornamental covering for the front of an altar, usually of rich fabric or precious metal. Synonym: altar frontal.

anthemion (Gk 'flower') An architectural ornament derived from the honeysuckle. It appears either on its own or alternates with lotus-and-palmette.

anti-art Term said to have been coined *c.* 1914 by Marcel Duchamp to describe work which has the character of art while at the same time challenging all preconceptions about the nature of art. Typical of anti-art was Duchamp's gesture in adding a moustache to a reproduc-

tion of the *Mona Lisa*, the point being that this was done by a man who was himself already recognized as an artist. DADA was the first anti-art movement.

antiphonary Liturgical book, often of large size, made for use in church services. It contained the texts and music of the responses (antiphons) for the Mass and other offices. It was frequently richly ILLUMINATED.

Antique, the Greek and Roman art of the period up to the 5th c. AD, from which ACADEMIC painters and sculptors from the RENAISSANCE onwards took their inspiration.

antis, in (Lat. 'between the antae') 1. Used of a PORTICO which is framed on either side not by COLUMNS but by the ends of the side walls which terminate in PILASTERS (here called *antae*). 2. By extension, used of any portico which is recessed in the FAÇADE of a building.

Antwerp Mannerists A group of painters, many of them now unidentifiable, who were active in and around Antwerp *c.* 1515–25. Their work, usually showing religious subject-matter, combined MANNERIST and GOTHIC tendencies.

A.P. See ÉPREUVE D'ARTISTE.

apadana (Skr.) A free-standing many-columned hall, often with a PORTICO. Used as a throne-room in Ancient Persia.

apotropaic (Used of images, especially deliberately ugly ones, for example the GOR-

GONEION on a Greek or Roman temple.) Serving to ward off harm.

applied art Art which is essentially functional, but which is also designed to be aesthetically pleasing (e.g. furniture, metalwork, clocks, textiles, TYPOGRAPHY). See also DECORATIVE ART.

applique (Fr.) A candleholder or other fitting 'applied' to a wall or a piece of furniture. To be distinguished from APPLIQUÉ.

appliqué (Fr. 'applied') A method of decoration in which a MOTIF is cut from one piece of material and attached, or 'applied', to another.

apsara (Skr., pl. **apsaras**) A water-sprite in Indian Vedic mythology, frequently represented as a voluptuous dancing-girl in the carving of Hindu temples.

apse A semicircular or polygonal VAULTED space, most commonly placed at the eastern end of a church. (GOTHIC CATHEDRAL, plan;★ GREEK ORTHODOX CHURCH.★)

apsidiole, absidiole A small APSE-like chapel, usually one of several built along the eastern side of a church TRANSEPT. (GOTHIC CATHEDRAL, plan.★)

aquamanile A bronze or POTTERY vessel, often in the shape of a human figure or animal, used for washing the hands at table.

aquatint A specialized ETCHING technique, which involves the use of a metal plate coated with a porous resin to create a granulated effect. The parts which are to appear completely white are STOPPED OUT with varnish. The plate is immersed in an acid bath, and the microscopic holes in the untreated areas allow the acid to bite into the copper. The resin is then removed, and the process repeated in order to emphasize particular areas, the rest being stopped out, until the plate is etched to the required degree of complexity. The plate, now etched in INTAGLIO, is finally inked and used for printing. Aquatint can also be combined with etched linework.

arabesque Intricate linear surface decoration with curves, tendrils and flowing lines based on plant forms.

arcade A series of ARCHES carried on PIERS or COLUMNS. (CAMPANILE,★ GOTHIC CATHEDRAL, section.★) If these are attached to a wall, it is called a blind arcade. (GOTHIC.★)

Detail of an English 19th-c. patchwork quilt with **appliqué** *flowers and leaves.*

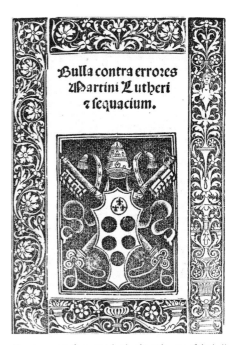

Renaissance **arabesques** *border this title page of the bull against Martin Luther, published in Rome in 1521.*

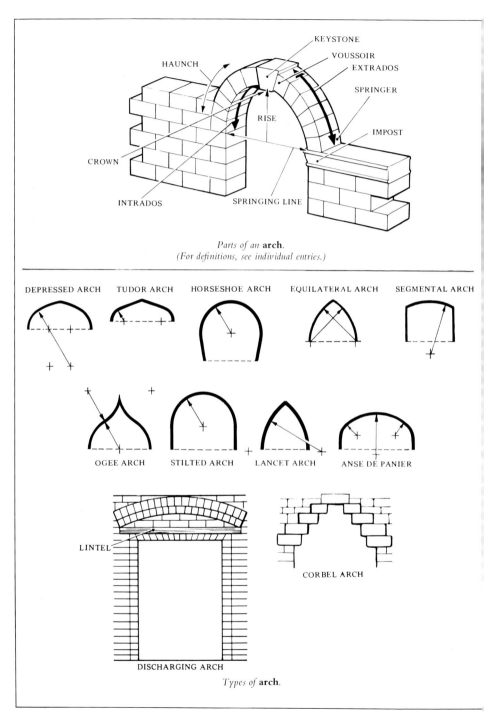

Parts of an **arch**.
(For definitions, see individual entries.)

DEPRESSED ARCH TUDOR ARCH HORSESHOE ARCH EQUILATERAL ARCH SEGMENTAL ARCH

OGEE ARCH STILTED ARCH LANCET ARCH ANSE DE PANIER

LINTEL

DISCHARGING ARCH

CORBEL ARCH

Types of **arch**.

arch A device for spanning an opening which converts the downward thrust of the weight above into an outward thrust sustained by flanking masonry. Usually a curved structure, it is composed of wedge-shaped blocks called voussoirs. The essence of any true arch (as opposed to a corbel arch) is that it derives its stability from the weight it supports. See also SPANDREL.

Anse de panier (Fr. 'basket handle'). An arch resembling the handle of a basket, formed of a segment of a large circle flanked by segments of a smaller circle. Synonym: basket arch.

Basket arch. Synonym of *anse de panier*.

Chancel arch. An arch marking the division between the CHANCEL and the western part of a church.

Corbel arch. An arch made up of a series of CORBELS, acting as CANTILEVERS, and surmounted by a stone block at the apex.

Depressed arch. A pointed arch of four segments, the two outermost springing from centres on the SPRINGING LINE, the two inner from centres below it. Synonym: four-centred arch.

Diaphragm arch. A transverse arch spanning the body of a church, and carrying a masonry GABLE above it. Such arches were used to support wooden roofs, dividing them into sections for greater protection against fire.

Discharging arch. An arch built into a wall, to carry masonry which would be too heavy for the opening immediately below it (e.g. a flat-headed door or window). Synonym: relieving arch.

Dropped arch, drop arch. Any pointed arch whose span is greater than its radii.

Equilateral arch. A pointed arch made up of two segments of a circle, each with a radius equal to the span of the arch.

Four-centred arch. Synonym of depressed arch.

Horseshoe arch. An arch with a rounded or pointed horseshoe shape; found in Islamic architecture.

Keel arch. Synonym of ogee arch.

Ogee arch. A pointed arch formed of two concave curves above, turning into convex curves below. Synonym: keel arch.

Relieving arch. Synonym of discharging arch.

Segmental arch. An arch formed from a segment of a circle whose centre is below the SPRINGING LINE.

Skew arch. An arch whose JAMBS are not at right angles to the face.

Stilted arch. An arch raised on vertical PIERS above the SPRINGING LINE.

Strainer arch. An arch inserted into an internal space (e.g. across the NAVE of a church) to prevent the walls being pushed inward.

Tudor arch. An arch constructed of four sections, the outermost two each forming a quarter circle, the inner two continuing in a straight line to meet in a shallow point. It is typical of early 16th-c. English architecture.

Archaic art 1. Strictly, Greek art of the period between the DAEDALIC and the CLASSICAL (*c.* 620–*c.* 500 BC). Greek statues of this time are characterized, among other things, by a conventional smiling expression known as the Archaic Smile. 2. More generally, and with a small 'a', art which seems old-fashioned for its time.

archaistic Self-consciously imitating ARCHAIC styles. (Especially the imitation of Archaic art in the HELLENISTIC and Roman periods.)

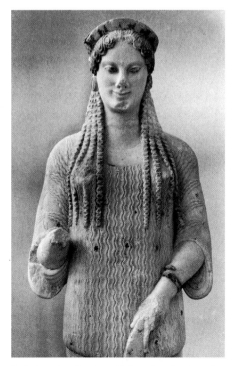

Archaic art: *a Greek marble kore from the Acropolis, Athens, of c. 510 BC, featuring the Archaic Smile.*

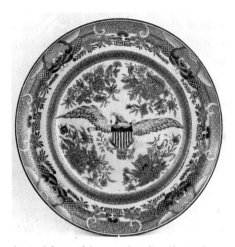

Armorial porcelain: an early 19th-c. Chinese plate in the famille rose palette, with the arms of the United States in the centre. The border is decorated with a scale ornament and diaper and Greek key patterns.

architectonic 1. Pertaining to architecture. 2. By extension, expressing the spatial qualities peculiar to architecture.

architrave 1. In CLASSICAL architecture, the main beam that rests on the ABACUS and forms the lowest part of the ENTABLATURE.★ 2. The MOULDING round a window or doorway. (DOOR, parts of a.★)

archivolt A continuous MOULDING – usually one of several – framing the face of an ARCH. (NORMAN STYLE.★)

arcuate, arcuated Constructed according to the principle of the ARCH (as opposed to TRABEATED).

arhat (Skr.) A figure, often found in early Buddhist temple carving, representing an individual who has reached the end of the Eightfold Path – right views, aspirations, speech, conduct, mode of livelihood, effort, mindlessness and rapture.

armature The rigid framework or skeleton used by a sculptor to support his modelling clay or other malleable material.

armorial porcelain A type of PORCELAIN decorated with European coats of arms, made in China for export to Europe in the 18th and early 19th c., generally using the FAMILLE ROSE palette.

Armory Show A highly influential international exhibition of modern art held in New York 17 February–15 March 1913 at the 69th Regiment Armory. It was responsible for introducing all the major Paris-based art movements of the time to the American public, though it omitted both German EXPRESSIONISM and Italian FUTURISM.

arras 1. Originally a TAPESTRY made at Arras, in Artois, which was the most important tapestry-weaving centre in Europe during the Middle Ages, receiving patronage from the Burgundian court in the late 14th c. 2. Now used as a generic word for tapestry.

Arretine pottery Red GLOSSY moulded POTTERY of the Roman period (TERRA SIGILLATA), often with decoration imitating REPOUSSÉ metalwork. In the first century BC the most famous centre of production was Arretium (Arezzo) in Italy, but it was also produced throughout Europe.

arricciato, arriccio (It. 'wrinkle') In FRESCO painting, the coat of plaster covering the ROUGHCAST wall, on which the composition is first sketched out.

arris See BRICKWORK, ELEMENTS OF; STONEWORK, ELEMENTS OF.

Art Autre, un (Fr. 'Other Art') The 'alienated' art in Europe immediately after the Second World War, which was produced by artists such as Wols and Fautrier, and which was thought to have a quality of 'otherness'. The term is derived from the title of a book by the French critic Michel Tapié published in 1952, in which he claimed that art since the war showed a complete break with all previous modes.

Art Brut (Fr. 'raw art') Term invented by the French artist Jean Dubuffet (1901–) to describe art by non-professional artists, particularly that created by children, psychotics, etc., where the artistic impulse seems to appear in a 'raw' state.

Art Deco A decorative style named after the great Paris 'Exposition Internationale des Arts Décoratifs et Industriels Modernes' held in 1925, but in fact the direct successor to pre-1914 ART NOUVEAU. Even more than Art Nouveau, it emphasized the use of luxurious materials – LACQUER, bronze, ivory, ebony, shagreen – but in contrast to it, stressed very simple, massive forms. Elements taken from the French LOUIS

XVI and EMPIRE STYLES were combined with others borrowed from African, Aztec, Chinese art of the Sung period (AD 960–1279) and CUBISM.

'Art for Art's Sake' (fr. Fr. 'L'Art pour l'Art') Phrase taken over by the English AESTHETIC MOVEMENT from Baudelaire and Gautier and used to imply that their artistic activities needed no moral or social justification.

Art Informel (Fr. 'Art without Form') Phrase coined by the French critic Michel Tapié to describe the ABSTRACT but non-geometric art produced in Europe in the years immediately following the Second World War. See also ART AUTRE, TACHISME.

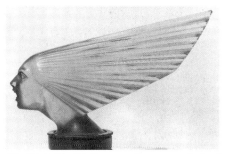

'The Spirit of the Wind', a 1920s glass car mascot by René Lalique in **Art Deco** *style, showing Aztec influence.*

art mobilier (Fr. 'furnishing art') Small portable art objects used for decorative purposes, e.g. RENAISSANCE bronze statuettes.

Art Nouveau An exaggeratedly ASYMMETRICAL decorative style which spread throughout Europe in the last two decades of the 19th and the first decade of the 20th c. It makes use of undulating forms of all kinds, notably the WHIPLASH CURVE of tendrils or plant stems, but also flames, waves and the flowing hair of stylized female figures. The chief importance of Art Nouveau is its rejection of 19th-c. HISTORICISM. It is an offshoot of SYMBOLISM on the one hand, and of the ARTS AND CRAFTS MOVEMENT on the other. (The name was taken from that of a shop which opened in Paris as late as 1895 and sold objects of 'original', as opposed to PERIOD, style.) JUGENDSTIL is the equivalent style in Germany, in France, 'Modern Style', and in Italy, 'Stile Liberty'.

Art Informel: *Antonio Tapiès'* Green and Black, *1957.*

Arte Povera (It. 'Impoverished Art') Term coined by the Italian critic Germano Celant to describe art produced in MINIMAL formats and with deliberately 'humble' and commonly available materials, such as sand, wood, stones and newspaper.

artefact, artifact A man-made object.

artist's proof See ÉPREUVE D'ARTISTE.

Arts and Crafts Movement A movement promoting craftsmanship and a reform of industrial design. Named after the Arts and Crafts Exhibition Society founded in England in 1882, it had earlier roots in Pugin's, Ruskin's and Morris's attempts to reform the decorative arts, emphasizing the potential for good social and moral influence, and encouraging a return

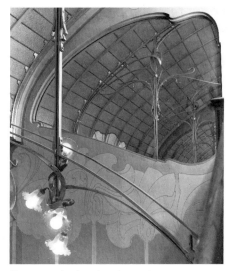

Flowing metalwork in the Belgian architect Victor Horta's **Art Nouveau** *studio in Brussels, 1898–1900.*

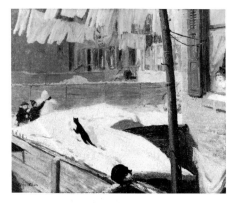

Ashcan School: *John Sloan's* Backyards, Greenwich Village, *1914.*

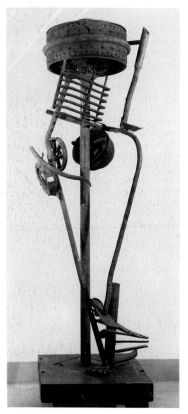

Assemblage: *Richard Stankiewicz's* Kabuki Dancer, *1956.*

to the 'fitness for use' of GOTHIC architecture. Especially influential was Ruskin's championship of the craft aesthetic in 'On the Nature of Gothic,' a chapter in the second volume of *The Stones of Venice* (1853). One aim of the Arts and Crafts Movement was to recreate the vernacular tradition which had been submerged by the Industrial Revolution. It spread from England to the US, and also affected the DECORATIVE ARTS in Germany and Austria.

artwork Drawings, photographs and type-matter, or any combination of the three, made up into a form where they can be used for printing or other reproduction.

aryballos (Gk) A small globular Ancient Greek pot, used to contain perfumed oil for the bath. It was also sometimes made in anthropomorphic or zoomorphic shapes. (GREEK VASES.★)

ascender Any stroke above the X-HEIGHT of a letter in either CALLIGRAPHY or type. (TYPEFACE.★)

Ashcan School Early 20th-c. school of American REALIST painters interested chiefly in the depiction of everyday urban scenes. Prominent members were Robert Henri, John Sloan, George Luks and George Bellows.

ashlar See STONEWORK.

askos (Gk 'wine-skin, leather bottle') An Ancient Greek small pottery vessel used for pouring oil into lamps. (GREEK VASES.★)

assemblage The use of three-dimensional found material (OBJETS TROUVÉS) to create art objects. This technique, which derives originally from COLLAGE, was widely popular towards the end of the 1950s, as part of the DADA revival (see NEO-DADA). See also COMBINE PAINTING.

Assumption A representation of the Virgin's soul and body being taken up to Heaven, three days after her death (cf DORMITION). The type first occurs in GOTHIC sculpture of the 13th c.

astragal 1. A MOULDING, semicircular in cross section, and often decorated with, e.g., a BEAD-AND-REEL ornament, placed at the top and/or bottom of a COLUMN, or forming part of an ENTABLATURE. (ORDERS OF ARCHITECTURE.★) 2. (Scot.) A glazing-bar.

asymmetrical Not the same on either side of an axis (but not necessarily out of BALANCE).

atelier (Fr. 'workshop') An artist's studio, or a print-maker's workshop.

atelier libre (Fr. 'free studio') Studio shared by artists, each of whom pays a fee to work there and have the use of a model. There is no master and no tuition.

atlantes (Gk, sing. **atlas**) Full- or half-length Atlantean figures, depicted in the round or in high RELIEF, which are used instead of COLUMNS to support an ENTABLATURE, or VAULT, or in furniture to support a tabletop, etc. Synonym: telamones.

atrium 1. Originally, the open central court in a Greek or Roman house. 2. The forecourt or VESTIBULE of an Early Christian church (BASILICA.★) 3. The colonnaded forecourt of a church. 4. Today, in the US, a large and grandiose room in a hotel or public building through which one enters another and more important room.

attic 1. In a CLASSICAL building, a storey above the main ENTABLATURE. 2. Also in classical architecture, a small ORDER (combination of columns and entablature) above a larger one. 3. By extension, the top storey of a building.

attribute A symbolic object which is conventionally used to identify a particular saint or deity. (ESCALLOP.★)

attributed to __ Considered to be by the artist named.

au premier coup (Fr. 'at the first stroke') Synonym of ALLA PRIMA.

Aubusson A generic name for TAPESTRIES and more especially carpets. Aubusson in France had a long history of tapestry-weaving, and Louis XIV granted it the status of Royal Manufactory in 1665. It specialized in BASSE LISSE weaving.

aureole Light shown as encircling the head or body of a sacred personage. (See also GLORY, MANDORLA, NIMBUS.)

auricular style A complicated style of ornament popular in Northern Europe in the very late 16th and early 17th c., and transitional from MANNERISM to the BAROQUE. So named from its resemblance to the cartilage of the human ear. Synonym: lobate style.

autodestructive art A type of art prevalent in the 1960s and 1970s which is designed to bring about its own disintegration.

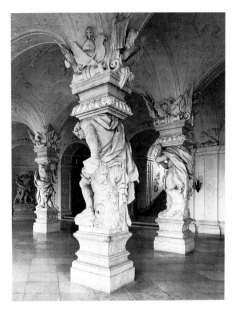

Atlantes *in Baroque style supporting a vault in the Upper Belvedere, Vienna, c. 1715.*

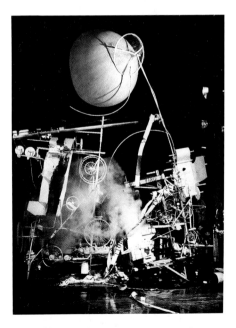

Jean Tinguely's **autodestructive** *sculpture,* Hommage à New York, *1960, in action at the Museum of Modern Art, New York.*

autograph A painting or drawing believed to be wholly by the hand of a particular artist, who can be named with certainty.

automata (sing. **automaton**) Figures animated by clockwork and other mechanisms, usually on a miniature scale but sometimes lifesize. They were known to the Ancient Greeks and to the Arabs, but were particularly popular in Europe during the late Middle Ages and in the RENAISSANCE. At this time they formed part of large clocks (some are still in working order) and were used as elaborate table decorations at feasts.

Automatism, automatic writing The 'automatic' use of brush or pencil, without rational control and thus at the prompting of subconscious impulses. First suggested by the SURREALISTS, and later greatly developed by the ABSTRACT EXPRESSIONISTS.

avant-garde Seeming to be ahead of its time.

avatar (fr. Skr. *avatara*, 'descent') In Hindu religion, the incarnation of a divine being which descends into the world to restore order – thus, for example, a statue might represent an avatar of Vishnu.

axis The imaginary straight line passing through a figure, a FACADE, a ground PLAN, or a pictorial or sculptural composition, and on either side of which the main parts are arranged so as to give an impression of BALANCE.

azulejos (Sp.) Painted and GLAZED POTTERY tiles, with floral patterns, landscapes, etc., used for the decoration of buildings in Spain, Portugal and Latin America.

B

Backsteingotik (Ger. 'brick Gothic') The simplified brick-built GOTHIC architecture typical of North Germany. The style reached its peak in the 14th c.

'Bad Painting' The American version of NEO-EXPRESSIONISM.

baguette See MOULDING.

bailey See MOTTE-AND-BAILEY.

balance The impression of equilibrium in a pictorial or sculptural composition. In order to achieve it, the forms are generally arranged about an axis. Balance depends both on the arrangement of forms (a small form which is further from the imagined fulcrum or point of rest may be a perfectly adequate counterweight to a large one which is much nearer the same point) and on COLOUR (a dark form looks heavier than a light form of the same size, even though it will also look smaller). It also depends on associative and psychological factors: for example, if the form is not abstract, but represents something the viewer knows to be heavy in reality, then he or she will experience it as heavy. Similarly, if it represents something the viewer thinks of as being particularly expressive – a face, for instance – he or she will automatically give it added importance, and therefore weight, when assessing the balance of the composition.

baldachin, baldachino (It.), **baldaquin** (Fr.) 1. Originally, a textile CANOPY supported by poles at the four corners. 2. Later, an architectural canopy in one of several forms. They were sometimes placed over the high altars in BAROQUE churches. The most famous example is the one designed by Gianlorenzo Bernini in St Peter's, Rome. They can also be hung from a ceiling, project from a wall, or be supported by COLUMNS, which are often twisted.

ball-flower ornament An ornament common in GOTHIC architecture, showing a three-petalled flower partly open to reveal a sphere. It was used to enrich concave MOULDINGS. ★

balloon-frame construction Fast, cheap and light method of wooden FRAME CONSTRUCTION developed in North America in the mid 19th c. Wooden uprights (studs) run from floor sill to eaves, with the floors attached to them.

baluster A small post or PILLAR, generally circular in section, with a curving outline.

balustrade A railing supported by short PILLARS (which are often but not always BALUSTER-shaped) or alternatively by ornamental OPENWORK panels.

bambocciata (It., pl. **bambocciate**) **bambocciade, bambochade** (Fr.) (fr. It. *bamboccio*, 'doll') A type of small painting, originally produced by northern European artists working in Italy in the 17th c., showing low-life and

peasant scenes with many small figures. The Italian word *bamboccio* can mean both a doll or a puppet, and a daub or bad painting. Some authorities refer the origin of the name to the nickname of the Dutch artist Pieter van Laer (1592/5–1642), nicknamed Il Bamboccio because of his low stature, and who painted such scenes. See also SCHILDERSBENT.

banderole (Fr.) 1. A long streamer with a split end. 2. A painted or carved ribbon-like scroll carrying an inscription.

banding Cabinet-making term for a decorative border made of a wooden INLAY in a contrasting colour to the rest of the piece. When the band consists of pieces set in a herringbone pattern, it is sometimes known as feather banding. When they are cut across the grain, it is called cross banding, and when with the grain, straight banding.

baptistery A small building, separate from the main church, and often octagonal or circular, in which the rite of baptism was often performed in Early Christian and medieval times.

barbarian art Art produced by various neolithic and Bronze Age peoples throughout Europe, which were organized as tribes rather than fully developed nations. ANIMAL INTERLACE is one of its typical characteristics.

barbican A fortified structure, either detached or projecting from a city or castle wall and designed to protect the entrance to it.

Barbizon School A group of French landscape painters who lived and worked in the village of Barbizon on the outskirts of the Forest of Fontainebleau *c.* 1835–*c.* 1870. The most important were Théodore Rousseau, Corot, Millet and Daubigny. Their style was NATURALISTIC, and marks the transition between ROMANTICISM and IMPRESSIONISM.

barbotine (Fr., fr. *barboter*, 'to daub') A freehand technique of decorating POTTERY in RELIEF with soft, almost liquid clay. The method was similar to piping icing onto a cake, using a bag and nozzle. Particularly associated with Gallo-Roman and Romano-British pottery.

barge-board A board fixed under the slope of a GABLE to protect the ends of the roof-timbers. (BLACK-AND-WHITE STYLE.★)

bargueño See VARGUEÑO.

bark cloth Synonym of TAPA.

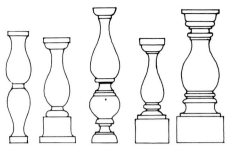

Types of **baluster**, *dating from the Renaissance.*

Scenes from Roman Life, a **bambocciata** *by Pieter van Laer, 1856.*

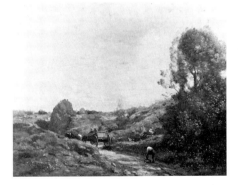

A typically informal and unambitious **Barbizon School** *landscape,* Cart – Souvenir of Marcoussis, *c. 1827, by Jean-Baptiste Corot.*

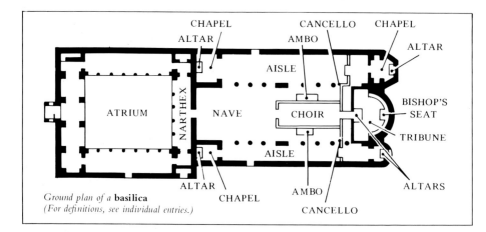

Ground plan of a **basilica**
(For definitions, see individual entries.)

Baroque, the Term coined by 19th-c. art historians for the prevailing style in Western European art *c.* 1580–early 18th c., their implication being that this art was essentially capricious and florid. In fact the Baroque combined many things: a revolt against MANNERISM and its intellectualism, elitism and emotional coldness, plus a desire to serve the religious impulse of the Counter-Reformation by creating religious types which were accessible to the masses, and also an interest in dynamic movement and theatrical effects. The most typical works of art produced under the Baroque combine architecture, sculpture and painting to create a synthesis which has a greater impact than any of these taken separately. (ATLANTES.★)

basaltes A hard black unglazed STONEWARE invented by Josiah Wedgwood and first produced in 1766.

base 1. The bottom COURSE of masonry in a wall. 2. The projecting series of blocks and MOULDINGS between the shaft of a column and its PLINTH. (ORDERS OF ARCHITECTURE,★ PEDESTAL★) 3. The PLINTH of a statue. 4. The lowest part of wall-panelling.

basement 1. In CLASSICAL architecture, synonym of PODIUM, especially one which is not solid masonry. 2. The lowest storey of a building, sometimes below ground and usually less tall than the storey immediately above it.

basilica (Gk 'royal') 1. Originally a COLONNADED hall built for a purely secular purpose. The type is thought to have been a Roman development of a Greek temple, providing more interior space, and it first appears in the 2nd c. BC. When Constantine recognized Christianity as an official religion in AD 312 and it at last became possible to celebrate Christian rites publicly, the basilica was adopted for this use. 2. By extension, any important church, often one with special privileges from the Pope.

basse lisse (Fr. 'low heddle') One of the two main types of TAPESTRY. It is made (as distinct from HAUTE LISSE) with the WARP stretched horizontally between rollers, with the CARTOON beneath, and manipulated by a treadle mechanism. Characteristic of BEAUVAIS and AUBUSSON tapestries. Synonym: low warp.

basse taille See ENAMEL.

basso rilievo See RELIEF.

batik (Javanese 'painted') A textile pattern-dyed by means of a wax resist process. The design is first painted on the fabric in wax, so that when the fabric is dyed these parts will not take the dye, but retain the original colour.

batten A thin strip of wood used as a point of attachment for slates or tiles, or as a basis for plastering.

batter The sloping face of a wall.

battle-piece 1. A type of composition popular in the 17th and 18th c. which tried to catch the atmosphere of battle rather than represent any specific conflict. They were often done on a comparatively small scale. 2. More generally, any painting or sculpture representing a battle.

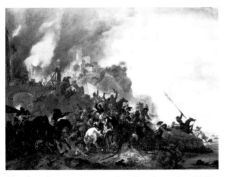

Cavalry Engagement, *a* **battle-piece** *by Philips Wouvermans (1619–68).*

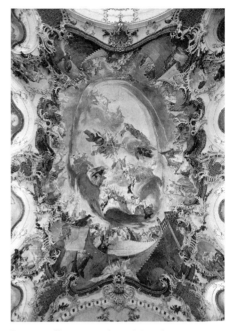

Baroque *illusionism with much use of* sotto in sù: *a ceiling painting in the church of Zwiefalten, Bavaria, by Johann Georg Bergmüller (1688–1762).*

Bauhaus (Ger. 'Building House') A design school founded under the leadership of the architect Walter Gropius at Weimar in 1919, which continued and extended the pre-war tradition of the DEUTSCHER WERKBUND. Its aim was to bring together all the arts under the primacy of architecture. After following the EXPRESSIONISTS in emphasizing creative intuition, the Bauhaus soon moved towards the modern world of industry, with teaching methods which stressed the need for a rational, practical approach to design problems, linked to the new doctrines of CONSTRUCTIVISM and NEO-PLASTICISM.

bay A division of a building, either inside or out, which is created by supporting members such as walls, COLUMNS, ROOF-TRUSSES or BUTTRESSES. See also bay WINDOW. (GOTHIC CATHEDRAL, section.★)

bead, beading See MOULDING.

bead-and-reel An architectural ornament consisting of alternate hemispherical (or elliptical) and oblong elements, used to enrich MOULDINGS.★

beakhead An ornamental motif in the shape of a bird's head and beak (more rarely, a beak with extended tongue) used to enrich MOULDINGS★ in NORMAN architecture.

beam-and-post Synonym of TRABEATED.

bearing wall, load-bearing wall A wall which supports part of the weight of the structure to which it belongs, as distinct from a wall which supports no weight.

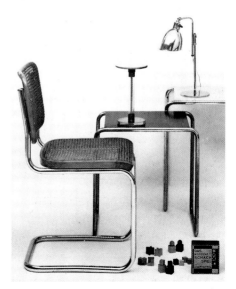

Typical **Bauhaus** *artefacts, including a cantilevered chair by Marcel Breuer, 1928.*

Beauvais Any type of TAPESTRY made at Beauvais. Many were produced, including VERDURES, COMMEDIA DELL' ARTE tapestries, CHINOISERIE, and also (later) carpets and furniture covers. The factory was founded under the patronage of Louis XIV in 1664 and amalgamated with the GOBELINS factory in 1940.

Beaux-Arts, Beaux-Arts tradition 1. Associated with the Ecole des Beaux-Arts in Paris (founded 1671), or with the French government's fine art department, also known as the Beaux-Arts. 2. In architecture, an ACADEMIC and ECLECTIC style of the 19th and 20th c., practised by graduates of the Ecole des Beaux-Arts and those following the same principles.

belfry 1. The upper storey of a tower in which bells are hung. 2. The bell-tower taken as a whole. (See also CAMPANILE.) 3. A timber frame inside a church steeple supporting a bell or bells.

Bellarmine A globular or pear-shaped STONEWARE jug with a bearded mask on or below the neck. Made in the Catholic Rhineland from the 16th to the 19th c., and named after Cardinal Bellarmine (1542–1621), a stern supporter of the Counter-Reformation, whom the mask was supposed to resemble.

bell-metal An ALLOY of copper and tin (4:1). Bells are made of it because of its resonance.

belvedere (It. 'beautiful view') Synonym of GAZEBO.

bema (Gk 'step') The SANCTUARY of an Armenian or GREEK ORTHODOX CHURCH,★ raised one or more steps higher than the NAVE.

benizuri-e (Jap. 'red-printed picture') A PRINT where the colour has been applied from more than one block, rather than hand coloured. See WOODBLOCK PRINT.

bentwood Plywood in sheet or rod form, bent under steam heat into curving forms. Often used to make furniture. First used commercially on a large scale by the Austrian designer Michael Thonet (1796–1871). Later employed in furniture designed by the architects Alvar Aalto (1899–1976) and Marcel Breuer (1902–81).

bestiary Strictly speaking, a moralized natural history, derived from the Greek *Physiologus*, containing a collection of illustrations of known and fabulous animals, usually with moral texts attached. Medieval bestiaries were often used as source material by illuminators and carvers of MISERICORDS and roof-BOSSES.

béton brut (Fr. 'concrete in the raw') Concrete left in the raw state after the removal of the formwork or SHUTTERING. Sometimes shuttering with a marked grain is used as this leaves a decorative impress on the concrete surface. (BRUTALISM.★)

bevel The slope or rounding-off of an acute angle in architecture, cabinet-making, etc.

bezant (name of an old Byzantine coin) A ROMANESQUE architectural ornament of flat discs closely spaced.

bezel 1. The setting for a stone in a piece of jewellery, especially a ring. 2. The metal frame which retains a watch- or clock-glass firmly in position. 3. The inner rim on a cover or lid of some kind, especially the lid of a box. 4. Synonym of BEVEL.

bibelot (Fr.) A small trinket or ornament.

Biblia Pauperum (Lat. 'Bible of the Poor') An illustrated book, in manuscript or printed, showing in pictures how the Life of Christ was prefigured in the Old Testament. It was devised in southern Germany in the late 13th c., and with the invention of printing was issued as a BLOCK BOOK. Typically, it contained 120 illustrations, divided into 40 sets, each of 3 juxtaposed subjects. Such books were a major source of inspiration for sculpture, TAPESTRIES and STAINED GLASS.

Bidri ware (fr. Bidar, a town in India) Articles made of DAMASCENED BELL-METAL from India.

Biedermeier A term used to describe the Central European decorative arts of the period 1820–40, which put a strong emphasis on unpretentious bourgeois comfort. The word derives from Gottlieb Biedermeier, a fictional character invented by the German satirical journal *Fliegende Blätter* to typify middle-class vulgarity. In fact, much Biedermeier furniture is simple and well-proportioned, and anticipates the 20th-c. tradition of FUNCTIONALISM.

binder 1. In painting, any substance (e.g. oil, gum arabic, CASEIN) mixed with PIGMENT in order to make it adhere to a surface. 2. In timber flooring, a beam supporting the joists.

biomorphic (Used in connection with ABSTRACT ART.) Containing irregular abstract forms based on shapes found in nature. These

Thonet **bentwood** *chair of c. 1900. The various parts could be unscrewed and packed flat.*

Biedermeier: *a walnut chair, 1820–25. The use of a native European wood is typical of the style.*

forms are frequently found in SURREALISM, for example in the paintings of Yves Tanguy and in the sculpture of Hans Arp.

biscuit Unglazed CERAMIC, particularly POR-CELAIN, which is either not yet GLAZED, or which is to be left as it is. Biscuit porcelain, also incorrectly called *bisque*, is often employed to make miniature versions of marble statuary. It takes its name from its grainy texture.

bisque See BISCUIT.

bistre (Fr.) Transparent brown PIGMENT made by boiling soot, often used as a WASH in pen-and-ink drawings.

biting in A term used in ETCHING to describe the action of acid on those parts of the copper or steel plate from which the protective GROUND has been removed.

bitumen Chemically unstable brown PIGMENT which never dries and which becomes darker and more opaque with age. At the same time it develops a marked CRAQUELURE. Its use as an underpaint in paintings dating from the late

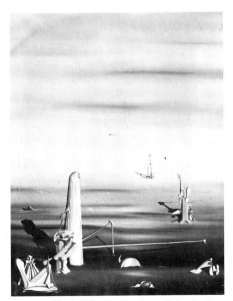

Biomorphic *forms in* The Sun in its Casket *by Yves Tanguy, 1937.*

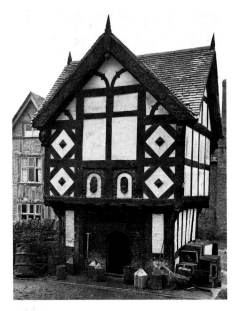

The Buttas at King's Pyon, Herefordshire, 1632, in the **black-and-white style**. Note the barge-board adorning the gable.

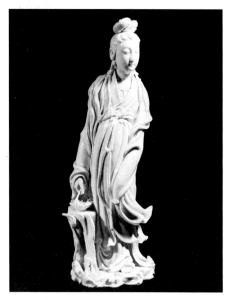

Porcelain figure of the goddess Kuan Yin, perhaps the most typical subject in **blanc de chine**. Ch'ing dynasty.

18th and early 19th c. (for example in the work of Sir Joshua Reynolds) has caused extensive damage. It is less harmful as a GLAZE.

bizarre silks Silks with asymmetrical designs of flowers and foliage, influenced by Oriental textiles but in fact produced in Europe (notably at Lyons and in Spitalfields) c. 1695–c. 1720.

black letter The earliest group of TYPEFACES, ★ also known as 'Gothic', which imitate Latin scripts of post-12th-c. origin (see CALLIGRAPHY★). They are characterized by broad main strokes, fine hair strokes, compressed letter forms and an avoidance of curves, and were used in Germany and Austria until after the Second World War. See also FRAKTUR, LETTRE BÂTARDE, SCHWABACHER.

black-and-white style A kind of HALF-TIMBERING characteristic of the English Midlands, where a fairly elaborate timber framework is left visible and is painted or stained black, with white-painted PLASTER filling the spaces in between.

black-figure A style of Greek vase painting of the 7th and 6th c. BC in which the decoration appears in black against a red GROUND. The decoration was painted on, using a mixture of clay containing iron oxide, rain water and wood ash. Under appropriate firing conditions the mixture changed from red to black, while the rest of the pot remained red. Black-figure was succeeded by RED-FIGURE.

blanc de chine (Fr. 'China white') Term, originating in 18th-c. France, for the translucent white PORCELAIN, without painted decoration, made at Tê Hua (Fukien Province) in China from the 17th c. onwards.

Blaue Reiter, Der (Ger. 'The Blue Rider') Name adopted by a group of AVANT-GARDE EXPRESSIONIST artists who came together in Munich in 1911. Founder members included Wassily Kandinsky and Franz Marc, and the source of the name was the title of a painting by Kandinsky. After exhibiting twice in Munich, in 1911 and 1912, the group held a show in Berlin, at the STURM gallery. It was dispersed by the war, in 1914. Der Blaue Reiter's aims were never precisely defined, but its members did profess a general desire to go, as they put it, 'behind the veil of appearances.' This streak of spirituality and mysticism makes the group a late offshoot of SYMBOLISM.

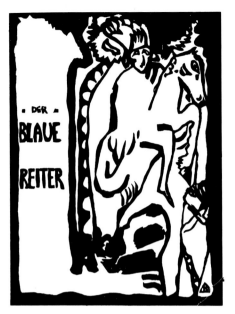

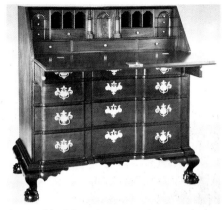

American **blockfront** *bureau in mahogany, 18th c.*

(Above) The dust-jacket of the **Blaue Reiter** *almanac, designed by Wassily Kandinsky.*

(Right) **Blot drawing:** *a landscape in watercolour by Alexander Cozens (1717–86).*

bleed 1. In painting, the seeping through to the surface of a colour underneath. 2. In printing, the technique of making an illustration extend beyond the intended edge of a page, so that when the page is trimmed the illustration appears without a margin.

blind blocked, blind stamped, blind tooled (Used of leather bookbindings.) Ornamented by the impress of BLOCKS, DIES or tools, without the addition of gold or colour. See TOOLING.

block 1. A piece of wood, or later metal, ENGRAVED in RELIEF, which is used to print an image onto a surface, or stamp one into it.

block-books Books printed from whole-page BLOCKS, as opposed to books printed from movable type. The earliest European block-books date from *c.* 1440–50. Few were printed after 1500. See also BIBLIA PAUPERUM.

blockfront A feature of much American 18th-c. CASE-FURNITURE, in which the front is composed of a central concave section flanked by two shallow convex sections.

blocking course See BRICKWORK, STONE-WORK.

bloom Increasing opacity which develops on varnished surfaces, especially in damp conditions.

blot drawing A technique described by the English watercolourist Alexander Cozens in his book *A New Method for Assisting the Invention in Drawing Original Compositions of Landscapes* (1786). Cozens proposed that the design be developed from some purely accidental mark or blot. SURREALISM made use of similar 'chance' methods in the 20th c., prompted by both Freud and Leonardo.

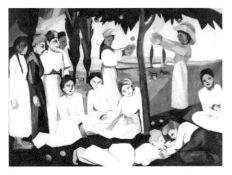

Picking Apples, *1909, by Natalia Goncharova of the* **Blue Rose Group**, *showing neo-primitive and Fauve influence.*

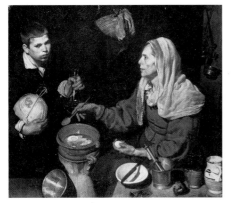

Old Woman Frying Eggs, *1618, one of the earliest examples of a* **bodegón**, *by Velásquez.*

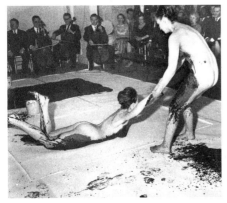

Body Art: Anthropometries of the Blue Period, *a performance by Yves Klein in 1960 at the Galerie Internationale d'Art Contemporain, Paris.*

Blue Rose Group (from Russian, *Golubaya Roza*) Russian AVANT-GARDE group, influenced both by SYMBOLISM and by FAUVISM. It published a magazine called *The Golden Fleece* (1906–07), and held exhibitions from 1907 onwards. Prominent members were Larionov and Goncharova. Its members were pioneers of the new PRIMITIVISM in Russian art.

boasted work Stone chiselled to the approximate shape of the final carving.

bocage (Fr. 'grove, thicket') Closely clustered PORCELAIN flowers, leaves or branches.

bodegón (Sp. 'tavern') A Spanish painting whose subject is primarily STILL-LIFE, though in the background there may be an interior, with or without figures.

bodhisattva (Skr. 'one whose essence is perfect knowledge') A saintly and compassionate being destined to become a Buddha, but choosing selflessly to remain on earth to help others. Often represented in Buddhist art.

body 1. In GOUACHE, a white filler used to make the paint opaque. 2. In oil painting, the density of the PIGMENT. 3. In CERAMICS, the type of clay of which a particular ware is made. 4. Also in ceramics, the main part of a vessel, as opposed to the GLAZE and any added features such as the lid, handles, surface decoration, etc.

Body Art A type of ACTION or HAPPENING, in which the artist uses his or her own body as the primary medium of expression. The term has been used from c. 1967. Synonym: Living Sculpture.

body colour Synonym of GOUACHE.

boiserie (Fr. 'wooden panelling') Panelling, often richly carved and painted, as found in French interiors of the 17th and 18th c.

bolection See MOULDING.

Bolognese Classicism The CLASSICALLY inspired BAROQUE art practised by Annibale, Agostino and Lodovico Carracci in Bologna in the first half of the 17th c., and later by their followers. Sometimes called ROMAN CLASSICISM, since many artists connected with the style moved to Rome to work for the Popes and the Papal Court.

bolus ground Reddish-brown clay preparation used as a GROUND in oil painting and also for gilding.

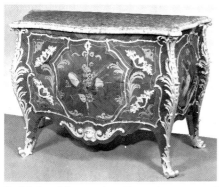

English **bombé** *commode with ormolu mounts and marquetry decoration, attributed to Pierre Langlois (fl. 1760).*

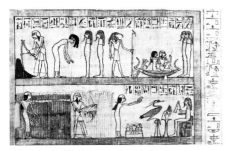

Ancient Egyptian **Book of the Dead**, *showing labours in the hereafter. The scenes are arranged in registers, with hieroglyphic inscriptions.*

Boiserie *in the Cabinet du Conseil de Louis XV, Versailles; an example of early, restrained Rococo, with two cartouches.*

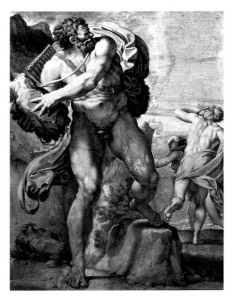

Bolognese Classicism: *a detail from Annibale Carracci's fresco of* Polyphemus Killing Acis *in the Palazzo Farnese, Rome, c. 1597–99.*

bombé (Fr. 'blown out') A convex shape on two or more axes. Used especially of furniture in the ROCOCO style.

bone china Translucent PORCELAIN containing bone ash, first manufactured in England c. 1748.

Book of Hours A book of prayers to be said at the canonical Hours, intended for a lay person's private devotion (e.g. Hours of the Blessed Virgin). Popular in the late Middle Ages and often containing rich ILLUMINATION.

Book of the Dead A modern term for a miscellaneous collection of formulae and incantations found inscribed on the PAPYRI which the Ancient Egyptians buried with their dead. The best examples, dating from the 18th and 19th dynasties (16th–13th c. BC), are finely illustrated.

Boulle marquetry: *an early 18th-c. cabinet attributed to André-Charles Boulle.*

Terracotta bozzetto *by Bernini for Pope Alexander VII's tomb, c. 1670.*

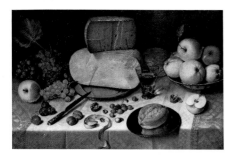

Floris van Dyck's Ontbijtje ('breakfast piece') *of 1613.*

boss A projecting ornament. In GOTHIC architecture, often placed at the intersection of RIBS or GROINS in a VAULT.★ (GOTHIC CATHEDRAL, section.★) See also KNOP.

bota (fr. Persian *buta*, 'flower, bush') A cone-shaped floral motif found on Indian textiles, particularly Kashmir shawls, and also on European fabrics imitating Indian patterns.

bottega (It. 'shop') 1. The workshop in which an established artist of the Italian Middle Ages or RENAISSANCE worked with his assistants. 2. A work of art which is not by the master himself but which was produced under his supervision. Synonym: shop picture.

Boulle marquetry, Buhl marquetry A luxurious form of VENEER popularized in France by the ÉBÉNISTE A.C. Boulle (1642–1732). It consists of a pattern cut from a sheet of tortoiseshell INLAID with a pattern in brass. 'Contre-Boulle' is a sheet of brass inlaid with tortoiseshell.

box-frame construction A type of concrete construction which is made of identical cells, one on top of the other, with the load taken on all the walls, rather than on vertical supports running the height of the building.

bozzetto (fr. It. *bozzo*, 'rough stone') 1. Strictly speaking, a small three-dimensional SKETCH in wax or clay made by a sculptor in preparation for a larger and more finished work. 2. By extension, a rapid sketch in oil, made as a STUDY for a larger picture.

brace A strengthening timber used diagonally in a ROOF★ and often supporting a beam.

bracket An architectural member projecting upward and outward from a vertical surface to support something above it.

brattishing In English late GOTHIC architecture, ornament along the top of a screen. It consists of foliage and small CRENELLATIONS.

breakfast piece A STILL-LIFE showing various items of food and drink, usually piled up in

some disorder. The term is often reserved for Dutch 17th-c. paintings of this type, especially those of the Haarlem School.

break-front On a piece of CASE-FURNITURE, a slightly projecting central section.

bressummer (fr. Fr. *sommier*, 'cross-beam, lintel') 1. The main horizontal beam in a HALF-TIMBERED wall. 2. A heavy wooden LINTEL spanning a wide opening, such as a large fireplace.

breviary A book containing the Offices to be said by the clergy at the canonical Hours.

brickwork, elements of
Arris. The sharp ridge formed when two surfaces of brickwork meet.
Blocking course. One or more projecting courses at the base of a building. See also STONEWORK.
Course. A continuous, usually horizontal, layer of bricks.
Footing. A course or stepped courses at the base of a wall, used to distribute the weight of the structure.
Header. 1. A brick laid crossways and if necessary cut flush with the wall, serving to strengthen it. 2. The exposed end of such a brick.
Stretcher. A brick laid lengthways.
String-course. A decorative horizontal course, usually projecting from the FAÇADE.

brickwork, types of
Brick-nogging. Brick in-filling between upright timber posts to make a wall or partition.
Chequerwork. Walls or pavements patterned with alternating squares of contrasting materials, e.g. stone with flint or brick.
English bond. Brickwork made up of alternate courses of headers and stretchers.
Flemish bond. Brickwork in which each course is made up of alternate headers and stretchers.
Gauged brickwork. Bricks rubbed or cut to a particular size or shape, e.g. to make the blocks, or VOUSSOIRS, of an ARCH.★ Synonym: rubbed brickwork.
Herringbone work. Bricks laid on a diagonal, with alternate courses facing in opposite directions.
Rubbed brickwork. Synonym of gauged brickwork.
See also MATHEMATICAL TILES.

bright cut decoration A type of ENGRAVING on late 18th- and 19th-c. silver which uses small, crisply cut marks arranged in geometrical patterns at an angle to give a glittering effect. The technique resembles CHIP CARVING in wood.

brise-soleil (Fr. 'sun-break') A LOUVRED sun-screen incorporated into the FAÇADE of a building to reduce glare. The device was invented by the architect Le Corbusier in 1933.

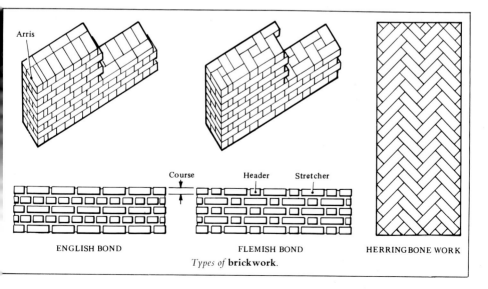

ENGLISH BOND FLEMISH BOND HERRINGBONE WORK

Types of **brickwork**.

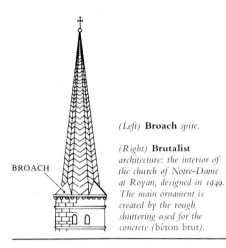

(Left) **Broach** *spire.*

(Right) **Brutalist** *architecture: the interior of the church of Notre-Dame at Royan, designed in 1949. The main ornament is created by the rough shuttering used for the concrete* (béton brut).

BROACH

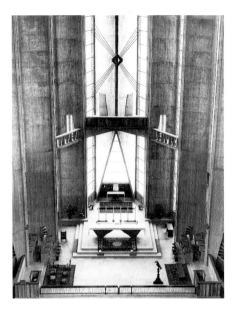

Britannia metal, white metal An ALLOY of tin, antimony and copper, used as a cheaper and more easily worked substitute for pewter. Large-scale manufacture started *c.* 1780 in England.

broach The part of a church STEEPLE that links an octagonal SPIRE to the square tower beneath.

broad manner Italian RENAISSANCE style of ENGRAVING where the design is rendered in combinations of thick lines, giving a bold effect. The 'fine manner' uses thinner lines, giving a greater degree of tonal gradation.

brocade A fabric with a raised pattern created during the weaving process by using supplementary WEFTS which are brought to the surface of the cloth when this raised pattern occurs.

broken pediment 1. A PEDIMENT whose upper angle is left open, or where the upper segmental curve has its central section missing. In both these cases the gap is often filled by a PLINTH, or a plinth carrying a vase or ornament. 2. A pediment where the base MOULDING is interrupted and left open.

Brücke, Die (Ger. 'The Bridge') An association of German AVANT-GARDE painters formed in Dresden in 1905. It included most of the leading German EXPRESSIONISTS, among them Kirchner, Schmidt-Rottluff, Heckel, Pechstein and Nolde. The group was disbanded in 1913.

brushwork The painter's 'handwriting', as expressed by the marks made by his brushes on the paint surface.

Brutalism Term coined in England in 1954 to describe the late architectural work of Le Corbusier and that of British contemporaries who were influenced by him. Brutalism makes extensive use of BÉTON BRUT and leaves functional objects undisguised.

bucchero Etruscan all-black POTTERY, dating from *c.* 8th c. BC, often in forms imitating metalwork and made from iron-bearing clay.

bucranium, bucrane (fr. Gk *boukranion*, 'ox-head') A decorative motif based on the horned skull of an ox. Often used as a repetitive unit in a FRIEZE.

buffet 1. A piece of 16th-c. furniture consisting of two or more tiers of open shelves and designed to stand against a wall. 2. A sideboard.

Buhl See BOULLE.

burin (Fr.) An ENGRAVING tool consisting of a short steel rod, usually of square section and cut obliquely at the end to make a diamond-section point. The rod is provided with a rounded wooden handle and is pushed by the palm of the hand. Synonym: graver.

burr 1. In PRINT-making and metal-working, the ridge of waste metal raised by the BURIN when a metal plate is ENGRAVED. Burr is retained in DRYPOINT engraving, as it softens the outlines and makes a characteristic part of the

intended effect. 2. In wood-working, the decoratively marked wood cut from an excrescence on the trunk of a tree, or from the root. It is used in making patterned VENEER.

bust A sculpted portrait or representation consisting of the head and part of the shoulders. (The word is sometimes, but wrongly, applied to the head alone.)

buttress A support built against the wall of a building, either inside or out. (GOTHIC CATHEDRAL, section.★)

byobu (Jap.) A Japanese movable screen.

Byzantine Of the art of the East Roman Empire, from the 5th c. AD to the fall of Constantinople in 1453. Such art is usually HIERATIC and other-worldly.

C

cabinet 1. In the 17th and 18th c., a small retiring room. 2. Now a piece of CASE-FURNITURE fitted with small drawers or pigeon-holes, which are usually concealed behind doors.

cabinet of curiosities 1. In the 17th and 18th c., a cabinet in which a collection of precious objects was kept. 2. The collection itself.

cabinet photograph A portrait photograph $5\frac{1}{2} \times 4$ in. (14×10 cm), on a mount $6\frac{1}{2} \times 4\frac{1}{2}$ in. (16.5×11.5 cm) popular from c. 1866 as an improvement on the CARTE DE VISITE.

cabinet picture A small, finely finished picture, with the quality of a precious object, which can be examined closely and at leisure. The term derives from the CABINET OF CURIOSITIES, where such objects were displayed.

cabinet-maker 1. Originally, a maker of CASE-FURNITURE, usually VENEERED, as opposed to seat-furniture. 2. By extension, any skilled maker of furniture.

cabochon 1. A smoothly convex, unfacetted GEMSTONE. 2. Any ornament resembling such a stone.

cabriole leg (fr. Lat. *caper*, 'goat') A type of curving leg on a piece of furniture, so called from its supposed resemblance to a goat's leg. It can terminate in a club, hoof, bun, paw, claw-and-ball or scroll foot.

Byzantine *icon of the early 12th c., depicting the Virgin of Vladimir.*

Chippendale-style side chair with **cabriole legs***, claw-and-ball feet, an openwork splat and green damask upholstery, c. 1745.*

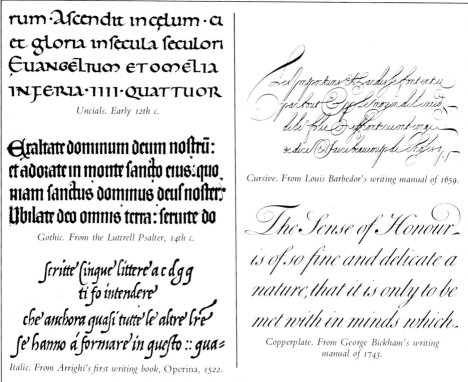

rum ·Aſcendit inçdum · a
et gloria inſecula ſeculori
Euangeltum etomélia
INFERIA·IIII·QUATTUOR

Uncials. Early 12th c.

Exaltate dominum deum noſtrū:
et adorate in monte ſancto eius: quo,
niam ſanctus dominus deuſ noſter:
Ubilate deo omnis terra: ſeruite do

Gothic. From the Luttrell Psalter, 14th c.

ſcritte' (inque' littere' a c d g g
ti ſo intendere'
che' anchora quaſi tutte' le' altre' lre'
ſe' hanno á formare' in queſto :: gua=

Italic. From Arrighi's first writing book, Operina, 1522.

Cursive. From Louis Barbedor's writing manual of 1659.

Copperplate. From George Bickham's writing manual of 1743.

Types of **calligraphy**. (For definitions, see individual entries.)

caisson (Fr., fr. It. *cassone*, 'chest') A sunken panel in a COFFERED ceiling. Synonym: lacunar.

calathus The inner bell-shaped core of a CAPITAL of the Corinthian ORDER OF ARCHITECTURE. ★

calligraphic painting 1. Modern art, usually ABSTRACT, and dating from the 1940s onwards, which puts the stress on the 'written' quality of the brush-stroke, with a consequent resemblance to oriental CALLIGRAPHY. 2. Chinese and Japanese ink-paintings, made with the same brush as for writing and built up from the same repertoire of strokes.

calligraphy Ornamental writing, done in the West mainly with a pen, in China and Japan with a brush. See also COPPERPLATE, CURSIVE, ITALIC, UNCIALS.

Callot figures Grotesque figures of dwarfs, found in 18th-c. goldsmiths' work and as decorations on PORCELAIN, which resemble Jacques Callot's series of ENGRAVINGS, *Varie*

figure gobbi, published in 1622, but were in fact based on a series of PRINTS after drawings imitating Callot by Wilhelmus Koning, published in Amsterdam in 1716.

calotype The earliest practicable negative-and-positive photographic process on paper, based on the discovery of the LATENT IMAGE.

calvary A sculptured representation of the Crucifixion, often with attendant saints.

camaïeu, en (Fr. 'like a cameo') 1. Painting in MONOCHROME, usually attempting to give the spectator the illusion that the image is carved in RELIEF. 2. See ENAMEL.

Camden Town Group An association of exhibitors at the POST-IMPRESSIONIST Exhibition of 1910–11 led by W.R. Sickert, and including artists such as Harold Gilman and Spencer Frederick Gore. They took their name from the fact that much of their subject-matter was found in the then run-down district of Camden Town in London.

Centre Agité Dominé, *a* **calligraphic painting** *by Mark Tobey, 1960, showing the influence of oriental calligraphy.*

Mornington Crescent, *Camden Town, by Spencer Gore, a member of the* **Camden Town Group**, *c. 1911.*

came See LEADED GLAZING.

cameo A GEMSTONE (or sometimes GLASS, CERAMIC or shell) which has layers of different colours, carved or moulded so that the design stands out in RELIEF in one colour against the background of the other. The opposite of an INTAGLIO.

Roman onyx **cameo** *of c. AD 12.*

camera lucida (Lat. 'light room') A device with the same effect as a CAMERA OBSCURA, but using a prism to concentrate and project the light from the object onto a piece of paper, on which it can be traced.

camera obscura (Lat. 'dark room') A darkened box with a hole (or lens) in one side which casts an image of the object onto a ground GLASS screen or a sheet of paper, which can then be traced. Canaletto used the device to make studies for his paintings. (A photographic camera works on the same principle, throwing the image onto a light-sensitive surface which retains it.)

Engraving of a **camera obscura**, *1835. Note the typical inversion of the image on the screen.*

Camp: Zeus and Ganymede, *1981–82, an ironic view of one of the icons of mass culture, the American cowboy, from the 'Gay Rodeo' series by Delmas Howe.*

The **campanile** *and piazza of St Mark's, Venice, with arcades on either side and the domes of St Mark's cathedral visible in the background.*

camp Theatrical and homosexual term taken over into the modern arts vocabulary to describe a kind of urban dandyism based on ironic appreciation of mass culture.

campanile (It. 'bell-tower') An Italian BELFRY, often one detached from the main building.

campo santo Italian for cemetery (lit. 'holy field').

cancello (It. 'iron railing', pl. **cancelli**) A latticed screen dividing the SANCTUARY from the rest of a BASILICA★ or Early Christian church.

canephora (Gk 'basket-bearer') 1. A CARYATID bearing on her head a basket which serves as a CAPITAL. 2. Any ornamental female figure, in RELIEF or free-standing, bearing a basket on her head.

Canon of Proportion In art, particularly sculpture, a mathematical formula establishing ideal proportions of the various parts of the body (human and animal), e.g. the relationship of head to torso. Such ratios began to be established very early – certainly under the Ancient Egyptians – and were well known to the Greek sculptors of the 5th c. BC.

canopic vase (fr. Lat. Canopus, a town in Ancient Egypt) A vase with a cover in the form of a human or animal head, first made by the Ancient Egyptians to hold embalmed entrails and later copied as a decorative object by Wedgwood in the 18th c.

canopy 1. In architecture, a small projecting roof-like structure, often over a NICHE. 2. A covering, usually made of fabric, over a bed, throne, etc. See also BALDACHIN.

canopy of state An honorific structure, often temporary and made of wood and fabric, which is put up to shelter some royal or noble personage, e.g. over a throne.

cantilever A projecting beam (e.g. a HAMMER BEAM) which is anchored at one end by the weight of the structure above, and can therefore carry loads throughout the rest of its unsupported length.

cantilevered chair A chair whose design makes use of the cantilever principle, usually with the seat supported on a U-shaped structure of metal tubing or bentwood. Famous examples of the cantilevered chair have been

Canon of Proportion: *this drawing of 'Vitruvian Man' by Leonardo da Vinci, c. 1490, divides the figure in half at the genitals. The ratio from the top of the head to the navel, and from the navel to the soles of the feet is 1:φ (the golden section).*

Alabaster **canopic vases**, *one with a human head and one with the jackal head of the god Anubis, 21st dynasty, c. 1000 BC.*

designed in the early part of this century by Mart Stam, Marcel Breuer and Mies van der Rohe. There is some disagreement about who originally applied the idea to furniture construction.

Canton enamel Chinese painted ENAMEL on copper. The technique was introduced to China from Europe in the 18th c., and early examples are in the FAMILLE ROSE palette.

Canton School Chinese artists working in European style for European patrons in the late 18th and early 19th c. The subject-matter was much like that of the Indian COMPANY SCHOOL and included series of trades, pictures of occupations such as PORCELAIN-making and tea-growing, views of Canton, and botanical drawings.

capital In architecture, the separate member which crowns a COLUMN, PIER, PILASTER or PILLAR. It provides a broader and therefore more efficient support for the ENTABLATURE than

Cantilevered chair *by Mies van der Rohe, 1926.*

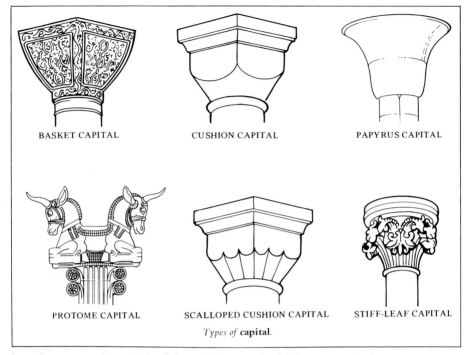

BASKET CAPITAL CUSHION CAPITAL PAPYRUS CAPITAL

PROTOME CAPITAL SCALLOPED CUSHION CAPITAL STIFF-LEAF CAPITAL

Types of **capital**.

the column, etc., alone. Each of the principal Greek ORDERS OF ARCHITECTURE★ has a capital of a different form, and many further variations are possible.

Basket capital. A block capital with intricately drilled carving which resembles basketwork. Typical of BYZANTINE architecture.

Bell capital. A capital shaped like an inverted bell.

Block capital. Synonym of cushion capital.

Composite capital. A capital which combines elements from both the Ionic and Corinthian ORDERS OF ARCHITECTURE.★

Cushion capital. A capital made from a cube-shaped block with the lower angles rounded off. Commonly met in ROMANESQUE architecture. Synonym: block capital.

Impost capital. A broad flattened capital which combines the functions of IMPOST BLOCK and capital. Found in BYZANTINE architecture.

Papyrus capital. A capital shaped like a bunch of papyrus leaves.

Protome capital. A capital consisting of two half-figures of animals back to back.

Scalloped cushion capital. A cushion capital with scalloped sides.

Stiff-leaf capital. A capital decorated with stylized foliage. Typical of English 12th- and 13th-c. GOTHIC architecture (GOTHIC REVIVAL.★)

See also ORDERS OF ARCHITECTURE.★

capriccio (It. 'caprice') A painting or PRINT showing a landscape or architectural scene, combining real and imaginary features (as opposed to a VEDUTÀ). The GENRE was much favoured in 18th-c. Venice. Synonym: vedutà ideata.

Caravaggisti A group of painters of different nationalities – e.g. Manfredi and Valentin – working in Rome in the first quarter of the 17th c. and influenced by the violent CHIAROSCURO of Caravaggio.

caravanserai (fr. Persian *kārwānsarāy*, 'caravan palace') A building, generally consisting of VAULTED shelters round a courtyard or series of courtyards, offering shelter to travellers along a caravan route.

carcass The underlying structure of a piece of VENEERED furniture.

caricature 1. Strictly, a portrait where the subject's characteristic features are exaggerated

Capriccio *with fanciful ruins on the sea shore by Francesco Guardi, c. 1775.*

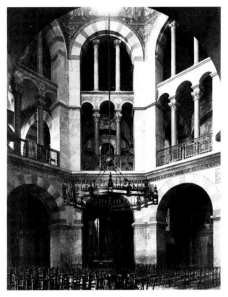

Carolingian Renaissance *architecture: the interior of the chapel at Charlemagne's palace, Aachen, AD 792–805, based on San Vitale at Ravenna, which Charlemagne considered to embody the classical tradition he aimed to revive.*

for satiric or humorous purposes. 2. Now, more loosely, almost any kind of satiric design or CARTOON.

carnations Flesh colours in painting.

Carolingian Renaissance The general revival of art and learning which took place in Western Europe (excluding Britain and Spain) under the Emperor Charlemagne and his successors (8th–10th c. AD). It represented the first conscious attempt to revive the CLASSICAL Greek and Roman heritage after the disruption caused by the Barbarian Invasions. The development of scripts – such as the UNCIAL – and manuscript ILLUMINATION, and of large-scale architecture, were among its major achievements.

'Carpenters' Gothic', 'carpenteresque' North American wooden architecture of the 19th c., ornamented with fretwork in GOTHIC REVIVAL style.

carpet page A full page of ABSTRACT patterning, sometimes incorporating sacred CIPHERS, placed opposite the conventional portrait of the Evangelist at the beginning of each of the Four Gospels in ILLUMINATED manuscripts of the Hiberno-Norse school of the 8th and 9th c. AD.

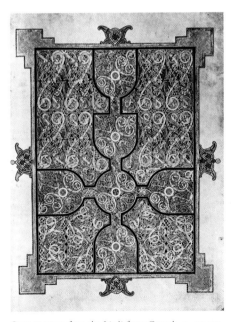

Carpet page *from the Lindisfarne Gospels, c. AD 700, showing elaborate animal interlace.*

43

Hans Schellenberger, *by Hans Burgkmair, c. 1510, featuring a* **cartellino** *which reads: 'I was twenty-five when I looked like this.'*

carte-de-visite (Fr. 'visiting-card') 1. Originally, a small portrait photograph used as a supplement to the ordinary visiting card. They were produced in quantity in the 1860s and enthusiastically collected and mounted in albums. 2. A photographic format derived from this, measuring $3\frac{3}{4} \times 2\frac{1}{4}$ in. (9.5×5.7 cm), which was used for both portraits and other subjects, e.g. landscapes.

cartel (Fr. 'notice of challenge, agreement', sometimes posted on a wall) 1. A clock-case designed to be hung on a wall. 2. The scrolled frame surrounding a painted decoration.

cartellino (It. 'small piece of paper') A TROMPE L'OEIL scroll or scrap of paper painted within a composition and used for an inscription, often the artist's signature.

cartoon 1. Originally, a full-scale preliminary design for a painting or TAPESTRY. 2. From the 19th c., a CARICATURE or comic drawing (perhaps derived from its use in connection with the

controversial designs exhibited in 1843 for the decoration of Barry's new Houses of Parliament).

cartouche (Fr. 'cartridge') 1. The oval frame used to enclose the name of an Ancient Egyptian pharaoh in an inscription. 2. By extension, any ornamental frame. (BOISERIE.★)

caryatid (fr. Gk *karuatis*, priestess at Caryae in Laconia) A female figure used in place of a COLUMN as an architectural support. See also ATLANTES, CANEPHORA, TELAMONES.

cased glass A piece of GLASS where an inner layer is covered by another of a different colour. The outer casing is blown first, and the inner layer blown into it (unlike FLASHED GLASS, where the vessel is dipped into molten glass). The outer casing is often partly cut away to reveal the colour beneath.

case-furniture Furniture intended as containers, e.g. desks, bookcases, cupboards, chests of drawers.

casein paint Any PIGMENT mixed with a BINDER made from casein (the protein of milk).

casemate A VAULTED chamber, with EMBRASURES to the exterior, built within the thickness of a wall in a fortress.

casement 1. A window-frame hinged vertically, so that it can swing open along its entire height. (WINDOW, TYPES OF.★) 2. A wide hollow MOULDING forming part of a door- or window-jamb in late GOTHIC architecture.

casino (It. 'little house') 1. A small house or ornamental pavilion built in the grounds of a larger one. 2. In the 18th c., a public saloon for dancing. 3. Today, a public gaming place.

cassone (It. 'chest') An Italian marriage chest, often of architectural form. In the 15th c. it was the custom to decorate the most important with inset PANEL paintings or 'cassone paintings'.

cast An object produced by CASTING.

castellated Ornamented with CRENELLATIONS. (MACHICOLATION.★)

casting The process of making an art object (e.g. a medal, a plaster cast) by running liquid material into a mould. Casting (as opposed to STRIKING) was the method favoured by leading RENAISSANCE medallists such as Pisanello. Types of casting include CIRE PERDUE.

catacomb An underground cemetery of linked GALLERIES and rooms with niches for tombs.

catafalque A temporary timber structure, often richly ornamented, used at a funeral service to support the coffin. Sometimes imitated in more permanent form in stone or bronze, to make a tomb.

catalogue raisonné (Fr. 'reasoned catalogue') A complete annotated catalogue of the works of one artist, usually giving PROVENANCE and bibliographical references for each work and listing ATTRIBUTED or doubtful works as well as ENGRAVINGS AFTER the artist.

cathedral A church which contains the *cathedra* or official throne of a bishop.

cathedral style 1. Synonym of TROUBADOUR STYLE. 2. A type of early 19th-c. French bookbinding, with MOTIFS derived from GOTHIC TRACERY.

catholicon (Gk) The NAVE of a GREEK ORTHO-DOX CHURCH.★

cave art The paintings, drawings and carvings of the Palaeolithic or Old Stone Age, first identified in the cave system at Altamira, Spain, in 1879.

cavea (fr. Lat. *cavus*, 'hollow') 1. The VAULTED cells under a Roman amphitheatre. 2. The whole seating space of a Greek theatre.

cavetto See MOULDING.

cavo rilievo (It. 'hollow relief') Synonym of INTAGLIO.

celadon The European name for Chinese STONEWARE or PORCELAIN with a soft olive-green GLAZE. The name probably comes from the fictional character Celadon, who wore grey-green ribbons, in Honoré d'Urfé's early 17th-c. pastoral *L'Astrée*.

cella (Lat.) The central structure of a CLASSICAL TEMPLE,★ excluding the PORTICO and COLONNADE.

cells 1. The compartments between the RIBS of a Gothic VAULT.★ 2. The individual components of a BOX-FRAME construction. 3. The spaces formed by the ribs of a geodesic DOME.★ 4. The small box-like spaces in precious metalwork made to contain stones or ENAMEL. 5. A group of enclosed units in a tightly meshed pattern, e.g. one resembling a honeycomb.

Cartouche *on a box from Tutankhamun's tomb. Among the hieroglyphic inscriptions is an ankh, centre left.*

One of a pair of Florentine **cassone**, *in carved and gilt wood, with inset paintings in tempera, 1472.*

Celadon *bowl and box with typical lotus patterns. Sung dynasty.*

(Above) **Celtic art:** *detail of the Tara brooch, decorated with interlace patterns. Bronze, set with amber and glass,* c. AD 700.

(Right) **Celtic cross** *at Ahenny, Co. Tipperary, 8th* c. AD.

Celtic art The art produced by Celtic peoples in western Europe from c. 450 BC to AD c. 700, notable for its use of asymmetrical and curvilinear ABSTRACT ornament, often combined with ZOOMORPHIC decoration. It falls into two main phases: an earlier, which was produced on the continent and often called the LA TÈNE style (to the beginning of the 1st c. AD), and a later, confined to Britain and Ireland, from about AD 150, and often showing signs of contact with Roman art. Jewellery, wood carving, pottery and metalwork are some of the most typical products of Celtic art.

Celtic cross A cross with a tall shaft, short horizontal arms and a circle centred on the point of their intersection.

cenotaph A commemorative monument erected to an individual or to a group of people whose bodies are lost or lie elsewhere.

cera colla (It. 'wax glue') A mixture of wax and glue water (size), used as a VEHICLE for TEMPERA painting by BYZANTINE and Italian PRIMITIVE artists.

ceramics A general term, in use since the 19th c., covering both PORCELAIN and all types of POTTERY.

Cercle et Carré (Fr. 'Circle and Square') Name taken by a group of artists formed in Paris in 1929 by Michel Seuphor and Joaquín Torres-García. It mixed quasi-mystical and symbolic ideas with the more rational influence of Mondrian.

cerography Synonym of ENCAUSTIC.

certosina (It.) North Italian INTARSIA of the 15th c., in a style originally associated with Carthusian monasteries, made with pieces of wood, bone and mother-of-pearl arranged in geometrical patterns.

chacmool A reclining male figure of a deity (whose significance is obscure) which was produced by a large number of PRE-COLUMBIAN cultures in Mexico, among them the Toltecs (11th–12th c.). The form of these figures influenced the British sculptor Henry Moore (1898–19).

chaitya (Skr.) An Indian Buddhist temple or prayer hall carved into the living rock.

chakra (Skr.) The disc or wheel which appears in Indian art as a sun symbol, as the weapon of the god Vishnu, and as an emblem of a concentration of psychic force.

Toltec **chacmool** *acting as a sacrificial altar*, c. AD 800–1000.

Cercle et Carré: *Joaquín Torres-Garcia's* Symmetrical Composition 1931 *represents a church façade in the early style of Mondrian, with Christian symbols such as the fish.*

Chatris *surmounting the north-west pavilion of the Ram Bagh, Agra, 1526.*

chalice A cup, usually provided with a foot and stem, and sometimes with handles, made of precious material and used for liturgical purposes. In Christian ceremonies it is used to contain the consecrated wine.

chamfer 1. An oblique surface made by bevelling an ARRIS, usually at 45°. 2. A splay at the base of an external wall.

chamfered rustication See STONEWORK.

champlevé See ENAMEL.

chancel The eastern part of a church, traditionally reserved for the clergy. It contains both the CHOIR, where divine service is sung, and the SANCTUARY, which shelters the altar, and is often divided from the rest by a screen.

chantry A small chapel where Masses could be sung for the soul of the person who had endowed the structure. (GOTHIC CATHEDRAL, plan.★)

chapter house A large room within, or a building attached to, a monastery or bishopric,

which is used for meetings (chapters) of the governing body. English GOTHIC★ examples are often octagonal, in order to stress the democratic nature of the proceedings.

charnel-house A place where human bones are deposited. It can either be part of a church or a separate building.

charpoy (fr. Persian *charpai*, 'four-footed') An Indian bed.

Chartreuse (Fr. 'charterhouse') A monastery belonging to the Carthusian order.

chasing 1. Ornament engraved on METALWORK. 2. The process of adding detail and removing small imperfections on a CAST metal object. Synonym: tooling.

chatri, chattra (Skr.) An umbrella-shaped DOME in Indian architecture. Usually built on a small scale as a subsidiary ornament.

chenet French for firedog.

chequering A pattern of alternating squares or LOZENGES of contrasting colour or texture.

47

Caravaggio's image of Amore Vincitore, *1598–99, uses* **chiaroscuro** *to stress the reality of this Roman street urchin wearing property wings.*

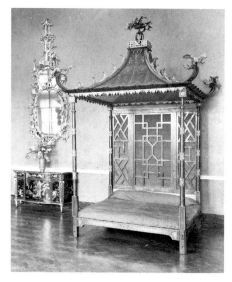

Chinese Chippendale *furniture from Badminton, Gloucestershire, c. 1760. The bed features a Chinese fret pattern.*

chequer-work See BRICKWORK, STONEWORK.

cherub 1. A MOTIF, in architecture or painting, of a child's head with a pair of wings. (LUNETTE.★) 2. More loosely, synonym of PUTTO.

chevaux-de-frise (Fr. 'Frisian horses') An arrangement of iron spikes to defend the top of a battlement (invented in the 17th c. by the Frisians who had no cavalry).

chevet (Fr. 'bolster, bedhead') The eastern end of a church beyond the CROSSING, and including the AMBULATORY and its RADIATING CHAPELS if any. (GOTHIC CATHEDRAL, plan.★)

chevron (Fr.) An ornamental device, especially a MOULDING,★ in the shape of a series of inverted Vs.

chiaroscuro (It. 'light-dark') In painting, the technique of modelling form by almost imperceptible gradations of light and dark. Its invention is generally associated with the career of Leonardo da Vinci. The effect is difficult to achieve in the clear quick-drying medium of TEMPERA, and therefore is associated with the rise of oil painting, reaching a climax in the 17th c. with the work of Caravaggio in Italy, Rembrandt in Holland, and Georges de la Tour in Lorraine.

chiaroscuro woodcut A WOODCUT printed in different colours, from several BLOCKS, so that the forms seem strongly modelled.

Chicago School A group of architects working in Chicago from the Great Fire of 1871 to the mid 1920s. They included Louis Sullivan, and the partnerships of Burnham & Root and Holabird & Roche. The Chicago School was closely connected with the evolution of the SKYSCRAPER. See also WINDOW, TYPES OF.

china Synonym of PORCELAIN.

chine See ÉPREUVE SUR CHINE.

Chinese Chippendale English CHINOISERIE furniture of the type illustrated in Thomas Chippendale's *The Gentleman and Cabinet Maker's Director* (1754).

ch'ing-pai ware (Chi. *ch'ing-pai*, 'bluish-white') Chinese PORCELAIN with a pale blue GLAZE, and usually with moulded ornament, made in Southern China during the Sung and Yüan periods. It was widely exported to the Middle East and to Europe.

chinoiserie Playful imitation of Chinese art and architecture generally associated with the ROCOCO style in 18th-c. Europe.

chip carving Sunk carved decoration made with chisel and gouge, often in roundels and geometric patterns, and found on oak furniture of the 15th and 16th c.

Chippendale English furniture in ROCOCO taste with much ornamental carving, often OPENWORK (e.g. in chairbacks and crestings). It takes its name from the designer and cabinet-maker Thomas Chippendale (1718–79), who produced a book of designs in this style in 1754, *The Gentleman and Cabinet Maker's Director.* (CABRIOLE LEG.★)

chi-rho Synonym of CHRISTOGRAM.

choir 1. Originally, the part of a church reserved for singers and clergy. (GOTHIC CATHEDRAL, plan.★) 2. Now more usually the area which extends from the CROSSING to the APSE, excluding the AMBULATORY and its RADIATING CHAPELS.

chrismatory In church architecture, a recess provided near the font to hold oil for anointing after baptism.

christogram A Christian symbol made up of the first two letters, *chi* and *rho*, of the Greek word Christos. Synonym: chi-rho.

chroma (Gk 'colour') The degree of vividness in a colour, i.e. a combination of HUE and SATURATION.

chromolithography Multicoloured LITHOGRAPHY, made by using a separate stone or PLATE for each colour.

chryselephantine Made of gold and ivory. The word is usually applied to important cult statues in ancient Greek temples, where the flesh was made of carved ivory, the drapery of gold sheet over a wooden framework.

Chün ware Chinese STONEWARE of the Sung period (AD 960–1279), made in Central Honan Province. It has a heavy BODY and a thick GLAZE which ranges from pale lavender to purple, sometimes mottled or splashed with crimson.

Churrigueresque An extravagant substyle of BAROQUE architecture and ornament found in Spain, Latin America and Portugal, named after the architect José Benito de Churriguera (1665–1725).

Chinoiserie: *detail of the porcelain room at the Museo di Capodimonte, showing Chinese figures framed by Rococo scrolls, 1757–59.*

Churrigueresque: *the altarpiece in the church of San Sebastian, Salamanca, by José Benito de Churriguera.*

ciborium (Lat.) 1. The covered receptacle in which the Eucharist is reserved in Catholic churches. 2. A CANOPY over an altar, usually of domical form and supported by COLUMNS.

cincture A ring MOULDING round the shaft of a COLUMN.

cinerarium (Lat.) A place for keeping funerary urns.

cinquecento (It. 'five hundred') The period 1500–1600 in Italian art.

cipher Interlaced initials, often forming a monogram. They are used by many artists instead of a full signature.

cippus (Lat. 'post') A short pillar used by the Romans as a landmark, or as a place for displaying notices, or sometimes as a gravestone (in which case it might carry an inscription giving the extent of the burial ground).

circle of __ Created by someone close to the artist named, in both time and place.

circus 1. In Roman times, an arena of elongated oblong form with rounded ends. 2. In the 18th and 19th c., a range of houses built to create a circle or near circle at the centre.

cire perdue (Fr. 'lost wax') A CASTING technique in which a model is first made of wax, which is then enclosed in a clay and PLASTER mould. The wax is melted out through a vent, and molten metal – usually bronze – is run in to replace it. To cast a hollow object it is necessary to insert a core of burnt clay, so that the wax occupies the thin surrounding space between this and the mould.

ciselure (Fr.) The final CHASING or smoothing of a metal object, especially one which has been CAST.

cist (fr. Lat. *cista*, 'box') 1. A lidded small bronze receptacle, used either for toilet articles or ceremonial objects, especially by the Ancient Greeks and Etruscans. 2. A somewhat larger stone or POTTERY box used to contain human remains.

cladding 1. Originally, a thin layer of one material used externally in building to protect or conceal another, for example in TILE-HANGING. 2. Now also used more specifically for lightweight building materials used to form non-loadbearing exterior walls in FRAME CONSTRUCTION.

clapboard construction Traditional North American building system using horizontal boards to cover a timber frame. The boards overlap one another, and each is narrower at the upper edge than at the lower. In Britain called weatherboarding.

classical 1. Strictly, of the art and architecture of Greek and Roman antiquity, especially Greek work of the 5th and 4th c. BC and faithful Roman copies. 2. More generally, of art and architecture which conform to Greek and Roman models. 3. More generally still, of art which aspires to a state of emotional and physical equilibrium, and which is rationally rather than intuitively constructed.

Classical Abstraction Compositions of an ABSTRACT nature, usually made up of cleanly defined geometrical shapes, which seem to express CLASSICAL principles of restraint, balance and order. Typical examples are certain works by Piet Mondrian and Ben Nicholson.

classical temple See diagrams.

clerestory A row of windows in the upper part of a wall, especially in a church, where they are above the roofs of the flanking AISLES and admit light to the NAVE. (GOTHIC CATHEDRAL, section.★)

cliché-verre (Fr. 'glass negative') A photographic PRINT made by scratching a design into the EMULSION coating (paint or albumen) on a glass PLATE, then using the plate as a form of negative with which to print on sensitized paper.

clipeus (Lat. 'round shield') An architectural ornament consisting of a medallion portrait of a deceased person. (The name may be derived from the Roman custom of decorating shields with ancestor portraits.)

clobbering ('clobber', English 19th-c. slang for clothing) 1. Overpainting in ENAMEL on PORCELAIN which has already been fully decorated. 2. Unfired painting or overpainting on either POTTERY or porcelain. The two techniques were often used to make Oriental wares more attractive to the European market.

cloison (Fr. 'partition') 1. In enamelling, a cell formed with metal wire or strip, attached to a base and designed to be filled with ENAMEL. 2. In CERAMICS, a cell formed with a ridge of clay on the surface of a piece, and designed to be filled with GLAZE.

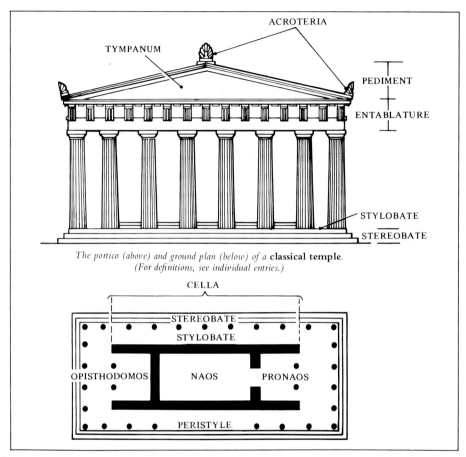

The portico (above) and ground plan (below) of a **classical temple**.
(For definitions, see individual entries.)

cloisonné 1. See ENAMEL. 2. (Of CERAMICS.) Decorated with GLAZES of different colours, kept separate by CLOISONS.

cloisonnism, cloisonnisme A style characteristic of POST-IMPRESSIONISM and evolved by Emile Bernard (1868–1941). Flat colours were separated by strong blue or black outlines, in the manner of cloisonné ENAMEL. See also SYNTHETISM.

cloisters A covered walk or ARCADE, usually surrounding all four sides of a QUADRANGLE, and usually connected with a church, especially a monastic one, or with a college. (GOTHIC CATHEDRAL, plan.★)

closed form Sculpture which echoes the form of the original block and does not reach out into the surrounding space. The opposite of OPEN FORM.

Cloisonnism: *Emile Bernard's* Breton Women with Parasols, *1892.*

(Above) Child and Beast II, *1951, a typically bold painting by Karel Appel, member of the* **COBRA** *group.*

(Right) The Marble Hall at Holkham Hall, Norfolk, begun in 1734, in English Palladian style, showing **coffering** *in the dome, and also a decoration of Vitruvian scroll and Greek key patterns.*

clunch A generic name for the harder grades of chalk, occasionally used for building but more suitable for interior carving.

clustered pier See COLUMN.

Coade stone A type of artificial CAST stone used in England *c.* 1770–*c.* 1820 for sculpture and architectural ornaments. It takes its name from Mrs Eleanor Coade, the original proprietor of the London firm that produced it.

cob Building material made of clay stiffened with straw, sand and gravel. It can be used on its own, or to fill a wooden framework.

COBRA A group of European artists founded in Paris in 1948, who aimed to revive EXPRESSIONISM. The name derives from the initial letters of the capital cities where important members of the group lived: COpenhagen, BRussels, Amsterdam. These members included Pierre Alechinsky, Karel Appel, Asger Jorn and Lucebert. The group was dissolved in 1951.

codex (Lat., pl. **codices**) A book made up of separate leaves, as opposed to a scroll. The form came into use in the 1st c. AD, and the earliest surviving illustrated examples date from the 4th c. AD.

coffering A system of deep panels or CAISSONS recessed into a VAULT, SOFFIT or ceiling. Synonym: LACUNAR.

cognoscenti (It.) Experts, especially in the field of art. See also CONNOISSEURSHIP.

coin silver 1. (Chiefly US.) A slightly baser ALLOY of silver than STERLING SILVER (90% silver to 10% copper, rather than 92.5% to 7.5%). 2. (In the US jewellery and antique trades.) More loosely, any fine grade of silver.

cold colour Synonym of COOL COLOUR.

cold painting, cold colours Unfired decoration in OIL PAINT or LACQUER on PORCELAIN or GLASS.

cold-working The process of hammering metal objects into shape without the use of heat.

collage (Fr., fr. *coller*, 'to stick') A technique invented by Picasso and Braque during their Analytical CUBIST phase. They began to stick fragments of newspaper and of pre-printed pattern into their compositions, as representatives of the tactile reality which Cubist formal analysis tended to destroy. Collage was later taken up by DADA and SURREALISM as a means of creating irrational conjunctions of 'found' imagery. (See OBJET TROUVÉ.) However it is used, collage tends to break the unity of the composition and create deliberate spatial disharmonies and incongruities of scale.

collar beam A short transverse beam linking the two sides of a timber-framed ROOF* high up near the ridge.

collodion wet plate process. See WET PLATE PROCESS, WET COLLODION PROCESS.

collotype An early photo-mechanical printing process using gelatin plates, which was introduced in Britain *c.* 1860.

Cologne School Term coined in the 19th c. for a number of different painters practising in various styles around Cologne from the 14th to the 16th c. The lyrical but mannered INTERNATIONAL GOTHIC of early 15th-c. painters such as the Master of St Veronica was succeeded by the greater realism of the Master of the Life of the Virgin (late 15th c.). This realism, however, never reached the intensity it did in contemporary Netherlandish art, though many Cologne painters seem to have trained in the Low Countries.

colonnade See COLUMN.

colonnette See COLUMN.

colossal order See ORDERS OF ARCHITECTURE.

colour circle, colour wheel Conventional means of arranging the primary colours (blue, red and yellow) and their principal mixtures or secondary colours (orange, green and violet), and other principal mixtures or HUES, so as to demonstrate their sequential relationship. Colours which fall directly opposite one another in the colour circle are called COMPLEMENTARY COLOURS. See also COLOURED GREY.

coloured grey The HUE which results from mixing COMPLEMENTARY COLOURS.

Cubist **collage** *by Georges Braque: Music, 1914. Among the components are* papier collé, gesso *and* sawdust.

Cologne School: The Conversion of St Hubert *by the 15th-c. Master of the Life of the Virgin, showing continuous representation (St Hubert is shown hunting in the background, top right).*

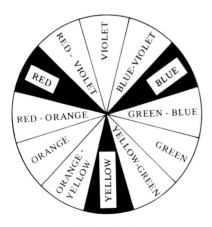

Colour circle.

Developed **colour-field painting:** *Barnett Newman's* Jericho, 1969, *which measures over 8 feet in height.*

colour-field painting Painting using compositional devices which suggest that the field of colour stretches beyond the canvas to infinity. There are no strong contrasts of TONE, and figure and ground are given equal value. (See FIGURE-GROUND RELATIONSHIP.) Though usually extremely large, colour-field paintings are nevertheless designed to be viewed at close quarters so that they occupy the whole of the spectator's field of vision. The term covers some aspects of ABSTRACT EXPRESSIONISM (found in the paintings of such artists as Ad Reinhardt, Mark Rothko and Barnett Newman) and the work of the generation which followed and achieved prominence in the late 1950s – Morris Louis, Kenneth Noland, Jules Olitski. See also POST-PAINTERLY ABSTRACTION.

columbarium (Lat. 'dovecote') A sepulchral chamber containing numerous niches for urns.

column A free-standing pillar, usually circular in section, and often built in accordance with one of the ORDERS OF ARCHITECTURE.★

Clustered pier. Synonym of compound pier.

Colonnade. A row of columns carrying either an ENTABLATURE or a series of ARCHES. (CLASSICAL TEMPLE, elevation.★)

Colonnette (Fr. 'small column'). A tall slender column, usually on a small scale and often purely ornamental.

Compound pier. A PIER with smaller columns attached to it so as to make a support of complex section. Often found in ROMANESQUE and GOTHIC★ architecture. Synonym: clustered pier.

Coupled columns. Linked pairs of columns.

Demi-column. A column apparently half-sunk into a wall, and therefore semicircular in section. (See also PILASTER.)

Engaged column. A column which looks as if it is embedded in a wall to some extent.

Entasis (fr. Gk *enteino*, 'to stretch'). The convex curvature, usually very slight, of the shaft of a CLASSICAL column. Without it, the shaft would appear to be concave.

Estípite (Sp.) A column or PILASTER tapering towards its base, and used in 17th- and 18th-c. Spanish and Latin American architecture. It is typical of the middle phase of the CHURRIGUERESQUE.

Intercolumniation. 1. The space between the shafts of two adjacent columns. 2. The ratio of the diameter of one shaft to the space between such shafts in a regular series.

Salomónica (Sp.) A column of twisted barley-sugar form, of a kind supposed to have been used in Solomon's Temple in Jerusalem. (An ancient Roman example attributed to this source exists in St Peter's, Rome.) Such columns were much used in Spanish and Portuguese BAROQUE architecture. Synonym: Solomonic column.

combine painting An extension of the principle of COLLAGE, in that flat or three-dimensional OBJETS TROUVÉS are attached to the surface of the composition, and are sometimes painted over, sometimes left in their natural state. The term was invented by the American Robert Rauschenberg (see NEO-DADA), who has made combine paintings incorporating such things as stuffed animals and fully functional radios. It is a short step from a combine painting to an ENVIRONMENT.

Commedia dell' Arte figures (It. *Commedia dell' arte*, 'Comedy of Art') In painting from the 16th c., and in PORCELAIN and furniture from the 18th, figures inspired by the characters (such as Harlequin and Columbine) from the theatrical performances of the itinerant Commedia dell' Arte troupes.

commercial art Art made not for its own sake but to help to sell something, especially in the fields of advertising and technical illustration.

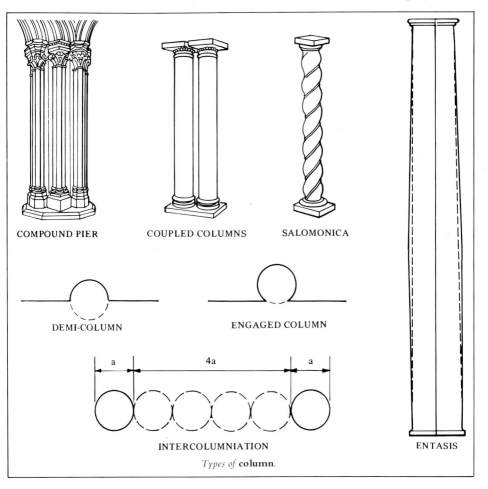

COMPOUND PIER COUPLED COLUMNS SALOMONICA

DEMI-COLUMN ENGAGED COLUMN

INTERCOLUMNIATION ENTASIS

Types of **column.**

The line between commercial art and FINE ART has become increasingly difficult to draw, especially since the rise of POP ART, which makes use of commercial imagery.

commode (Fr.) 1. A chest of drawers, usually decorative rather than utilitarian. So named because the chest of drawers was more convenient (*commode*) than the simple chest which preceded it. (BOMBÉ.★) 2. A chair containing a chamber-pot.

community art A range of activities undertaken in the 1970s and 1980s by AVANT-GARDE artists with the aim of establishing close relationships with particular communities, often socially deprived. Community art frequently asks to be judged by the effect produced within the community itself, rather than by established specialist standards.

Compagnie des Indes (Fr. 'East India Company') Chinese PORCELAIN made specifically for the European market in the 18th c.

Company School Various groups of Indian painters working for the British (i.e. largely for patrons connected with the East India Company) in the 18th and 19th c. Centres of activity were Madras and Thanjavar in the south, Delhi in the north, Lucknow, Calcutta and Patna in the east. Techniques were adapted from European WATERCOLOUR, and subjects included trades, caste groups, festivals and botanical drawings as well as pictures of animals and birds.

55

Computer art *by John Whitney, 1969. The images are produced by generating sequences of abstract designs on a computer and then photographing them with a motion picture camera.*

Conceptual Art: One and Three Chairs *by Joseph Kosuth, 1965, which consists of a photograph of a chair, an actual chair and a dictionary definition of a chair.*

complementary colour A PRIMARY COLOUR which, when placed opposite the SECONDARY COLOUR produced by the other two primaries on the COLOUR CIRCLE, makes it seem brighter or stronger. For example, red strengthens green, blue strengthens orange and yellow strengthens violet.

compo 1. (Abbreviation for 'composition plaster'.) A generic term for the various PLASTER mixtures developed in late 18th-c. England as a substitute for STUCCO, most of them containing gypsum and SIZE. They were fireproof, did not have a tendency to crack, hardened more rapidly and could therefore be painted almost at once. 2. A mixture of whiting, resin and SIZE, which was also developed in the 18th c., and was generally used for modelled ornament on furniture. 3. Cement-lime mortar used in building.

composition 1. The combination of elements in a painting or other work of art so that they seem satisfactory to the artist. 2. More loosely, a painting, RELIEF or sculptured group, especially if it contains a large number of different elements. 3. See COMPO.

compound pier See COLUMN.

computer art Art, mostly drawings and GRAPHICS, produced with the aid of computers. The first computer art appeared in the mid 1950s.

Conceptual Art, Concept Art Art of the 1960s, 1970s and 1980s which is created according to one or more of the following principles: 1. That art consists in the basic idea, which does not have to be embodied in a physical form. 2. That language becomes the basic material of art, and the barrier between art and art theory is breached. 3. That artistic activity becomes an enquiry into the nature of art itself, and any result or embodiment must be regarded simply as an interim demonstration of the general conclusion reached by the artist. Among the artists associated with Conceptual Art are Lawrence Weiner, Sol LeWitt, Joseph Kosuth and Bruce Nauman, though some of these are also categorized as MINIMALISTS.

concetto (It. 'concept, conceit') A RENAISSANCE, and more especially MANNERIST, term which designates the underlying idea or conception which gives a particular work of art its meaning. It is similar to DISEGNO, but with the implication that the meaning is in some way surprising or paradoxical.

conch See DOME.

Concrete Art Art composed of simple, non-REPRESENTATIONAL visual forms, linked to the notion of structure as a continuous organizing principle (see Theo van Doesburg, *Manifesto of Concrete Art*, 1930). The name was chosen in preference to ABSTRACT ART on the grounds that the artist's activity is the reverse of a process of abstraction. Max Bill defined Concrete Art as

the effort 'to represent abstract thoughts in a sensuous and tangible form'.

concrete poetry Texts arranged for visual as much as verbal effect, either quite freely or in strictly organized patterns, across a surface which need not be the page of a book. The idea was given a formal launching by a group of Brazilian poets and artists at the São Paulo exhibition of CONCRETE ART in 1956, but can be traced back much further, to the work of the French poets Mallarmé and Apollinaire.

Concrete Art: Endless Loop I *by Max Bill, 1947–49.*

connoisseurship A term coined by the art historian Bernard Berenson (1865–1959) to mean the ability to deduce from the work of art alone, without additional supporting evidence, its period, its aesthetic merits or lack of them, and its possible relationships to other similar works which the connoisseur has seen in the past.

console 1. In CLASSICAL architecture, an ornamental BRACKET, taller than its projection, made up of two reversed VOLUTES and thus in section shaped like a letter S. 2. A shelf or shelf-like table, usually with a marble or SCAGLIOLA top, and richly ornamented brackets or bracket-like legs.

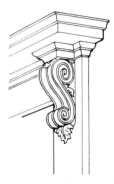

Console.

Constructivism An ABSTRACT art movement which manifested itself in Russia shortly before the Revolution. The Constructivists aimed to make art a detached, scientific investigation of abstract properties (picture surface, construction, line and colour). They also wished to apply this art to the social and industrial needs of the time, integrating it with architecture and experimenting with such things as the design of clothing. Outside Russia it exercised a great influence over institutions such as the BAUHAUS.

consular diptych An ivory DIPTYCH, hinged so as to open like a book. The outer sides were carved with the portrait of a Roman Consul, and the inner sides were hollowed and filled with a thin layer of wax which could be inscribed. From AD 384 until the abolition of the consular office in 541, these diptychs were an official emblem of consular power.

Consulat (Fr. 'Consulate') A continuation of the DIRECTOIRE style under the first years of Napoleon's rule, 1799 – c. 1804. It is often characterized by Egyptian motifs inspired by Napoleon's campaign in Egypt of 1798–99 (see EGYPTIAN TASTE).

Constructivism: *Vladimir Tatlin's* Corner Relief, *1915, represents a formal exercise in the use of constructional materials in space, using sheet metal, wood, wire and cables.*

Conté A trade-name for synthetic chalks, available in black, sanguine and sepia.

content The subject-matter of a work of art, as opposed to its style or the method of physical embodiment.

continuous representation A technique, common in both ancient and European medieval art (especially PREDELLE★), of showing consecutive episodes in a narrative side by side against an apparently continuous background. Sometimes inaccurately termed SIMULTANEOUS REPRESENTATION. (COLOGNE SCHOOL.★)

contour The outline which defines a particular form. By using thick contour lines an artist is also able to suggest greater PLASTICITY.

contrapposto (It. 'placed opposite') A way of representing the various parts of the body so that they are obliquely balanced around a central vertical AXIS: for example, the upper portion of the torso will twist in one direction, while the lower part twists in the opposing direction. First developed by CLASSICAL Greek sculptors as a means of avoiding stiffness, contrapposto was carried to extremes in the 16th c. under the influence of MANNERISM.

contre-boulle See BOULLE.

contre-épreuve French for COUNTER-PROOF.

conversation piece A portrait group with several figures (usually full-length and on a small scale) shown engaged in everyday occupations, often against the interiors or exteriors of their own houses. Especially popular in 18th-c. England.

cool colour A colour which suggests KINAES-THETIC sensations of coolness, such as blue or its associated HUES blue-green and blue-violet. In painting, cool colours appear to recede from the PICTURE-PLANE, and therefore suggest depth.

copper engraving 1. A PRINT made from a copper plate engraved with a pointed instrument such as a BURIN. 2. The engraved plate itself.

copperplate A rounded, formal script with ligatures. (CALLIGRAPHY.★)

Coptic art Late CLASSICAL art (4th–7th c. AD) of the Copts (Egyptian Christians), often stumpy in proportion and crowded and clumsy in design. It was heavily influenced by non-classical EXPRESSIONIST tendencies imported from Syria and the Near East. Typical Coptic products are stone and ivory carvings, woven textiles and manuscript ILLUMINATION.

copy A duplicate of an already existing work of art, usually not made by the artist who created the original. See also REPLICA, REPRODUCTION.

coquillage (Fr. 'shell') An ornament in shell form, typical of the ROCOCO style. See also ROCAILLE.

corbel A projecting architectural member, of stone, brick, wood, etc., which supports a weight. (ARCH,★ MACHICOLATION,★ hammer-beam ROOF,★ VAULT.★)

corbelling A series of CORBELS, each projecting beyond the one below.

corbie step Synonym of CROW STEP.

core glass The earliest type of GLASS vessel, made in Egypt, Mesopotamia and the Eastern Mediterranean c. 1500–c. 1200 BC, and again c. 800–1st c. BC. It was made by one of two methods: either by trailing threads of molten glass around a core, probably first composed of mud and straw, and later of clay, which was then removed; or else by dipping the core several times into a pot of molten glass to build up the thickness. The technique was superseded by the invention of blown glass. It is still occasionally described (wrongly) as 'sand-core glass'.

cornice 1. In CLASSICAL architecture, the third and uppermost part of the ENTABLATURE.★ 2. By extension, a projecting MOULDING which runs round the top of a building and throws rain-water off the wall below it. 3. The uppermost part of a PEDESTAL.★ 4. The internal ornamental moulding round the walls of a room, linking the wall to the ceiling.

Coromandel lacquer Brightly coloured incised LACQUER produced for export in China from the 17th c. onwards. It was shipped through the British East India Company's trading posts on the Coromandel coast of India, hence the name.

corona 1. A hanging light made of one or more hoops, and containing oil lamps or candle-sockets. 2. The projecting vertical face of the upper part of an external CORNICE. 3. In GOTHIC architecture, a large, roughly circular interior space, surrounded by windows – in

Coptic art: *detail of a tapestry-woven wall hanging, c. AD 400, with heads of a faun, two women and a man in roundels.*

A Mannerist figure of Astronomy by Gian da Bologna (1529–1608), showing **contrapposto.**

Coulisses *in* The Embarkation of the Queen of Sheba, *by Claude Lorrain, 1648.*

particular 'Becket's Corona', once the shrine which held the tomb of St Thomas à Becket, to the east of the CHOIR in Canterbury Cathedral.

coroplastics Sculpture and RELIEF decoration in TERRA COTTA.

corps de logis (Fr. 'body of house') The main structure of a building when this also has attached pavilions and outbuildings.

cortile (It. 'courtyard') An internal courtyard surrounded by ARCADES.

Cosmati work Architectural decoration in MOSAIC and marble INLAY found in Roman church interiors dating from the 12th to the 14th c. The first name Cosmas was frequently

given in two of the families who practised the technique.

cottage orné (Fr. 'decorated cottage') A small building, not necessarily for habitation, in playfully rustic form. Associated with the PICTURESQUE movement in English landscape gardening during the late 18th and early 19th c., and the early GOTHIC REVIVAL.

coulisses (Fr. 'wings' of a theatre) Elements arranged at the sides of a picture, particularly a landscape, so as to direct the spectator's eye towards some central point.

counterchange pattern A pattern composed of identical interlocking elements, distinguished by a difference in colour or texture.

counter-proof A reproduction of a drawing or PRINT made by damping the original and running it through a press, face to face with a new sheet of paper. The result will be a mirror-image of the original.

cour d'honneur (Fr. 'court of honour') The chief, and usually outer, courtyard of a large public building or palace, leading to the main apartments.

course See BRICKWORK, ELEMENTS OF; STONEWORK, ELEMENTS OF.

coving A deep concave MOULDING, especially at the junction internally of wall and ceiling.

crackle, cracklin Synonyms of CRAZING.

cradling A method of strengthening a wooden PANEL by means of attaching both ends of slotted wooden strips vertically to the back, with horizontal strips passing freely through the slots. This method allows for expansion and contraction caused by changes of temperature or humidity.

craquelure (Fr.) 1. The network of fine cracks which covers the surface of an old oil painting, created by the shrinkage of both paint and GROUND. Each type of ground and paint-film develops a different pattern of cracks in the course of time, and craquelure has become one of the tests of authenticity in an old painting. 2. Synonym of CRAZING.

crayon 1. Strictly, PIGMENT and chalk bound with gum so as to form a stick which can be used for drawing. 2. Now, more loosely, pigment combined with wax to make a stick for drawing.

crayon manner An ENGRAVING technique used to reproduce drawings in chalk. It made use of toothed wheels, or roulettes, and similar instruments to imitate the grainy effect of chalk on paper. It was invented in France *c.* 1750, then widely used in England.

crazing Cracks in any VITREOUS material (GLAZE, GLASS or ENAMEL) caused by unequal shrinkage or too rapid cooling. In the case of CERAMICS it is often caused by the glaze and the BODY shrinking at different rates, and is sometimes induced deliberately, as a decorative feature. When it appears in ceramics it is sometimes called CRAQUELURE or crackle. (JU WARE.★)

creamware Lead-glazed EARTHENWARE with a tough cream-coloured body containing flint. It was perfected by Josiah Wedgwood, who in 1765 began to produce the variety of it he christened 'Queen's Ware' in honour of Queen Charlotte, but it had already been produced previously in Staffordshire by Enoch Booth. It had the durability and thinness of PORCELAIN, was suited to OPENWORK decoration, TRANSFER PRINTING and painted decoration.

credence (fr. It. *credenza*, 'sideboard') The table or shelf near the altar of a church, placed there to hold the sacraments.

credenza (It.) A sideboard. So called because it was originally used for preliminary tasting of a prominent person's food to eliminate suspicion of poison, i.e. to give 'credence'.

cremorne bolt (US) An ESPAGNOLETTE.★

crenellation A notched PARAPET, originally for the protection of defenders and lookouts. Synonym: battlements. (MACHICOLATION.★)

cresset A metal BRACKET designed to hold a torch.

cresting A decoration running horizontally along the top of a wall, screen, roof or piece of furniture. (ROOD-SCREEN.★)

crewel-work Coarse, boldly designed EM-BROIDERY using brightly coloured worsted yarn. Favoured for hangings and upholstery in England and North America from the early 17th c. onwards.

criselling A fine network of cracks on the surface of old GLASS, caused by the progressive degeneration of the material.

crocket In GOTHIC architecture, an ornament resembling an outward curving leaf, used on SPIRES and CANOPIES.

cromlech 1. A prehistoric structure comprising a large unhewn slab resting horizontally on three or more large stones which have been set upright. Synonym: DOLMEN. 2. A circle of large stones constructed in prehistoric times.

croquis French for SKETCH.

crossing The part of a church where the NAVE is intersected by the TRANSEPTS. (GOTHIC CATH-EDRAL, plan.★)

crow step One of the steps of a stepped GABLE. Synonym: corbie steps (Scot.).

(Above) **Cul de lampe**, *17th c.*

(Left) Analytic **Cubism***: Picasso's* Still-life with a Violin, *1911–12, showing the image fragmented into numerous facets, which are then recomposed on planes parallel to the picture surface.*

crown The highest point of an ARCH,★ i.e. the underside of the KEYSTONE.

crown glass A type of GLASS, formerly used for windows, which is made by flattening a bubble from a glass-blower's pipe into a circular plate of irregular thickness.

crucks Curved timbers used in pairs which form the main arched framework of early timber-framed buildings.

crypt An underground chamber, usually with a VAULT, beneath the floor of a church.

crystal Any colourless, transparent GLASS that resembles rock-crystal (e.g. LEAD GLASS).

Cubism An art movement which came into being *c.* 1909, led by Picasso and Braque and with its roots in theories put forward by Cézanne. It was an attempt to represent fully and exhaustively on a flat surface all aspects of what the artist saw in three dimensions. *Analytic Cubism* showed different aspects of the same object simultaneously, abandoning conventional perspective and using overlapping facets. COLLAGE was a means of importing 'raw' reality in order to disrupt the two-dimensionality of this process.

Making use of the insights gained through Cubist analysis, *Synthetic Cubism* translated everything seen into a language of visual signs, providing every object with a coded equivalent, and turning the painting into a parallel reality rather than a reflection of the reality which the painter observed.

Cubo-Futurism See FUTURISM.

cuerda seca (Sp. 'dry cord') A method of decorating POTTERY, in which GLAZES of different colours are kept separate from one another by means of lines drawn in a mixture of manganese and grease. Invented in the Near East, it was used in Spain from *c.* 1500.

cul de lampe (Fr. 'bottom of lamp') 1. Originally, a triangular CORBEL supporting a church lantern or other feature. 2. Now also a VIGNETTE or printer's ornament used as a tailpiece, originally of the same shape.

cupola 1. A small DOME, particularly one ornamenting a roof or crowning another dome. 2. A semi-circular or polygonal domical VAULT. 3. The inner ceiling of a dome, not corresponding to the outside curvature. 4. (Wrongly.) Synonym of dome.

cursive 1. Any form of CALLIGRAPHY★ in a flowing style and in which the letters are joined rather than remaining separate. 2. Any TYPEFACE★ which imitates such calligraphy.

curtain wall 1. The outer free-standing wall of a castle. 2. A non-loadbearing outer wall (i.e. a type of CLADDING).

cusp The point made where FOILS in TRACERY meet. (TREFOIL.★)

cut-card ornament Ornament cut out of one layer of material and attached to another. So named because it looks as if the model was a piece of cut-out card laid against a plain one. Commonly found on 17th- and 18th-c. silver.

cybernetic art Mechanical sculptures and other works of art capable of responding to external stimuli, such as the proximity of the spectator, or to noises made by him or her. It represents a further and more elaborate development of KINETIC ART.

Cycladic art The Bronze Age art of the Cycladic archipelago, 2500–1600 BC, influenced by both MINOAN and HELLADIC art. The best-known Cycladic objects are stylized female figurines carved from the local white marble. Also typical are pottery jugs with beaked spouts, simple vessels made of marble, and pottery 'frying-pans' which are supposed to have been used as mirrors.

cyclopean masonry See STONEWORK.

cyma recta, cyma reversa (Gk 'upright wave, reversed wave') Double-curved MOULDINGS.★ The cyma recta is concave at the top, turning to convex below, the cyma reversa is convex above and concave below. Synonyms: ogee, reverse ogee mouldings.

cymatium (Lat.) The uppermost member of the cornice in CLASSICAL architecture, being of CYMA RECTA shape. (ENTABLATURE.★)

D

Dada (probably fr. Fr. *dada*, 'hobbyhorse') Deliberately meaningless name of the first ANTI-ART movement. In Zürich in 1916, during the First World War, Hugo Ball, Hans Arp, Tristan Tzara and other fugitives from the war used nonsense texts and performances, and ABSTRACT works of art, as a protest against the lofty pretensions of the Western civilizations which had produced the war. Their techniques of provocation were borrowed from FUTURISM. Marcel Duchamp in New York adopted the name Dada, as did post-war movements in Berlin, Paris and elsewhere. In Paris the Dada exploration of the irrational led to SURREALISM.

A poster by Kurt Schwitters and Theo van Doesburg, featuring nonsense texts, for a **Dada** *recital at the Hague, 1923.*

dado (It. 'die') 1. The plain central part of a PEDESTAL.★ Synonyms: die, tympanum. 2. The lower part of an interior wall, marked off above by a MOULDING (the dado rail) or line of paint and below by the skirting.

Daedalic style The Greek sculptural style which intervened between the GEOMETRIC and the ARCHAIC (660–620 BC). Named after Daedalus, the legendary craftsman, to whom the Ancient Greeks attributed the earliest statues of the gods. Also called Early Archaic.

daguerrotype, daguerreotype The first practicable photographic process, announced to the public in 1839. The image was a direct POSITIVE on a polished silvered copper PLATE sensitized with iodine and/or bromine vapour. The inventor was Louis Jacques Mandé Daguerre, who made use of experiments made earlier by Nicéphore Niépce.

damascening 1. Originally, the process of imparting a MOIRÉ pattern to sword-blades, supposedly invented at Damascus. 2. Later, the technique of decorating steel with an INLAY of precious metal.

damask 1. A reversible MONOCHROME textile where the pattern (positive on one side, negative on the other) is revealed only by differences in texture or surface sheen. (CABRIOLE LEG.★) 2. More loosely, any silk fabric with a raised pattern.

Dance of Death A representation of an allegorical procession or dance in which both the

(Left) Death and a Monk, *a woodcut from Hans Holbein's* **Dance of Death**, *published in Lyons in 1538.*

(Right) Limestone statuette of a goddess in **Daedalic style**. *The strong Egyptian influence (the wig-like hair) and the Cretan shawl are typical features.*

living and the dead take part. The participants are usually arranged in hierarchical sequence, from the Pope downwards. The Dance of Death became popular as a subject for mural painting in the late Middle Ages, the first known example (in the CLOISTER of the cemetery of the Holy Innocents in Paris) dating from 1424–25. After the invention of printing the subject was soon taken up by PRINT-makers. The most famous series of such prints is the one by Hans Holbein, but many other artists have tackled the theme. Synonym: danse macabre.

danse macabre See DANCE OF DEATH.

Dantesque style The mid 19th-c. Italian equivalent of the GOTHIC REVIVAL in Britain. It used RENAISSANCE in addition to strictly medieval forms.

Danube School A loosely associated group of painters, PRINT-makers, sculptors and architects active in the German territories flanking the Danube during the first half of the 16th c. Their art was based on a fantastic transformation of late GOTHIC forms, as opposed to the contemporary CLASSICISM of Dürer. Albrecht Altdorfer is the best-known artist associated with the group. His work shows their special interest in LANDSCAPE, then still a novelty when depicted for its own sake.

dead colour A neutral colour, usually dull brown, green or grey, used as underpainting. The colour is made lighter or darker to indicate the main tones.

One of the earliest autonomous landscapes in European art, c. 1518–20, by Albrecht Altdorfer of the **Danube School**.

MESSALINA.

Beardsley's Messalina Returning from the Bath, *1899, illustrating* Juvenal, Satire VI, *typifies the* **Decadent Movement** *in both subject-matter and treatment.*

The **Decorated style:** *a detail of Beverley Minster, Yorkshire, showing characteristic ogee curves in the tracery, and lavish use of ornament on the finials.*

Decadent Movement Late 19th-c. European artistic and literary movement associated with SYMBOLISM, but also pervaded by the idea that art and society were irreversibly in decline. It took much of its inspiration from J.K. Huysmans' novels *A Rebours (Against Nature)* (1884) and *Là-bas (Down There)* (1891). The artists and writers associated with it (e.g. Aubrey Beardsley in England) often set out to shock conventional morality with imagery connected with sex and Satanism.

decalcomania 1. Decoration made by using sheets of paper printed with LITHOGRAPHIC designs, which are cut up to fit the object and pressed to a slightly tacky surface. The paper is then sponged off and the resulting design protected with a coat of varnish. 2. A SURREALIST technique for generating images invented by the artist Oscar Domínguez. The artist puts a blot of ink or a dab of paint onto a piece of paper, which is then either folded while still wet so that the ink or paint runs into a symmetrical pattern on either side of the fold, or is pressed against another sheet, creating two patterns which are mirror images of each other. The artist then elaborates what the image suggests to him, as in BLOT DRAWING.

deckle edge The ragged, irregular edge found on untrimmed hand-made paper, which is sometimes imitated by machine-made papers.

décollage (Fr. 'unsticking') A work of art based on the destruction or breaking down of materials, e.g. the peeling away of posters. See also COLLAGE.

Decorated style English GOTHIC architecture of the late 13th and the first half of the 14th c., intervening between EARLY ENGLISH and PERPENDICULAR, and characterized by lavish use of ornament, especially FOLIATION. Windows filled with TRACERY replace plain LANCETS, and arches and window tracery alike show frequent use of the OGEE or double S-curve.

decorative art Any of the APPLIED ARTS (e.g. furniture, CERAMICS, GLASS, ENAMEL, textiles, metalwork, etc.) when found in a domestic context or contributing to interior decoration.

découpage (Fr. 'cutting out') The process of cutting designs out of paper and applying them to a surface to make a COLLAGE.

deësis (Gk 'prayer') A BYZANTINE representation of Christ between the Virgin and St John the Baptist, who are interceding for mankind.

'degenerate art' See ENTARTETE KUNST.

deinos, dinos (Gk) A wide-mouthed vessel without handles, sometimes on a matching stand, used for mixing wine with water. (GREEK VASES.★)

Dekor Synonym of PATTERN PAINTING.

__del., __delin. (fr. Lat. *delineavit*, 'drew') An abbreviation seen on PRINTS or drawings, which indicates that the signature it follows is that of the person responsible for the design, but not necessarily, in the case of a print, for the ENGRAVING of the PLATE. See also EXC., IN., P.

Delft 1. A type of TIN-GLAZED EARTHENWARE decorated in blue-and-white patterns inspired by Chinese PORCELAIN, and later in a more colourful PALETTE and in a wider range of patterns. It was made in Holland from the mid 17th c. 2. Similar wares made throughout Northern Europe, especially in England and Germany.

demilune (Fr. 'half moon') 1. In military architecture, a detached part of the fortification, triangular or crescent-shaped, built in the moat of a fortress. 2. (Used of a COMMODE or side-table.) Of semicircular form.

dentils (fr. Fr. *dentilles*, 'little teeth') Small square blocks which appear in Ancient Greek CORNICES, especially those supported by columns of the Ionic, Corinthian and Composite ORDERS OF ARCHITECTURE.★

depth 1. The degree of SATURATION in a particular HUE. 2. The degree of recession in PERSPECTIVE.

descender Any stroke below the base line of a letter in either CALLIGRAPHY or type. (TYPEFACE.★)

desco da parto (It. 'birth plate') A decorated tray used in medieval and early RENAISSANCE Italy to bring sweetmeats and other small gifts when paying a ceremonial visit of congratulation to a woman who had just given birth.

design 1. The general form or COMPOSITION of any building or work of art. 2. In APPLIED ART, the shape given to any object of use and also the way in which it functions.

Deutscher Werkbund (Ger. 'German Work Federation') A German association of manufacturers and architects, inspired by Hermann Muthesius and including architects and de-

(Above) Dutch blue **Delft** *tulip-holder of the 17th c.*

(Left) **Device:** *Whistler's butterfly signature.*

signers such as Peter Behrens and Henry van de Velde. It was formed in Munich in 1907 with the aim of 'selecting the best representatives of art, industry, crafts and trades, of combining all efforts towards high quality in industrial work, and of forming a rallying point for all those who are able and willing to work for high quality.' The Deutscher Werkbund made an important contribution to the design philosophy that afterwards inspired the BAUHAUS. It collapsed under the Nazis and underwent a brief revival after the Second World War.

device An EMBLEM or monogram used as an artist's signature (e.g. Whistler's butterfly signature) or a printer's trade-mark.

dhurrie, dhurry (fr. Hindi, *dari*) A TAPESTRY-woven carpet or rug made of cotton.

diaconicon (Gk) In BYZANTINE churches, a room placed to the south of the SANCTUARY which serves as a SACRISTY.

diamond-point engraving A technique for decorating GLASS, and sometimes PORCELAIN, by scratching or stippling it with a diamond-tipped STYLUS.

65

Directoire style: *an X-stool based on a Roman Imperial model. The lions'-head finials and animal-paw feet are also borrowed from classical originals.*

diaper work An all-over surface pattern of small identical units, such as lozenges or squares. (ARMORIAL PORCELAIN.★)

die I. The DADO of a PEDESTAL.★ 2. An INTAGLIO stamp used for STRIKING coins and MEDALS or EMBOSSING paper or other materials. 3. A hollow mould for CASTING metal.

dinanderie (Fr., from the Belgian town of Dinant) I. Specifically, the work of the medieval Mosan metalworkers. 2. By extension, simple domestic objects made of brass.

diorama A large-scale scenic painting housed in a special building, often given the same name, which by means of translucent areas and special lighting effects could be animated so as to give the spectator the impression of being present at the actual scene. It was invented by Louis Jacques Mandé Daguerre and Charles Bouton in 1822.

diptych A pair of PANELS or leaves hinged together.

Direct Art Name given by a group of Austrian artists active in the 1960s, among them Otto Mühl and Hermann Nitsch, to brutally explicit sexual and sado-masochistic ACTIONS devised by themselves.

Directoire style In French DECORATIVE ART, a simplified version of the LOUIS XVI STYLE, popular *c.* 1795–99 under the Directory. It mingled NEO-CLASSICAL elements with Republican motifs such as the FASCES and cap of liberty.

discharge printing A method of decorating previously dyed textiles by printing the design with bleach, thus creating a white pattern against a coloured GROUND.

disegno (It. 'design, drawing') I. In RENAISSANCE Italy, where the foundation of art was considered to be drawing, 'the conception of a work'. 2. By extension, the work of art in ideal or Platonic form, which could never be fully embodied, and existed only in the artist's mind. It is used in this sense in MANNERIST art theory. See also CONCETTO.

distemper Water-based paint with glue as a BINDER and chalk as a FILLER. Early authorities, such as Vasari, do not distinguish it clearly from TEMPERA, though it is far less durable because it does not make a chemical combination with the PLASTER SUPPORT. It is often used in wallpaper printing. See also PEINTURE À LA COLLE.

Divisionism Synonym, preferred by the NEO-IMPRESSIONISTS,★ for POINTILLISME.

diwan-i-am (Persian) A public audience hall in India.

diwan-i-khas (Persian) A private audience hall in India.

Doctors of the Church Certain Early Christian theologians who were thought to have guided the early development of the Christian religion. In Western art, eight are normally represented, usually as venerable old men standing and holding books. The four Western or Latin fathers – Ambrose, Augustine, Jerome and Gregory the Great – are by far the commonest. The four Eastern or Greek fathers are Basil, Gregory of Nazianzus, John Chrysostom and Athanasius.

dog of fo (Chi. *fo*, 'buddha') A fanciful Chinese representation of a lion.

dog-tooth An architectural ornament of raised four-pointed stars placed diagonally, which are thought to resemble a dog's molars. Typical of EARLY- ENGLISH architecture (MOULDING.★)

dolmen See CROMLECH.

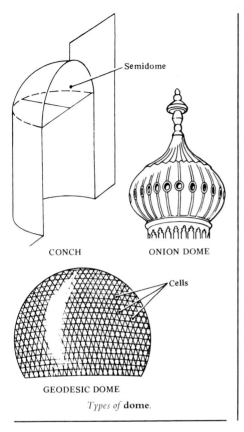

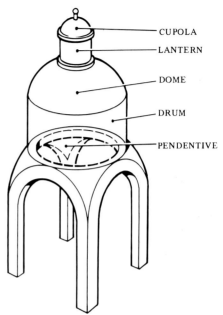

Types of **dome.**

Parts of a **dome.**
(For definitions, see individual entries.)

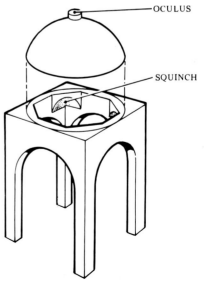

dome An evenly curved VAULT on a circular, elliptical or polygonal base. In cross section it can have any of the configurations of an ARCH. Sometimes wrongly called a cupola.

Conch. A semi-dome covering an APSE, plus its supporting wall.

Geodesic dome. A lightweight dome supported by a grid of short rigid members dividing the surface into regular facets, each one of which strengthens the others (a type of SPACE-FRAME). This method of construction was devised and the name coined by the American engineer Buckminster Fuller (1895–1983).

Onion dome. A dome, used in Russian and East European ecclesiastical architecture, which bulges outwards from its base, then comes inward again to culminate in a point.

Semi-dome. 1. The ceiling of an APSE, which forms a section (half or less than half) of a full dome. 2. A dome of conspicuously shallow curvature.

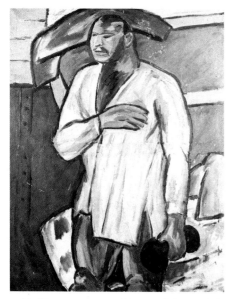

Mikhail Larionov's portrait of the artist Vladimir Burliuk, c. 1908, shows the stylistic primitivism typical of the **Donkey's Tail** *group.*

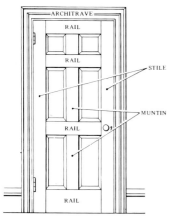

Parts of a **door**.

Byzantine capital with a **dosseret**.

donjon Synonym of KEEP.

Donkey's Tail (Russian, *Oslinniy Hwost*) An AVANT-GARDE association of artists formed in Moscow in 1911 by a group who had seceded from the JACK OF DIAMONDS. Their leading principle was to try to free Russian art from dependence on the West by turning instead to traditional Russian forms such as ICONS and various types of FOLK ART. Among the artists chiefly involved were Larionov, Goncharova, Malevich and Tatlin. Larionov chose the name for their first exhibition, having heard of some French artists who tied a brush to a donkey's tail and showed the resulting 'painting'.

donor The person responsible for commissioning a painting – typically a late medieval altarpiece – who is portrayed within the painting itself (a donor portrait), and often accompanied by a patron saint.

doom A painting of the Last Judgment on the CHANCEL ARCH of a medieval parish church.

door, parts of a
Architrave. The MOULDING round the doorway.
Muntin. The vertical member between two panels.
Rail. The horizontal part of the framing.
Stile. The vertical part of the framing.

Dormition (Lat. 'sleeping') A painting or FRESCO showing the death of the Virgin, who is traditionally held to be only sleeping. See also ASSUMPTION.

dosseret (Fr.) In BYZANTINE and ROMANESQUE architecture, an additional block placed on top of a CAPITAL, and coming between it and the SPANDREL of the arch above. Often confused with an IMPOST BLOCK. Synonym: pulvin.

dotted print An ENGRAVING in which the design is created by punching a series of dots into the plate. (MANIÈRE CRIBLÉE is an early form of dotted print.)

dragging In painting, a technique for producing effects of broken colour, by drawing a brush loaded with almost dry PIGMENT over a still tacky undercoat.

drapery The fall of cloth, as represented in a painting or sculpture. Often used as a counterpoint to the shapes made by limbs and torso, and as a means of reinforcing the rhythm of the COMPOSITION as a whole.

drapery man A studio assistant employed by an established artist, especially a portraitist, to paint DRAPERY and background – i.e. the less important parts of the picture. Common from the RENAISSANCE to the 19th c.

dravid'ha (Skr.) A Hindu temple of octagonal PLAN.

drawing 1. A representation by means of lines. 2. The arrangement of lines which determine a particular FORM. Something is said to be 'out of drawing' when the representation in two dimensions does not reconstitute itself, in the spectator's eye and mind, into a convincing three-dimensional form.

dressed stone Synonym of ashlar (see STONEWORK).

dressings See STONEWORK.

drip painting A technique in which the paint is dripped directly onto the canvas, which is often laid on the floor instead of being placed on an easel. It is chiefly associated with Jackson Pollock and ABSTRACT EXPRESSIONISM,★ but was used previously by SURREALIST painters such as Max Ernst.

drip-mould, drip-stone See MOULDING.★

drôlerie (Fr.), **drollery** A humorous design in the margin of a medieval manuscript, or in an inconspicuous part of wood or stone carving in a medieval church.

drop ornament Synonym of PENDANT.

drop-leaf front A normally vertical panel in a piece of CASE-FURNITURE (e.g. a SECRÉTAIRE) which drops forward and outward so as to provide a writing surface. Synonym: fall front.

drum 1. A cylindrical block forming part of a COLUMN. 2. A wall supporting a DOME.★ 3. A cylindrical PEDESTAL supporting a figure, vase, lamp or other subject.

dry brush painting In oils or watercolour, the very scanty use of PIGMENT on a textured surface. The paint clings to the raised parts of the surface only.

dry plate process, gelatin dry plate process A photographic process using a gelatin EMULSION on a glass PLATE. Being more convenient than the earlier collodion WET PLATE PROCESS, it soon replaced it. Gelatin dry plates first appeared on the market in 1873.

Drôleries *in the margin of a 14th-c. illuminated manuscript,* De Nobilitatibus Sapientiis et Prudentiis Regum, *by Walter de Milemete.*

drying oils Fatty oils of vegetable origin which are of major importance in oil painting as a MEDIUM for PIGMENT, because they harden into a solid, transparent substance on exposure to air. They also serve as a binder, ·fixing the pigment to the GROUND. The chief drying oils are linseed, walnut and poppy. Synonym: fixed oils.

dry-point 1. The technique by which a PRINT is made by ENGRAVING directly on copper with a sharp needle. It is also sometimes used to strengthen details in an ETCHING. 2. A print so produced.

duecento, dugento (fr. It. *due cento*, 'two hundred') The period 1200–1300 in Italian art.

dun An ancient Celtic hill fort with an earthen wall and ditch.

duomo (It.) A cathedral or other major church.

durbar, darbar (Persian) An audience hall in India and Persia.

Dutch gable A GABLE crowned with a PEDIMENT.

dwarf gallery A low exterior wall passage, lit by an equally low ARCADE, usually just below the roof of a building. Met with in German and Lombardic ROMANESQUE architecture.

dymaxion (conflation of 'dynamism', 'maximum' and 'ion') Adjective coined in 1929 by the public relations department of a Chicago department store to describe an experimental house devised by the architect Buckminster Fuller. Fuller took over the word and subsequently used it to describe many of his inventions, with the implication that these showed maximum efficiency using the available technology.

E

é. d'a. Abbreviation of ÉPREUVE D'ARTISTE.

Early Christian art Art produced by Christians in the early period of the Faith (up to *c.* AD 500), regardless of style.

Early English The earliest type of English GOTHIC architecture, typified by windows which are pointed but narrow, without MULLIONS. The style appeared with the building of the choir of Canterbury Cathedral (begun in 1174), and was supplanted by the Decorated upwards of a century later.

Earth Art Term used from the mid 1960s to describe works of art, either in art galleries or in the open, which made use of natural materials such as earth, rocks, turf and snow.

earth colours Pigments such as brown or yellow, which occur naturally in earth or clay and are usually metallic oxides. Chemically, they are the most stable of all pigments and therefore the least subject to change in the ageing process.

earthenware Articles made of clay and fired at 700°C or less, which remain porous unless treated with a GLAZE.

easel picture A painting of moderate size, such as could be executed on an artist's easel. Such pictures are also sometimes displayed on easels. See also CABINET PICTURE.

Easter Sepulchre 1. A carved representation of the burial and resurrection of Christ, shown either temporarily or permanently in a church. 2. The niche in which this was shown, the earliest examples dating from the 13th c.

ébéniste (Fr.) A CABINET-MAKER specializing in VENEERED furniture. The word came into use in the early 17th c. because ebony (*ébène*) was then popular for furniture of this type. The *ébéniste* had a different function from the MENUISIER, who made carved pieces in plain wood; i.e. seat-furniture rather than CASE-FURNITURE.

Ecce Homo (Lat. 'Behold the Man') A representation of Christ crowned with thorns, presented to the people (John 19:5).

Ecclesia (Lat. 'church') The Christian Church represented in art as a crowned female figure with a cross and chalice, or a banner, and sometimes paired with Synagoga, another female figure, blindfolded and with the crown slipping from her head, who represents Judaism. They can also be seen as allegories of the New and Old Testaments.

echinus (Lat. 'bowl') 1. Strictly, the moulding below the abacus of a Greek Doric capital. (ORDERS OF ARCHITECTURE.★) 2. More loosely, any moulding of this form.

eclectic (Used of artistic styles.) Consisting of an amalgam of elements from other styles. The term originated in Greek philosophy where it was applied to philosophers who tried to take the best from several conflicting schools.

École de Paris (Fr. 'School of Paris') 1. Originally, those non-French painters, predominantly FIGURATIVE and EXPRESSIONIST, and often Jewish, who settled in Paris just before and just after the First World War (Soutine and Krémègne being typical examples). 2. Later, the whole of the modern movement in painting which took Paris for its centre. (See MODERNISM.)

Ecological Art Art which engages in a dialogue with natural physical forces and with cyclic biological processes, and which is intended largely as a demonstration of how these forces and processes work. The artists involved included Hans Haacke and Alan Sonfist, whose *Time Landscape*, a sculptural ENVIRONMENT created in La Guardia Plaza, New York, in 1977, was an attempt to show the native forest this urban site had replaced. The term has been in use since *c.* 1968.

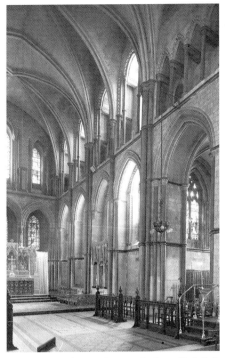

The south wall of the presbytery in Rochester Cathedral, 1214, with the narrow, pointed windows characteristic of the **Early English** style.

Ecce Homo by *Hieronymus Bosch (1474–1516):* Christ Shown to the People.

écorché (Fr. 'flayed') A drawing or sculpture, either of a human figure or an animal, where the skin has been stripped off to show the working of the muscles.

edition All the copies of a PRINT or book made from a single printing.

editioning The process of producing a specific quantity of a PRINT, authorized by the artist, which makes up the signed and numbered EDITION.

effigy vessel A type of pot representing a figure or an animal, produced by a large number of PRE-COLUMBIAN cultures.

egg-and-dart See MOULDING.★

eggshell porcelain Popular name for extra-thin PORCELAIN, especially wares made in China from the 15th c. onwards.

églomisé See VERRE ÉGLOMISÉ.

Ecorché: *an illustration from Vesalius's* De Humani Corporis Fabrica, *1547, showing the major muscles.*

Egyptian hall A hall with an internal PERI-STYLE, derived by the RENAISSANCE architect Palladio from his study of the Roman architectural theorist Vitruvius. It has nothing to do with Egyptian architecture.

Egyptian taste A style of decoration derived from Ancient Egyptian architecture, introduced by the engraver and ornamental designer G.B. Piranesi in 1769 and popularized by Napoleon's campaign in Egypt in 1798. Also popular in England thanks partly to the influence of Thomas Hope.

Eight, the A group of American artists who came together in 1907, in revolt against ACADEMIC art and with the determination to bring painting back into contact with ordinary life. The members were Arthur B. Davies, Maurice Prendergast, Ernest Lawson, Robert Henri, George Luks, William J. Glackens, John Sloan and Everett Shinn. They painted in very different styles and not all supported progressive trends.

Einzelkunst (Ger. 'art of individual things') (Used of PALAEOLITHIC and PRIMITIVE art.) Paintings made up of unrelated depictions of persons, animals and objects.

ekistics (fr. Gk *oikizo*, 'creating a settlement') Term invented *c.* 1944 by the Greek architect and environmental theorist Constantine Doxiadis to describe a new science of human settlements – one which took into account all the factors, historical, sociological, economic and architectural, which have a bearing on the success or failure of such settlements.

ekphrasis (Gk 'description') A description of a work of art, which might be imaginary, undertaken as a rhetorical exercise. Two Greek writers, both called Philostratus (2nd–3rd c. AD), produced examples which influenced RENAISSANCE artists.

electroplating A process, patented by G.R. Elkington in 1840, which makes use of electrolysis to coat a base metal, usually nickel, with a thin layer of silver.

electrotype A metal reproduction made in a mould, using both electrolysis and a plating vat, in place of more traditional methods of CASTING. The method permits extremely accurate reproduction of fine detail. It was invented *c.* 1836, and was perfected in the 1840s under the influence of G.R. Elkington.

Egyptian hall *in the English Palladian style: the Assembly Rooms at York, 1731–32, by the Earl of Burlington.*

electrum A naturally occurring ALLOY of silver and gold, used in ancient civilizations (especially Persia and Ancient Egypt) for precious objects, and occasionally for coinage.

Elementarism A successor to the NEO-PLASTICISM promoted by the Dutch artists connected with De STIJL, this new movement was announced by Theo van Doesburg in a manifesto published in the magazine *De Stijl* in 1926. Forms were still to be right-angled, as in Neo-Plasticism, but inclined planes could now be used.

elevation 1. A drawing of the face of a building, looking directly towards its centre. See also PLAN, PROJECTION.★ 2. Any outside vertical face of a building.

Elizabethan Built or made in England or Wales during the reign of Queen Elizabeth I (1551–1603). Elizabethan art and architecture combines RENAISSANCE, particularly MANNERIST, GOTHIC and VERNACULAR elements. (The equivalent style in Scotland is called Scottish Renaissance.)

ell (US) A single-storey, lean-to wing added to the main part of a building, and generally containing the kitchen.

émail brun (Fr. 'brown enamel') A technique of coating copper with linseed oil which was then burnt off to turn the metal a rich brown colour. It was used in the Middle Ages in conjunction with champlevé ENAMEL, but is not itself true enamelling.

Egyptian taste: *designs for a fireplace and chair by Thomas Hope, from his* Household Furniture and Interior Decoration, *1807.*

The Picnic, *1915, by Maurice Prendergast, a member of* **the Eight**.

émail en ronde bosse See ENAMEL.

emaki-mono See MAKEMONO.

emblem An image, usually composite, with a specific symbolic meaning. Printed collections of emblems, each accompanied by a motto, were popular in the 16th and 17th c. and were used as source-books by artists. One of the best-known English books of this type is Geoffrey Whitney's *A Choice of Emblemes* (1586).

emblema (Gk, pl. **emblemata**) 1. A design made in MOSAIC and then inserted into a patterned floor of coarser mosaic work. 2. (Usually pl.) The allegorical and symbolic objects and actions found in Dutch genre scenes and still-lifes of the 17th c. A woman smelling a flower, for example, may be an ALLEGORY of the sense of smell, and is likely to belong to a series depicting the Five Senses. The type of still-life known as a VANITAS is generally packed with many such symbols.

embossing Any process – e.g. CASTING, CHASING, stamping, carving or moulding – designed to make a pattern or FIGURATIVE composition stand out in RELIEF. Sometimes also used as a synonym for REPOUSSÉ.

embrasure A window or other opening splayed towards the inner face of the wall or parapet in which it is built.

embroidery A method of decorating textiles with stitched threads in different patterns. (As opposed to TAPESTRY where the design is woven into the fabric.)

Elementarism: *Theo van Doesburg's* Simultaneous Counter-composition, *1929–30.*

An **emblem** *of fame, symbolized by pyramids (as monuments) and the pen carried by the angel, designed to commemorate the poet Thomas Howard, Earl of Surrey. From Geoffrey Whitney's* A Choice of Emblemes.

empaquetage (Fr. 'wrapping') An art form associated with the Bulgarian artist Christo (Christo Javacheff, b. 1935), which consists in wrapping objects, some of them – e.g. buildings – very large. The technique has also been applied to whole landscapes. Christo's first wrapped objects were made in 1958.

empathy The emotional bond formed by the spectator with the work of art.

Empire style A late version of NEO-CLASSICISM popular in France during the first Napoleonic Empire, and particularly associated with the types of furniture and decoration ordered by the Emperor Napoleon for his residences – which are characterized in particular by ANTIQUE forms and lavish draperies. The Empire style was influential throughout Europe and also in North America.

emulsion A mixture of two liquids, one being distributed in the form of minute droplets throughout the other, with which it does not mix. Examples include TEMPERA (a mixture of fatty and watery constituents) and the light-sensitive coating containing silver bromide on photographic PLATES (a photographic emulsion).

enamel Coloured GLASS, in powder form and sometimes bound with oil, which is bonded to a metal surface or PLAQUE by FIRING.

Basse taille (Fr. 'low cut'). A technique which gives graduated effects of light and shade. The design is first sculpted in the thickness of the plaque. It is then covered with transparent enamel. Those parts remaining near the surface are pale, while those cut deeper are darker. The technique seems to have originated independently in France and Italy towards the end of the 13th c.

Camaïeu, en (Fr. 'in cameo'). A kind of grisaille enamel, in which the design is first traced onto a plaque covered with black or dark enamel paste, a white layer of enamel then superimposed on this and the outlines of the design carved down into the dark ground to achieve a CAMEO-like effect.

Champlevé (Fr. 'raised ground'). A technique dating from Roman times or earlier, in which grooves cut in the surface of a thick metal plaque (usually of bronze or copper, but sometimes of gold) are filled with enamel and fired. Synonym: en taille d'épargne.

Cloisonné (Fr. 'partitioned'). A technique dating from the 6th c. AD, in which the various colours are separated by metal wire or strips SOLDERED to the plaque. Synonym: cell enamelling.

Counter-enamelling. A technique invented in the late 15th c., in which both sides of the plaque are covered with enamel of the same thickness, and which prevents the object from curling (caused by the different rates of expansion and contraction of metal and glass). It made possible the use of thin plaques in painted enamel.

Encrusted enamel. Synonym of *en ronde bosse*.

Filigree enamel. A type of cloisonné enamel which originated in 13th-c. Venice. A silver plaque was decorated with a design (usually floral) in silver wire, and any cloisons so formed were then filled with enamel. The technique was further developed in Hungary during the 15th c. (where the whole plaque was covered in enamel), and also spread to Austria, Poland and Russia.

Grisaille. An early type of painted enamel in MONOCHROME (usually greys on a white ground, but sometimes purple or brown). The plaque was entirely coated with dark enamel, fired, then covered with translucent white enamel and fired again. The design was then developed by successive paintings in the various tones and in different thicknesses to create an effect of RELIEF.

Lavoro di basso rilievo (It. 'work in low relief'). Italian equivalent of *basse taille*.

Painted enamel. Enamel produced by a technique invented in the 15th c., in which a plaque of copper, gold or silver is painted with layers of enamel of various colours. As the colours have different melting points, those with higher melting points are applied first, the object being fired each time, to prevent the various layers intermingling. The technique became widespread after the invention of counter-enamelling.

Plein, en (Fr. 'in full'). A technique which involves the application of enamel straight onto the surface of an object rather than onto panels (*plaquettes*) which are then attached to it.

Plein sur fond réservé, en (Fr. 'in full on a restricted ground'). *En plein* enamelling on certain areas of an object only.

Plique à jour (Fr. 'openwork fold'). Enamel held in unbacked cells formed by wires so that it is transparent or at least translucent, like a STAINED-GLASS window in miniature.

Résille sur verre, en (Fr. 'in a net on glass'). A technique in which incisions in blue or green

GLASS are lined with gold and packed with enamel. When the object is fired to a precise temperature, the glass, gold and enamel bond together. It was used in France *c.* 1625–50, mainly for cases containing MINIATURES.

Ronde bosse, en (Fr. 'in the round'). Opaque enamel applied in several layers and colours straight onto a curved three-dimensional object. Synonym: encrusted enamel.

Surrey enamel. Enamel of the 17th c., in which brass objects such as candle-sticks and sword hilts were cast with hollows into which the enamel was inserted and fired.

Taille d'épargne, en (Fr. 'with a restricted cut'). Synonym of *champlevé*.

enamel colours Metallic PIGMENT mixed with powdered GLASS in an oily MEDIUM, applied to a GLAZED and finished CERAMIC or glass object, and fused on by refiring at a lower temperature than the original FIRING. FAMILLE JAUNE, NOIRE, ROSE and VERTE are all decorated with enamel colours. See also LOW FIRED.

encaustic A painting technique which originated in ancient times, using PIGMENTS mixed with hot wax as a BINDER. Synonym: cerography. (FAYUM PORTRAIT.★)

encaustic tiles Tiles made with a clay INLAY of a different colour, treated with a GLAZE and fired. The technique was used extensively in the Middle Ages, and was revived by the Victorians.

enceinte (Fr. 'girdle, enclosure') The main enclosure of a castle, contained within a wall or ditch.

encrusted With decoration applied in low RELIEF, often in a different material to the GROUND. See also ENAMEL.

end-grain Wood cut across the grain of the fibres, thus at right angles to the direction of growth. It is used decoratively in MARQUETRY, and in making blocks for WOOD ENGRAVING.

enfilade (Fr.) The alignment of the doors in a suite of rooms so as to create a vista through them.

engagé See ART ENGAGÉ.

engine-turned decoration Incised decoration in the form of CHEQUERING or DIAPER WORK, applied to metal or POTTERY by means of an engine-turning lathe.

English bond See BRICKWORK.

Empaquetage: *Christo's* Wrapped Coast – Little Bay, Australia, *1969.*

Design for a bedroom in **Empire style** *by Percier and Fontaine, 1801.*

Encaustic tiles *from the 13th-c. cloister of Titchfield Abbey, Hampshire.*

engobe (Fr. 'slip') In English, a SLIP applied all over a piece of POTTERY, in order to hide the colour of the BODY.

engrailed Decorated with a border pattern consisting of a series of small indented curves.

engraving 1. The process of making a design on a hard surface by inscribing it with a point. 2. By extension, an INTAGLIO PRINT made by cutting into the printing surface with a point. See also ETCHING, COPPER ENGRAVING, WOOD ENGRAVING. (CAMERA OBSCURA,★ SUBLIME.★)

entablature The upper part of one of the ORDERS OF ARCHITECTURE.

Entartete Kunst (Ger. 'Degenerate Art') The title of an exhibition held in 1937 in Munich, containing all types of AVANT-GARDE art disapproved of by the Nazi party. EXPRESSIONISM figured prominently.

entasis (fr. Gk *enteino*, 'stretch') The convex curvature, usually very slight, of the shaft of a CLASSICAL COLUMN or a SPIRE. Without it the shaft or spire would appear to be concave.

entrelacs (Fr. 'interlace') A surface ornament of intertwining lines and curves.

entresol (Fr. 'floor between') A half storey inserted between the first and ground floors (second and first in the US). See also MEZZANINE.

environment, environmental art Term used from the late 1950s for a three-dimensional work of art, often of a temporary nature, which the viewer can enter (although in practice exhibiting authorities often prevent this). Ed Kienholz has produced many works of this type.

epinaos Synonym of OPISTHODOMOS. (CLASSICAL TEMPLE, plan.★)

epitaphion (Gk) An embroidered cloth showing the dead body of Christ and used in the Good Friday ceremonies of the BYZANTINE church.

épreuve d'artiste (Fr. 'artist's proof') 1. Originally, a PROOF of a PRINT. 2. Now usually a first IMPRESSION kept by the artist. It is unnumbered, and sold at a higher price than the main EDITION. Often marked A.P. or E. d'A.

épreuve sur chine (Fr. 'proof on China paper') A proof PRINT pulled on a thin, tough, smooth-surfaced paper, which is also used for

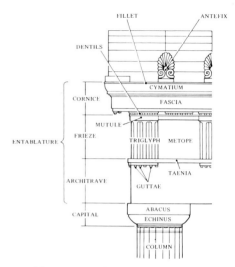

Entablature. *(For definitions, see individual entries.)*

books where compactness and durability are desirable (e.g. bibles and prayer-books).

épreuve sur japon (Fr. 'proof on Japan paper') A proof PRINT pulled on a thin, soft, toned paper with visible random fibres, normally made from mulberry bark.

escallop 1. An ornament in the form of a scallop shell. 2. In the Middle Ages it acquired religious significance as the emblem of St James the Greater, and was therefore adopted as a badge of the pilgrims to his shrine at Compostela in Spain.

escutcheon 1. A shield with a coat of arms on it. 2. By extension, any shield-shaped ornamental device. 3. Also by extension, the metal plate protecting a key-hole.

esonarthex See NARTHEX.

espagnolette (Fr.) 1. A decorative MOTIF found in French ROCOCO furniture, consisting of a female head backed by a ruff. 2. (UK) A double bolt used on a CASEMENT or FRENCH WINDOW, with a hinged handle.

esquisse French for SKETCH.

estampille (Fr.) A mark, bearing the maker's name, initials or monogram, which was struck with an iron stamp on some inconspicuous part of a piece of French furniture made by one of

Espagnolette.

St James the Greater, *by Simone Martini and his assistants,* c. *1284–1344, showing an* **escallop.**

the members of the Paris Corporation des Menuisiers-Ebénistes during the period 1751–91 when such marking was enforced by Corporation statutes. Royal craftsmen and those who worked for the Crown were exempt. A widow carrying on her husband's workshop was allowed to use his *estampille.*

estípite (Sp.) See COLUMN.

etching 1. The process of making a design on a metal PLATE by means of the action of acid. The design is scratched through an acid-resistant coating, or etching-ground, with a needle, exposing these parts of the metal beneath. The plate is then immersed in an acid bath, where the acid bites into the lines of the design. The longer the plate is left, the deeper the lines become. Repeated bitings may be used to emphasize certain parts of the design, the rest being protected (stopped out) with varnish. This technique is often combined with ENGRAVING. 2. A PRINT produced by this method.

Etruscan art Art produced by the people of Etruria (approximating to modern Tuscany) from the 7th to the 3rd c. BC. In its earlier phase it was strongly influenced by the ARCHAIC style of Ionian Greece and later incorporated marked realistic traits which were inherited by Roman art.

Etruscan *art: a terracotta antefix in the form of a Silenus mask,* c. *500 BC. The style is influenced by Archaic Greek art.*

77

The reverse of a Syracusan Greek decadrachm, 425–406 BC, with a group of arms and armour in the **exergue** *below the chariot.*

Euston Road School: *William Coldstream's portrait of Mrs Winifred Bunger, 1936–37.*

Expressionist *subjectivity and disregard for conventional realism: Oskar Kokoschka's* Pietà, *a poster for an exhibition at the Salzburger Residenzgalerie, 1916.*

Euston Road School An association first founded as a school of painting in 1937 by a group of artists led by William Coldstream who wanted to oppose extreme MODERNIST tendencies. It was named after the Euston Road in London where the school itself was situated. The group formally ceased to exist in 1939. Among the other painters associated with the group were Victor Pasmore and Rodrigo Moynihan. Their work is FIGURATIVE, subdued in colour and unobtrusive in brushwork. It owes much to Sickert and the CAMDEN TOWN GROUP.

evangeliary A liturgical book, usually large and with rich ILLUMINATION, containing the Gospels read at Mass. Synonym: Gospel Book.

—exc., —excud., —excudit (Lat. 'beats out') An abbreviation seen on PRINTS, indicating that the name it follows is that of the printer (not that of the designer). Synonym: imp.

exedra (Lat.) 1. A semicircular or rectangular recess, strictly speaking one provided with seats. 2. An APSE which runs the full width of the space to which it is attached.

exergue (Fr.) The small space below the device represented on a coin, medal or gem.

exonarthex See NARTHEX.

Expressionism 1. A term first popularized by the German art critic Herwarth Walden, publisher of the Berlin AVANT-GARDE review *Der*

Sturm (1910–32), to characterize all the modern art opposed to IMPRESSIONISM. 2. Later, art in which the forms arise, not directly from observed reality, but from subjective reactions to reality. 3. Today, any art in which conventional ideas of REALISM and PROPORTION seem to have been overridden by the artist's emotion, with resultant distortions of shape and colour.

extrados (Fr.) The outer face of an ARCH.★ See also INTRADOS.

ex-voto (Lat. 'from a vow') An object or picture given to a shrine as a votive offering.

eye level A line imagined as running horizontally across a drawn or painted COMPOSITION, which the viewer uses as a reference to tell him where the artist was originally placed in relation to the subject shown, or imagined himself as being placed.

eye-catcher A decorative building (e.g. a FOLLY), used to terminate a view or to punctuate the layout of a park or landscape garden.

F

f Abbreviation of FOLIO.

__f., __fe., __fec., __fecit (Lat. *fecit*, 'made') An abbreviation found on PRINTS, indicating that the name it follows is that of the etcher or engraver, who may not necessarily have been the designer of the image. (See ETCHING, ENGRAVING.) Synonyms: s., sculp., sculpsit (Lat. 'cut'). See also INV.

__f.f., f.f.__ (Lat. *fieri fecit*, 'caused to be made') 1. An abbreviation found on PRINTS indicating that the name it precedes or follows is that of the patron (not the artist) who was responsible for the creation of the work. 2. (Usually lowercase.) An abbreviation of FOLIOS.

façade The main ELEVATION of a building; sometimes also one of its subsidiary elevations. (CLASSICAL TEMPLE,★ GOLDEN SECTION.★)

face-painting Archaic English term for portrait painting, dating from the 16th c., when painters were still regarded as artisans.

facia See FASCIA.

façon de Venise (Fr. 'manner of Venice') (Used of glass.) In Venetian style, but made by non-Venetian glasshouses.

A **famille noire** *vase with decoration in the* famille verte *palette, showing a dragon chasing a pearl amid cloud scrolls. The black ground is covered with transparent green enamel. Ch'ing dynasty, early 18th c.*

facsimile 1. Strictly, a copy which is exact in all respects, including the MEDIUM. 2. More loosely, a printed reproduction of a DRAWING, PRINT, manuscript or printed book which cannot be distinguished without close examination from the original.

facture (Fr.), **fattura** (It.) ('handling') The characteristic way in which the MEDIUM is used by a particular artist or craftsman. Synonym: handling.

faience (French name of Faenza, in Italy) 1. Any TIN-GLAZED EARTHENWARE. 2. Glazed VITREOUS wares from Ancient Egypt (see FRIT).

fake A work of art intended to deceive. It may be a copy of an existing work, a PASTICHE of a particular artist's style or decorative work of a particular period, or a genuine work so much altered and 'improved' – by recarving in the case of furniture or sculpture in wood – as to have lost its original character.

fall front Synonym of DROP-LEAF FRONT.

famille jaune, noire, rose and **verte** (Fr. 'yellow/black/pink/green family') Chinese PORCELAIN of the 17th and 18th c. decorated in ENAMEL COLOURS, and named according to which colour predominates in the decoration. *Famille verte* and *famille rose* are the commonest. In the former, strong apple green is combined with iron red, yellow, purple and violet blue. Famille rose adds to these a rose-pink introduced to China from Europe.

Fancy picture: *Thomas Gainsborough's* Going to Market, *c. 1770, depicts rustics in a stylized landscape.*

Fantastic Realism: *Ernst Fuchs's* The Conception of the Unicorn, *1951, clearly shows the influence of Hieronymus Bosch and Gustave Moreau.*

fancy picture Term used in the 18th c. for: 1. A painting which seems to escape from the realistic conventions of GENRE painting into a world of fantasy. 2. A portrait in which the sitter appears in fancy dress, especially idealized peasant costume.

fanlight 1. A window over a door, often semicircular and whose glazing bars suggest the ribs of a fan. 2. The upper part of a window, hinged so as to open independently of the rest.

Fantastic Realism The work of a group of Austrian artists, among them Erich Brauer, Ernst Fuchs and Rudolph Hausner, who came together in the 1940s. It combines SURREALISM with elements borrowed from late medieval fantastic art and 19th-c. ACADEMICISM.

fasces (Lat. 'bundles') A bundle of rods tied around an axe, originally the emblem of a Roman consul's authority, carried before him by his lictors. Later it became part of the CLASSICAL repertoire of architectural ornament.

fascia, facia 1. In CLASSICAL architecture, one of the plain horizontal bands forming the ARCHITRAVE. (ENTABLATURE,★ ORDERS OF ARCHITECTURE.★) 2. (Or 'fascia board'.) In modern architecture, a flat wooden board fixed to the ends of the rafters (or to the WALL PLATE), serving as an attachment for the guttering round the eaves. 3. The flat band above a shop-window where the lettering is placed. 4. The whole shopfront.

fat over lean Archaic studio expression applied to oil painting, which indicates that PIGMENTS mixed with oil ('fat') should be used on top of those thinned with turpentine or other spirit ('lean').

Fauves (Fr. 'wild beasts') Term coined by the French art critic Louis Vauxcelles to describe a group of young painters who showed together for the first time in the Paris SALON D'AUTOMNE of 1905. Their nickname came from their fierce, non-realistic colour and bold, apparently crude draughtsmanship. Among the original members of the group were Matisse (generally regarded as the leader), Derain, Marquet and Vlaminck. The term was later applied to other artists such as Rouault and Van Dongen. Although the Fauves owed much to the earlier POST-IMPRESSIONISTS such as Gauguin and Van Gogh, 1905 is generally regarded as the date of inception of the Modern Movement (see MODERNISM).

Favrile glass A kind of multicoloured iridescent GLASS invented and manufactured by Louis Comfort Tiffany (1848–1933), and so named by him. The word derives from the obsolete old English 'fabrile', meaning 'related to a craftsman or his craft', and was registered as a trade-name by Tiffany in 1894.

Fayum, Faiyum portraits (Fayum, a region of Upper Egypt) Portrait paintings found on the faces of mummies in Roman cemeteries in Ancient Egypt, dating from the 1st c. BC to the 3rd c. AD. The MEDIUM can be either TEMPERA or ENCAUSTIC. Bold but remarkably NATURALISTIC in style, the paintings seem to have been made in the subjects' lifetimes.

feathered, feather-edged, ornament Finely CHASED FLUTED decoration, most commonly used as an ornamental border on the handles of silver spoons and forks. Popular in Britain and the US in the second half of the 18th c. (TRANSFER PRINTING.★)

__ fecit See F., FE., FEC., FECIT.

Federal style A style of decoration prevalent in the US from the establishment of the Federal Government in 1789 to c. 1830. It was influenced by English and French NEOCLASSICISM, and the designers associated with it included the silversmith Paul Revere, and the cabinet-makers Charles-Honoré Lannuier, Duncan Phyfe and Michael Allison.

fenestration The arrangement of windows on a FAÇADE.

ferro-concrete Concrete reinforced with iron bars, used both architecturally and for sculpture.

ferrotype Synonym of TINTYPE.

Festival Cycle In BYZANTINE art, the major feasts of the Church, usually twelve in number, represented as a series.

festoon An architectural ornament in the form of a garland of flowers or fruit, suspended in a loop. Synonym: swag.

fête champêtre (Fr. 'outdoor feast'), **fête galante** (Fr. 'feast of courtship') A characteristic type of early 18th-c. ROCOCO GENRE painting, found chiefly in France. Small figures – either courtly ladies and gentlemen or a company of actors – are seen in a parkland setting. It is chiefly associated with Watteau and his followers Lancret and Pater.

A **Fauve** *still-life, 1909, showing typically bold forms, by Maurice de Vlaminck.*

Fayum *portrait painted in encaustic, 3rd c. AD.*

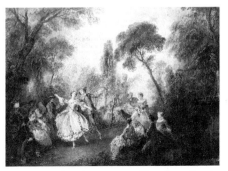

La Camargo Dancing, c. 1740, a **fête champêtre** by Nicolas Lancret.

fetish In African art, a material representation (e.g. a sculpture) of an entity which has spiritual power.

fettling A finishing process applied to a clay or PORCELAIN vessel or ornament before FIRING, especially if it has been made in a mould. It involves the use of a metal tool to remove visible seams, CASTING marks, etc.

feuille de chou (Fr. 'cabbage leaf') 1. A distinctive decoration of overlapping raised leaves found on Chinese export and ARMORIAL PORCELAIN. 2. A 17th-c. Brussels VERDURE tapestry with a design of giant leaves.

fibula (Lat.) A brooch used to fasten a tunic at the shoulder, found in a number of ancient and MIGRATION PERIOD cultures, and sometimes resembling the modern safety-pin.

fictile Made of clay, or of any substance capable of being moulded.

fictive sculpture A type of TROMPE-L'OEIL painting, in which figures are modelled in MONOCHROME to look like sculpture.

fielded panel In furniture, etc., a wooden panel with a plain raised area in the centre, surrounded by an unornamented border.

figurative art Art which portrays, in however altered or distorted a form, things perceived in the visible world. Synonym: representational art. See also ABSTRACT ART.

figure painting Painting representing the human figure.

figured (Used particularly of woven and printed stuffs and wallpapers.) Ornamented with a pattern which is FIGURATIVE rather than ABSTRACT.

figure–ground relationship In a painting, the way in which an object or shape is related to the background against which we see it. Human perception normally operates in such a way that the 'figure' seems to advance, and lie in front of the background. Sometimes, however, especially with ABSTRACT ART where the 'figure' and the 'background' occupy approximately the same amount of space, the relationship becomes confused, so that the background assumes equal importance to the subject of the work.

filigree Elaborate OPENWORK patterns made from precious metal (usually gold or silver) by SOLDERING together very fine wire and minute balls. Filigree is generally used on a small scale, sometimes for miniature objects, but more especially in jewellery.

filler 1. Material added to paint in order to increase its opacity. 2. Material used to fill the pores of a GROUND to be used for painting, to make it more solid. 3. Material used to fill cracks and holes in wood, stone, etc.

fillet 1. A narrow flat raised band used to give emphasis in architecture, e.g. between each curve of FLUTING★ on a column. (ORDERS OF ARCHITECTURE.★) 2. The topmost step of a cornice. Synonym: listel.

fin de siècle (Fr. 'end of century') The amalgam of artistic and literary tendencies typical of the 1890s.

fine art Architecture, sculpture and painting, as opposed to APPLIED ART or DECORATIVE ART. The distinction did not fully establish itself until the mid 18th c.

fine manner See BROAD MANNER.

finial Ornament crowning an architectural feature such as a GABLE or FLYING BUTTRESS, the cover of a vessel or the upper part of a piece of furniture. (DIRECTOIRE STYLE,★ GOTHIC CATHEDRAL, section.★)

firing Heating CERAMIC, GLASS or ENAMEL objects in a kiln, either to harden them, to fuse the components, or to fuse GLAZE or enamel to a ceramic BODY or metal PLAQUE.

five colours Synonym of WU T'SAI.

fixative A colourless solution sprayed onto designs made in impermanent materials such as chalk, pastel or charcoal to fix them in place and prevent smudging.

fixed oils Synonym of DRYING OILS.

fl.__ (fr. Lat. *floruit*, 'flourished') An abbreviation used in conjunction with a period of time, exactly known or approximate, during which an artist is known to have been active. It is employed when dates of birth and death are unknown.

flambé A crimson GLAZE derived from copper and streaked or suffused with blue so as to produce a flame-like effect. First developed in China during the Sung dynasty (AD 960–1280).

Flamboyant style (fr. Fr. *flamboyer*, 'to flame') The final stylistic development of French

GOTHIC architecture, from *c.* 1460 onwards, in which the elaborate flowing lines of TRACERY create flame-like shapes.

flashed glass A type of GLASS made up of two layers, produced by dipping a glass object into molten glass of a contrasting colour. Similar to CASED GLASS, but with a much thinner outer layer.

flashing 1. Protective material, usually in the form of strips of metal, used to cover the external joints of a roof and also the angle between a roof and a wall (e.g. the line where a roof joins a chimney). 2. The thin outer layer of a FLASHED GLASS object.

flatware 1. Traditionally, flat or shallow tableware, such as plates, saucers, etc. – as opposed to HOLLOW WARE. 2. Now used chiefly to mean cutlery.

Flemish bond See BRICKWORK.

fleuron (Fr.) An ornament shaped like a formalized flower. In TYPOGRAPHY it is usually circular, but not necessarily floral. (Synonym: printer's flower).

flint glass 1. A type of GLASS made originally in England in the 17th c. by George Ravenscroft, who used English flints as a source of silica (the basic constituent of glass). 2. The name was later applied to English LEAD GLASS, though here the source of silica is not flint but sand.

flock printing The technique of creating a raised velvety design on paper, or occasionally on cloth, by printing the designs in glue instead of ink, then, while the glue is still wet, sprinkling the surface evenly with finely shredded fragments of cloth. Used in Europe in the 15th c. for making a type of WOODBLOCK PRINT, and from the 17th c. onwards for wallpaper.

Florentine mosaic Synonym of PIETRE DURE.

flush bead See MOULDING.★

fluting In architecture, closely spaced parallel grooves used to ornament COLUMNS, PILASTERS, etc. (ORDERS OF ARCHITECTURE.★) Also used in the DECORATIVE ARTS, for example on silver. The opposite of REEDING.

flux In metalwork, a substance, such as borax, used to keep surfaces to be soldered free from dirt and to dissolve oxides which might prevent a join. It is also used to make the SOLDER flow easily.

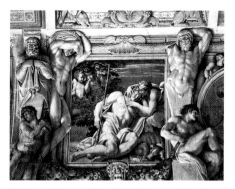

Fictive *sculpture and* ignudi *flanking a* quadro riportato *of Diana and Endymion by Annibale Carracci, in the Palazzo Farnese, Rome, c. 1597–99.*

The Kirkoswald brooch in **filigree** *silver, Scottish, 8th–9th c.* AD.

Fillet

Fluting.

Fluxus (Lat. 'flux') Name taken by an international art movement founded in 1962 to unite members of the extreme AVANT-GARDE in Europe and later in America. The group had no stylistic identity, but its activities were in many respects a revival of the spirit of DADA.

flying buttress An exterior arched prop designed to resist lateral thrust in a building (e.g. the tendency of a VAULT to push the walls outward). (GOTHIC CATHEDRAL, section.★)

flying façade A FAÇADE continued above the roofline, e.g. in Mayan architecture.

focal point The area in a pictorial composition to which the eye returns most naturally.

foil 1. In GOTHIC architecture, an arc-shaped form which occurs in TRACERY. The foils intersect to make cusps, thus creating the typical lobes one sees in Gothic windows. See QUATREFOIL, TREFOIL.★ 2. A thin slip or sheet of gold, silver or other metal.

foliation Ornamental leaf carving, often found in GOTHIC architecture, especially in the DECORATED STYLE.★

folio 1. A book composed of sheets folded once only to make four pages or two leaves (which vary in size according to the size of the paper). 2. Loosely, any large book. 3. One leaf of a book. Manuscripts and many printed books up to the 17th c. are numbered not in pages but in 'folios' or leaves – i.e., not 1, 2, 3, etc., but ff. 1r (1 RECTO), 1v (1 VERSO), 2r, 2v, 3r, 3v, etc.

folk art Unsophisticated art, both FINE and APPLIED, which is supposedly rooted in the collective awareness of simple people. The concept of folk art is a distinctively 19th-c. one. Today it carries with it a tinge of nostalgia for pre-industrial society. See also NAIVE ART, PRIMITIVE ART.

'follower of __' Indicates that a particular work is not by the artist named but by an unknown contemporary imitator.

folly A functionless or apparently foolish building. Follies on a small scale were often built by wealthy and eccentric landowners in the 18th c. to ornament their parks and gardens. See also EYE-CATCHER.

fondamenta (It.) Italian for embankment or quay.

Fontainebleau School A group of Italian, French and Flemish artists working for the Valois Court at Fontainebleau from c. 1530 to c. 1560, in a style derivative of Florentine and North Italian MANNERISM and containing both playful and erotic elements. Art historians also distinguish, after the hiatus imposed by the Wars of Religion, a less inspired second School of Fontainebleau, which decorated French royal residences under the patronage of Henri IV, during his reign (1589–1610). Rosso, Primaticcio and Niccolo dell' Abbate are leading figures in the first School of Fontainebleau; Ambroise Dubois and Toussaint Dubreuil are prominent in the second.

footing See BRICKWORK, STONEWORK.

fore-edge, foredge, painting A painting broken up into many separate parts, each of which appears on the right-hand (fore-edge) margin of each RECTO page of a book. The whole painting only becomes visible when the pages are fanned out.

foreshortening The technique of depicting an object lying at an angle to the PICTURE-PLANE, by means of PERSPECTIVE devices (e.g. making it narrower and paler as it recedes). The eye of the spectator then automatically reconstructs the object in its correct proportions. See also CHIAROSCURO, SOTTO IN SÙ.

form The individual shapes and volumes, and their relationships, depicted in a work of art, whether FIGURATIVE or ABSTRACT (as distinct from its subject-matter or CONTENT).

formalism Art, and critical writing about art, which place the emphasis on the analysis of FORM and the use of formal elements rather than on CONTENT. Often used as a term of abuse by Communist critics, who regard it as the inverse and opponent of SOCIALIST REALISM.

format The size and proportions of a piece of paper, canvas, or book page.

formeret A RIB which runs up against the wall, continues onto the ceiling, and down the opposite wall. Used to strengthen medieval VAULTS. Synonym: wall rib.

formwork Synonym of SHUTTERING.

forum An open public space, especially in Ancient Rome, surrounded by temples and public buildings, which is used as a gathering place for political discussions and as a market.

Fontainebleau School: The Dance of the Hours, *a design by Francesco Primaticcio (1504–70) for the ceiling of the Galerie d'Ulysse at Fontainebleau.*

Andrea Mantegna's Dead Christ, *late 15th c., shows the figure in a steeply* **foreshortened** *view, with striking distortions in the proportions of the body.*

found object Synonym of OBJET TROUVÉ.

fount (pronounced 'font') A complete alphabet of type in any TYPEFACE and type-size.

foxing The appearance of brown spots on paper due to dampness.

fractur A type of Pennsylvanian Dutch FOLK ART derived from the decoration of official documents with German FRAKTUR lettering, which later developed into ABSTRACT patterning.

Fraktur The most formal version of BLACK LETTER. (TYPEFACE.★)

frame construction Any system of building (e.g. BALLOON-FRAME CONSTRUCTION, HALF-TIMBERING) which relies on a framework rather than the walls to support the building.

free form Irregular or asymmetrical shapes, especially curvilinear ones, in painting, sculpture or decorative objects.

freestone Limestone or sandstone with a fine grain, suitable for fine quality masonry, and for architectural and other carving.

fresco (It. 'fresh') True fresco (*buon affresco*, as distinct from *fresco* SECCO) is painting done with mineral or earth PIGMENTS upon wet lime or gypsum PLASTER. (Vegetable pigments cannot be used as they are attacked by the lime.) The pigments are suspended in water, and unite

with the plaster as they dry. The basis is a ROUGHCAST wall, covered with a layer of plaster (the *arricciato*), on which the composition (the *sinopia*) is sketched out in charcoal and SINOPIA. Only enough wet plaster (the *intonaco*) is then applied for a day's work, any subsequent retouching being done in *fresco secco*.

fret 1. Synonym of GREEK KEY PATTERN. 2. Angular relief or OPENWORK pattern, often of Chinese inspiration ('Chinese fret'). (CHINESE CHIPPENDALE.★)

frieze 1. In CLASSICAL architecture, the part of the ENTABLATURE★ between the architrave and the cornice, sometimes decorated with RELIEF sculpture. 2. By extension, any relief or painting used decoratively in a long horizontal FORMAT. 3. The interior space, decorated or not, between the top of wall panelling, or picture rail, and the ceiling. 4. A rough woollen cloth, usually with a NAP only on one side.

friggers Colloquial term for a GLASS-maker's spare-time products, made from left-over material. They include glass walking-sticks, model ships and figures of animals.

frit 1. The basic material for GLASS-making before FIRING. 2. The material used to make PÂTE TENDRE, also before firing. 3. Powdered glass used in making GLAZE for CERAMICS of all types. 4. A VITREOUS substance, later glazed, used by the Ancient Egyptians and elsewhere in

(Above) **Futurism:** *Carlo Carrà's* Red Horseman, *1913, uses simultaneity to represent speed by depicting the horse's legs and hooves in several different positions.*

(Left) **Funk art:** *a detail of Ed Kienholz's* Environmental Assemblage: Back Seat Dodge, *1964.*

the Ancient Near East for making USHABTIS, other statuettes, seals and amulets. (In its glazed state this type of frit is also called FAIENCE.)

frontality Term coined by the Danish scholar Julius Lange in his *Die menschliche Gestalt in der bildenden Kunst* (1899) to describe the insistence on a frontal view in a painting or sculpture, with no indication of PERSPECTIVE. He applied it particularly to the art of early civilizations.

frontispiece 1. An illustration preceding, and usually facing, the title-page of a book or one of its divisions. 2. The decorated entrance bay of a building. 3. The whole of its main FAÇADE.

fronton (Fr.) A PEDIMENT crowning a window or other small opening.

frottage (Fr. 'rubbing') The technique of reproducing a given texture or RELIEF design by laying a piece of paper over it and making a rubbing with a crayon or pencil. Much used by the SURREALISTS, especially Max Ernst, in the development of images. See also DECALCOMANIA.

frottie Thin transparent or semi-transparent TONE lightly rubbed into the GROUND when an artist is starting work on a painting.

fugitive colours Those PIGMENTS which fade easily, especially on exposure to light.

functionalism The theory that 'form follows function', first enunciated by the American architect Louis Sullivan at the end of the 19th c., but anticipated by the empiricist philosophy of the 18th c. According to this theory, only objects which both function well and use material with economy are admissible in the domestic environment.

funk art In the US, the adjective 'funky' (originally meaning 'smelly') began to be applied to art produced in and around San Francisco in the late 1950s, by artists such as Bruce Conner. Later the term became 'funk art'. It is used largely to describe work which is between painting and sculpture, in deliberate bad taste and making use of bizarre combinations of materials. Its content is frequently pornographic or scatological, as in the work of Ed Kienholz. See also the HAIRY WHO.

fusuma (Jap.) A sliding door in a Japanese house, either a wooden frame with paper stretched over it or a panel made entirely of wood.

Futurism An art movement founded in 1909 by the Italian writer F.T. Marinetti. It was originally purely literary, aiming to break the bonds of grammar, syntax and logic in a celebration of the sensations and sounds of the

technological world of the future. Museum art was spurned as 'passéist', and the coming war eagerly welcomed. In the Futurist painting and sculpture of Giacomo Balla, Umberto Boccioni and others, the emphasis was on giving an impression of speed, on SIMULTANEITY and on the interpenetration of planes. Futurism was skilfully publicized in a series of manifestos and in public performances in which the audience was goaded into uproar. It influenced CUBO-FUTURISM, DADA, SUPREMATISM, and VORTICISM. The JACK OF DIAMONDS group was the focus of the movement in Russia.

G

gable The upper part of the wall at the end of a pitched ROOF. ★ (QUEEN ANNE STYLE. ★)

gadrooning Lobed ornament which consists of a series of convex curves. It is usually found on a surface which is itself curved in more than one plane, and often in EMBOSSED metalwork.

galilee A one-storey PORCH or chapel at the entrance of a church, usually at the west end. See also ANTECHURCH, NARTHEX, WESTWORK.

gallery 1. In ecclesiastical architecture, the upper storey over a side AISLE, open to the body of the church but not to the exterior. Often wrongly called a TRIFORIUM. 2. (Or 'long gallery'.) A long narrow room in a grand private house used for recreation and exercise, particularly in bad weather. 3. A place where paintings and other works of art are displayed. 4. An upper storey open on one side to the main interior space, especially in a place of public resort, such as a theatre. 5. In both churches and secular buildings, a kind of exterior corridor, communicating through an ARCADE or COLONNADE with the open air. Synonym: loggia. 6. A narrow passage running along the side of a larger room or interior space, with openings into it.

galvanoplastic copy Synonym of ELECTROTYPE.

gargoyle A stone (occasionally lead) spout to carry water clear of the walls of a building. Those in stone are often carved so as to resemble beasts or monsters.

Gadrooning.

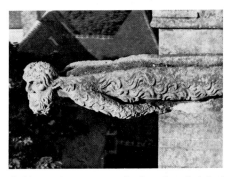

Gothic carved stone **gargoyle** *from the cathedral of Notre-Dame at Senlis.*

garniture de cheminée (Fr. 'chimney decoration') A set of ornaments designed for display on a chimney piece. A common type is a set of five vases, two of which are trumpet shaped, the other three covered BALUSTER vases. Often found in 17th-c. Chinese PORCELAIN.

garzone (It.) During the RENAISSANCE and BAROQUE periods, a boy serving as an apprentice in an Italian artist's studio.

gauffering 1. An EMBOSSED pattern on textiles (other than embossed velvet, which is more correctly termed 'stamped velvet'). 2. A decorative pattern on the gilded edges of a book.

gazebo (jocularly fr. 'gaze', + Lat. future tense) A small tower or summer-house with a view. In the latter form, a common feature of landscape gardens. Synonym: belvedere.

gelatin dry plate Synonym of DRY PLATE PROCESS.

gelatin print Photographic PRINT made on paper which is coated with gelatin impregnated with light-sensitive salts. Now the standard way of making black and white photographs.

gemstone Any crystalline mineral (as well as the opal, which is not crystalline) used in jewellery.

A Lady at her Toilet, c. 1660, by Gerard Terborch, is a typical example of a Dutch 17th-c. **genre** scene.

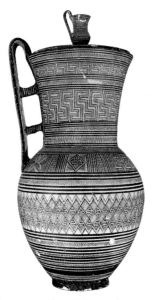

Early **Geometric** giant Attic oenochoe, c. 750 BC, showing patterns typical of the style, including two versions of Greek key. A miniature oenochoe forms the knob.

genre (Fr. 'kind, sort') 1. A type of painting, judged by its content or subject-matter, e.g. still-life, landscape, portraiture, history painting. 2. Art which shows scenes from daily life, especially of the kind popular in Holland in the 17th c. (LABOURS OF THE MONTHS.★)

Geometric art Greek art of the period c. 1100 –c. 660 BC, when pottery was covered with a network of fine geometric patterns.

Georgian style A style of architecture and decoration associated with the 'four Georges' in England: George I, II, III and IV (1714–1830). It is not in fact a coherent entity, but combines RENAISSANCE, ROCOCO and NEO-CLASSICAL elements, with CLASSICISM predominating in some form. See also REGENCY.

German silver Synonym of nickel silver.

Gesamtkunstwerk (Ger. 'total work of art') The idea of the complete integration of several art-forms – painting, words, dramatic action, poetry, music – so that none is dominant. The concept was originally associated with Wagner and his music-dramas.

gesso (It. 'gypsum') A mixture of gypsum and SIZE, used both as a GROUND for TEMPERA, for some types of oil painting and gilding, and for modelled decoration on furniture and picture-frames (gesso rilievo). See also COMPO.

Gestalt (Ger. 'configuration') A term imported into modern art criticism from psychology. Gestalt psychology, founded by Max Wertheimer, Kurt Koffka and Wolfgang Kohler, holds that the parts are determined by the whole, and that all experience, including aesthetic experience, is related to certain basic structures which cannot be subdivided. Gestalt criticism is opposed to the idea of EMPATHY, and holds that we do not ourselves project aesthetic and emotional qualities into the work of art, but find them there waiting for us. Defenders of MINIMAL ART claim that the spectator finds a 'good Gestalt' in the most primary forms.

gestural painting A general term for the work of leading American ABSTRACT EXPRESSIONISTS, and also that of European artists working in the same vein. The idea is that the marks on the canvas are the record of the artist's characteristic physical gestures and therefore express not only his emotions at the time when the painting was made, but also his whole personality.

Ghat *beside the River Ganges at Benares.*

ghat (Hindi) In India, an elaborate landing-place with steps on the banks of a river.

giant column, giant pilaster A COLUMN or PILASTER more than one storey high. Part of the GIANT ORDER.

giant order Synonym of colossal order (see ORDERS OF ARCHITECTURE).

girandole (Fr., fr. It. *girandola*, 'catherine wheel') 1. A candelabrum. 2. A wall-light or wall-bracket, usually with a mirror back.

gisant (Fr. 'recumbent') An effigy on a tomb showing the deceased as a corpse.

glair White of egg used as a MEDIUM for PIGMENT in TEMPERA painting, and also for gold dust in gilding.

Glasgow School A term confusingly applied to two quite different groups of late 19th- and early 20th-c. Scottish artists: 1. The group led by William Yorke Macgregor, and also including John Lavery and David Cameron, which was influenced by the more decorative aspects of French IMPRESSIONISM. 2. The group led by the architect Charles Rennie Mackintosh which produced a distinctive Scottish version of ART NOUVEAU.

glass A hard, brittle, non-crystalline substance, made by fusing silica with an alkali such as potash or soda. Evidence of its first use dates from *c.* 3500 – *c.* 3000 BC, when it was used in Mesopotamia as a GLAZE. See also CORE GLASS, CROWN GLASS, FLINT GLASS, LEAD GLASS, PÂTE DE VERRE.

Glasgow School *(1): an Impressionist-influenced portrait by John Lavery (1856–1941) of his wife Hazel.*

Glasgow School *(2): Charles Rennie Mackintosh's Art Nouveau design for a poster, 1896.*

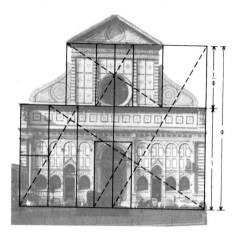

The 15th-c. façade of Santa Maria Novella, Florence, shows Alberti's use of the **golden section**: *the sides of the rectangles marked (there are many more) are in the ratio 1:φ.*

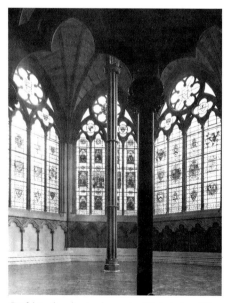

Gothic: *the chapter house in Westminster Abbey, 1245–53, showing pointed arches, rib vaults and a compound pier supporting the structure at its centre. Beneath the windows are blind arcades.*

glaze 1. In CERAMICS, a VITREOUS coating designed to make the BODY impervious to water, and also serving as decoration. 2. In painting, a transparent layer of paint applied over another layer, or over a GROUND, of a different colour in order to modify it. 3. To fill a window with panes of GLASS.

glazing bar A wooden or metal bar used to hold panes of GLASS in place in a WINDOW.★

glory In painting, light represented as emanating from a sacred personage or object. See also AUREOLE, NIMBUS.

gloss In Greek and Roman POTTERY, a sheen obtained by using a SLIP of very fine clay containing illite and fired in a REDUCING ATMOSPHERE. It should not be confused with a GLAZE, which is VITREOUS.

glyptic (fr. Gk *gluptikos*, 'carved') 1. Of carving. 2. A carved object. (Used especially of INTAGLIO or RELIEF carvings on precious and SEMI-PRECIOUS stones.)

Gobelins 1. Originally, TAPESTRY made at the Gobelins factory, which underwent its most brilliant period first under Louis XIV, and through to the late 18th c. It specialized in the HAUTE LISSE method, and produced an infinite variety of tapestries, from the CLASSICAL BAROQUE designs of Le Brun to tapestries with elaborate ALENTOURS of the late 18th c. 2. Now also sometimes used as a generic word for tapestry, especially imitations of the old Gobelins style.

gold ground A medieval painting technique in which TEMPERA or OIL PAINT is applied to a PANEL previously treated with GESSO and covered with gold leaf. The gold leaf thus forms the background.

golden section Traditional proportion which is supposed to express the secret of visual harmony. In its simplest form it consists of a line divided into two so that the smaller part is to the larger as the larger is to the whole. The ratio 1:φ (1:1.6180339...) is 'irrational', i.e. inexpressible in whole numbers. It is roughly equivalent to 8:13. (CANON OF PROPORTION.★)

Good Shepherd A representation of Christ as a shepherd bearing a sheep on his shoulders, in allusion to the parable of the good shepherd (John 10:11). This form of ICONOGRAPHY was popular in EARLY CHRISTIAN art.

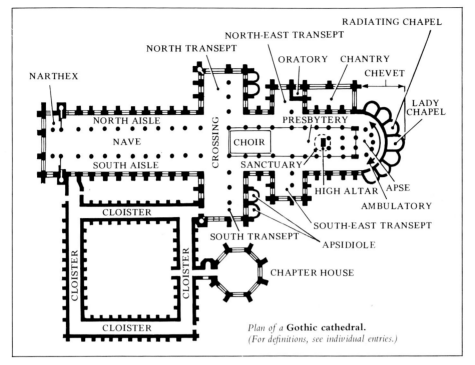

Plan of a **Gothic cathedral**.
(For definitions, see individual entries.)

gopis (Skr.) The female cowherds who sport with the Hindu god Krishna.

gopuran, gopuram (Tamil) The elaborate gateway with prominent towers characteristic of Hindu temples in south India.

gorgoneion (Gk) In a CLASSICAL temple, and in the decorative arts, an ornament representing the Gorgon's severed head. (Originally a protective amulet against evil.)

Gospel book Synonym of EVANGELIARY.

Gothic A word now used to describe all medieval art from the end of the ROMANESQUE period (mid 12th c.) to the beginning of the RENAISSANCE (early 15th c.), but applied especially to architecture using pointed arches, rib VAULTS.★ FLYING BUTTRESSES, etc. The classification of Gothic traditionally used in England runs from EARLY ENGLISH, through DECORATED, to PERPENDICULAR and is based on the development of window forms. The term was coined by Renaissance architects in order to deride their immediate predecessors as 'Goths' or barbarians.

Gothic cathedral See diagrams.

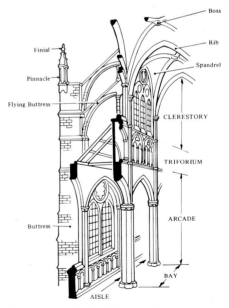

Sectional view of a **Gothic cathedral**, *featuring a quadripartite vault. (For definitions, see individual entries.)*

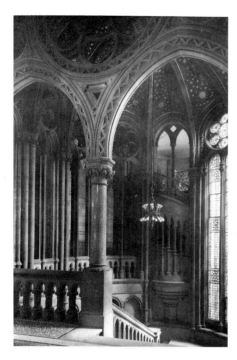

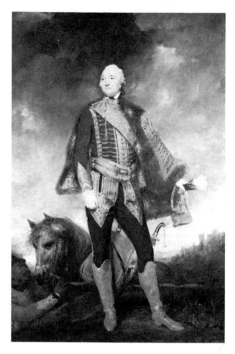

Gothic Revival: *the staircase of Manchester Town Hall, 1867–77, by Alfred Waterhouse. The details, such as the stiff-leaf capital, are correct to period; the main structure is entirely of its own time.*

The **Grand Manner** *applied to portraiture: Sir Joshua Reynolds' full-length portrait of Louis Philippe, Duke of Orléans (1793–1850), who lived in exile in England for a number of years.*

Gothic Revival A revival of GOTHIC architecture which took place, largely in England and the US, from the mid 18th c. to the mid 19th c. Gothic forms were revived in England in the mid 18th c. in a spirit of playfulness and even mockery, e.g. Horace Walpole's villa at Strawberry Hill, near Twickenham, Middlesex, which he described as a 'plaything house'. From the early 19th c. the Gothic style began to be taken more seriously, and eventually was applied, not merely to churches as hitherto, but to all types of public and private buildings. Synonym: Neo-Gothic.

Gothick The fanciful early phase of the GOTHIC REVIVAL.

gouache (Fr. 'wash') Painting in opaque WATERCOLOURS. The PIGMENTS have a gum BINDER, and the FILLER is invariably some form of opaque white (such as clay or barite) which gives a typical 'chalky' look even to dark HUES. Synonyms: poster paint, body colour.

graffiti (It. 'scratched drawings') Words or drawings (often obscene), scrawled or scratched on walls, etc., usually in public places. See also SGRAFFITO.

graffito (It.) 1. A technique of decorating either PLASTER by scratching through a wet layer to a dry one of a different colour, or POTTERY by scratching through the SLIP to the BODY beneath. Synonym: sgraffito. 2. Singular of GRAFFITI.

grand feu (Fr. 'great fire') Synonym of HIGH FIRED.

Grand Manner The elevated and ambitious style of HISTORY PAINTING advocated by leading 18th-c. art theorists, notably by Sir Joshua Reynolds in his third and fourth *Discourses* (1770, 1771). He urged that contemporary art should try to absorb the influence both of the ANTIQUE and of the great masters of the Italian RENAISSANCE. His theory also extended to por-

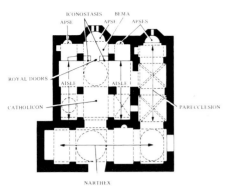

Plan of a **Greek Orthodox church**. *(For definitions, see individual entries.)*

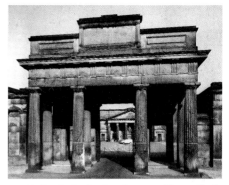

Greek Revival: *the Propylaeum at Chester Castle, 1788–1822, by Thomas Harrison. Using Stuart and Revett's drawing of the Acropolis as his source, the architect has produced an accurate version of the Doric order.*

Greek key pattern

traiture – e.g., in his own work, the depiction of aristocratic grandees in poses borrowed from famous CLASSICAL statues, such as the Apollo Belvedere.

Grand Rapids Pejorative term for mass-produced American furniture, especially for pieces produced between the 1850s and the 1920s. (Grand Rapids, Michigan, was the biggest furniture manufacturing centre in the US during this period, with a high degree of mechanization.)

grand tour An educational journey through Europe, often of a year or more's duration, undertaken by wealthy young Englishmen during the 17th and 18th c. The places chiefly visited were France, the Low Countries and, above all, Italy.

granulation Minute grains ('granules') of gold used as decoration on a gold surface, massed together or in outline patterns. The technique has been known since the 3rd millennium BC, and was practised especially by the ETRUSCANS. There are also a number of new 19th- and 20th-c. methods of creating the same effect.

graphic art A form of artistic expression where the statement is made, usually on paper, through emphasis on lines, marks or printed letters rather than on colour. It includes everything from drawing, through PRINT-making of all kinds, to TYPOGRAPHY.

graphics 1. Synonym of GRAPHIC ART. 2. Illustrations, diagrams or designs accompanying printed matter.

graver Synonym of BURIN.

gravure A commercial printing process using resin- or bitumen-coated PLATES or cylinders, photographically ETCHED or ENGRAVED in INTAGLIO.

Greek cross A cross whose vertical and horizontal arms are of equal length.

Greek key pattern An ornament consisting of lines turning at right angles to one another to form a squared spiral. Synonyms: fret, meander pattern. (GEOMETRIC ART.★).

Greek Orthodox church See diagram.

Greek Revival As Greece became more accessible to antiquaries and architects in the mid 18th c., the established English and American PALLADIAN style was challenged by a new type of architecture which tried to conform more closely to genuine Greek models. The key date is 1762, the year in which Stuart and Revett published their *Antiquities of Athens*. The style continued in England until *c.* 1840, and longer in the US. It also influenced the development of German architecture.

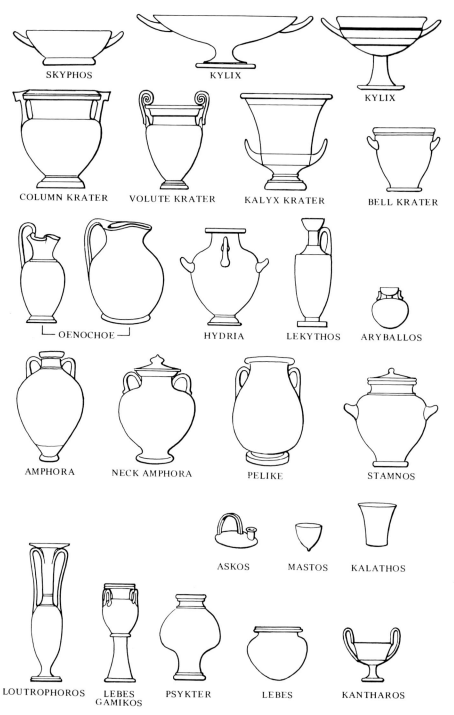

SKYPHOS

KYLIX

KYLIX

COLUMN KRATER

VOLUTE KRATER

KALYX KRATER

BELL KRATER

OENOCHOE

HYDRIA

LEKYTHOS

ARYBALLOS

AMPHORA

NECK AMPHORA

PELIKE

STAMNOS

ASKOS

MASTOS

KALATHOS

LOUTROPHOROS

LEBES
GAMIKOS

PSYKTER

LEBES

KANTHAROS

Greek vases
(For definitions, see individual entries.)

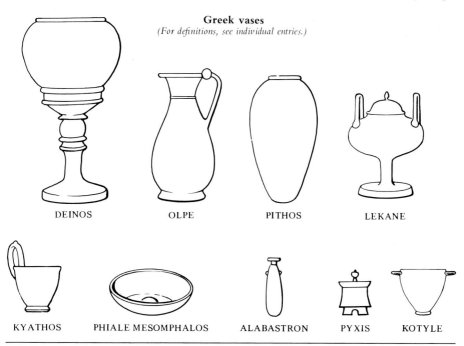

DEINOS OLPE PITHOS LEKANE

KYATHOS PHIALE MESOMPHALOS ALABASTRON PYXIS KOTYLE

Greek vases Ancient Greek POTTERY vessels of the ARCHAIC or CLASSICAL period.

grès French for STONEWARE.

grisaille 1. Painting in grey or greyish MONO-CHROME, sometimes heightened with gold. 2. See ENAMEL.

groin The angle formed by two intersecting VAULTS.★

groove-and-tongue ornament Ornament, carved on furniture, which consists of FLUTING, each groove being filled with spaced convex MOULDINGS resembling tongues.

grotesque 1. A kind of ornament derived by RENAISSANCE architects and artists from Ancient Roman decorations. These they discovered in subterranean ruins, then popularly known in Italy as *grotte* – hence the name. The decoration consists of loosely connected MOTIFS, often incorporating human figures, birds, animals and monsters, commonly arranged round small tablets or MEDALLIONS filled with painted scenes or imitating CAMEOS. 2. By extension, any distorted representation, especially one which combines human and animal characteristics.

Grotesques *from Lukas Kilian's* Neues Gradesco Büchlein, *1607.*

1 Copy, 1959, by François Morellet, a member of the **Groupe de Recherche d'Art Visuel**.

ground 1. A surface specially prepared for painting, perhaps with GESSO or a layer of paint of even TONE. An absorbent ground is one that contains no oil and therefore absorbs the oil from the paint, which becomes matt and dries quickly. 2. More loosely, the SUPPORT on which a painting or drawing is executed – canvas, paper or PLASTER. 3. A subordinate background in a painting. See FIGURE-GROUND RELATION-SHIP. 4. In the decorative arts, the basic material on which a representation, ornament or pattern is superimposed. For example, in ENAMELLING, the ground is usually of metal, and in CERAMICS it is the BODY of the vessel used as a background for decoration. 5. In ETCHING, the acid-resistant coating on the metal plate through which the needle is drawn.

ground-line In PRIMITIVE and NAIVE forms of painting, a line indicating the ground on which figures and objects stand.

ground-plane A surface which appears to recede into the PICTURE SPACE in PERSPECTIVE★ drawing and painting, and which provides a base for the figures and objects depicted.

Groupe de Recherche d'Art Visuel (GRAV) A group of artists founded in Paris in 1960. Their approach to art was quasi-scientific, and concerned with the qualities of colour, light and movement. The group owed much to CONSTRUCTIVISM, and in turn made an important contribution to the development of KINETIC ART. The artists associated with it were Garcia-Rossi, Julio Le Parc, François Morellet, Francisco Sobrino, Joël Stein and Yvaral.

guéridon (Fr.) A table with a very small top, with one central support (often a carved wooden figure), and sometimes intended to support a candlestick. The name derives from a Moorish character in a late 17th-c. French play.

guild In medieval times, an association of artists, craftsmen or tradesmen, organized along strictly hierarchical lines, so that a member began as an apprentice, became a journeyman, and finally a master. It was only at this stage that he had full liberty to practise his craft or profession independently, though still acting within the limits of guild regulations. At the end of the 19th c. an attempt was made to revive the guild system, though in looser form, as part of the ARTS AND CRAFTS MOVEMENT. An example was C.R. Ashbee's Guild of Handicraft, founded in 1888.

guilloche (Fr.) A running ornament of interlacing bands giving the effect of a plait or braid. Often used architecturally to enrich a MOULDING.★

guri (Jap.) A type of LACQUER made up of a number of layers of different colours, subsequently deeply carved to expose the layers below the surface.

Gutai Group (Jap. gutai, 'configuration') Japanese AVANT-GARDE art movement founded in Osaka in 1954. It specialized in elaborate HAPPENINGS and public events.

gutta 1. A small teardrop-shaped vessel. 2. In architecture, the conical ornaments under the triglyphs of a frieze in the Doric order. (ENTABLATURE.★)

gutta-percha (fr. Malay getah, 'gum'; percha, a type of tree) The hardened sap of the East Indian tree Dichopsis gutta, used in the 19th c. for moulded decorations and even whole objects. Some ambitious items of furniture made of gutta-percha in ROCOCO style were exhibited in London at the Great Exhibition of 1851.

H

haboku (Jap. 'splattered ink') An extreme later version of the freely brushed ink-painting style popular in China under the southern Sung (AD

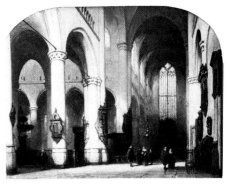

(Above) **The Hague School:** *Johannes Bosboom's* The Interior of the Pieterskerk, Leiden, *1855, revives Dutch architectural painting in the style of Saenredam (1597–1665).*

(Left) Detail of Monkeys, Birds and Trees *by Sesshu (1420–1506), a typical example of* **haboku**.

960–1279). It was practised by Japanese as well as by Chinese artists; the 15th-c. Japanese painter Sesshu was particularly famous for his use of the technique.

Hague School A group of REALIST artists who worked in Holland between 1850 and 1900, reviving many of the traditions of 17th-c. Dutch landscape and architectural painters. The group included Anton Mauve, Johannes Bosboom, the Maris brothers and Joseph Israels.

ha-ha ('Ha-ha!' as an exclamation of surprise) An obstacle made by building a RETAINING WALL in a hollow and filling the near-side with earth. Used in country estates to keep the animals confined to their own grazing land and out of the gardens surrounding the house, without interrupting the view.

Hairy Who Name adopted by a group of Chicago artists founded in 1966, among them Jim Nutt, Gladys Nilsson and Karl Wirsum. Their work has affinities with Californian FUNK ART, but is two- rather than three-dimensional.

half-length 1. A standard picture size (50 × 40 in., 127 × 102 cm) suitable for a half-length portrait on the scale of life. 2. Any

painting which depicts half the human figure, on whatever scale (e.g. works by the 16th-c. Master of the Female Half-lengths).

half-timbering 1. A vernacular building style used extensively in northern Europe in the 16th and 17th c. The principal supports were made of stout timber, while the interstices between them were filled with WATTLE-AND-DAUB, brick or stone. The whole structure might then be covered with PLASTER, weather-boarding or tiles. The BLACK-AND-WHITE STYLE is a type of half-timbering. 2. More loosely, 19th-c. buildings with a false timber frame attached to the outside wall.

halftone A commercial reproduction process in use since 1876 which enables the printer to reproduce subjects where the TONES are continuous – i.e. shading into one another without a visible break – by resolving the image into dots of various sizes, the dots growing larger where the tones are darker. The effect is achieved by photographing the subject through a special screen.

Hallenkirche (Ger. 'hall church') A church whose NAVE and AISLES are of equal height.

hallmark An official mark stamped on a piece of gold or silver as a guarantee that it conforms to a certain standard of purity. The main mark is that of the appropriate Assay Office (indicated by a symbol, e.g. a leopard's head for London), others showing the precise standard of fineness, the maker and the date.

halo See NIMBUS.

hamam, hammam (Arabic 'bath') A Turkish bath, generally constructed in three sections: the *camekân*, or dressing and relaxing room, the *soğukluk*, or antechamber, and the *hararet*, or steam room. It is usually heated by a furnace below.

hammer beam See ROOF, TYPES OF.

han Turkish for CARAVANSERAI.

handling Synonym of FACTURE.

haniwa (Jap., lit. 'clay image') Figures and models in POTTERY which were placed on large tomb mounds in Japan, 3rd–6th c. AD.

happening An art event typical of the 1960s and 1970s which synthesized both planned and improvised theatrical activity, the visual arts and found materials (see OBJET TROUVÉ). Audience participation was also often invited. The form evolved *c.* 1957–59 in New York as an extension into time and space of the free improvisation of ABSTRACT EXPRESSIONISM and was an important stage in the evolution of POP ART. Its emergence was also influenced by the composer John Cage and his theories concerning the use of chance. The most striking difference between the happening and more conventional kinds of theatre is the lack of narrative. See also ACTION.

hard-edge painting. 1. A term coined in 1958 by the Los Angeles art critic Jules Lansner to describe the work of local artists using cleanly defined forms and flat colour. 2. By extension, any modern ABSTRACT painting with these characteristics.

hard paste Synonym of PÂTE DURE.

hare's-fur glaze Synonym of TEMMOKU.

harling Synonym of ROUGHCAST.

harmonic proportions A system of architectural proportions evolved by RENAISSANCE architects who saw an analogy with the way sounds are produced on stringed instruments. For example, if two strings, one half the length of the other, are vibrated, then the difference in pitch will be an octave. If the ratio is 2:3 the difference is a fifth; and if it is 3:4 the difference is a fourth. The suggestion was that buildings constructed according to these musical ratios would inevitably be harmonious to the eye. See also GOLDEN SECTION.

Harrowing of Hell Christ's descent into Hell after His death, where he overcame Satan and liberated the souls of the Old Testament saints (see ANASTASIS). Popular as part of the PASSION CYCLE in medieval art, but seldom found after the 16th c. Christ is generally shown holding a banner with a red cross on a white ground and entering the doors of hell, which, broken from their hinges, crush Satan beneath them.

hatching A series of closely spaced parallel lines, used in drawing or ENGRAVING to render a uniform colour or shadow. In cross-hatching two sets of lines are used, placed across one another, usually at right angles.

haunch The lower part of an ARCH.★

Hausmalerei (Ger. 'home painting') Factory-made PORCELAIN, FAIENCE or GLASS decorated with ENAMELS and gilt by independent decorators (*Hausmaler*) at home. The custom began in 17th-c. Germany when independent glass-enamellers started imitating contemporary faience. Meissen and Vienna porcelains were often decorated in this way in the first half of the 18th c.

haute lisse (Fr., lit. 'high heddle') High-warp TAPESTRY, i.e. made with the WARP stretched vertically between rollers and manipulated by hand (as distinct from BASSE LISSE, or low warp). Characteristic of GOBELINS tapestries.

h.c. Abbreviation of HORS COMMERCE.

header See BRICKWORK.

helix Any spiral motif, but particularly the inner curve of a VOLUTE on an Ionic or Composite capital. (ORDERS OF ARCHITECTURE.★)

Helladic Dating from the Bronze Age on the Greek mainland (*c.* 2600–1100 BC).

Hellenic Dating from the period between the beginning of the Iron Age in the late 11th c. BC to the end of the CLASSICAL period in the 4th c. BC.

Hellenistic Dating from the time of Alexander the Great's successors (*c.* 323–100 BC). Such

art was produced in a variety of styles, from the BAROQUE to the ARCHAISTIC, throughout the territories Alexander had conquered, from Egypt to the borders of India. (PERGAMENE SCHOOL, bas RELIEF.★)

herm A bust, originally one portraying the Greek god Hermes, placed on top of a quadrangular PILLAR, usually one about the height of a man and tapering towards its base. In Greek ARCHAIC and CLASSICAL examples a phallus is represented on the front of the pillar. In Greek and Roman times herms were often used as boundary stones and to mark crossroads and street corners. Since the RENAISSANCE they have formed part of the general vocabulary of decoration. See also TERM.

heroic I. (Used of sculpture.) Substantially larger than life, but remaining within the human scale and frame of reference. 2. (Used of landscape painting.) Designed to evoke noble and elevated sentiments. The equivalent in the landscape tradition of the GRAND MANNER. 3. More generally, aspiring towards the SUBLIME.

herringbone work Stones, bricks or tiles laid on a diagonal, with alternate COURSES facing in opposite directions. (BRICKWORK.★)

hieratic (Of painting, sculpture, etc.) Keeping a certain formality because of a concern with the sacred rather than the everyday.

hieroglyphic (Gk 'sacred carving') I. (Used of Ancient Egyptian pictorial writing.) Containing signs representing either complete words, or syllables forming part of a word. (BOOK OF THE DEAD,★ CARTOUCHE.★) 2. (Used more loosely of any representation) Conveying a secret meaning by the substitution of one image for another.

high altar The main altar in a church or temple.

high art Art which aspires towards an elevated, generalized, usually CLASSICAL style.

high fired (Used of PORCELAIN and of tin ware decorated with high temperature ENAMEL COLOURS.) Fired in a kiln which reaches temperatures from 1100° to 1450° C. Synonym: *grand feu*.

High Renaissance The culminating phase of RENAISSANCE art, *c.* 1495–1520, typified by the work of Raphael, Michelangelo and Leonardo da Vinci.

Hard-edge *painting in the wider sense of the word: Josef Albers'* Homage to the Square: Silent Hall, *1961.*

Hatching: *study for a nativity, c. 1495–97, by Leonardo da Vinci. Since he was left-handed, the main lines run from top to bottom right.*

The Parthenon frieze, 5th c. BC, shows typical **high art** *idealization of an everyday event, in this case a religious procession.*

high warp Synonym of HAUTE LISSE.

highlight The brightest part of a picture.

hip The angle formed when two sloping ROOF★ surfaces meet.

hipped gable A GABLE whose upper part slopes back towards the ridge of the ROOF.★

hippodrome 1. An enclosed racecourse. The term derives from those designed in Roman times for horse and chariot races, which were of elongated form with a spine down the centre around which the race was run. 2. In Britain, a name sometimes given to a theatre, derived from the fact that such theatres usually began their careers as music halls, offering animal acts as part of the entertainment.

Hirado Blue-and-white Japanese PORCELAIN made on Hirado island, at the Mikawachi kilns. (CELADON was also made at these kilns.) The finest pieces date from the mid 18th to the mid 19th c.

Hispano-Moresque (Used of architecture and decorative art.) Spanish but Moorish-influenced.

historiated initials Large initial letters used in manuscript ILLUMINATION and occasionally in early printed books. They can be composed of animals, birds, foliage and ornamental scrolls, and can also be used as frames for various pictorial subjects.

historicism (fr. Ger. *Historismus*) The 19th-c. revival of historical styles, particularly in architecture and the DECORATIVE ARTS.

history painting A type of FIGURE PAINTING which illustrates historic or legendary incidents in a deliberately grand and noble way. Considered by the ACADEMIC theorists of the 17th and 18th c. the highest form of art next to religious painting. See also GRAND MANNER.

Hochschnitt (Ger. 'high cut') Glass ENGRAVING where the decoration appears in RELIEF rather than INTAGLIO.

Hodgetaira A type of BYZANTINE Madonna, named after a painting for a long time preserved in the monastery of the Hodgeton in Constantinople and traditionally ATTRIBUTED TO St Luke, which shows the Virgin with the child on her left arm. (ICON.★)

hog-backed (Used of a roof-ridge.) Rising slightly towards the centre.

An elaborate **historiated** *initial letter S from the Tickhill Psalter, c. 1310. The six scenes include one of St Thomas à Beckett (at the bottom).*

ho-ho bird A strange crane-like bird used decoratively in Chinese art, and borrowed for European CHINOISERIE decoration.

Holbein rugs Turkish rugs of the 16th and 17th c. which have a border of stylized KUFIC lettering, and a red ground decorated with octagonal motifs in blue and yellow. They are named after the European painter Hans Holbein because examples appear in his paintings.

hollow-ware Any hollow container, such as a jug or kettle, as opposed to FLATWARE. The word is applied chiefly to metalwork and CERAMICS.

holography The process of recording an image on photo-sensitive material, without the use of a lens, in the form of an interference pattern produced by splitting a beam from a laser. When the resulting pattern is scanned by another laser, or even by a concentrated beam of light from a normal source, the image reconstitutes itsef as a 'hologram', which is fully three-dimensional, and which will retain its coherence from whatever angle it is viewed, appearing just as we would expect to see it in the real world (except, usually, for its colour). The image can lie behind, intersect with, or seem to float in front of the reflective surface or transparent plate on which it is recorded.

Holy Family See SACRA FAMIGLIA.

hood-mould, hood-moulding, hood-stone Synonyms of DRIP-STONE.

(Above) **Hudson River School:** *Thomas Cole's* The Oxbow, *1846, is a typically grandiose view of native American scenery, in this case the Connecticut River near Northampton.*

(Right) Russian **icon** *of c. 1600 showing a favourite subject, the Virgin hodgetaira.*

horizon-line In linear PERSPECTIVE,★ the line where sky and earth seem to meet. It is on this line that the VANISHING POINT is located.

hors commerce (Fr. 'not for sale') A PRINT, often one displayed in an exhibition, which does not form part of a regular numbered EDITION and is therefore not for sale. Such prints are usually marked h.c.

Hortus Conclusus (Lat. 'enclosed garden') A representation of the Virgin and Child in a fenced garden, sometimes accompanied by a group of female saints. The garden is a symbolic allusion to a phrase in the *Song of Songs* (4:12) 'A garden enclosed is my sister, my spouse'.

hot colour Synonym of WARM COLOUR.

Hudson River School A group of North American painters active *c.* 1820 – *c.* 1850, whose chief subject-matter was the scenery of the Hudson River valley and the Catskill Mountains. Among the members of the school were Thomas Cole and Frederic Edwin Church.

hue The word is confusingly used in three related but different senses: 1. A colour. 2. Synonym of SATURATION. 3. A compound colour in which one of the PRIMARY COLOURS predominates, e.g. blue-grey.

Huguenot silver Silver made by, or in the style of, the Huguenots, the Protestant refugees

who settled in England after the Revocation of the Edict of Nantes (1685). It comprises many different manners.

hydria (fr. Gk *hudor*, 'water') A Greek water-jar, generally urn-shaped and with three handles, a pair of horizontal ones for lifting the vessel and an upright one for pouring. Synonym: kalpis. (GREEK VASES.★)

Hyper Realism Synonym of SUPER REALISM.

hypocaust A Roman system of heating buildings by means of steam circulating beneath a pavement.

hypogeum (Lat., lit. 'under the earth', pl. **hypogea**) An underground building or part of a building.

hypostyle hall (fr. Gk 'under columns') In ancient times, a large hall with its roof supported on a forest of columns. More commonly used of Ancient Egyptian than of Greek architecture.

I

icon A painting by a Greek or Russian Orthodox believer on PANEL, generally of a religious subject strictly prescribed by tradition, and using an equally strictly prescribed pattern of representation. An authentic icon can be of any age from the 6th c. AD to the present day.

Iconoclast art A type of BYZANTINE art without FIGURATIVE religious images, created during the period AD 730–843 (the reigns of Leo III and the majority of his successors) when such images were officially banned.

iconography 1. The study and identification of portraits. 2. The systematic investigation of subject-matter, as opposed to style.

iconology The interpretation of subject-matter, as illuminated by a study of the broad cultural and historical background.

iconostasis (Gk 'standing image') The screen separating NAVE from CHANCEL in a GREEK ORTHODOX CHURCH,★ and usually covered with ICONS. (The equivalent of the ROOD-SCREEN in a Western church.)

Idea Art Synonym of CONCEPTUAL ART.

Ideal, the That which unites artistically in a single form all the excellencies found in nature in different individual forms of the same type or belonging to the same category. 'The Ideal' thus aims to be more perfect than anything which can actually be observed but necessarily proceeds from the artist's own idea of perfection. The notion has its roots in RENAISSANCE Neo-Platonism, and exercised most influence on artists in the second half of the 18th c. See also NEO-CLASSICISM.

ignudo (It., pl. **ignudi**) A male nude, in particular Michelangelo's nude figures on the Sistine ceiling. (FICTIVE SCULPTURE.★)

ikat, ilkhat (Malay) 1. The process whereby a pattern is RESIST DYED on the warp (warp ikat), on the weft (weft ikat) or both (double ikat) before the fabric is woven. 2. The textile thus produced.

illumination The illustrations and book decorations found in medieval and later manuscripts, usually painted in GOUACHE or TEMPERA with gold highlights – hence the name. (DROLERIES.★)

illusionism The use of pictorial devices, chief among them PERSPECTIVE and FORESHORTENING, so as to persuade the spectator that what he or she sees is real.

Imago Pietatis (Lat. 'image of piety') An image of Christ standing on the tomb.

Imari (Jap.) Richly decorated PORCELAIN made at Arita in Japan for the export market and

Porcelain figure of a Japanese beauty from Arita, c. 1673–83. Her robes are decorated in **Imari** *style.*

shipped to Europe from the port of Imari. It dates from the late 17th c. onwards and combines UNDERGLAZE blue with OVERGLAZE ENAMEL (chiefly red) and gold. Chinese Imari imitates the Japanese original, competing for the same European markets, and Imari decoration was also used by English porcelain factories in the 18th and 19th c.

imbricated Decorated with a SCALE ORNAMENT.

imp. (fr. Lat. *impressit*, 'printed') Synonym of EXC.

impasto (It.) The texture produced by the thickness of PIGMENT in a painting.

impost The horizontal moulding or COURSE of stone or brickwork at the top of a PILLAR or PIER, from which the ARCH★ springs.

impost block In CLASSICAL, EARLY CHRISTIAN and BYZANTINE architecture, a block of masonry inserted above the CAPITAL★ and below the ABACUS.

impresa (It.) An EMBLEM used in Italy during the RENAISSANCE as a personal badge or device by princes, scholars and other prominent people.

impression 1. An individual copy of a PRINT or ENGRAVING, meaning specifically the sheet of paper upon which the design has been 'impressed'. 2. The process of impressing the PLATE on the paper.

Impresa: *the book cupboard on this personal medal of Galeotto Marzio da Narni, a teacher of humanities at Bologna in the 15th c., is a typical subject.*

Monet's Le déjeuner, *c. 1873, comes from the high period of* **Impressionism** *and shows a characteristic* plein air *scene.*

Impressionism French 19th-c. art movement which tried to use contemporary scientific research into the physics of colour (including work carried out by Eugène Chevreul) to achieve a more exact representation of colour and TONE. The majority of the Impressionists applied paint in small touches of pure colour rather than broader, blended strokes, thus making pictures which seemed dazzlingly brighter than those of contemporary SALON artists. They also believed in painting out of doors, and in trying to catch a particular fleeting impression of colour and light rather than making a synthesis in the studio. The painters connected with the movement came together just before the Franco-Prussian War of 1870–71. The First Impressionist Exhibition was held in 1874, and included work by Monet, Renoir, Sisley, Pissarro, Cézanne, Degas, Guillaumin, Boudin and Berthe Morisot.

imprimatura (It. 'primary coat') A WASH or GLAZE of thin colour used to tint or tone down a white canvas or panel GROUND before painting on it.

__in., __inv., __invenit, __inventor (Lat. *invenit,* 'invented') An abbreviation seen on PRINTS, which indicates that the name it follows is that of the creator of the design (who was not necessarily the ENGRAVER or ETCHER).

__inc., __incid., __incidit, __incisor (Lat. *incidit,* 'cut') An abbreviation seen on PRINTS, which indicates that the name it follows is that of the ENGRAVER or ETCHER.

incunabula, (Lat. 'swaddling band(s)', sing. **incunabulum**) Books printed before 1501, i.e. during the infancy of printing.

Independent Group A group of British artists, architects and art critics (among them Richard Hamilton and Eduardo Paolozzi) who met for discussion at the ICA (Institute of Contemporary Arts) in London in the mid and late 1950s. The Independent Group was responsible for the birth of British POP ART.

Individualists Chinese artists who withdrew from the official SCHOOLS and painted on their own in protest against Manchu rule after the fall of the Ming dynasty in the 17th c.

industrial design The reasoned application of aesthetic and practical criteria to the design of machine-made articles from the mid 19th c. onwards, in the hope of creating a successful marriage between the two.

inlay Any process (e.g. MARQUETRY) by which small pieces of one material are inserted into a large piece of another, so as to create a design.

inrō (Jap. 'medicine box') A small LACQUER box worn at the belt in place of a pouch in traditional Japanese costume, which has no pockets. The *inrō* is generally divided into several compartments and is richly decorated. (NETSUKE.★)

insufflation A Chinese technique for decorating PORCELAIN by blowing powdered PIGMENT through a tube whose end is covered with fine gauze so as to spread it evenly.

Intarsia: trompe l'oeil *panels from the studio of Federigo, Duke of Urbino, after designs by Botticelli, 1476.*

Gentile da Fabriano's Madonna *from the Quaratesi altarpiece, 1425, typifies the* **International Gothic** *style in its elegance, detail and rich colour.*

intaglio 1. A hollow-cut design, i.e. the opposite of RELIEF. An intaglio is often used as a MATRIX from which a relief can be made for a coin, MEDAL or sealing. Synonym: cavo rilievo. 2. A hollow-cut GEMSTONE. See also CAMEO.

intaglio printing A printing process (e.g. GRAVURE) by which the design is ETCHED or ENGRAVED onto the plate, which is then covered with ink. The surface is wiped clean, leaving ink only in the incised lines, and the IMPRESSION made directly onto the paper.

intarsia (It.) A type of MARQUETRY used in Italy for the decoration of choir-stalls and the panelling of rooms, etc. It often has FIGURATIVE subjects, or shows elaborate PERSPECTIVE effects. Synonym: tarsia.

intercolumniation See COLUMN.

interlace Decoration made of intertwined lines, particularly that in CELTIC ART.★

Intermedia Synonym of MIXED MEDIA.

International Gothic The development in GOTHIC style, particularly in painting and sculpture, throughout Europe around 1400 towards courtly elegance and NATURALISM. In painting the label has been applied to Pisanello and Gentile de Fabriano in Italy, André Beauneveu in France, and Bernardo Martorell in Spain.

International Modern Synonym of INTERNATIONAL STYLE.

International Style Name coined by the architectural historian Henry Russell Hitchcock and the architect Philip Johnson to characterize the AVANT-GARDE architecture which appeared in Europe between 1920 and 1930. Their criteria were that it was architecture which worked from the inside of the building outward to its FAÇADES, replacing the search for axial symmetry by one for logical planning, and that it eliminated all arbitrary decoration. Synonym: International Modern.

intimisme (Fr.) The name given to the late IMPRESSIONIST tendency (one especially closely associated with the work of Bonnard and Vuillard) to show informally intimate scenes in bourgeois domestic interiors.

intonaco (It.) The final layer of PLASTER on which a FRESCO is painted.

intrados (Fr.) The inner face of an ARCH.★ See also EXTRADOS.

Edouard Vuillard's double portrait of Misia Sert (then Natanson) with the painter Félix Vallotton, 1894, shows a bourgeois interior typical of **intimisme**.

International Style: *the Tugendhat House at Brno, 1930, an early work by Mies van der Rohe, shows characteristic lack of decoration and asymmetrical façades.*

Istoriato: *a majolica dish commemorating Pope Leo X's visit to Florence in 1516.*

Isnik Turkish POTTERY of the 16th and 17th c., from Isnik (ancient Nicea) in Anatolia. It is painted in bold floral patterns, related to those on OTTOMAN textiles of the same period, and in brilliant colours (typically, blue, turquoise and green, often with the addition of a bright sealing-wax red).

isocephaly The arrangement of figures so that they are all at the same height, no matter what posture they are in. Typical of Ancient Greek art of the CLASSICAL period.

istoriato (It. 'historiated') Italian MAJOLICA of the late 15th and 16th c., especially plates and chargers, which is decorated over its entire surface with FIGURATIVE scenes drawn from history, CLASSICAL mythology or the Bible.

Italianate Derived from Italian RENAISSANCE architecture and decoration.

Italianate style 1. A 19th-c. English architectural style, derived from Italian RENAISSANCE buildings, and applied to public buildings, grand town architecture, and also to country houses and villas. 2. A mid 19th-c. North American architectural style applied to houses, many with a low-pitched hipped ROOF topped by a BELVEDERE.

Italianizer Synonym of ROMANIST.

The **Italianate style** *in England: Charles Barry's Reform Club in Pall Mall, 1837, which derives from the 16th-c. Palazzo Farnese in Rome.*

italic 1. Of the Ancient Italian civilizations, to *c.* 1st c. BC, excluding the Romans, the Etruscans and the Greek colonies in southern Italy. 2. A form of CALLIGRAPHY★ first used by the Italian Humanists in the 15th c., with sloping letter-forms. 3. A TYPEFACE★ based on this.

iwan (Arabic) In SASSANIAN and Islamic architecture, a large porch or shallow hall with a pointed barrel VAULT.

J

Jack of Diamonds (fr. Russian, *Bubnovii Valet*) A Moscow-based group of progressive, Western-oriented Russian artists who first exhibited together in 1910. Their work was typified by brilliant colour and radical simplification of FORM to create surface pattern. Contributors to the exhibition included Larionov, Goncharova and Malevich, and there were also painters from abroad, such as Delaunay and Léger. The group later became one of the focal points of Russian FUTURISM.

Jacobean Style Style of architecture and decoration prevalent in England during the reign of James I (1603–25). RENAISSANCE architectural motifs, coarsely rendered and ungrammatically used, are combined with STRAPWORK and other decorative forms associated with MANNERISM in northern Europe. In interiors, there is much use of elaborate PLASTER-work and wood-carving.

Jacobethan 1. A mixture of Elizabethan and JACOBEAN styles, especially free 19th-c. imitations, which combines the characteristics of the two periods. 2. (Incorrectly.) Genuine Elizabethen and Jacobean styles.

jamb The side of a window-, door- or other wall-opening.

jamb figure A carved figure forming part of the JAMB on a medieval church doorway.

Japanned work European imitations of oriental LACQUER, produced by a number of different techniques.

japon See ÉPREUVE SUR JAPON.

japonaiserie (Fr.) 1. European imitations of native Japanese arts and crafts. 2. Japanese products which most appealed to Europeans at the height of the European enthusiasm for Japan during the second half of the 19th c. These included WOODBLOCK PRINTS in UKIYO-E style, PORCELAIN, fans, LACQUER and metalwork.

Japonisme (Fr.) The influence of Japan on European art, especially in IMPRESSIONISM and POST-IMPRESSIONISM.

Jazz Modern A popular decorative style of the 1920s and 1930s featuring jagged patterns which ultimately derive from CUBISM.

Jesuit porcelain Chinese PORCELAIN decorated, usually in monochrome, with subjects taken from European PRINTS.

jetty In architecture, the projecting upper storey of a timber-framed building, supported by CANTILEVERS and joists.

jib door, gib door A door made flush with the wall surface, and perhaps further concealed by having patterned wallpaper, the DADO, etc., taken straight over it without interruption.

joinery Architectural woodwork and furniture made of pieces of wood fitted together with pegs and MORTICE-AND-TENON JOINTS.

journeyman (fr. Fr. *journée*, 'day') Artist or craftsman who was fully trained in his chosen profession, but who was not yet master in his particular GUILD. He was thus not free to work on his own account, but worked by the day for a master.

Ju ware Chinese STONEWARE made at Ju Chou in central Honan province for the use of the Sung Imperial court in the early 12th c. Production ceased when the court moved south in 1128, and examples are exceedingly rare. Ju ware has a buff BODY covered with a CRACKLED blue-to-lavender GLAZE.

jubé French for ROOD-SCREEN. The word comes from the Latin phrase *Jube domine benedicere* ('Let us bless the Lord'), which is commonly spoken by a Catholic priest before the lesson, while standing in front of the screen.

Jugendstil (Ger. 'Young Style') The German and Austrian form of ART NOUVEAU, generally later in date and more restrained in style than its French and Belgian counterparts. It was named after the magazine *Jugend* ('Youth'), founded in Munich in 1896. Among the designers associated with the style were Hermann Obrist and Richard Riemerschmidt in Germany, and Joseph Maria Olbrich in Austria.

Jacobean *romanticism: the 'Little Castle' by John Smythson at Bolsover Castle, Derbyshire, 1612, is an incongruous mixture of Renaissance and Gothic elements.*

Junk Sculpture A variety of ASSEMBLAGE made by such artists as John Chamberlain from the late 1950s, out of discarded industrial items and the detritus of modern consumer culture.

K

kachina-doll A North American Indian carved wooden doll representing a supernatural being in the human guise of a masked dancer. They are related to fertility beliefs and are also used to educate children concerning the spirits and their functions.

kakemono (Jap. 'hanging picture') A Japanese painting, PRINT or piece of CALLIGRAPHY on a hanging vertical scroll.

Kakiemon (Jap.) Fine-quality Japanese POR-CELAIN, sparsely and asymmetrically decorated with OVERGLAZE ENAMELS and sometimes gold. It is named after the porcelain-maker Sakaida Kakiemon (1596–1666), who is said to have introduced overglaze enamel painting to Japan from China in 1644. The Kakiemon style was much imitated by leading European factories, among them Meissen, Chantilly, Mennecy, Chelsea, Bow and Worcester.

kalathos (Gk) 1. A wicker basket, or a representation of one in some other material such as stone. According to legend, the Corinthian CAPITAL was based on an ACANTHUS growing in a kalathos. (ORDERS OF ARCHITECTURE★.) In Christian times, because baskets were used for bread, the kalathos became a symbol of the Eucharist. 2. A type of KRATER, bucket-shaped and without handles. (GREEK VASES.★)

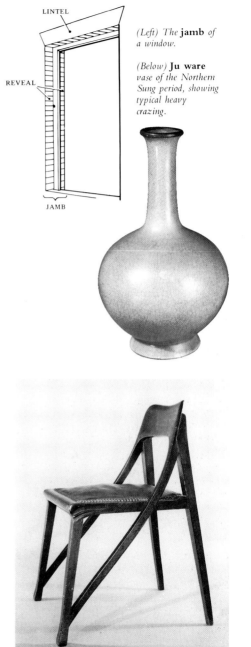

(Left) The **jamb** *of a window.*

(Below) **Ju ware** *vase of the Northern Sung period, showing typical heavy crazing.*

Jugendstil *chair by Richard Riemerschmidt, 1899, designed with the restraint and lack of ornamentation characteristic of this version of Art Nouveau.*

Kalighat *devotional painting showing the death goddess Kali standing on Shiva the creator, c. 1880.*

Kalighat painting An Indian school of popular painting associated with a temple built in 1809 in honour of the goddess Kali at Kalighat, two or three miles south of the centre of Calcutta. The bold, rough paintings in WATER-COLOUR on paper were mass-produced as devotional images for poor pilgrims from *c.* 1832 onwards. Secular subjects in the same style were also produced. The school survived until *c.* 1930.

kalpis (Gk) Synonym of HYDRIA.

Kaltemail (Ger. 'cold enamel') A kind of LACQUER used in the 16th and 17th c. to imitate ENAMEL, and usually applied to objects too large or too delicate for FIRING.

Kamares ware A type of finely painted MINOAN pottery with designs in red and white on a dark GROUND. Named after the sacred cave on Mount Ida in Crete, where it was first found.

Kangra School A school of Indian painting of the late 18th and early 19th c., connected with the state of Kangra in the western Himalayas, and with the rajah Sansar Chand (1775–1823), who was its patron. Paintings of lovers and of women waiting for their lovers were especially favoured by Kangra artists.

Kanō School (Jap.) Hereditary school of painting in Japan, founded during the Muromachi period (1392–1573) by Kanō Masonobu. It lasted until the 19th c. Kanō artists worked both in the decorative tradition native to Japan, and in that of Chinese ink painting.

kantharos An Ancient Greek two-handled goblet with a deep bowl. (GREEK VASES.★)

kara-e (Jap. 'China painting') A painting by a Japanese artist in Chinese style. See also YAMATO-E.

keep The strongest and most important tower in a castle, generally in the centre. Synonym: donjon.

kendi (Persian) A globular drinking vessel with a vertical neck for filling, and a short projecting spout by which liquid can be poured directly into the mouth.

key The average of TONAL VALUES in a painting. High-key painting is nearer white than black, low-key painting the reverse.

key pattern Synonym of GREEK KEY PATTERN.

keystone The central wedge-shaped stone or VOUSSOIR of an ARCH.★

khan (Arabic, 'inn') Synonym of CARA-VANSERAI.

kilim (fr. Turkish) Middle Eastern rug, usually the work of nomads, with no PILE and the same design on both sides of the weaving. Synonyms: pala, karamani.

kinaesthetic art Art which seems to stimulate in the spectator physical sensations other than visual ones.

kincob (fr. Persian *khimkab*) A fabric BROCADED with gold or silver thread.

kinetic art Art which incorporates an element of mechanical or random movement, or which gives the illusion of movement by the use of optical techniques (OP ART). It was first used by the CONSTRUCTIVISTS in the early 20th c. and

was further popularized by Alexander Calder with his MOBILES in the 1930s, but came to full prominence in the 1950s.

king post See ROOF, TYPES OF.

kiosk (fr. Turkish *kösk*, 'pavilion') A small PAVILION, generally consisting of a roof supported by pillars.

kirigane (Jap.) Any surface (e.g. LACQUER or paper) scattered with tiny pieces of gold FOIL for decoration.

kirin (Jap.) The Japanese version of a KYLIN.

Kit-cat One of the standard sizes of canvas, measuring 36 × 28 in. (91.5 × 71 cm). The name originates from Sir Godfrey Kneller's choice of it for his series of portraits (1702–17) of members of the Whig Kit-Cat club, which was named after Christopher ('Kit') Cat, keeper of the pie-house where they met. A Kit-cat portrait should, strictly speaking, show the head, shoulders and one hand.

Kitchen Sink School Term coined by the British art critic David Sylvester for a SOCIAL REALIST tendency in British painting of the 1950s. Its subject-matter frequently anticipated that of POP ART. The artists involved included John Bratby, Derrick Greaves and Jack Smith.

kitsch (Ger. 'trash') Mass-produced art and ARTEFACTS unsuccessfully aping the aesthetic standards of élite culture.

knock-down furniture Furniture which can be disassembled and packed completely flat. Synonym: package furniture.

knop (Dutch 'knob') A rounded BOSS or ornament, sometimes in the form of a bunch of flowers or leaves.

ko kutani (Jap. 'old kutani') See KUTANI.

kōbako (Jap.) A Japanese incense box.

koftgari (Persian) 1. The technique of decorating iron or steel with an INLAY of precious metal. (See also DAMASCENING.) 2. The technique of decorating iron or steel with metal FOIL, which is stuck on with adhesives.

koine (Gk) The stylistic characteristics common to a particular geographical region during a particular epoch.

kondo (Jap.) The main hall of a Japanese Buddhist monastery.

The Coach House Door, *a typically banal* **Kitchen Sink School** *painting by John Bratby, c. 1959.*

kore (Gk 'maiden', pl. **korai**) A sculpture of a standing draped female figure, typical of Greek art of the ARCHAIC★ period (*c.* 620–*c.* 500 BC). See also KOUROS.

Kōrin School (Jap.) School of Japanese decorative painting named after the artist Ogata Kōrin (1658–1716). It was in fact founded by Honnami Koětsu (1558–1637) and Nonomura Sotatsu (d. 1643) and represented a movement away from Chinese influence. The works it produced are characterized by sumptuous colour and bold and unexpected pattern.

kotyle (Gk) 1. An Ancient Greek deep two-handled cup. 2. Sometimes wrongly used as a synonym for SKYPHOS. (GREEK VASES.★)

kouros (Gk 'youth', pl. **kouroi**) A sculpture of a nude youth, representing either a god or the victor of some athletic contest, typical of Greek art of the ARCHAIC period (*c.* 620 – *c.* 500 BC). See also KORE.

kraak porcelain (Dutch *kraak*, 'carrack') Late 16th- and 17th-c. Chinese blue-and-white POR-CELAIN made for export, and usually painted with panels of repeating designs. So named after a Portuguese carrack, or merchant ship, loaded with the ware which was captured by the Dutch in 1603.

krater (Gk, lit. 'mixing bowl') An Ancient Greek vessel for mixing wine and water, with an almost hemispherical BODY and a wide mouth. (GREEK VASES.★)

Kufic, Cufic (fr. Cufa, a city south of Bagh-dad) A formal angular variety of Arabic CAL-LIGRAPHY, used decoratively on buildings, POTTERY, textiles, metalwork, etc.

külliye (Turkish) A complex of buildings centred on a mosque and including a school and hospital.

Kunstkammer (Ger. 'art chamber') An as-semblage of art objects and curiosities brought together by German princely and noble houses in the 16th and 17th c. Despite their miscel-laneous character, these collections were the fore-runners of the museums we know today. Synonym: Wunderkammer.

Kunstwollen (Ger. 'art wish') Artistic intention.

Kütahya (Turkish) A type of TIN-GLAZED POTTERY from Kütahya in Central Anatolia which continues the ISNIK tradition but uses a slightly different PALETTE including yellow (which is never found on Isnik).

kutani (Jap.) 1. Strictly speaking, Japanese PORCELAIN made at Kutani (Kaga province) in the 17th and 18th c. Synonym: *ko kutani* ('old kutani'). 2. More loosely, Japanese CERAMIC ware in Kutanic style of any date and provenance.

kyathos (Gk) 1 A cup-like ladle with an upright, looped handle. (GREEK VASES.★) 2. A small KANTHAROS without a foot.

kylin (Chi., 'male-female') 1. A Chinese myth-ical beast with the head of a dragon, a scaly body, the hooves of a deer, a bushy tail and a single horn similar to a unicorn's. 2. Sometimes wrongly used as a synonym of DOG OF FO.

kylix (Gk) An Ancient Greek drinking cup with a wide shallow bowl, a pair of horizontal handles, a slender stem and a small foot. (GREEK VASES.★)

L

La Tène style See CELTIC ART.

label 1. A band or scroll bearing an inscription. 2. See MOULDING.

label-stop See MOULDING.

Labours of the Months A series of twelve scenes, one for each month, each showing a different country occupation, and usually ac-companied by the appropriate sign of the zodiac. Found in medieval sculpture and STAINED GLASS, and often in the calendar of a BOOK OF HOURS decorated with ILLUMINATION.

lac burgauté (Fr. 'mother-of-pearl lacquer') Black LACQUER decorated with mother-of-pearl INLAY. It was sometimes used on Chinese PORCELAIN.

lacertine Synonym of ANIMAL INTERLACE.

lacquer An extremely hard waterproof var-nish which originated in the Far East. One kind is made from the sap of the *Rhus vernicifera* tree, which polymerizes on exposure to air. For use as lacquer, it needs only to be strained and heated to reduce the volume of liquid. It can be built up in layers, and is then hard enough to be carved. (COROMANDEL LACQUER is made by this method.) Another kind (shellac) is made by extracting the secretion of the lac insect, *Coccus lacca*, by immersing the creature in boiling water. This secretion, called lac, is then melted into thin flakes and dissolved in alcohol so that it can be used as lacquer. See also JAPANNED WORK, VERNIS MARTIN.

lacunar 1. Synonym of COFFERING. 2. Syn-onym of CAISSON.

Lady chapel A chapel dedicated to the Virgin, generally built at the extreme east end of a church, as an extension of the CHANCEL. (GOTHIC CATHEDRAL, plan.★)

lajvardina ware (fr. Persian *lajvard*, 'lapis lazuli, cobalt') Persian POTTERY painted in colours or gold over a deep blue or turquoise GLAZE.

lambrequin (Fr., name of the scarf worn by a knight across his helmet) 1. A CORNICE or shelf with pendent ornaments. 2. A piece of fabric hung from a cornice or shelf. 3. A scalloped border ornament.

lampas A heavy form of DAMASK where the pattern, formed of WEFT floats (threads crossing two strands or more before they are bound once more into the WARP), is additionally held by a separate binding warp. In the 18th c. lampas was used for best-quality silk upholstery.

lanceolate Shaped like a lance-blade.

lancet A tall narrow opening crowned with a steeply pointed arch. Found in GOTHIC architecture, especially that of the 13th c. (WINDOW, types of.★)

landscape format A painting, drawing, etc., which is wider than it is high (i.e. the opposite of PORTRAIT FORMAT). So called because most ·representations of landscape have this shape.

lantern In architecture, a small turret at the highest point of a DOME,★ fitted with windows or other openings and used to light the space below.

lanx (Lat.) A large flat dish, often oblong.

latent image Invisible photographic image present after only a short exposure using Fox Talbot's process of 'photogenic drawing'. It could subsequently be developed with gallo-nitrate of silver. The discovery of the latent image made the CALOTYPE process practicable.

Latin cross A cross with a lower shaft longer than the other three.

latten A base metal ALLOY resembling brass, and composed of copper, zinc, lead and tin. White latten, common in the Middle Ages, was a mixture of brass and tin, used for monumental brasses and other articles of ecclesiastical use.

lattice An arrangement of narrow bars forming a diamond pattern and often filling a window opening.

lattimo (fr. It. *latte*, 'milk') Opaque white GLASS, either forming the whole BODY of the object, or used as decoration in stripes, festoons or threads. Often confused with LATTICINO, which is synonymous only when thread decoration is used.

latticino, latticinio (fr. It. *latte*, 'milk') Clear GLASS with a decoration of embedded threads, which are usually but not invariably opaque white. The technique was invented in Murano. See LATTIMO, VETRO DA TRINA.

White marble slab from Egypt, 9th–10th c. AD, *bearing a* **Kufic** *inscription (the first three words of the Basmalah).*

A 14th-c. German wood carving showing six **Labours of the Months**. *The small genre scenes are matched with the appropriate zodiacal symbols.*

Lambrequin *border ornament on an 18th-c. Rouen faience dish.*

Linenfold *panels on a 16th-c. English oak armchair.*

lavoro di basso rilievo See ENAMEL.

lay figure A jointed wooden manikin which can be arranged in almost any attitude with or without clothing and which is used by artists for the study of the proportions of the human body.

lay-in Synonym of DEAD COLOUR.

laying in In traditional oil painting (as opposed to ALLA PRIMA), the process of painting the canvas in a monochrome DEAD COLOUR as a first step in the development of TONAL VALUES and of the COMPOSITION as a whole.

layout An annotated diagram showing the positioning of typographical matter, and illustrations if any, on the page. (See also ARTWORK.)

lead glass A type of GLASS with a high proportion of lead oxide, which enhances its brilliance. It was first used by George Ravenscroft in *c.* 1676, and is often ENGRAVED or facetted.

leaded glazing, leaded lights Small panes or pieces of GLASS of various shapes, and usually various colours, held together by H-section lead strips, or 'cames'.

lebes (Gk) 1. An Ancient Greek cauldron, used for boiling meat. 2. A later version of the DEINOS, provided with two vertical handles,

and used for the same purpose. A *lebes gamikos* was one used as a wedding gift. (GREEK VASES.★)

lekane, lekanis (Gk) In Ancient Greece, a shallow basin with a foot, a cover and two handles. (GREEK VASES.★)

lekythos (Gk) In Ancient Greece, a cylindrical oil jug, with a single vertical handle, a narrow neck and small mouth. (GREEK VASES.★)

lettre bâtarde (Fr. 'bastardized letter') French GOTHIC TYPEFACE similar in style to SCHWABACHER, and used in the 15th c. by Caxton.

lettrism, lettrisme Term used since the 1950s to describe works of art which use words, letters and signs for purely visual effect, without reference to their meaning.

Liberty style See STILE LIBERTY.

lich, lych gate A covered gate at the entrance to a churchyard.

lierne See VAULT.

life drawing A drawing of a nude made from a living model.

light A window opening formed by MULLIONS or TRACERY.

limner Old name for an artist, used in 15th- and 16th-c. Britain chiefly (in 18th-c. New England exclusively) for a portrait painter.

line engraving A type of ENGRAVING in which the design is made directly with a BURIN on a metal (usually copper) plate. The resulting BURR is then removed, leaving a clean groove to hold the ink.

linearity The reliance on line for the principal effect in a drawn or painted COMPOSITION, rather than on colour or TONE.

linenfold Carved ornament, often used in the late 15th and during the 16th c. to fill wooden panelling and to ornament furniture. So named because it resembles a loosely folded linen napkin.

linga, lingam (Skr. 'mark') A phallic emblem of the Hindu god Shiva, sometimes combined with one or more faces of the god.

linocut A RELIEF PRINT made from linoleum fastened to a wooden block.

lintel The horizontal piece of stone or timber inserted across an opening to take the weight of the wall above it. (ARCH,★ JAMB.★)

listel Synonym of FILLET.

lithograph A PRINT made by drawing on fine-grained porous limestone or on a zinc plate with greasy material, then wetting the stone or plate and applying greasy ink, which will adhere only to the drawn lines. Dampened paper is applied to the stone and is rubbed over with a special press to make the final print. (PYLON. ★)

Little Masters 1. Minor German artists, especially the PRINT-makers of the 16th and 17th c., who produced works of small dimensions – hence their name. Among them are Jost Amman, Hans Burgkmair, Hans Sebald Beham and Heinrich Aldegrever. 2. A group of Attic BLACK-FIGURE cup painters, whose work is characterized by miniature figures painted in the zone closest to the rim.

Living Sculpture Synonym of BODY ART.

loaded brush Synonym of IMPASTO.

lobate style Synonym of AURICULAR STYLE.

local colour The colour of a particular object as seen in daylight against a white background irrespective of surrounding influences such as shadows and reflections.

loggia (It.) Synonym of GALLERY.

lohan (Chi.) A Buddhist immortal, often represented in Chinese art.

long house A one-storey dwelling raised on PILES, and of extended oblong shape. Found in New Guinea and Sarawak, and occupied by a number of families in an inter-related tribal group, each with its own area of floor-space.

lost wax process Synonym of CIRE PERDUE.

Lotto rug A type of 16th-and 17th-c. Turkish rug with a border of stylized KUFIC lettering, and a trellis of formalized PALMETTES in blue and yellow on a red ground. They were named after the European painter Lorenzo Lotto because examples appear in his paintings.

Louis XIV style The rich, formal style of decoration in vogue under King Louis XIV of France. It combines elements borrowed from the Italian BAROQUE with devices taken from the standard CLASSICAL repertoire of ornament. GOBELINS tapestries, BIZARRE SILKS and BOULLE MARQUETRY were among the luxurious products manufactured.

Rock crystal **linga** *from Rajasthan, engraved with a yantra, 17th c.*

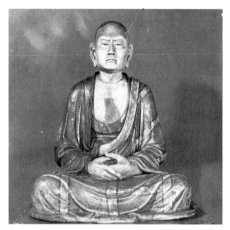

Glazed pottery figure of a seated **lohan** *from Hopei, China, 10th–11th c.*

Lotto rug *covering a table in this* Family Group *by Lorenzo Lotto (c. 1480–1556/7).*

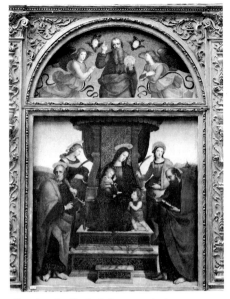

*Altarpiece by Raphael (1483–1520) showing a sacra conversazione crowned by a **lunette** of God the Father blessing. He is flanked by two angels and two cherubs.*

Lyrical Abstraction: *Jack Tworkov's* North American, *1966.*

Louis XV style The French version of ROCOCO, popular between 1720 and 1750 and already out of fashion by the time of the King's death in 1774. It is typified by the love of asymmetry, with lavish use of ABSTRACT C-scrolls and shell- and rockwork ornament. See also ROCAILLE.

Louis XVI style Early NEO-CLASSICAL style of decoration already popular by the time of Louis XVI's accession in 1774. It also shows traces of influence from the restrained BAROQUE of LOUIS XIV. It was succeeded by the DIRECTOIRE style from *c.* 1795.

Louis Philippe style Term used for a whole group of different styles prevalent in France during the reign of Louis Philippe (1830–48). They included a continuation of the EMPIRE STYLE, and also of the mock-Gothic TROUBADOUR STYLE, plus a heavier and more accurate version of GOTHIC and of the RENAISSANCE. There was even a movement towards a revival of the ROCOCO fashions of the mid 18th c.

loutrophoros (Gk 'carrier of cleansing water') In Ancient Greece, a tall, long-necked vessel, sometimes open at the bottom to allow offerings to touch the ground. Often used as a funerary vase. (GREEK VASES.★)

louvres (Fr.) Inclined slats making up a door or shutter which thus repels rain and intruders, and deflects glare and draughts, without impeding ventilation.

low warp Synonym of BASSE LISSE.

lower-case In TYPOGRAPHY, small letters as opposed to capitals (upper case). So-called from the container in which the printer using metal type traditionally keeps these letters. (TYPEFACE.★)

low-fired 1. (Of POTTERY). Fired at a low temperature. 2. (Of ENAMEL COLOURS on PORCELAIN.) Fired a second time at a lower temperature. (Synonymous in this case with *petit feu.*)

lucarne (Fr.) 1. A small opening or sky-light in an attic. 2. A DORMER WINDOW.

lug handles Vestigial handles, in the form of small projections. (GREEK VASES, alabastron.★)

Luminism 1. In the work of the HUDSON RIVER SCHOOL,★ the fascination with ATMOSPHERIC PERSPECTIVE and effects of light, especially on

water. 2. The light-saturated effect of many IMPRESSIONIST and NEO-IMPRESSIONIST paintings.

lunette (Fr. 'little moon') A semicircular space, often a window, or the area of wall between a rectangular window and the VAULT above it. (In this latter case, synonymous with TYMPANUM.) Lunettes also appear at the tops of large ALTARPIECES.

lustre 1. The iridescent metal decoration applied OVERGLAZE to CERAMICS which are then fired again at a low temperature. 2. A similar metallic decoration used on GLASS. 3. A chandelier. 4. One of the individual prismatic glass pendants of a chandelier. 5. An English 19th-c. term for a vase with cut-glass drops hanging from the rim.

luting Joining together the various parts of a CERAMIC object with liquid SLIP, or 'lute', before FIRING.

lych gate See LICH GATE.

Lyrical Abstraction The continuation of ABSTRACT EXPRESSIONISM in the 1960s and 1970s, in the work of such artists as Jack Twork ov and Paul Jenkins. It is typified by a sumptuous, PAINTERLY approach.

M

macchiaioli (It., fr. *macchia*, 'stain, blot') A group of Italian painters working in Florence *c.* 1855–65. They rebelled against the prevailing ACADEMIC style by exploiting the effect of individual touches or blobs of paint. They were influenced by Corot and Courbet, and in some ways foreshadowed the techniques of French IMPRESSIONISM. Among the most prominent were Giovanni Fattori and Telemaco Signorini.

machicolation Openings beneath a fortified PARAPET supported on CORBELS, from which to cast stones, burning pitch, etc., upon attackers below.

macramé (fr. Turkish *macrama*, 'bedspread') 1. A knotted fringe, similar to those found on traditional Turkish towels. 2. A technique of knotting derived from this, and used to create a variety of craft objects.

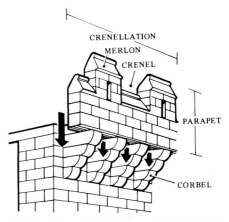

Machicolation. *(For definitions, see individual entries.)*

maculature A weak PRINT made by taking a second impression without re-inking the PLATE. Sometimes used as a PROOF, so that corrections can be made to the plate before it is re-inked.

Madonna della Misericordia (It. 'Madonna of Mercy') A representation, popular from the 13th to the 16th c., of the Virgin sheltering devotees who kneel beneath her cloak.

Madonna of Humility A representation, popularized by the Franciscans, of the Virgin seated on the ground. It symbolizes the Virgin's care for all, the sinners as well as the righteous, and involves a pun on the word 'humility' which is derived from the Latin *humus*, earth.

madrasah See MEDRESE.

Maestà (It. 'majesty') A representation, popular in 13th- and 14th-c. Italy, of the Madonna and Child enthroned and surrounded by saints and/or angels. See also SACRA CONVERSAZIONE, SACRA FAMIGLIA.

Magic Realism Term coined in 1924 by the German art critic Franz Roh to describe the more conservative and less expressive element of the NEUE SACHLICHKEIT. Also termed Sharp-focus Realism.

magot (Fr. name of a tailless monkey) 1. An 18th-c. term for a GROTESQUE figure in Oriental PORCELAIN. 2. (In the 19th c.) Cheap and ugly Chinese and Japanese export wares.

mahlstick A long stick, one end of which a painter holds in his left hand to support and steady his right (brush-holding) hand. The other end is padded and rests against the canvas.

Majesty 1. A representation of Christ in glory, seated and giving a blessing. 2. A CANOPY OF STATE.

majolica, maiolica (It.) Any LOW-FIRED, TIN-GLAZED POTTERY. The name comes from the fact that such wares were supposedly introduced into Italy around the 12th c. from the island of Majorca, where they were made by Moorish craftsmen. The great period of Italian majolica was the first half of the 16th c., when the subject-matter of the decoration was closely related to RENAISSANCE painting. DELFT and FAÏENCE are made by the same technique. See also ISTORIATO.

makimono, emaki-mono (Jap. 'scroll picture') A horizontal scroll designed to be unrolled between the hands, and used for either painting or calligraphy. See also KAKEMONO.

maki-e (Jap. 'sprinkled picture') A decorative effect in LACQUER, achieved by building it up in layers and sprinkling each layer before it dries completely with gold or silver powder.

malerisch See PAINTERLY.

Man of Sorrows An image of the suffering Christ, wearing the crown of thorns and showing the wounds of the Crucifixion.

mana (Tahitian) The sacred essence of an object, structure or place.

mandala (Skr. 'disk, circle') A diagrammatic representation of the cosmos or some aspect of it, used in Eastern religions as a focus for contemplation, and occurring frequently in Buddhist art. See also YANTRA.

mandapa (Skr.) A large open hall in a Hindu temple complex.

mandorla (It. 'almond') An almond-shaped GLORY of light enclosing the whole of some sacred figure, such as the resurrected Christ. Synonym: vesica piscis.

manière criblée (Fr. 'sieved manner') An early form of DOTTED PRINT, where the design appears – as in WOOD ENGRAVING – in white lines against a black background, and there is extensive ornament in the form of punched dots.

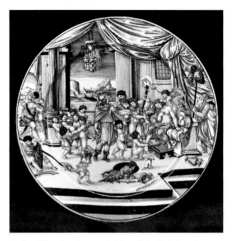

*Early 16th-c. istoriato **majolica** dish, depicting the story of Alexander and Roxana, by Francesco Xanto.*

manner of __ Indicates that the work is by an unknown imitator of the artist named.

Mannerism (fr. It. *maniera*, 'style') 1. Term coined in the 20th c. to describe the European art of the period *c.* 1515 – *c.* 1610. It is typified by stylistic trickery and a liking for bizarre effects. CONTRAPPOSTO★ and the extreme elongation of the figure occur frequently in both painting and sculpture. Mannerist art conveys a sense of neurotic disquiet, and tends to concentrate on style rather than content, while the content itself is often complicated and esoteric. In the DECORATIVE ARTS there is a taste for virtuosity and the unexpected. Outside Italy, Mannerism was nearly always a court style, and everywhere it addressed the few rather than the many. 2. (With a small 'M'.) Any art of any period with some of the characteristics described above, e.g. the AMARNA★ art of Ancient Egypt.

mansard style Colloquial term for 19th-c. imitations of French 17th-c. architecture, typified by mansard ROOFS.★

Manueline The last phase of GOTHIC architecture in Portugal, named after King Manuel I (1495–1521). Among its distinguishing features are maritime motifs, especially ornamental carvings of twisted rope and coral, and a general proliferation of fleshy, organic forms.

One of a series of nine **mandalas** *from a Tibetan tanka, c. 19th c.*

Mappa Mundi (Lat.) A medieval representation of the world as a flat disc with Jerusalem in the centre.

maquette (Fr. 'model') A small, three-dimensional sketch, usually roughly finished, for a sculpture. See also BOZZETTO.

marchand-mercier (Fr.) A member of the Parisian Mercers' GUILD in the 18th c., who combined the functions of today's antique dealer and interior decorator. *Marchands-merciers* offered commissions to independent craftsmen, since guild regulations would not allow them to have their own workshops, and thus played an important role in the evolution of decorative style.

marine painting A painting representing the sea and shipping, often a naval battle or other historical event. It first became an independent genre in 17th-c. Holland. Among the leading Dutch practitioners in the 17th-c. were the Van de Veldes, father and son. Synonyms: seapiece, seascape.

marouflage (Fr., from *maroufle*, glue made from the residue of paint) The process of sticking a canvas onto a wall or panel (or paper onto canvas), usually with an oil adhesive.

marquetry Wooden INLAY used on furniture. See also INTARSIA, VENEER. (BOMBÉ.★)

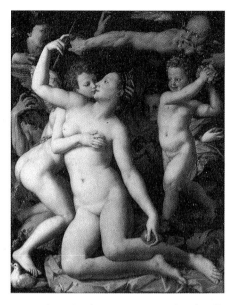

Mannerism: *Agnolo Bronzino's* Venus, Cupid, Folly and Time, *c. 1540–50. The elongation of the figure of* Venus, *the lack of logical space construction and the overt eroticism are all typical features.*

Manueline *architecture: a window of the chapter house at Tomar designed by King Manuel I, c. 1520, carved to imitate ropes and coral formations.*

mascaron, mascaroon A grotesque MASK used as decoration both in architecture and in the DECORATIVE ARTS, e.g. as a gilt-bronze mount on 18th-c. French furniture.

mask 1. A REPLICA of the face, made by taking a CAST from a live person or a dead body (in the latter case, also called a death mask). 2. A representation of the face. 3. A disguise for the face or body, worn in a theatrical performance or masquerade. 4. A representation of some legendary or supernatural being who takes possession of the wearer for as long as the mask is worn (as with African ritual masks). 5. A painted or carved representation of a theatrical mask (e.g. the masks of Comedy and Tragedy, used as an architectural ornament).

mastaba (Arabic) An Ancient Egyptian tomb of rectangular form with sloping sides. Several mastabas placed one on top of another make a STEPPED PYRAMID.

master See GUILD.

Master of __ A conventional name (such as 'The Master of Flémalle' or 'The Master of the Female Half Lengths'), applied to a group of works which are recognizably by one artist whose identity is unknown.

masterpiece Under the medieval GUILD system, the obligatory test-piece by which an apprentice showed that he had qualified as a master of his craft. Later the word was applied to any work of pre-eminent merit.

mastos (Gk 'breast') A drinking cup shaped like a woman's breast, which had no foot and could only be rested safely upside down. (GREEK VASES.★)

Mater Dolorosa (Lat. 'sorrowful mother') A representation of the Virgin which indicates her woe by showing her pierced with a sword, with her heart having seven wounds, or weeping and holding the body of the dead Christ in her lap. See also PIETÀ.

Mater Misericordiae (Lat. 'mother of mercy') Synonym of MADONNA DELLA MISERICORDIA.

mathematical tiles Tiles made to look like brickwork.

matière (Fr. 'material') The physical substance of a work of art. The word is nowadays applied particularly to paint.

matrix See INTAGLIO.

A **mascaron** *forming part of a typographical ornament.*

mausoleum A magnificent tomb, usually for one important individual, named after King Mausolus of Caria (4th c. BC) whose tomb at Halicarnassus in Asia Minor was one of the Seven Wonders of the Greek and Roman world.

meander pattern Synonym of GREEK KEY PATTERN.

mechanical furniture Synonym of PATENT FURNITURE.

medal A small piece of metal, generally gold, silver or bronze, bearing a RELIEF design on one or both sides, and often with a commemorative purpose. Unlike coins, medals are frequently produced by CASTING rather than STRIKING.

medalet A small MEDAL.

medallion 1. A large MEDAL. 2. Any ornament or frame shaped like a medallion, especially in architecture (see also PLAQUE, PLAQUETTE). 3. In Persian carpets, any strong central MOTIF.

medium 1. The liquid in which PIGMENT is suspended in any kind of painting. Thus linseed oil is the medium most often used in oil painting. 2. The physical substance chosen as a vehicle of expression by any visual artist. Thus, marble is a medium in sculpture.

medrese, madrasah (Arabic) An Islamic school or college, sometimes attached to a mosque in the form of a courtyard.

megalith A large standing stone, roughly shaped or left in its natural condition.

megalithic (Used of prehistoric constructions.) Made up of very large stones, or MEGALITHS.

megaron The chief or 'men's' hall in a MYCENAEAN palace or house.

Reconstruction of a **mastaba** *at Saqqara, 4th dynasty.*

memento mori (Lat. 'reminder of death') Any symbol, e.g. a skull or an hour-glass, designed to remind the viewer of the transience of human life. (VANITAS.★)

menhir A colossal block of roughly hewn stone, found standing on its own or as part of a prehistoric monument.

menologium, menology A book containing the Lives of the Saints arranged according to the Church's calendar.

menorah (Hebrew 'candlestick') A Jewish seven-branched sanctuary lamp which formed part of the furnishings of the Temple in Jerusalem, and which has since been frequently used as an emblem of Judaism in both painting and as a decorative object.

Representation of a **menorah** *from a French illuminated manuscript, 1299.*

menuisier (Fr.) Originally the word meant a maker of small (*menu*) objects. In the mid 17th c. it came to mean a joiner – a chair-maker or maker of other joined furniture – as opposed to an ÉBÉNISTE or cabinet-maker working with VENEERS. (See also JOINERY.)

merlons (Fr., fr. It. *merlone*, 'battlement') The solid parts of a battlement, separating the EMBRASURES. (MACHICOLATION.★)

Merz Nonsense name given by the German artist Kurt Schwitters (1887–1948) to his own personal version of DADA. The name is derived from the phrase Kommerz- und Privatsbank, which Schwitters encountered when fitting a fragment of business letterhead into a collage.

metal cut A PRINT produced by using a metal plate engraved in RELIEF (like a WOODCUT). MANIÈRE CRIBLÉE is a type of metal cut.

metal point A method of drawing with a rod of soft metal, frequently silver, on specially prepared paper (see SILVER POINT).

The Merzbau – or **Merz** *Environment – constructed by the Dadaist Kurt Schwitters in his own house in Hanover, c. 1927 and destroyed in the Second World War.*

(Above) Roman **millefiore** *glass bowl.*

(Right) Late 15th-c. **mille-fleurs** *tapestry showing the unicorn in captivity, from the Château of Verteuil.*

Metaphysical Painting (See PITTURA META-FISICA.

métier (Fr.) 1. An artist's or craftsman's profession. 2. The particular type of activity in which he or she specializes.

metope (Gk) The square space between the TRIGLYPHS in the FRIEZE of the Doric order, sometimes adorned with RELIEF carving. (ENTABLATURE. ★)

mezzanine (fr. It. *mezzano*, 'middle') A low storey inserted between two taller ones. See also ENTRESOL.

mezzo rilievo See RELIEF.

mezzotint (It. 'half tint') A method of EN-GRAVING in which the artist works from dark to light. The whole GROUND is first of all covered with a regular fine scratching made by using a rocking tool called a cradle. This takes the ink and appears as a black background. The design is burnished onto it, does not take the ink and therefore appears in white.

Migration Period art The art of the migrating Germanic tribes of the period of the Barbarian Invasions (4th – 9th c. AD) who tra-

velled as far afield as Spain and North Africa. Their art consists largely of jewellery and other articles of personal use, with much use of simple units of pattern such as CHEVRONS and crosses.

mihrab (Arabic) The niche in the wall of a mosque which indicates the direction of Mecca. Synonym: qibla.

millefiore glass (It. *millefiore*, 'thousand flowers') Brightly coloured discs of GLASS fused together to make a sheet. Each disc consists of thin sections of various coloured rods fused together in a bundle. Synonym: mosaic glass.

mille-fleurs (Fr. 'thousand flowers') Medieval TAPESTRIES in which the figures appear against a GROUND thickly scattered with flowers, and sometimes also with small animals and birds. They date from the late 15th and early 16th c.

mimbar, minbar (Arabic) The pulpit in a mosque. (MIHRAB. ★)

mina'i (Persian, 'enamel') Persian POTTERY of the 12th and early 13th c., with an opaque white or turquoise GLAZE and elaborately decorated in blue, green, brown, black, red and white ENAMELS and also with gold.

minaret A tall turret connected to a mosque or standing nearby, with a balcony from which the *muezzin* can give the call to prayer.

mingei (Jap.) Japanese folk art.

miniature 1. A highly finished painting or drawing, usually a portrait, in WATERCOLOUR and/or GOUACHE, carried out on a very small scale. 2. Synonym of (a single) ILLUMINATION.

minimal art Term coined in the 1960s to describe art which abandons all pretensions at either expressiveness or illusion. It is generally three-dimensional, and either shaped by chance – e.g. a heap of sand – or made up of simple geometrical forms, often used repetitively. Carl André's sculptures made of bricks are the most famous example of the latter. See also GESTALT.

Minoan art Cretan art of the Bronze Age (c. 2300–1100 BC), so named in modern times after the legendary Minos, King of Crete. Its most striking characteristics are delicate NATURALISM, especially in the depiction of animals and plants, and lack of strong formal organization. See also MYCENAEAN ART.

Minor Arts, the Visual arts other than fine art (i.e. any art which is not painting, sculpture or architecture).

minster 1. Originally a monastic church, or even the whole monastic establishment. 2. Later a large church of monastic origin. 3. More loosely, any major church.

Mir Iskusstva (Russian 'World of Art') Art movement founded in St Petersburg by Serge Diaghilev, and promoted by him in the magazine of the same title first published in 1898. The movement linked contemporary Russian painting, usually of a SYMBOLIST type, to the Russian art of the past.

misericord 1. A small BRACKET fixed to the back of a folding seat in a choir stall. It enabled an ecclesiastic who was forced to stand through much of a long church service to take some of the weight off his feet. Misericords are often used as a vehicle for GROTESQUE and fantastic carvings. 2. A small straight dagger used to inflict the 'mercy stroke' on a fallen opponent through the chinks in his armour.

mission furniture Very simple furniture made in America imitating that of the English Arts and Crafts Movement in the early 20th c. There is a dispute about the sense in which the

Mihrab *with, to the right, a* **mimbar** *in the Sokullu Mehmed Pasha mosque, Istanbul, by Sinan. Built A.H. 979 (a.d. 1571–72).*

This design for an oriental backcloth, an unrealized project by Leon Bakst, c. 1910, is typical of the orientalizing side of **Mir Iskusstva**, *and echoes Russian architecture of the 16th c.*

Late 15-c. **misericords** *from St Mary's cathedral, Limerick.*

word 'mission' should be taken. Either it derives from an association with the early Franciscan mission stations in California, or from the FUNCTIONALIST assertion that all furniture has a mission – which is to be put to good use.

Mixed Media 1. Art of the 20th c. which combines different types of physical material. 2. Art which draws on several disciplines, for example music, movement and environmental sculpture. In this sense, synonymous with Intermedia and Multimedia.

mixed method A painting technique in which the final touches and GLAZES are of OIL PAINT, applied to TEMPERA underpainting.

mobile A complex work of art, constructed of moving parts, hanging or standing, which can be either wind-driven or mechanically powered. Its form continually changes, as each shift creates a new set of relationships. The term itself was coined by Marcel Duchamp in 1932, to describe Alexander Calder's works.

modelling 1. The representation of three-dimensional forms in two dimensions so that they appear solid. 2. The use of malleable material (e.g. wax or clay) to create a form which is three-dimensional.

modello (It. 'model, pattern, LAY FIGURE') A small, often quite highly finished version of a larger painting or sculpture, made to be shown to the patron in order to indicate what is intended.

Modern Movement See MODERNISM.

Modern Style French term for ART NOUVEAU.

Modernism, Modern Movement General name given to the succession of AVANT-GARDE styles in art and architecture which have dominated Western culture almost throughout the 20th c.

modillion One of a series of brackets forming part of the cornice in a Corinthian or Composite order. (ORDERS OF ARCHITECTURE.★)

module Term used in modern architecture to denote any convenient unit of measurement, usually 4 inches or 10 centimetres, from which all other measurements in a building are derived. The use of a module facilitates PRE-FABRICATION.

Mogul, Moghul art See MUGHAL ART.

moiré (Fr.) Any pattern with a watered or rippled look. In some cases this can be so pronounced that it produces an illusion of movement.

mokume (Jap. 'wood grain') 1. Japanese metalwork, and European versions of it, where the layers of metal are forged and welded together so that they appear in concentric whirls, like wood grain. 2. Japanese LACQUER with a similar appearance, produced by successive layers being superimposed on each other, then rubbed down again.

mon (Jap.) A Japanese heraldic badge, at first used only by aristocratic families, later also as a trade-mark by commercial enterprises. (WOODBLOCK PRINT.★)

monochrome In a single colour. See also GRISAILLE.

monolith A sculpture, monument or architectural member (e.g. a pillar) made from a single block of stone.

monotype A PRINT made by making a design in OIL PAINT or printer's ink on a plain copper plate, which is then printed either on a press, or occasionally by rubbing the paper with the heel of the hand. The paint is thus transferred directly to the paper, making each monotype unique.

monstrance A transparent PYX made of GLASS or crystal surrounded by metalwork. They are usually highly decorated and are used for exhibiting the consecrated Host in Roman Catholic churches.

montage (Fr. 'mounting') 1. A design, not necessarily intended as a work of art, made by sticking one material over another (e.g. a montage of medals). 2. The process of creating such a design. See also COLLAGE, PHOTO-MONTAGE.

morbidezza (It.) Exaggerated delicacy or softness. Applied particularly to the painting or carving of flesh.

mordant 1. The substance used to fix the colour in dyeing or fabric-printing. 2. The adhesive used by gilders to secure leaf-gold to paper, PARCHMENT or wood.

moresque A style of intricate surface decoration derived from Islamic art, and especially typical of Spain. (STALACTITE WORK.★) See also ARABESQUE, GROTESQUE.

Mobile *by Alexander Calder, 1934, made of iron, coloured glass and string.*

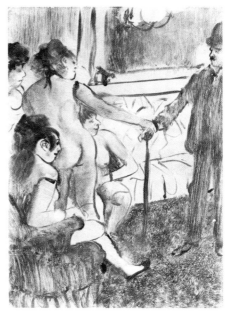

The Client, *c. 1879, one of a series of* **monotypes** *of brothel scenes by Edgar Degas.*

morse A large clasp or fastening, used on ecclesiastical vestments and decorated with a religious subject. Often very large (5–7 in., or 13–18 cm).

mortice-and-tenon, mortise-and-tenon, joint In woodwork, a joint of members usually at right angles, in which a projecting part (the tenon) of one fits into a corresponding hole (the mortice) in the other.

mosaic A design made by cementing small pieces (*tesserae*) of hard, coloured substances (e.g. marble, GLASS, CERAMIC or SEMI-PRECIOUS stones) to a base. (OPUS VERMICULATUM.★)

mosaic glass Synonym of MILLEFIORE GLASS.

Mosan enamels Champlevé ENAMELS made in workshops in the valley of the Meuse in the 12th c.

motif 1. A distinct or separable element in the design of a painting, sculpture, building or pattern. 2. The subject of a painting.

motte-and-bailey A primitive castle consisting of a wooden tower placed on top of a mound (motte) and surrounded by an open space (bailey), which is itself surrounded by a ditch and a row of strong pointed wooden stakes (palisade).

An early 17th-c. Spanish **monstrance** *in silver gilt.*

moulding

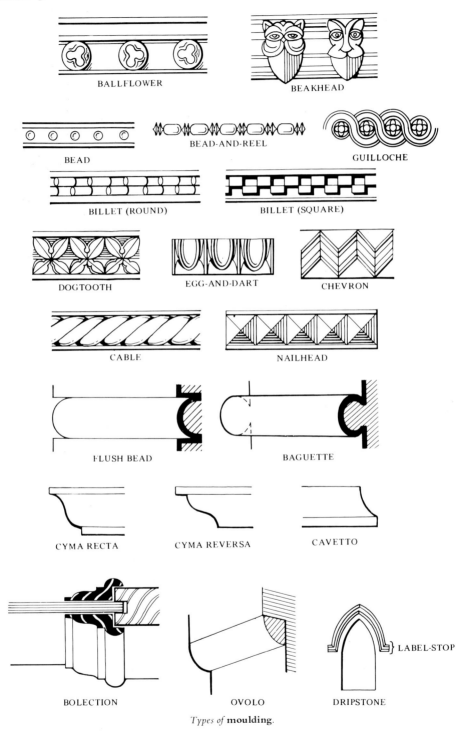

BALLFLOWER

BEAKHEAD

BEAD

BEAD-AND-REEL

GUILLOCHE

BILLET (ROUND)

BILLET (SQUARE)

DOGTOOTH

EGG-AND-DART

CHEVRON

CABLE

NAILHEAD

FLUSH BEAD

BAGUETTE

CYMA RECTA

CYMA REVERSA

CAVETTO

BOLECTION

OVOLO

DRIPSTONE

} LABEL-STOP

Types of **moulding**.

moulding A decorative strip or edging, which may be either concave or convex, and plain or with a wide variety of different patterns.

Baguette (Fr. 'stick, moulding'). A small convex moulding, nearly cylindrical in section.

Bead, beading. In cabinet-making, either any small, plain moulding, or a moulding consisting of a row of ovoids or half-spheres. In this latter case, synonymous with paternoster.

Billet moulding. A concave moulding containing short raised cylinders or rectangles. Groups of billet mouldings are frequently found in ROMANESQUE architecture.

Bird's beak moulding. Synonym of BEAKHEAD.

Bolection. A moulding which completely covers the join between two different surface levels, e.g. a frame and a panel in woodwork.

Cable moulding. A moulding resembling twisted rope.

Cavetto (It., fr. Lat. *cavus*, 'hollow'). A concave moulding which is quarter-round, or nearly so.

Cyma recta, cyma reversa (Gk 'upright wave, reversed wave'). Double-curved mouldings. The cyma recta is concave at the top, turning to convex below; the cyma reversa is convex above and concave below. Synonyms: ogee, reverse ogee, mouldings.

Drip-mould, drip-stone. A small moulding running over the top of a door or window and designed to prevent rainwater dripping down the face of a building. Synonyms: hood-mould, hood-moulding, hood-stone. See also label, label-stop.

Egg-and-dart, egg-and-tongue. An ornamental moulding consisting of alternating oval and pointed forms.

Flush bead moulding. A convex moulding inset so that the highest point is flush with the adjacent surfaces.

Label, label-moulding. A drip-mould of rectangular section.

Label-stop. An ornament terminating each end of a label.

Ovolo. A quarter-round convex moulding. Synonym: quadrant moulding.

Paternoster (Lat. 'Our Father'). A small bead moulding. Named after the paternoster bead in a rosary.

Sunk moulding. Any moulding that is sunk below the surface it is decorating, e.g. a flush bead moulding.

Mound Builders, the Name given to a fairly advanced North American Indian culture

Coloured glazed tilework in **Mudéjar** *style, with an Islamic star pattern, from Alcazar, Seville.*

which developed around AD 300 in the east-central region of the US, south of the Great Lakes and between the Ohio and the Mississippi rivers, and continued until the Europeans appeared in the late 17th c. Among the artefacts produced were metalwork, woven textiles and POTTERY.

Mozarabic (fr. Sp. *Mozarabe*, a Christian owning allegiance to a Moorish king but allowed his own religion) Of the Christian but Moslem-influenced art of Spain in the 10th and 11th c. AD.

ms. mss. Abbreviations for 'manuscript' and 'manuscripts'.

mudéjar style (Sp., fr. Arabic *mudajjan*, 'allowed to remain') Decorative style which evolved in Spain, in the hands either of Moslems working for Christian masters, or of Christians imitating Moslem forms.

mudra (Skr.) Hand gesture used in Indian art to show a specific mood or action, such as protection, compassion, meditation or teaching.

Mughal, Mogul art The art of the Moslem (Mongolian) courts of India, starting with the reign of the Emperor Babur (1526–30) and ending with the Indian mutiny.

mullion A vertical stone or wooden division splitting a WINDOW★ into two or more LIGHTS.

Multimedia See MIXED MEDIA.

multiples Works of art designed for mass production, which can thus (at least theoretically) be produced in unlimited numbers without loss of quality or dilution of content.

muntin 1. See DOOR, PARTS OF A. 2. (In the US, and incorrectly in the UK.) Synonym of MULLION. 3. (In the US) a GLAZING BAR.

mural, mural painting Any painting made directly on a wall, or fastened permanently to a wall.

mural crown A crown or coronet in the form of miniature city walls. (The usual feature of a TYCHE.)

Musée Imaginaire (Fr. 'imaginary museum') Phrase coined by André Malraux to describe the sum total of illustrations and reproduction which now make works of art available to almost everyone. He also uses the phrase 'Musée sans Murs' in his book *Les Voix du Silence* (1954) to mean the same thing.

mushrabiyyah (Arabic) Wooden lattices made of TURNED bobbins, used as windows in Arab houses to admit light and air and preserve privacy.

mutule One of the blocks projecting above the TRIGLYPHS on the underside of a Doric CORNICE. (ENTABLATURE.★)

Mycenaean Of the Greek mainland civilization of the 2nd millennium BC which was heavily influenced by MINOAN culture. It takes its name from the city of Mycenae, on which it was centred.

N

Nabeshima (Jap.) Japanese PORCELAIN made at Okawachi, Hizen province, in kilns founded in the mid 17th c. by Nabeshima, Prince of Kaga. The decoration often takes the Japanese taste for asymmetry to extremes.

Nabis (Hebrew 'prophets') A group of French artists founded in 1888 under the influence of Gauguin's work at PONT-AVEN in Brittany. Its members included Bonnard, Vuillard, Maurice Denis, Sérusier and Maillol. The Nabis mingled Gauguin's doctrines concerning expressive (as opposed to realistic) colour with ideas borrowed from SYMBOLISM.

naga (Skr.) In India, a protective snake-spirit, often represented as half-human and half-animal.

nailhead A small architectural ornament in the shape of a series of four-sided PYRAMIDS. Sometimes used to ornament a MOULDING.★

naive art The work of 20th-c. painters with a European cultural background who have not received a professional training.

namban (Jap. 'southern barbarians') 1. Japanese art depicting the Portuguese, Spanish and Dutch visitors to Japan in the 16th and 17th c. 2. More generally, Japanese art portraying European fashions. 3. Japanese objects in quasi-European style – e.g. LACQUER with Christian emblems.

Nanga School (Jap. *nanga*, 'southern painting') A school of Japanese painting which flourished from the end of the 17th c. until the late 18th c. Its members imitated the 'literary painting' practised by distinguished Chinese amateurs from Yüan times (13th c.) onwards. Even when they were in fact professionals the Nanga artists held themselves apart from the more openly commercial KANŌ and TOSA SCHOOLS.

naos (Gk 'house') 1. The SANCTUARY in a CLASSICAL TEMPLE,★ housing the image of the deity. 2. The sanctuary of a BYZANTINE church.

nap A surface made of short upright fibres of equal length, found on cloth and also on FLOCK PRINTED paper, etc.

narrative painting Painting whose chief intention is to tell a story. It was especially popular in Victorian England, and is typified by the work of W.P. Frith.

narthex (Gk) A single storey porch or large room leading into, and usually the full width of, the main body of an Early Christian or BYZANTINE church. If within the body of the building it is called an esonarthex; if it projects from the face it is an exonarthex. A double narthex is two BAYS deep. (GREEK ORTHODOX CHURCH.★) See also ANTECHURCH, GALILEE, WESTWORK.

nashiji (Jap. 'pear ground') Thick LACQUER decoration built up in layers, each containing widely dispersed pieces of gold FOIL, so that the gold appears to be floating at different depths within it.

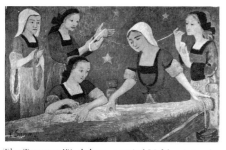

The Tapestry Workshop, *a typical* **Nabi** *painting by Paul Sérusier (1863–1927), showing the influence of Gauguin's Breton peasant scenes.*

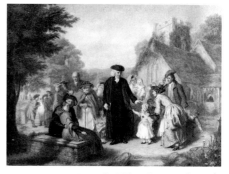

Narrative painting: The Village Pastor, *a late 19th-c. illustration by William Frith to Goldsmith's poem* The Deserted Village *(1770). It mirrors Goldsmith's description almost exactly: 'E'en children followed with endearing wile, And plucked his gown to share the good man's smile.'*

naturalism 1. An artistic tendency prevailing throughout Europe in the second half of the 19th c., which led painters to become more and more interested in the depiction of the trivia of ordinary life. It also had a parallel in literature – e.g. in the novels of Zola and the Goncourts. Naturalism influenced artists otherwise as different from one another as Degas, Adolf von Menzel and Ilya Repin. 2. Any art dependent on suggestions taken from nature rather than on intellectual theory. Often confused with REALISM.

nature morte French for STILL-LIFE.

nave The main western space in a church, as distinct from TRANSEPTS, CHANCEL, etc. It is, however, sometimes used to include AISLES. Where the church has a CHOIR for the singers and clergy, the nave is the part reserved for the laity. (GOTHIC CATHEDRAL, plan.★)

Navicella (It. 'little ship') A representation of a ship in a stormy sea with the apostles on board (Matthew 14: 22–23). Used in medieval art as a symbol of the Church as a refuge for mankind.

Nazarenes (fr. Ger. *Nazarener*) A group of early 19th-c. German artists living in Rome, among them Johann Friedrich Overbeck, Peter von Cornelius and Franz Pforr. They came together after 1810, and several converted to Catholicism. Their idea was to regenerate German painting by imitating Dürer, Perugino and the young Raphael.

necking A narrow MOULDING separating a capital from the column supporting it. (ORDERS OF ARCHITECTURE.★)

necropolis (Gk 'city of the dead') A cemetery or burial place.

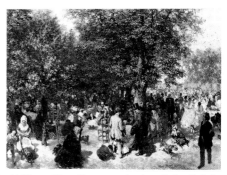

Adolf von Menzel's panoramic view of the Tuileries gardens, 1867, contains many details typical of **naturalism**, *such as the Breton nursemaid in the left foreground.*

The portrait of Franz Pforr, 1811, by Overbeck, a founder of the **Nazarenes**, *imitates a 15th-c. type – as seen in the work of Perugino and Raphael – where the sitter is characteristically placed behind a ledge.*

Neo-Classicism: *Antonio Canova's sculpture of Napoleon's sister, Pauline Borghese, as a semi-nude Venus holding an apple shows typical flattening of the figure.*

Neo-Impressionism: *Georges Seurat's* Evening, Honfleur, *1886, demonstrates his systematic application of Divisionist procedures.*

Neo-Expressionism: *Rainer Fetting's* Green Mountain Indian, *1982, shows his dependence on Expressionist paintings done before the First World War by Kirchner.*

negative I. A photographic PLATE or film with tonal and (where present) colour values reversed, which produce a POSITIVE image when light is passed through it to fall on sensitized paper. 2. An INTAGLIO stamp or mould. 3. A negative image is one where the effect of RELIEF or colour seems to have been reversed, and to have become the opposite of what it is in reality.

negative volume, negative space An enclosed empty space in architecture, sculpture or painting which makes an essential contribution to the COMPOSITION.

Negoro (Jap.) A type of Japanese LACQUER named after the Negoro Temple in Kü Prefecture, where it was first made. A black GROUND was covered with vermilion lacquer. The red was at first worn away accidentally by use, so as to reveal the black in patches, but this effect was soon deliberately imitated by the craftsmen.

Neo-Attic style The decorative late HELLE-NISTIC sculpture of the 1st century BC, which copies ARCHAIC and CLASSICAL Greek motifs in a stiff and slightly affected way.

Neo-Classicism The style of decoration, based on Ancient Greek and Roman examples, which made its appearance in the 1750s as a reaction to the capricious excesses of the ROCOCO, and which was fully established by the 1770s. It is characterized by a preference for the linear and the symmetrical, and for flatness rather than PLASTICITY.

Neo-Dada Term adopted by certain artists of the late 1950s – e.g. Robert Rauschenberg and Jasper Johns – to describe their work, which they saw as a revival of the original DADA.

Neo-Expressionism Violent FIGURATIVE art, largely a revival of early 20th-c. German EXPRESSIONIST forms, which manifested itself in the US, Italy and (especially) West Germany during the late 1970s. Among the artists associated with the tendency were Georg Baselitz, Rainer Fetting and Anselm Kiefer (German), Julian Schnabel (American) and Sandro Chia (Italian). In the US it is termed 'Bad Painting', in Italy 'TRANSAVANGUARDIA', and in Germany the artists are known as 'Neue Wilden' ('New Wild Ones').

Neo-Plasticism: *Theo van Doesburg's* Composition, *1920, shows characteristic reliance on horizontal and vertical lines.*

Neo-Gothic Synonym of GOTHIC REVIVAL.

Neo-Impressionism An offshoot of IM-PRESSIONISM which subjected Impressionist techniques to rigorous intellectual analysis. Seurat was its leader, and Signac and (for a while) Camille Pissarro were among its chief adherents. It was characterized by the use of DIVISIONISM and by strictly formal compositions.

Neo-Plasticism (Fr. *néo-plasticisme*, fr. Dutch *nieuwe beelding*, 'new forming') Theory of art propounded by Mondrian which influenced his painting, and that of disciples such as Theo van Doesburg, between 1912 and 1920. Its precepts were that art was to be entirely ABSTRACT, that only right angles in the horizontal and vertical positions were to be used, and that the colours were to be simple PRIMARIES, supplemented with white, black and grey. See also STIJL, DE.

Neo-Romanticism Strongly theatrical, romantic style of painting of the 1930s and 1940s, influenced by SURREALISM. Among the artists connected with the movement were the Frenchman Christian Bérard, the American Eugene Berman, and the Englishman John Piper.

netsuke (Jap.) A Japanese toggle in the form of a miniature sculpture, designed to be tied to the upper end of the silk cord which held the INRO to the sash of a kimono. They are made of ivory

John Piper's **Neo-Romantic** *style found its fulfilment during the Second World War. This watercolour records Coventry cathedral after it had been ruined in an air raid in November 1940.*

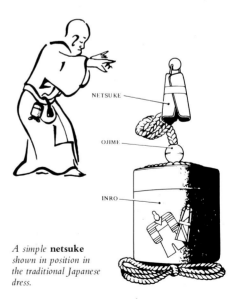

A simple **netsuke** *shown in position in the traditional Japanese dress.*

The Artist and His Model *by Otto Dix (1891–1969) demonstrates that the realism of the* **Neue Sachlichkeit** *does not exclude an element of cynical comment.*

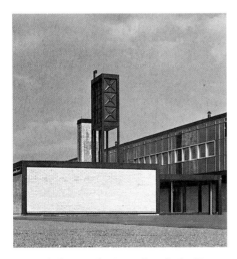

Peter and Alison Smithson's secondary school at Hunstanton, Norfolk, 1949–54, is typical of the **New Brutalism**. *In this detail, note the boldly exposed water tower.*

and other materials such as wood and horn, and show an immense variety of subject-matter, including animals and illustrations to Japanese folk-tales.

Neue Sachlichkeit (Ger. 'New Objectivity') Term coined in 1923 by G.F. Hartlaub, director of the Kunsthalle in Mannheim. He spoke of 'resignation and cynicism after a period of exuberant hopes.' The style was a post-war reaction against German EXPRESSIONISM, and paid close attention to the detailed representation of objects. Many, though not all, of its practitioners were socially committed artists, the two most famous being Georg Grosz and Otto Dix. See also MAGIC REALISM.

Neue Wilden (Ger.) See NEO-EXPRESSIONISM.

New Brutalism, the A British architectural movement of the 1950s. It opposed the dilution of MODERNISM and advocated the direct expression of functions and services and the equally direct use of materials such as concrete. The chief figures in the movement were the architects Alison and Peter Smithson, and the architectural critic Rayner Banham.

New Objectivity See NEUE SACHLICHKEIT.

New Realism See NOUVEAU RÉALISME.

New York School The innovative, New-York-based ABSTRACT painting which began to develop during the 1940s. It included ABSTRACT EXPRESSIONISM, but also artists only very loosely related to this movement. Among its principal members were Jackson Pollock, Mark Rothko and Adolph Gottlieb.

niche A recess in a wall, often used to hold a statue.

nickel silver An ALLOY of 50% copper, 25% zinc and 25% nickel which resembles silver in colour. It was developed in England between 1840 and 1847, but nevertheless is sometimes called German silver.

niello (It., fr. Lat. *nigellus*, 'black') A technique of decorating gold (or occasionally silver) with a black INLAY. The design is first ENGRAVED in the metal, and the grooves filled with an ALLOY of powdered copper, silver, lead and sulphur, with the addition of FLUX. The whole is then heated to the melting point of the alloy (lower than that of gold), so that it runs and becomes fused into the grooves. The object is finally polished.

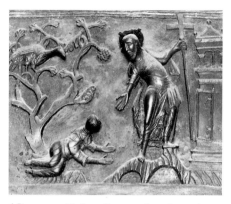

A Romanesque **Noli me Tangere** *from a bronze door at Hildesheim cathedral, c. 1020.*

Adolph Gottlieb's Red and Blue, Number 2, 1966, *demonstrates how* **New York School** *painting of this period combines iconic and symbolic elements, since it can be interpreted as a sun blazing above a planet.*

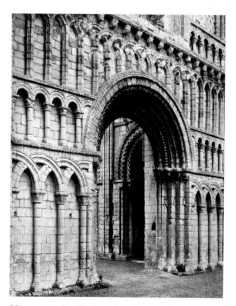

Norman *style: this detail from the west façade of Castle Acre Priory, Norfolk, c. 1150, shows the round arches and richly carved ornament (including chevron mouldings), associated with the style.*

Nihon-ga (Jap. 'Japanese painting') Painting in Japanese style.

nimbus (Lat. 'cloud, aureole') The disc or halo, usually golden, placed behind the head of a saint or other sacred personage to distinguish him or her from ordinary people. See also AUREOLE, GLORY, MANDORLA.

nishiki-e (Jap. 'brocade picture') A sumptuous Japanese PRINT, using many colours.

nocturne (Fr. 'night piece') A musical term first applied by Whistler to certain of his paintings, and later adopted by other artists.

Noli Me Tangere (Lat. 'Touch Me Not') A representation of Christ's appearance to Mary Magdalene after the Resurrection (John 20: 17), in which he moves away as she tries to touch him.

non-objective (Used especially of modern art.) Containing no representation of recognizable figures and objects, i.e. the opposite of FIGURATIVE ART.

Norman style The English version of the ROMANESQUE, associated with the Norman Conquest of 1066 but showing characteristics borrowed from Burgundy and the Rhineland as well as Normandy itself. Among its most striking features were rounded arches and a profusion of carved ornament. The style retained its vitality until near the end of the 12th c.

(Above) Houses and Wherries on the River Wensome, Norwich *by John Crome (1768–1821) shows the concentration of the* **Norwich School** *painters on the* genius loci.

(Right) Dialogue, *1920, a powerful woodcut by Max Pechstein, demonstrates the Expressionist component in the work of the* **Novembergruppe**.

Norwich School School of English painters specializing in East Anglian landscapes. It was founded at a meeting at John Crome's house in Norwich in 1803, and from 1805 functioned as an exhibiting society. Its two most important members were John Crome and John Sell Cotman.

Nouveau Réalisme (Fr. 'New Realism') Term coined by the French art critic Pierre Restany in a manifesto published in 1960. He used it to characterize a group of French artists, among Jean Tinguely, Yves Klein and Arman, who were rejecting the free abstraction of the period in order to make use of existing objects, particularly found material (OBJETS TROUVÉS) from the urban environment, to make ironic comments on contemporary society. See also ASSEMBLAGE.

novecento (It. 'nine hundred') Italian term for 20th-c. art in general.

Novecento Italiano (It. 'Italian nine hundred') An association founded in 1922 which included Sironi, Carrà and Campigli amongst its members. Its aim was to revive the large-scale FIGURATIVE compositions of CLASSICAL art, and to some extent it became associated with Fascism.

Novembergruppe (Ger. 'November Group') An art group with leftist political tendencies formed in Berlin in November 1918, and constituting an alliance of EXPRESSIONISTS and DADAISTS. Among the artists associated with it were Pechstein and Campendonck.

nuraghe, pl. **nuraghi** A prehistoric Sardinian fortified tower, usually conical or triangular, with BATTERED walls made of cyclopean masonry (see STONEWORK). They date from *c.* 1800 BC to the conquest of Sardinia by the Romans in 238 BC.

O

obelisk A single tapering rectangular block of stone which terminates in a PYRAMID. Obelisks are particularly associated with Ancient Egypt, where they were used as commemorative monuments.

objet d'art (Fr. 'art object') A piece of decorative art of small size and (generally) exquisite finish.

objet de vertu See VIRTÙ.

(Above) **Odalisque** *by Jean–Auguste–Dominique Ingres, 1814. The mannered elongation of the figure stresses its eroticism.*

(Left) Detail of a **nuraghe**, *showing rough Cyclopean masonry.*

objet trouvé (Fr. 'found object') An object found by an artist in his or her environment and presented, either with no alteration at all, or with only minimal alteration, as a work of art in itself or as part of a work of art. See also COLLAGE, READY-MADE.

obverse The side of a coin or MEDAL upon which the head or main design is struck. The opposite of the REVERSE.

octavo A book composed of sheets which have been folded to make eight leaves. Generally it measures between $6 \times 9\frac{1}{2}$ inches and $5 \times 7\frac{1}{2}$ inches (*c.* 15×24 and 13×19 centimetres).

oculus (Lat. 'eye') A small circular opening in a wall or DOME. ★

odalisque (Fr., from Turkish *odaliq*) A female slave in an Oriental harem, adopted as a subject by 19th- and 20th-c. artists (e.g. Ingres, Delacroix and Matisse) as a conventional type of voluptuous female nude or semi-nude, often with the addition of Oriental accoutrements.

oeil-de-boeuf See WINDOW, TYPES OF.

oenochoe (Gk) A wine jug with a vertical loop handle and often a TREFOIL lip. (GEOMETRIC ART, ★ GREEK VASES. ★)

oeuvre (Fr. 'work') The total output of a given artist.

oeuvre catalogue A complete record of an artist's OEUVRE. See also CATALOGUE RAISONNÉ.

off-stretcher Painting, usually ABSTRACT, done on unstretched canvas or fabric, often irregularly shaped. Examples occurred in both Europe and the US during the 1970s.

ogee A shape based on the double curvature of an OGEE MOULDING. (DECORATED STYLE. ★)

ogee moulding Synonym of CYMA RECTA.

oil paint Paint made with PIGMENTS bound with DRYING OILS.

ojime (Jap.) A small bead, generally made of metal or a SEMI-PRECIOUS stone, used to tighten the cord joining the NETSUKE ★ to the INRO.

Old Master A painting of high quality produced before 1800. (Formerly used of paintings earlier than 1700.)

oleograph A photographically produced image printed by LITHOGRAPHY on a textured surface so as to imitate oil painting.

olla (Lat.) A wide-mouthed cooking pot.

(Above) **Omega workshops:** *a plate with overglaze painting by Duncan Grant, 1913, showing Fauve influence.*

(Right) **Open form:** *the young Bernini demonstrates his virtuosity in his* Apollo and Daphne, *1622–24, in which the many projecting parts seem to refer to painting rather than to work by other earlier sculptors.*

Metagalaxy, 1959, a work by Victor Vasarely, one of the pioneers of **Op Art**.

olpe (Gk 'leather jug') A jug with no spout, but with an even lip. (GREEK VASES.★)

Omega workshops Workshops for the DECORATIVE ARTS set up by the painter-critic Roger Fry in London 1913. He wanted to make use of the work of the leading English fine artists of the time such as Duncan Grant, Vanessa Bell and Wyndham Lewis. Under his guidance they tried to apply FAUVE and CUBIST principles to interior decoration. The workshops, never financially successful, closed in 1920.

Op Art An ABSTRACT art movement of the 1960s concerned with the exploration of various optical effects achieved by retinal stimulation. Typical works were produced by Bridget Riley, Solo and Victor Vasarely. See also KINETIC ART, MOIRÉ.

open form A sculpture, part of which projects conspicuously into the surrounding space.

(Above) **Opus vermiculatum:** *in this detail from a Roman mosaic from Hadrian's villa, 2nd c. AD, both the bird's feathers and the water show the characteristic wandering lines.*

(Left) **Opus Anglicanum:** *detail of an early 14th-c. English church vestment with lavish use of gold and silver thread.*

openwork Any form of decoration which is pierced through from one side to the other.

opisthodomos (Gk 'back room') A room behind the NAOS of a CLASSICAL TEMPLE★ which was used as a treasury.

optical correction The small variation in the form of an architectural member – e.g. ENTASIS in a COLUMN,★ or a slight upward curve in a LINTEL – in order to correct an apparent bulge or sag.

optical mixtures Pure PRIMARY COLOURS used in small touches in close juxtaposition so that they seem to merge, producing SECONDARY COLOURS. This effect was exploited by the IMPRESSIONISTS and in a more systematic way by the NEO-IMPRESSIONISTS under Seurat.

opus Alexandrinum See STONEWORK.

opus Anglicanum (Lat. 'English work') English church embroidery of the 13th and 14th c., renowned throughout Europe for its quality.

opus incertum See STONEWORK.

opus quadratum See STONEWORK.

opus sectile (Lat. 'cut work') A form of INLAY, in marble and other materials, used for flooring and walls in Roman, BYZANTINE and Islamic buildings. Quite large pieces of material were used, cut to follow the pattern of the design (as opposed to MOSAIC, where the pieces are much smaller, and the design's effect depends on their grouping alone).

opus vermiculatum (Lat. 'work of worms') Classical MOSAICS using very small TESSERAE. The wandering lines in which they were laid were supposed to resemble worm-tracks.

orangery An early kind of greenhouse, built to give winter shelter to ornamental trees (originally orange-trees) in tubs.

orans, orant (Lat. 'praying') A figure with hands upraised in prayer or supplication.

oratory 1. A small chapel for private prayer, either part of a larger ecclesiastical building or in a house. (GOTHIC CATHEDRAL, plan.★) 2. A church belonging to the Oratorian Order, e.g. the Brompton Oratory in London.

orchestra 1. The large circular space in front of the stage in an Ancient Greek or Roman theatre, used by the chorus. 2. In the theatres of today, a space between the stage and the audience, occupied by the musicians accompanying the performance. If (as frequently) this space is sunken, it is called an orchestra pit.

order 1. See ORDERS OF ARCHITECTURE. 2. A combination of COLUMNS and ENTABLATURE.

orders of architecture A system devised by the Roman architectural historian Vitruvius (1st c. BC) to categorize the various types of CLASSICAL architecture. He bases his system on three standard types of COLUMNS, together with their BASES, PLINTHS, CAPITALS and ENTABLATURE.

The *Doric order* is the oldest, plainest and sturdiest looking. The column is FLUTED, the capital has a flat ABACUS, resting on an ECHINUS moulding. Roman Doric almost always has a BASE, but Greek Doric never. The FRIEZE is divided into square METOPES alternating with grooved TRIGLYPHS. (GREEK REVIVAL.★)

The *Ionic order* has a slenderer column and a capital with symmetrical VOLUTES.

The *Corinthian order* has a capital which represents an ACANTHUS growing in a basket (see KALATHOS).

The Romans introduced in addition the *Tuscan order*, which is simplified Doric with unfluted columns, and the *Composite order*, which combines Ionic and Corinthian.

A *colossal order* is any order in which the columns (or sometimes PILASTERS) rise through more than one storey. Synonym: giant order.

oribe (Jap.) 1 Japanese tea-ceremony ware from the Mino potteries north of Nagoya with decorations in brown and coloured GLAZES on a pink ground, named after the tea-master Oribe-no-Sho Shigenaris (1544–1615). 2. Now also a general term for any POTTERY resembling the Japanese original.

oriel See WINDOW, TYPES OF.

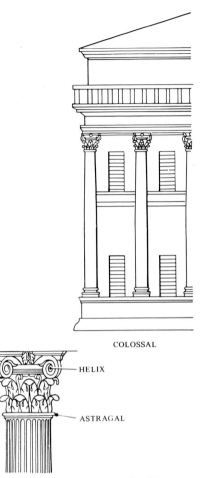

COLOSSAL

HELIX

ASTRAGAL

COMPOSITE · **Orders of architecture.**

Oriental Lowestoft Any PORCELAIN made in China during the 18th c. for export to Europe. It was erroneously attributed by Chaffers, in his classic *Marks and Monograms on Pottery and Porcelain* (1863), to the Lowestoft factory in England.

orientation The relationship of the FAÇADES of a building to the points of the compass, and especially in the planning of western European churches so that the main AXIS generally lies east-west, the main entrance being at the west end and the altar at the east.

original A work of art which the artist made himself, as opposed to copies by other hands.

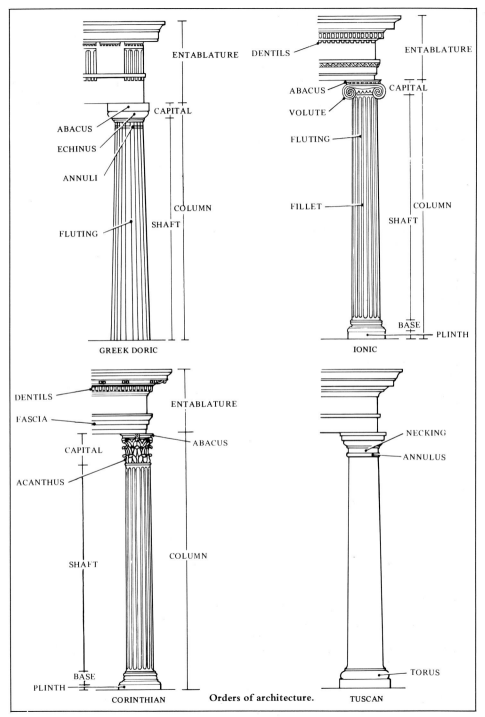

ENTABLATURE

DENTILS

CAPITAL

ABACUS

ECHINUS

ANNULI

COLUMN

SHAFT

FLUTING

GREEK DORIC

DENTILS

ENTABLATURE

ABACUS

VOLUTE

CAPITAL

FLUTING

FILLET

COLUMN

SHAFT

BASE

PLINTH

IONIC

DENTILS

FASCIA

CAPITAL

ABACUS

ENTABLATURE

ACANTHUS

NECKING

ANNULUS

SHAFT

COLUMN

BASE

PLINTH

TORUS

CORINTHIAN

Orders of architecture.

TUSCAN

Ormolu *mounts of the second half of the 18th c., on a Meissen porcelain vase.*

Robert Delaunay's Disc, 1912. Paintings of this type prompted Apollinaire to coin the term **Orphism**.

ormolu (Fr. 'powdered gold') Gilded bronze, used for furniture mounts, and also for candlesticks, candelabra and other ornamental objects.

Orphism, Orphic Cubism Orphism was a word coined in 1913 by Guillaume Apollinaire to describe a type of entirely ABSTRACT art with CUBIST affinities – an art which tried to create an independent reality of its own. He saw Robert Delaunay as the chief representative of this tendency. Delaunay himself adopted the label, but later modified it to mean an abstract or even semi-abstract art based on the analysis of the movement of light, and therefore a descendant of IMPRESSIONISM. See also SECTION D'OR, SYNCHRONISM.

orthogonal In linear PERSPECTIVE, ★ lines which in reality would be at right angles to the PICTURE-PLANE, but which seem to converge to a VANISHING POINT, in obedience to the laws of perspective.

orthostat A slab of stone, often carved, set upright at the base of a wall.

ossuary A place where the bones of the dead are kept.

ostraca (Gk 'oyster shells', sing. **ostracon**) Flakes of limestone, and also potsherds, used by Ancient Egyptian artists for freehand sketches as well as for written notes.

ottocento (It. 'eight hundred') The period 1800–1900 in Italian art.

Ottoman 1. Of Muslim Turkish art and architecture from 1326 (the taking of Bursa by Orthan I, founder of the Ottoman dynasty) to 1922 (the abolition of the Turkish Sultanate). 2. (With a small 'O') Term coined in the 18th c. for a low, completely upholstered sofa.

Ottonian A style of art and architecture under the Ottonian emperors in Germany (AD 919–1024) and their immediate successors. It combines characteristics from the CAROLINGIAN style which preceded it and the ROMANESQUE which followed.

oubliette (Fr., fr. *oublier*, 'to forget') A pit or shaft in the thickness of the walls of a fortress or under one of the floors, used in medieval times as a dungeon or for the secret disposal of bodies.

outline In drawing, an imaginary line which marks the boundary of an object or figure, without taking into consideration light, shade, internal MODELLING or colour.

(Above) **Palissy ware:** *a dish by Bernard Palissy with typical relief decoration, some of it possibly cast from life.*

(Left) **Ottonian** *architecture: the west front of St Pantaleon, Cologne, c. 1000, showing the exterior of the westwork, whose massive structure is reminiscent of the architecture of the Carolingian period.*

overdoor Synonym of SOPRAPORTA.

overglaze Decoration in ENAMEL on CERAMICS, applied on top of the GLAZE, and fixed by means of a second FIRING at a lower temperature.

ovolo (fr. Lat. *ovum*, 'egg') A quarter-round convex MOULDING.★ Synonym: quadrant moulding.

P

_p., _pinx., _pinxit, _pictor (Lat. *pinxit*, 'painted') 1. On a painting follows the name of the artist. 2. On a PRINT, indicates that the name it follows is that of the author of the original design which the print is now reproducing (the print being done AFTER a painting).

PRB See PRE-RAPHAELITE BROTHERHOOD.

package furniture See KNOCK-DOWN FURNITURE.

pagod, pagoda figure 1. An 18th-c. term for an oriental idol. 2. Later, a European parody of such a figure.

pagoda An Indian or Chinese Buddhist temple, built as a tower with successively diminishing storeys separated from one another by emphatic roofs. Later occasionally built as a CHINOISERIE eye-catcher in European landscape gardens.

painterly (fr. Ger. *malerisch*) Representing form, not by means of outline, but by the mingling of light and shade, rendered as indeterminate patches of colour. The Swiss art historian Heinrich Wölfflin first used the word in this sense in 1915.

pala (d'altare) (It.) A large altarpiece. See also ANCONA.

palette (Fr., fr. Lat., 'little spade') 1. A portable tray (usually made of wood) on which an artist sets out his colours, and also mixes them. 2. By extension, his choice of colours as seen in his work. 3. The precise range of ENAMEL COLOURS found in a particular type of PORCELAIN. (See FAMILLE JAUNE, NOIRE, ROSE and VERTE.)

palimpsest 1. A PARCHMENT from which one text has been removed in order to substitute another. 2. An inscribed slab or sheet of brass which has been turned back to front to hide an old inscription and leave room for a new one.

Palissy ware 1. The GLAZED POTTERY made by the French potter Bernard Palissy (*c.* 1510 – *c.* 1590), which is decorated with naturalistically modelled reptiles, etc., in RELIEF and in their natural colours. 2. Any imitation of this ware.

Palladian window Synonym of VENETIAN WINDOW.

Palladianism Architectural movement which flourished in England *c.* 1720–70, taking its inspiration from the 16th-c. Venetian architect Andrea Palladio (1508–80), the chief RENAISSANCE disciple of the Roman architectural theoretician Vitruvius. The 17th-c. architect Inigo Jones (1573–1652) was Palladio's first English disciple. He was followed in the 18th c. by the Scotsman Colen Campbell, by the architect and patron of architects Richard Boyle, 3rd Earl of Burlington, and by Burlington's protégé William Kent. Palladianism had political overtones, as it was particularly favoured by aristocratic members of the Whig party, who supported the House of Hanover. The BAROQUE style, which was still prevalent throughout most of Europe, was associated by them with Roman Catholicism and the deposed Stuarts. In general, Palladianism involved a free adaptation of Imperial Roman architecture to 18th-c. social needs, with MOTIFS borrowed from Roman public buildings and adapted for use in churches, other public buildings and private houses. (COFFERING,★ EGYPTIAN HALL.★)

palmette (Fr., fr. Lat. 'little palm') An ornament consisting of stylized leaves radiating like the fingers of a hand. The leaves are always odd-numbered, and the central leaf is the largest. (ANTHEMION.★)

pane work In architecture, the ornamental or structural division of a surface into separate panels.

panel painting A painting on wood.

panorama A circular painting on the scale of life which surrounds the spectator so that he or she has the impression of looking at a real view. Panoramas were popular entertainments in the late 18th and early 19th c. See also DIORAMA.

pantheon (Gk 'all gods') A temple dedicated to all the gods. The most famous example is the circular Pantheon of Agrippa in Rome, built *c.* 25 BC, and the name has therefore since been applied to all buildings resembling it.

pantiles Roofing tiles of 'S'-section which fit together like scales.

pantocrator (Gk *panto*, 'all'; *krater*, 'powerful') In BYZANTINE art, an image of Christ as ruler of the universe.

papier collé (Fr. 'stuck paper') 1. A COLLAGE made entirely of layers of paper glued to a GROUND. 2. The glued paper itself.

papier mâché (Fr. 'chewed paper') Pulped paper, usually combined with glue, chalk and sometimes sand. It can be shaped by moulding and then baking, and was used extensively in the 18th and 19th c. for small articles of furniture and decorative objects.

papyrus A species of rush. The stem was flattened and used by the Ancient Egyptians as a surface to write on, and the external appearance of the plant inspired the architectural ornament of some of their buildings, e.g. papyrus CAPITAL.★

paradise 1. An enclosed space open to the sky, in front of a church (Also termed a PARVIS). 2. An enclosed garden, often a cemetery attached to a monastery, sometimes in the centre of a CLOISTER.

parapet A wall bordering any sudden drop, such as the edge of a roof or the sides of a bridge. (MACHICOLATION.★)

parcel gilt Partially gilded silver or wood.

parchment Any animal skin, especially that of a sheep or goat, prepared for writing.

parecclesion (Gk 'beside the church') A side-chapel. (GREEK ORTHODOX CHURCH.★)

parergon A detail in a painting, subsidiary to the main theme.

pargetting, parging 1. The technique of covering HALF-TIMBERED buildings with PLASTER mixed with ox-hair and often patterned with a special comb. 2. The painting of flues with mortar.

Parian A type of PORCELAIN, usually without a GLAZE and produced by CASTING, which was first made in England at the Copeland factory at Stoke-on-Trent in 1846. So called because of its resemblance to the white marble of the Greek island of Paros. Synonym: statuary porcelain.

Paris, School of See ECOLE DE PARIS.

parquet 1. Flooring made of wooden blocks laid in geometrical designs. 2. A technique for preventing wooden panels from warping by reinforcing them at the back with battens. 3. (US) All or part of the main floor of the auditorium in a theatre.

Palladianism: *Chiswick House by the Earl of Burlington, c. 1725, based on Palladio's Villa Rotonda, Vicenza, begun c. 1550.*

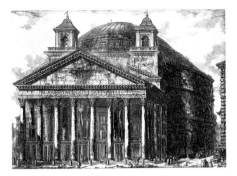

Piranesi's engraving of the **Pantheon** *in Rome, from the* Vedute di Roma, *1761.*

parquetry Geometrically patterned MARQUETRY.

parvis, parvise (Fr.) 1. Synonym of PARADISE. 2. (Incorrectly.) A room or porch connected with the main entrance of a church.

pashmina (fr. Persian *pashm*, 'wool') Fine woollen cloth, of the type used for Kashmir shawls.

passage 1. A particular area in a painting, often where one TONE blends with another. 2. In architecture, a covered connecting space.

Passion Cycle A series of scenes depicting the events of Christ's Passion, from the Entry into Jerusalem to the Crucifixion. Such scenes occur in Christian art as early as the 4th c. AD.

pastel Dry PIGMENT bound with gum and used in stick form for drawing. A fixative is used to make it adhere to the GROUND.

pastiche (Fr.) **pasticcio** (It.) A work of art using a borrowed style and usually made up of borrowed elements, but not necessarily a direct copy. A pastiche often verges on conscious or unconscious CARICATURE, through its exaggeration of what seems most typical in the original model.

pastoral A landscape painting which represents the countryside as a sort of Arcadia peopled with demi-gods, nymphs, satyrs, shepherds and shepherdesses. See also FÊTE CHAMPÊTRE.

Pantiles.

Christ the **Pantocrator**, *an 11th-c. mosaic in the dome of the church of Daphni.*

Patent furniture: *Rudd's dressing-table, from* The Cabinet-maker's and Upholsterer's Guide, *1788, shows characteristic ingenuity in its adaptation to several functions.*

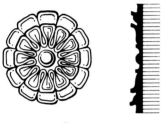

Patera.

Kim MacConnel's Baton Rouge, *1978, is typical of* **Pattern Painting** *in its dependence on post-Matisse wallpaper and fabric designs.*

pastose Thickly painted.

pâte de verre (Fr. 'glass paste') Powdered GLASS FIRED in a mould so that it fuses. The effect is like that of translucent SEMI-PRECIOUS stones.

pâte dure (Fr. 'hard paste') French term for 'true' PORCELAIN.

pâte tendre (Fr. 'soft paste') A European imitation of 'true' PORCELAIN, first produced in the 16th c. (the earliest surviving examples are from the Medici factory in Florence), and then more extensively in the 18th c. by Sèvres and other factories in France, England and Italy. It was usually made of a mixture of white clay and GLASS and could be fired at a comparatively low temperature (less than 1250°C.). Synonym: soft paste porcelain.

patent furniture Furniture, often equipped with ingenious mechanisms, which serves two or more functions, because it can be unfolded, transformed, adjusted into several different positions, etc. The term itself dates from the early 19th c., and refers to the fact that the mechanical features are often the subject of patents. Most examples are late 18th- to mid-19th c. in date. Synonym: mechanical furniture.

patera 1. Latin synonym for the Greek PHIALE. 2. An architectural ornament of this form.

paternoster See MOULDING.

pâte-sur-pâte (Fr. 'paste-on-paste') A 19th-c. method of decorating PORCELAIN in RELIEF by using successive coats of SLIP.

patina 1. Strictly, the coloured (usually green or brown) incrustation on bronze caused by oxidation. 2. By extension, any pleasing alteration of surface colour or texture due to age, use or exposure.

Patroon Painters The first clearly recognizable school of North American art, produced in the first half of the 18th c. by a group of anonymous portrait painters who worked for the patroons, Dutch settlers in the Hudson River valley.

Pattern Painting A school of post-Matisse decorative painting, often deliberately coarse in the way it uses FIGURATIVE motifs, which flourished in New York during the second half of the 1970s. Joyce Kozloff, Kim MacConnel and Brad Davis are among the artists involved. Synonym: Dekor.

pavilion 1. A lightly constructed pleasure-house, often an ornamental feature in a garden. 2. A building subordinate to a larger one, and generally attached to it, e.g. as a projection from a main FAÇADE or as the termination to a wing. 3. A building serving a sports ground, with changing rooms and other facilities.

pax (Lat. 'peace') A silver tablet, usually with a representation of the Crucifixion, to which the 'kiss of peace' is given, rather than directly to another communicant.

pebbledash Synonym of ROUGHCAST.

pedestal 1. The lowest part of the supporting masonry for a CLASSICAL COLUMN. 2. A base supporting a statue or other object. In this case synonymous with socle.

pediment A GABLE or gable-like ornament over a PORTICO, door or window. Originally triangular (CLASSICAL TEMPLE, portico★), but sometimes segmental. Synonym: SOPRAPORTA.

peintre-doreur (Fr. 'painter-gilder') Under the 18th-c. French GUILD system, a man responsible for painting and gilding the carved and joined work produced by a MENUISIER. (He was never called upon to gild metal.)

Peintres de la Réalité, Les (Fr. 'The Painters of Reality') A loosely related group of French 17th-c. painters, who examined daily life and the objects connected with it with a kind of sober reverence. They include followers of Caravaggio, such as Georges de La Tour; artists linked to Dutch genre painting, such as the brothers Louis, Antoine and Mathieu Le Nain; and painters of still-life such as Louise Moillon and Sebastien Stoskopff. The phrase first gained currency as the title of an exhibition held in Paris in 1934. See also REALISM.

peinture à la colle French for DISTEMPER (lit. 'painting with glue').

pele tower A small fortified tower, tall in proportion to its diameter, common along the borders between England and Scotland.

pelike (Gk) A type of GREEK VASE★ derivative of the AMPHORA, with a pear-shaped body and a wide mouth.

pencil 1. In the 18th c. an artist's brush. Hence 'pencilling' meant brushwork. 2. In modern usage, a drawing or writing instrument generally consisting of a stick of graphite or chalk encased in either wood or metal.

A superior garden **pavilion**:*the temple of Aeolus at Kew, designed by Sir William Chambers and built in 1760.*

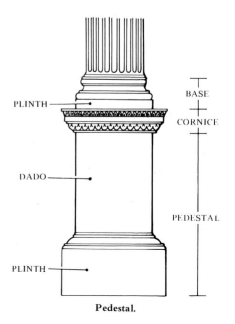

Pedestal.

The emotionalism of the **Pergamene School** *is demonstrated in this head of a winged giant from the great altar at Pergamum, c. 180 BC.*

Perpendicular style: *the soaring but simplified lines of the church of St Botolph, Boston, 14th–16th c.*

pendant (Fr. 'hanging') 1. An ornament hanging from a stone VAULT or wooden roof (usually GOTHIC). Synonym: drop ornament. 2. One of a pair of paintings, sculptures, RELIEFS, or ornaments, where these have been conceived by the artist as related and interdependent in subject and composition.

pendentive The curving triangular surface used to link a DOME★ or its supporting DRUM to a space below which is of square plan.

pensiero (It. 'thought') Synonym of SKETCH.

pentimento (fr. It. *pentirsi*, 'to repent') Evidence of an artist's change of mind in a painting.

Performance Art Art of the 1960s and later which is closely linked to the performing arts – mime, dance and theatre – and which is presented as an ephemeral event before an audience. Comprises ACTIONS, BODY ART and HAPPENINGS.

Pergamene School A school of HELLENISTIC sculpture which flourished at Pergamum in Asia Minor in the third and second centuries BC. Powerfully realistic, it also seems to us BAROQUE in its violent movement and strong emotionalism.

period (Used adjectivally of architecture and the decorative arts.) Of a certain period in the past.

peristyle (Gk *peri*, 'round'; *stulos*, 'column') 1. An open court within a building, with a COLONNADE surrounding it. 2. A continuous colonnade around a building. (CLASSICAL TEMPLE, plan.★)

Perpendicular style The last major style of English GOTHIC architecture. It originated at the end of the 14th c., following the Black Death (which caused a shortage of skilled craftsmen to undertake the elaborate work of the DECORATED style). It is marked by simplification and angularity, with strong emphasis on soaring vertical lines. Towards the end of its development, the characteristic pointed ARCH of Gothic becomes increasingly flattened. FLAMBOYANT STYLE is the equivalent in France.

perron (Fr.) A flight of steps, usually double, with a platform and PARAPET, forming the approach to an important entrance.

persienne (Fr.) A slatted window-blind, either hanging or hinged at the side.

perspective The method of representing a three-dimensional object, or a particular volume of space, on a flat or nearly flat surface.

Atmospheric perspective. A means of representing distance and recession in a painting, based on the way the atmosphere affects the human eye. Outlines become less precise, small details are lost, HUES become noticeably more blue, colours in general become paler, colour contrasts are less pronounced. These effects had already been observed by FRESCO painters of the Roman period but on the whole are most typical of NATURALISTIC European landscape painting from the 16th c. onwards. There is also an attempt at atmospheric perspective in Chinese and Japanese ink painting.

Centralized perspetive. Linear perspective in which the eye is drawn towards a single VANISHING POINT in the centre of the composition, usually on the horizon-line. Synonym: one-point perspective.

Linear perspective uses real or suggested lines converging on a vanishing point or points on the horizon or at eye-level, and linking receding planes as they do so.

One-point perspective. Synonym of centralized perspective.

petit feu (Fr. 'little fire') Synonym of LOW-FIRED (enamel).

petit feu colours ENAMEL COLOURS on PORCELAIN.

phiale (Gk) Shallow bowl without handles used for making libations. A phiale with a hollow central BOSS serving as a grip for the fingertips is called a phiale mesomphalos. (GREEK VASES.★)

photo realism Synonym of SUPER REALISM.

photogram A photograph produced without a camera, by the action of light on sensitive paper. The technique was used in the 1920s and 1930s by artists such as Man Ray and Moholy-Nagy, but also by Fox Talbot in the 1840s.

photogravure Synonym of GRAVURE.

photomontage A pictorial composition made by covering a sheet of paper or card with overlapping photographs or fragments of photographs. See also MONTAGE.

piano nobile (It. 'noble floor') The main floor of an Italian palazzo, or grand town house, containing the reception rooms, raised one storey above ground level.

*The **perron** on the south side of Kedleston Hall, Derbyshire, by Robert Adams, c. 1761.*

Claude Lorrain's The Mill, *1631, is a refined example of atmospheric **perspective**, especially in its treatment of the middle and far distance.*

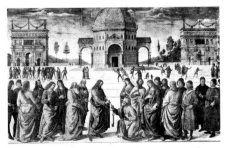

*Centralized linear **perspective**: the orthogonals formed by the lines in the paving stones in Perugino's* Christ's Charge to St Peter, *1481, draw the eye towards a central vanishing point within the door of the domed building. This is flanked by two triumphal arches.*

piazza (It.) 1. An open space surrounded by buildings. (CAMPANILE.★) 2. (Archaic.) A LOGGIA.

pickling 1. Cleaning oxide or FLUX from silver, etc., by the use of extremely dilute sulphuric acid. 2. Giving wood a whitish finish by scraping off paint, while leaving the remains of the GESSO base still embedded in the grain.

pictograph A highly simplified symbol of an object or action.

picture space The apparent space behind the PICTURE-PLANE, created by the use of PERSPECTIVE and other illusionist devices.

picture-plane The imaginary plane represented by the physical surface (canvas, paper, etc.) of a painting.

Picturesque, the The principle, originating in the 18th c., of arranging architectural elements, the parts of a pictorial or sculptural composition, or a garden design, in a pleasingly irregular way (as in the paintings of Claude Lorrain and Poussin). It was Uvedale Price's *An Essay on the Picturesque, as Compared with the Sublime and the Beautiful* (1794), which first established the use of the term. (PERSPECTIVE.★) See also the SUBLIME.

piece-goods Fabrics woven in recognized lengths.

pied-de-biche (Fr. 'hind's foot') A type of foot found on French 18th-c. furniture, either carved or in the form of a metal SABOT, which resembles a deer's cloven hoof. It is often combined with a CABRIOLE LEG.

pier 1. A large, free-standing PILLAR, of rectangular, square or composite section, supporting an ARCH, the span of a bridge, etc. 2. The solid masonry supporting a series of doors, windows or other openings. 3. A BUTTRESS bonded to a wall throughout its height.

Pietà (It. 'pity') A representation of the dead Christ lying in the lap of the mourning Virgin. It originated as a type in Germany in the 14th c.

pietre dure (It. 'hard stones') A type of MOSAIC work made of SEMI-PRECIOUS STONES, typically in RELIEF and representing birds, fruit, etc. It was a speciality of the Grand Ducal workshops in Florence, from the late 16th c. onwards. The singular form (*pietra dura*) should strictly be kept for mosaic work containing stones of one type. Synonym: Florentine mosaic.

pigment 1. The colouring agent in paint or dye. 2. The same colouring agent isolated in dry form, usually as a powder.

pilaster A rectangular PIER engaged in a wall and projecting only slightly from it. Its function is usually decorative rather than structural.

pile 1. A long support, of timber, steel or concrete, driven into soft or unstable soil as a foundation for building. 2. The short fibres (either cut or looped) forming the surface of certain woven materials, e.g. velvet, carpeting.

pilgrim bottle A globular or pear-shaped bottle, flattened so that it is oval in SECTION, and provided with loop handles for suspension on the shoulders. The shape derives from the dried gourds in which pilgrims carried their drinking water, and appears both in Chinese PORCELAIN and in European metalwork and CERAMICS from the 16th c.

pilgrimage church 1. A church built to receive pilgrims to a shrine (e.g. the BAROQUE church of Die Wies in Germany). 2. A large church especially designed for crowds of pilgrims and built during the 11th c. along the main routes to the shrine of St James the Greater at Compostela, in northern Spain. Examples include the churches at Conques, Nevers and Tours, in France.

pillar A free-standing upright in architecture, of any regular shape.

pilotis (Fr. 'piles') Stilts which raise a modern building above ground level, to make space for car-parking, etc.

pinacoteca (It.), **Pinakothek** (Ger.) (fr. Gk 'picture box') An art gallery.

pinchbeck (the name of an English watchmaker, d. 1732) An ALLOY of copper and zinc in almost equal parts, used for inexpensive jewellery because it resembles gold.

pinnacle A small decorative feature crowning a SPIRE, BUTTRESS, etc., in GOTHIC architecture. (GOTHIC CATHEDRAL, section.★)

pique (Fr.) A stiff ribbed fabric.

piqué work (Fr. *piqué*, 'pitted') 1. Material, usually tortoiseshell or ivory, ornamented with an INLAY of minute points of gold. 2. A kind of fine embroidery, made with very short stitches which appear as points of colour.

piscina (Lat. 'fishpond') In church architecture, a built-in stone basin, generally on the south side of the altar, where the priest washes the Communion vessels after the service.

pisé, pisé de terre (Fr. 'pounded earth') 1. Compressed earth mixed with straw and squeezed between boards until it dries. 2. A method of construction which uses this material. See also COB.

pitch The angle by which a sloping roof departs from the horizontal.

pithos (Gk, pl. **pithoi**) A large storage jar. (GREEK VASES.★)

Pittura Metafisica (It. 'Metaphysical Painting') Term coined by the Italian artists Giorgio de Chirico and Carlo Carrà for the calm, empty architectural scenes enlivened by mysteriously inappropriate objects such as tailor's dummies, which they both produced during the First World War. Pittura Metafisica influenced both Veristic SURREALISM and MAGIC REALISM.

plan 1. The horizontal disposition of the parts of a building. 2. A drawing or diagram showing this, as if seen from above.

planishing The removal of irregularities from sheet metal by means of a smooth-faced hammer.

planography Any method of printing from a flat surface, e.g. a LITHOGRAPHIC stone.

plaque 1. An ornamental tablet. 2. Synonym of a metal SHINGLE. 3. A flat piece of metal used as a basis for ENAMEL.

plaquette (Fr.) 1. A small RELIEF resembling a MEDAL, but almost always UNIFACE and rectangular or irregular rather than circular. 2. A small plate which is covered with ENAMEL and attached to the surface of an object.

plaster Malleable material which hardens when dry and is made from a wide variety of materials, most of the mixtures containing limestone, sand and water, with hair as a strengthener. It is used to coat walls, externally or internally (sometimes as a GROUND for FRESCO), for moulded and carved architectural ornament (see also STUCCO), for moulded copies of sculpture (PLASTER OF PARIS), and (usually as a basis for gilding) on a wooden foundation for picture frames and ornamental furniture. See also COMPO, GESSO, STUCCO, PLASTER OF PARIS.

(Above) **Pietre dure:** *a 17th-c. Florentine table-top incorporating semi-precious stones including lapis lazuli.*

(Right) T'ang dynasty **pilgrim bottle** *with relief decoration showing classical influence in its motif.*

The Disquieting Muses, *1917, an example of* **Pittura Metafisica** *by Giorgio de Chirico.*

Plaster of Paris A type of PLASTER made of dehydrated gypsum (anhydrous calcium sulphate) and mixed with water. It is used for carving and to make plaster CASTS.

plastic arts Those arts which involve modelling, such as sculpture and ceramics, or represent solid objects.

plasticity 1. The real or apparent three-dimensionality of a work of art, and its interaction with the surrounding space. 2. The malleability of soft but solid materials, which enables them to be easily shaped or modelled.

plate 1. The piece of metal, ENGRAVED or ETCHED with a design, which is used for printing. 2. The part of a lock, hinge or handle which attaches it to a piece of furniture or door. 3. A beam attached to a wall along its whole length, which supports the joists or timbers of a ROOF.* 4. Gold or silver, or objects made of gold and silver (in this sense, the word is derived indirectly from the Spanish *plata*, or 'silver'). 5. By extension, something which is coated or plated with a layer of precious metal. (See ELECTROPLATE.) 6. The piece of glass coated with light sensitive EMULSION, which forms the NEGATIVE in a plate-camera.

plate mark The identation left in the paper by the edge of the PLATE when an ETCHING, ENGRAVING or MONOTYPE is printed.

plateresque (fr. Sp. *platero*, 'silversmith') Spanish architecture of *c.* 1520, which combines GOTHIC and RENAISSANCE characteristics, and which is often so elaborate that it is reminiscent of fine metalwork rather than stone-carving.

platinotype 1. A photographic printing process invented *c.* 1859, but in general use only after its commercial launching in 1879. It used platinum instead of silver salts, and gave greater permanence and finer gradations of TONE. (The rise in the price of platinum during the First World War put an end to its use.) 2. A PRINT produced by this process.

plein, en See ENAMEL.

plein air (Fr. 'open air') 1. (Used of landscapes in oils.) Painted out of doors. The practice was probably begun by François Desportes in the early 18th c., but was made a matter of doctrine by the IMPRESSIONISTS.* 2. Sometimes incorrectly applied to landscapes painted in the studio which employ such a direct technique that they seem to have been done out of doors.

plinth 1. The base of a building or piece of furniture. 2. The square lowest member of the base or PEDESTAL* of a COLUMN.* (ORDERS OF ARCHITECTURE.*) 3. The PEDESTAL of a statue.

plique à jour See ENAMEL.

pochade French for SKETCH.

pochoir French for stencil (see STENCILLING).

podium 1. A continuous base supporting a building or row of COLUMNS. 2. The lowest part of the base of an individual COLUMN.* (Synonym of PLINTH.) 3. The lowest storey of a building, treated so as to seem like a base for the rest. (Synonym: basement). 4. The platform surrounding the arena in a Roman AMPHITHEATRE.

pointillism, pointillisme (fr. Fr.) In painting, the systematic use of OPTICAL MIXTURES. Synonym: DIVISIONISM. (NEO-IMPRESSIONISM.*)

pointing 1. A mechanical process for enlarging a small model, or BOZZETTO, into a full-sized sculpture by measuring off from a series of 'points' marked on the original to similar points on the copy (i.e. a three-dimensional equivalent of SQUARING FOR TRANSFER). 2. The process of raking out joints in building mortar and pressing in new mortar to create a smooth surface.

Polonaise carpet An extremely luxurious type of carpet made in Persia in the 16th and 17th c., apparently chiefly for export and as diplomatic gifts. These carpets were formerly supposed to have been made in Poland, where many of them were found. They have a silk PILE and are often decorated with gold and silver thread.

polygonal masonry Masonry made of irregular blocks fitted together.

polyptych A painting made up of a number of panels fastened (usually hinged) together.

Pont-Aven School A group of painters, with Gauguin as their inspiration and chief figure, who worked in and around the town of Pont-Aven in Brittany. Gauguin first visited Pont-Aven in 1886, and began to gather disciples on his second visit in 1888, when he met Emile Bernard. Gauguin advocated a rejection of NATURALISM in favour of the symbolic expression of ideas and emotion. See also SYNTHETISM, CLOISONNISM.

Pop Art: *in his portrait of Marilyn Monroe, 1967, Andy Warhol makes deliberately crude use of serigraphy.*

Plateresque: *the elaborately decorated Renaissance façade of Salamanca University, 1529.*

pontil, ponty, punty An iron rod used for the final shaping of molten GLASS, and to which it is transferred from the blow-pipe.

pontil mark The scar left by the use of a PONTIL.

Pop Art Art which makes use of the imagery of consumerism and mass culture (e.g. comic strips, pin-ups and packaging), with a finely balanced mixture of irony and celebration. Pop Art began in the 1950s with various investigations into the nature of urban popular culture, notably by members of the Independent Group at the ICA (Institute of Contemporary Arts) in London. It blossomed in 1960 as a major style, having taken on board certain ideas which had their roots in DADA. It finally affected not only FINE ART but many aspects of DECORATIVE ART. Pop artists in the US included Roy Lichtenstein, James Rosenquist and Claes Oldenburg, and in Britain Richard Hamilton, Allen Jones and Peter Phillips.

poppy-head Any ornament, often but not necessarily floral, crowning GOTHIC bench-ends or other ecclesiastical woodwork.

porcelain An extremely hard, translucent variety of CERAMIC ware made with kaolin and silica and fired at a high temperature (1250°–1350°C). It was first produced in China in the 7th or 8th c. AD, but the method of

At the time when Gauguin was leader of the **Pont-Aven School***, his work was characterized by the flattened perspective and simplified drawing seen here in* The Haystacks, *1889.*

manufacturing it was not discovered in Europe until 1709, at Meissen. Synonyms: true porcelain, pâte dure. See also BONE CHINA, PÂTE TENDRE, PROTO-PORCELAIN, STONEWARE.

porcelaine de Paris (Fr.) The PORCELAIN which was made at a number of small factories in and around Paris *c.* 1770 – *c.* 1830. Being under royal or noble patronage, these factories evaded the monopoly granted to Sèvres by Louis XV.

porch 1. A structure sheltering the entrance to a building from the weather. 2. (US.) A verandah.

porte cochère (Fr. 'coach door') 1. An opening or passage-way wide and high enough to allow a vehicle to pass through a building or screen-wall into an interior courtyard. 2. A PORCH large enough to allow the passengers in a coach or other vehicle to alight in shelter, before entering the building.

portico A roof supported by COLUMNS and usually attached to the front or sides of a building. (CLASSICAL TEMPLE.*)

portrait format A painting, drawing, etc., which is higher than it is wide. (The opposite of LANDSCAPE FORMAT.)

positive 1. A PRINT obtained from a photographic NEGATIVE. 2. A RELIEF object produced by using an INTAGLIO stamp or mould.

poster paint Synonym of GOUACHE.

postern A subsidiary entrance to a fortress, town or monastery.

posticum (Lat.) Synonym of OPISTHODOMOS.

Post-Impressionism General term for the work of the major artists of Western Europe, not closely linked stylistically, who developed away from IMPRESSIONISM. Chief among them were Cézanne, Gauguin, Van Gogh and Toulouse-Lautrec. The term was first used *c.* 1914 by the English critic and artist Roger Fry.

Post-Modern Term used to describe the attempt to modify and extend the tradition of MODERNISM in 20th-c. architecture with borrowings from the CLASSICAL tradition, from vernacular building methods and from commercial styles. Many of these references are used ironically. The word was first used in an architectural context by Joseph Hudnut in 1949, but given wider circulation by Charles Jencks and his associates and allies from 1975, and much elaborated upon in Jencks' book, *The Language of Post Modern Architecture* (1977).

Post-Painterly Abstraction Term coined by the American art critic Clement Greenberg in 1964 to describe the work of American artists such as Morris Louis, Kenneth Noland, Jules Olitski and Ellsworth Kelly, who were then using large fields of pure colour, unmodulated by brushwork. Such work is also sometimes described as COLOUR-FIELD PAINTING, in spite of the fact that this term also includes an earlier generation of artists such as Yves Klein, Ad Reinhardt and Barnett Newman. The term is thus dependent not merely on the appearance of the work, but on the identity of the artists Greenberg associated with it.

potiche (Fr.) A covered POTTERY or PORCELAIN jar without handles. The shape is said to derive from Chinese bronze wine-vessels of the Chou dynasty (1122–249 BC).

potlatch (fr. Nootka, *patlatsh*, 'gift') A term originating in the Indian cultures of the Northwest coast of North America and applied by extension to other PRIMITIVE cultures, designating the competitive ceremonial display, destruction and giving away of goods, including works of art.

pottery All wares made of fired clay except PORCELAIN – i.e. EARTHENWARE and STONEWARE.

pouncing 1. The technique of copying a design by pricking holes in the outlines and using fine chalk or graphite powder to transfer these to a sheet beneath. 2. Decoration of a metal surface, particularly silver, with fine dots so as to give it a matt finish.

poupée, à la (Fr. 'with a dabber') A method of making colour ETCHINGS or ENGRAVINGS by making several IMPRESSIONS from the same PLATE, each time applying a different colour by means of dabbers (paper rolls or cloth pads). It was first used in Holland in the 17th c.

Poussinism, Poussinisme The doctrine espoused by those French painters of the 18th c. who emphasised line as opposed to colour and therefore declared themselves to be followers of Poussin. See also RUBÉNISME.

prayer rug A rug on which a Muslim prays. The design usually consists of a niche or arch which can be pointed towards Mecca. See also SAF.

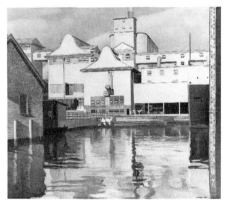

*(Top) Detail from a 15th-c. **predella** depicting the miracle of the Host, by Paolo Uccello, which also makes use of continuous representation.*

*(Above) The River Rouge Plant, 1932, by Charles Sheeler, one of the **Precisionist Painters**.*

*(Left) **Post-Painterly Abstraction**: large fields of colour in Ellsworth Kelly's Orange and Green 1966.*

Precisionist Painters A school of North American artists who painted industrial scenes and architectural motifs from *c.* 1915 onwards in a simple, formal clean-cut way, usually avoiding human reference and thus making representational work seem almost ABSTRACT. Prominent representatives of this tendency were Charles Sheeler, Charles Demuth and Georgia O'Keefe.

precious stone One of the four 'noble' GEM-STONES used in jewellery – diamond, sapphire, emerald, ruby – which are considered inherently more valuable than other gemstones, such as topaz, amethyst or aquamarine, which are in some cases mineralogically similar. The pearl, which is an organic product rather than a gemstone, is sometimes incorrectly included among the precious stones.

Pre-Columbian Made by the indigenous peoples of North America before Columbus' first voyage in 1492.

predella (It. 'altar-step') A painting placed beneath the main scene or main series of panels in an altarpiece so as to make a kind of PLINTH. Since predelle are by their nature horizontal, long and narrow, they are often NARRATIVE PAINTINGS, sometimes making use of CONTIN-UOUS REPRESENTATION.

prefabrication The manufacture of building components away from the site, for rapid subsequent assembly when they reach it.

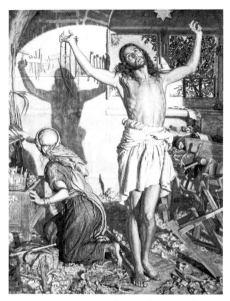

Holman Hunt's painting of Christ in the carpenter's shop, The Shadow of Death, *1873, is typical of the way* **Pre-Raphaelite** *painting combines the symbolic element with extreme realism.*

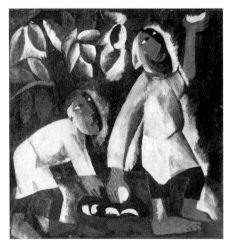

Primitivism: *Natalia Goncharova's* Peasants Picking Apples, *1911, demonstrates the combined influence of Russian folk art and French Cubism on Russian avant-garde painting of this period.*

Pre-Raphaelites A group of English artists, among them Holman Hunt, Millais and Rossetti, who in 1848 formed the Pre-Raphaelite Brotherhood (PRB), aiming to produce work in the spirit which imbued Italian artists before Raphael's move to Rome. The movement was a mixture of romantic medievalism and the desire to return to a realistic depiction of nature, disregarding what they considered to be the arbitrary rules of ACADEMIC art. These preoccupations were unified by a kind of seriousness which turned painting into a moral as well as an aesthetic act. The group also had an impact on the decorative arts through painted furniture, tapestries, stained glass and designs for fabric and wallpaper. A number worked for the firm of Morris, Marshall, Faulkner & Co., and were thus instrumental in creating the ARTS AND CRAFTS MOVEMENT.

presbytery 1. The part of a church reserved for the use of the clergy. (EARLY ENGLISH,★ GOTHIC CATHEDRAL, plan.★) 2. An independent dwelling-house built for their use.

primary colours, primaries Blue, yellow and red. The colours from which all others are derived, and which cannot be resolved or decomposed into other colours. (COLOUR CIRCLE.★)

primary structures Minimal sculpture (i.e. MINIMAL ART in three-dimensional form).

priming Material, usually neutral-coloured paint, applied to a canvas or wooden panel to protect and seal it before the final painting.

primitive 1. Of the work of European artists working before 1500, especially those who seem to use a conspicuously archaic style. 2. Of the work of self-taught and unsophisticated artists of any period. 3. Of the art of Black Africa, Oceania and the American Indians. In this third sense the word is often placed within quotation marks, since it is increasingly felt to be pejorative. 4. Occasionally, of art which seems to stand at the beginning of some development, and thus to be underived.

Primitivism 1. Any art which deliberately adopts PRIMITIVE characteristics. 2. A Russian art movement of c. 1905–20 which combined influences from Russian FOLK ART with ideas borrowed from CUBISM and FUTURISM. Among its adherents were Larionov, Goncharova, and the young Malevich. (DONKEY'S TAIL.★)

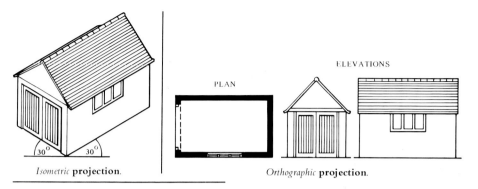

PLAN

ELEVATIONS

Isometric **projection**.

Orthographic **projection**.

print 1. An image which exists in multiple copies, and which has been taken from an engraved PLATE, WOODBLOCK, SILKSCREEN stencil, lithographic stone, photographic negative, etc. 2. Typeset or filmset material.

printer's flower Synonym of FLEURON.

Process Art Art of the mid 1960s and 1970s where the process of creation becomes the subject-matter. The spectators are invited to reconstruct what has been done, through the evidence placed before them. Among the artists associated with the term are Richard Serra, Robert Morris and Lawrence Weiner.

profil perdu (Fr. 'lost profile') (Used of a head or other object.) More than half turned away from the spectator.

profile 1. The SECTION of a MOULDING. 2. The outline of a building, piece of furniture or decorative object. 3. A depiction of a person's face, as seen from the side.

projection The representation of (or technique of representing) three-dimensional objects, especially buildings, on a flat surface, using one of a number of systems, each of which is coherent in its own terms.
 Isometric projection shows the horizontals of the structure at equal angles (usually 30°) to the base-line. A right angle formed by two walls, for example, thus becomes obtuse in the drawing. Isometric projection is useful in showing the details of more than one façade.
 Orthographic projection shows the PLAN and ELEVATION(S) as separate designs.

pronaos (Gk 'before the naos') The VESTIBULE before the NAOS in a CLASSICAL TEMPLE,★ enclosed by side walls, but with only COLUMNS in front.

T'ang dynasty **proto-porcelain** *ewer with olive-green glaze.*

proof A trial pull, or proof impression, of an ETCHING or ENGRAVING, made so that the artist can see whether the composition needs to be revised, or whether it can be left as it is. A 'touched proof' is one with alterations made by hand.

proportion The ratio between the respective parts in a building or any work of art. See also CANON OF PROPORTION.

propylaeum (Gk 'gate in front') 1. The entrance to a temple. 2. By extension, the porch or entrance gateway to any important building. (GREEK REVIVAL.★)

prothesis (Gk 'before the place') A room to the north of the SANCTUARY in a BYZANTINE church, used for keeping the sacraments.

proto-porcelain High-fired STONEWARE produced in China 4th–3rd c. BC, now considered to be the direct ancestor of true PORCELAIN.

153

(Above) This 20th-c. Zuñi water jar shows the bold patterning typical of **Pueblo** *pottery.*

(Right) Le Corbusier's Vertical Guitar, *1921, shows* **Purism's** *liking for basic forms, and its simplification of the Cubist idiom. The flattened water carafe is a typically banal subject.*

Proto-Renaissance Any revival of the CLASSICAL style between the 12th c. and the RENAISSANCE proper.

provenance The record of all known previous ownerships and locations of a work of art (as given in a CATALOGUE RAISONNÉ).

prunt Decoration on GLASS, consisting of an applied and modelled blob of molten glass.

psalter A manuscript or printed book containing the text of the psalms.

psychedelic art Art which tries to reproduce or reflect the change in mental states brought about by the use of hallucinogenic drugs such as LSD. Psychedelic art was especially associated with the rock music of the late 1960s.

psykter (Gk) A POTTERY vessel designed to be filled with snow or ice and used as a wine-cooler. (GREEK VASES.★)

Pueblo art Art produced by the Zuñi and Hopi (Pueblo) Indians of the southwestern US from *c.* AD 700 to the present day.

pugging The kneading process which homogenizes a CERAMIC BODY by making sure that air bubbles are eliminated and all elements are thoroughly combined.

pulvin (fr. Lat. *pulvinus*, 'cushion') Synomyn of DOSSERET.

pulvinated (Used of an architectural feature, particularly a FRIEZE.) Having a convex PROFILE.

punty Synonym of PONTIL.

Purism Art movement founded in 1915 by the painters Amédée Ozenfant and Charles Edouard Jeanneret (better known as an architect under his pseudonym Le Corbusier). They published a manifesto entitled *Après le Cubisme* ('After Cubism') in 1918. Purism was an attempt to reform the later, more decorative, phase of CUBISM by returning to simple, extremely generalized basic forms.

purlin A transverse horizontal beam in a timber ROOF,★ supporting the RAFTERS.

push and pull Term coined by the ABSTRACT EXPRESSIONIST American painter Hans Hofmann to refer to the dynamic variations in pictorial depth found in ABSTRACT paintings made up of many juxtaposed patches of strong colour.

putto (It. 'boy', pl. **putti**) Any plump naked boy, for example a cupid or a young angel, not necessarily winged. (STUCCO.★)

pylon (Gk *pulon*, 'gateway') 1. A tall tapered tower, especially one of a pair flanking the gateway to an Ancient Egyptian temple. 2. Any tall structure used as a support or to mark a boundary, or simply as decoration.

pyramid Any structure with a square base and sides which slope regularly upward to meet at an apex.

pyramidal composition A COMPOSITION in which the figures or objects represented fill the volume of an imaginary PYRAMID. Raphael often used this formula when depicting the Madonna and Child.

pyx A container for the sacred Host.

pyxis (Gk) A covered box or box-like jar, not necessarily for sacred use. (GREEK VASES.★)

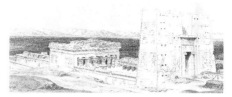

Pylons *at the Temple of Edfu, Upper Egypt, in a lithograph after a drawing by David Roberts, 1856.*

Q

qibla (Arabic 'direction of prayer') Synonym of MIHRAB.

quadrangle A rectangular courtyard, especially in a college building.

quadrant moulding Synonym of OVOLO.

quadrature (It. 'perspective schemes', sing. **quadratura**) Painted MURAL decorations of the 18th c. done in TROMPE L'OEIL, usually depicting architectural subjects, with special emphasis on violent FORESHORTENING and strong PERSPECTIVE effects.

quadraturisti (It.) Specialists in painting QUADRATURE.

quadriga (Lat.) A chariot drawn by four horses abreast, sometimes used in sculptural form to crown a TRIUMPHAL ARCH or other monument.

quadro riportato (It. 'transferred picture') A ceiling painting which uses normal PERSPECTIVE, as in a wall painting, instead of SOTTO IN SÙ. (FICTIVE SCULPTURE.★)

quarry A small square pane of glass.

quarry tile A square clay paving tile with no GLAZE.

quartering A type of VENEER made of two pairs of wooden sheets, each pair sliced and opened like the pages of a book, so that the pattern of the grain on the right is a mirror image of that on the left.

quarto (fr. Lat. *in quarto*, 'in fourth') A book made up of sheets folded into four leaves, usually not larger than c. $12\frac{1}{2} \times 9\frac{1}{2}$ in. (c. 32×24 cm).

Raphael's Canigiani Holy Family, c. 1507, makes use of a **pyramidal composition**.

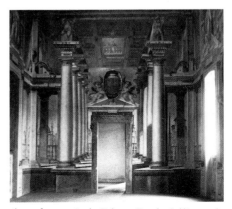

A **quadratura** in the Palazzo Ducale, Sabbioneta, by Pietro Pesenti and the Alberti brothers, 1590.

Quatrefoils.

Newnham College, Cambridge, by Basil Champneys, begun in 1875, typifies the English **'Queen Anne' style**. *Note the Prominent Dutch gables and the use of stone and brick together, with wooden window frames.*

A malisri **ragini** *from a ragamala series, Mewar School, 1605. The lady, attended by servants, sits plucking petals from a lotus flower beside an empty bed, suggesting the 'feminine' emotion of longing for an absent lover.*

quatrefoil (Anglo-French 'four-leaf') A four-lobed decorative motif, especially a four-lobed shape in Gothic TRACERY.

quattrocento (It. 'four hundred') The period 1400–1500 in Italian art. The term is often used for the characteristic style of Early RENAISSANCE artists in Italy, such as Donatello, Masaccio and Botticelli.

Queen Anne style 1. Strictly, English domestic architecture and decoration of the reign of Queen Anne (1702–14), characterized by sensible straightforward plainness and the widespread use of red brick, though the phrase is sometimes used to comprehend work done as early as the accession of William III in 1688. 2. (With the phrase usually in inverted commas.) A late 19th-c. English and North American architectural style influenced by Richard Norman Shaw (1831–1912), with features borrowed from both English Queen Anne and 17th-c. Dutch architecture (e.g. shaped GABLES) and with a strong emphasis on irregularity, asymmetry and diversity of materials and textures within the same building.

queen post See ROOF, TYPES OF.

quoins See STONEWORK.

R

r., r° See RECTO.

radiating chapel A chapel leading off the ambulatory of a ROMANESQUE or GOTHIC CATHEDRAL★ or church.

rafter A sloping ROOF★ timber fixed at the top to the ridge and at the bottom to the WALL PLATE, and supported in between by horizontal PURLINS. Stronger *principal rafters* are usually placed at the BAY divisions, while *common rafters* intervene. They form the support for BATTENS or other roof covering to which the tiles, slates, etc., are fixed.

raga, ragini (Skr.) Indian musical modes portraying emotions seen as masculine (*raga*) or feminine (*ragini*) which are often personified in miniature paintings as heroes and heroines, frequently in series called *ragamalas*.

rail 1. The horizontal part of the framing in a panelled DOOR★ or in wall-panelling. 2. A wooden strip fixed to the wall as protection at chair-back height (chair-rail, DADO-rail). 3. The front member of the seat-frame on a chair (seat-rail).

raising The process of making a vessel from a metal sheet by hammering it into shape over a wooden block.

raku (Jap. 'enjoyment') Japanese or Japanese-style moulded tea ware, usually of irregular shape and texture. It is fired at a very low temperature and covered with a thick lead GLAZE which can be of varying colours, but with a preference for dark HUES. The name derives from the Raku dynasty of potters who adopted the Japanese word *raku* as their seal, and who have been active from *c.* 1580 to the present day.

Rayonnism(e), Rayonism, Rayism (fr. Russian *Luchizm*) Art movement founded in 1911 or 1912 by the Russian painter Mikhail Larionov, in association with his wife Natalia Goncharova. The 'subject' of Rayonnist paintings, Larionov thought at this time, should be beams of colour, parallel or crossing at an angle. Rayonnist paintings are therefore quasi-ABSTRACT and have links with Italian FUTURISM and with experiments made by Robert Delaunay in their emphasis on apparent movement and lines of force.

rayonnant (Fr.) Radiating. Used in particular of French GOTHIC TRACERY.

ready-made Term coined by Marcel Duchamp *c.* 1913 for an everyday object isolated from its normal context and treated as a work of art. See also OBJECT TROUVÉ.

realism 1. Art which aims to reproduce reality exactly. 2. (With a capital R.) A phase of 19th-c. French art. Rejecting the idealistic tendencies of ROMANTICISM, leading French artists of the mid century such as Courbet concentrated on reproducing what was immediately accessible to them, in terms of both social and sensory experience. Their bent towards detailed, accurate, sober representation was encouraged by the impact of photography. See also PEINTRES DE LA RÉALITÉ, LES.

rebate, rabbet A groove cut in the surface or edge of a piece of stone or wood and intended to receive a tongue or flange.

The Beach, *1913–14, a typical* **Rayonnist** *painting by Mikhail Larionov.*

Realism: *Courbet's* Bonjour Monsieur Courbet, *1854, represents an ordinary event – Courbet's arrival at Montpellier as the guest of his patron Alfred Bruyas – as a momentous experience.*

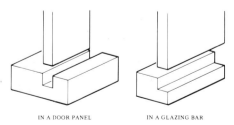

IN A DOOR PANEL IN A GLAZING BAR

Rebates.

Reeding.

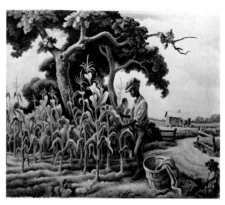

American **Regionalism:** *Thomas Hart Benton's* Roasting Ears *portrays a typically rural subject.*

rebus (Lat. 'concerning the things') 'A word represented by a picture.' (Dr Johnson.) The word itself is most usually a proper name. In the Middle Ages a rebus was often adopted as a badge by ecclesiastics and others not entitled to bear arms. The term comes from the Latin phrase *de rebus quae geruntur,* or 'concerning the things that are taking place', which was applied in 16th-c. Picardy to satirical pieces containing word pictures.

recession The appearance of depth in a picture.

réchampi (Fr. 'set off') Carved ornament picked out in gold or in a contrasting colour.

recto, r., r° (fr. Lat. *recto folio,* 'on the straight leaf' – as opposed to the *verso folio,* or 'turned leaf') The 'right' or more important side of a two-sided object, e.g. a sheet of paper. In a book, the right-hand page (the left being the verso). See also FOLIO.

red-figure A style of Greek vase painting of the 6th and 5th c. BC, in which the decoration appears in red against a black GROUND (the opposite of BLACK-FIGURE, which preceded it). The background is painted on, and turns black in FIRING, leaving the design in the red of the clay.

reducing atmosphere A kiln atmosphere rich in carbon monoxide, which makes a GLAZE pigmented with copper turn purple or red. Wet wood is often used as fuel to achieve this effect. Synonym: oxidizing atmosphere.

reduction A copy of a work of art on a smaller scale.

reeding An ornament made of narrow convex semicircular MOULDINGS, straight and extremely closely spaced (i.e. the inverse of FLUTING). So-called because of its supposed resemblance to a group of reeds.

reflected colour A change of HUE brought about when one colour is reflected onto another.

Régence (Fr.) An architectural and decorative style prevalent in France during the regency of Philippe Duc d'Orléans (1715–33). It was a type of early ROCOCO, but still heavily influenced by the BAROQUE.

Regency A style of furniture and decorative art prevalent in Britain during the regency of George IV (1811–20). The term is also used for the period of his reign (1820–30). A variety of NEO-CLASSICISM based on Greek rather than Roman prototypes, it makes room for Egyptian, CHINOISERIE and ROCOCO influences.

Regionalism The work of a small group of North American artists of the 1930s and 1940s who concentrated on rural Midwestern subject-matter and rejected most forms of European influence. Leading members of the group were Thomas Hart Benton, Grant Wood (see AMERICAN GOTHIC) and John Steuart Curry. Many of the artists concerned were closely connected with the WPA.

register 1. In colour printing, the accurate positioning of each successive PLATE or BLOCK on the paper to recreate the full colour image, which has been separated into more than one colour and each of these printed from a separate plate or block. An image is spoken of as being 'in register' if satisfactory, and 'out of register' if not. 2. In painting, when figures stand on different GROUND-LINES within the same composition they are spoken of as being in different registers. (BOOK OF THE DEAD.★)

Relief: alto rilievo *on a Roman sarcophagus, showing the Labours of Hercules, 2nd c.* AD.

Relief: *a Hellenistic terracotta* bas-relief *depicting a grape harvest.*

relief 1. A composition or design made so that all or part projects from a flat surface. 2. The impression or illusion of three dimensions given by a painting.

Alto rilievo (It. 'high relief'). Relief sculpture which is carved deeply enough to suggest that the main parts of the design are almost detached from their support.

Anaglyph. Low relief sculpture or EMBOSSING, usually only just rising proud of the surrounding surface.

Bas-relief (Fr.), *basso rilievo* (It.) ('low relief'). Relief sculpture in which the figures project less than half their true depth from the background. Synonym: low relief.

High relief. See alto rilievo.

Low relief. See bas-relief.

Mezzo rilievo. Relief sculpture in which figures and objects are seen in the half-round – i.e. with half their volume projecting from the surface.

Rilievo stiacciato, rilievo schiacciato (It. 'flattened relief'). Finely graded low relief where the transitions are compressed and the true relationships of the overlapping parts to some extent falsified so as to suggest atmosphere (e.g. SFUMATO) as well as purely three-dimensional effects. Found at its most developed in the work of Italian RENAISSANCE sculptors such as Donatello.

See also CAVO RILIEVO.

relief process Any method of printing where the surface to be inked is in RELIEF rather than INTAGLIO.

Relief: *the Waggoners' Memorial, a* mezzo rilievo *from Sledmere, Yorkshire, c. 1919.*

Relief: The Resurrection, *a* rilievo stiacciato *from Donatello's pulpit in the church of San Lorenzo, Florence, c. 1460–66.*

Figures of the Greek philosophers Plato and Aristotle from Raphael's **Renaissance** *masterpiece* The School of Athens *painted in 1510–12, in the Stanza della Segnatura in the Vatican. The two figures stand at the centre of the composition, whose central vanishing point lies between them. The heavy drapery they wear is influenced by ancient statues.*

Repoussé *decoration in Rococo style on a silver tea caddy made in London in 1748.*

relining The process of mounting a painting, together with its original canvas, on a new supporting canvas.

reliquary A container for sacred relics (of a Christian saint, the Buddha, etc.).

Renaissance The classically inspired revival of European arts and letters which began in Italy in the 14th c. Intellectually it was inspired by the ideas of humanist scholars, and in the visual arts its progress was marked by greater and greater command of anatomy and of the techniques of linear and atmospheric PERSPEC-TIVE, as well as by increasingly secular subject-matter, with themes taken from classical legend and history as well as from religion. The Renaissance in Italy lasted from the 14th c. until about 1580 (thus incorporating early MANNER-ISM), but the High Renaissance lasted only from *c.* 1480 to *c.* 1527 (the Sack of Rome), and is dominated by Leonardo, Raphael, and Michelangelo in his earlier phases. Its influence was also felt throughout Europe, and the paintings of Albrecht Dürer and of the FONTAINEBLEAU SCHOOL can also be described as Renaissance art.

rendering A waterproof coating, generally PLASTER or cement, on a wall exposed to the weather.

replica 1. Strictly, an exact copy of a painting or sculpture done by the artist who created the original. 2. More loosely, one of two versions of a painting when it is not known which is the original. 3. An object exactly reproducing another object, usually one by a different hand.

repoussé (Fr. 'pushed back') Metal hammered into a RELIEF design from the back. Sometimes termed EMBOSSING. (ANIMAL STYLE.*)

repoussoir (Fr., fr. *repousser*, 'to push back, set off') An object or figure placed in the immediate foreground of a pictorial composition, whose purpose is to direct the spectator's eye into the picture. Generally, therefore, repoussoirs are placed towards the left- or right-hand edge.

representational art Synonym of FIGURATIVE ART.

reproduction 1. A copy of a work of art, especially one made by mechanical means (e.g. CASTING, photography). 2. (Of furniture, etc. Also used adjectivally.) A more or less accurate copy of an earlier piece in PERIOD style.

(Above) Greek gold **rhyton**, *300 BC, in the form of a deer's head, from the Panagyurishte hoard.*

(Left) In his Hagar and the Angel, *1646, Claude Lorrain uses the tall trees to the right as* **repoussoirs**.

reredos The screen behind an altar.

résille sur verre, en See ENAMEL.

resist Wax or varnish used to cover areas of cloth, POTTERY or an ETCHING plate, which are to be left clear of dye, LUSTRE or acid. (In the latter case, refers to both the 'ground' and the 'stopping-out varnish'.)

respond A supporting member in architecture (e.g. a PILASTER), which is attached to a wall and paired with another supporting member.

Restauration style A decorative style prevalent in France from the restoration of the Bourbons in 1815 to the fall of Charles X in 1830. It was a development of the preceding EMPIRE style, and took over forms from NEO-CLASSICISM, but with a preference for light-coloured woods and brighter colours.

Restoration style The opulent English BAROQUE style of decoration introduced into England with the restoration of Charles II to the throne in 1660. It was influenced by Holland, and to a lesser extent by France. There was also a marked oriental influence, with fashions for Indian chintz and Japanese LACQUER. VENEERED furniture in walnut increasingly tended to replace solid oak furniture.

retable, retablo, retablum 1. A shelf for ornaments at the back of an altar. 2. A painting or sculptural panel behind an altar.

retaining wall A wall built to hold back or confine a mass of earth or body of water.

retardant, retarder A substance added to paint to slow its drying rate, e.g. a DRYING OIL in OIL PAINT.

retardataire (Fr. 'tardy') Lagging behind the accepted stylistic norm of its time.

reticulated (fr. Lat. *reticulum*, 'small net') Constructed or decorated in a net-like pattern.

retinal painting Synonym of OP ART.

retreating colour Any colour, but usually a COOL COLOUR such as blue, which seems to recede from the PICTURE-PLANE.

retro-choir In a large church, the continuation of the CHOIR behind the high altar.

return Any change of direction in a part of a building, particularly a turn at right-angles made by some feature such as a CORNICE or drip-stone (see MOULDING★).

reveal The part of a door- or window-JAMB★ which lies at an angle to the wall, but is not concealed by the frame.

reverse 1. The back of a MEDAL or coin, bearing a design subordinate to the one on the OBVERSE. 2. The back of any object.

revetment 1. A CLADDING of fine material over a coarser one, e.g. marble over rubble or concrete. 2. A RETAINING WALL.

rhyton (Gk) A drinking vessel shaped like an animal's head, usually with a small hole in the bottom to allow the liquid to spurt directly into the drinker's mouth.

Rococo *decoration with typical S-scrolls in ormolu on a commode made by Gaudreau (c. 1680–1751) for Louis XV's bedroom at Versailles.*

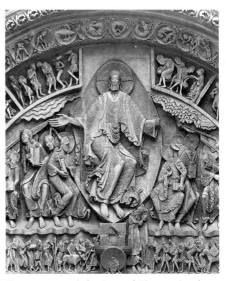

Romanesque *relief sculpture of Christ in glory from a tympanum at the church of La Madeleine, Vézelay, c. 1150. Note the marked distortion of the figure.*

rib A convex MOULDING which divides the compartments of a ribbed VAULT★ and is usually structural as well as ornamental.

ridge-piece A timber running along the apex of a ROOF.★

rilievo schiacciato See RELIEF.

rinceau (Fr.) Decoration made up of scrolls of formalized leaves and stems.

rise 1. The height of an ARCH,★ measured from the SPRINGING-LINE to the CROWN. 2. The height of a staircase, measured from one landing to the next.

riza (Russian) A coating of precious metal which partly covers an ICON, but leaves the faces and hands of the figures exposed.

rocaille (Fr. 'rockwork') 1. The kind of ornamental rock- and shellwork first used in grottoes from the mid 16th c. onwards, and in the mid 18th c. imitated as ornamentation on buildings, small articles of furniture, picture frames, etc. 2. A synonym of ROCOCO, especially in its more extravagant versions (first used in this sense from *c.* 1730).

Rococo (Fr., fr. *rocaille*) A lighter and more playful version of the BAROQUE, associated with the reign of Louis XV in France, and typified by asymmetry, the use of florid S-CURVES and C-scrolls, and of naturalistic motifs derived from rocks, shells and plants. The Rococo is more immediately identifiable in the DECORATIVE ARTS than it is in architecture or painting. The term did not come into general use until the 1830s, and long retained a pejorative implication.

rollwork Synonym of STRAPWORK.

Roman Classicism 1. The Roman manifestation of 17th-c. BOLOGNESE CLASSICISM. 2. The US equivalent of English PALLADIAN architecture, favoured by Thomas Jefferson and in use *c.* 1790 – *c.* 1830, i.e. considerably later than Palladianism.

Romanesque Term coined around 1825 to describe pre-GOTHIC art and architecture on the continent of Europe from the close of the 8th until the 12th c. AD. The first half of this period, until the end of the 10th c., is now sometimes described as 'pre-Romanesque'. In architecture the Romanesque is typified by the use of the round arch and conspicuously heavy construction. In painting and sculpture forms are linear

and are often expressively distorted to convey religious emotion. See also NORMAN STYLE.

Romanists Northern European artists of the 16th c. who were heavily influenced by Italian RENAISSANCE art (in particular, the work of Raphael and Michelangelo). They included Mabuse, Van Orly and Maerten van Heemskerck.

Romanticism In the visual arts, as in literature and music, Romanticism can be defined in both negative and positive terms. Its negative aspect is a sometimes disordered revolt against the formality, containment and intellectual discipline of NEO-CLASSICISM. Its positive – and more important – aspect is its commitment to feeling and to the individual's sovereign right of expression. Its influence was first felt in the mid 18th-c. cult of the PICTURESQUE in English garden design and in the first stirrings of the GOTHIC REVIVAL. It became more fully recognizable with the Sturm und Drang ('Storm and Stress', a mainly literary movement advocating the expression of violent emotion in a melodramatic and chaotic way) in late 18th-c. Germany. In its most fully developed form its influence was chiefly felt in Britain, Germany and France, all of which produced typically Romantic artists who were nevertheless very different from one another – in Britain Turner, in Germany Friedrich, and in France Delacroix and Géricault. In a narrow sense Romanticism died when it finally modulated into the REALISM of the mid 19th c., but in a broader one it is still with us, since it was the insistence on the rights of the imagination that led eventually to a genuinely modern art.

Romayne work A type of English 16th-c. carved decoration which is a provincial version of Italian RENAISSANCE prototypes, featuring heads within MEDALLIONS, foliage, vases and other elements thought to be CLASSICAL.

ronde-bosse (Fr. 'in the round') 1. A sculpture in the round, as opposed to RELIEF. 2. See ENAMEL.

rood A representation of Christ crucified. In English churches the figure was most usually sculptured in wood, and was flanked by mourning figures of the Virgin and St John. The whole group was carried on the ROOD-BEAM (see ROOD-SCREEN★). Many roods, together with their ROOD-LOFTS, were destroyed during the Reformation.

Rocky Landscape in the Elbsandstein Mountains, c. 1823, by the greatest German **Romantic** painter, Caspar David Friedrich. This painting, with its fallen tree, expresses a strongly subjective view of the terror and majesty of nature.

English oak chair of c. 1535 decorated with **Romayne work** in bastardized classical style.

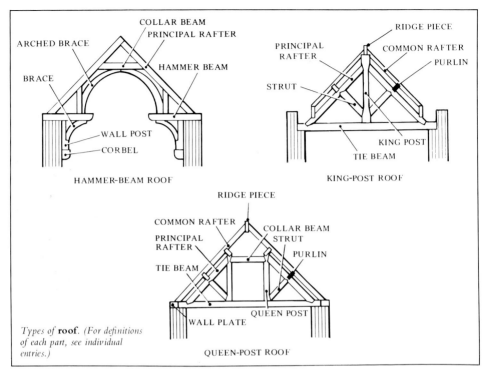

*Types of **roof**. (For definitions of each part, see individual entries.)*

HAMMER-BEAM ROOF

KING-POST ROOF

QUEEN-POST ROOF

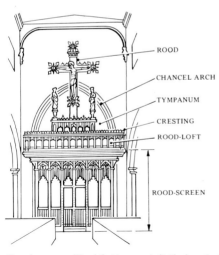

Rood-screen. *(For definitions, see individual entries.)*

rood-beam A beam which runs along the top of a ROOD–SCREEN where there is no ROOD–LOFT, and supports the ROOD.

rood-loft A gallery running across the top of the ROOD–SCREEN,★ and to which access was gained by a stair at one side.

rood-screen The altar-screen of a church which runs across the CHANCEL ARCH and which in the Middle Ages generally carried a ROOD.

roof, types of

Cradle roof. Synonym of wagon roof.

Gambrel roof. 1. A roof which is similar to a mansard roof, but with a GABLE at each end of the ridge. 2. (US) A mansard roof with flat ends.

Hammer-beam roof. A type of timber-framed roof in which the usual TIE BEAM, which stretches the full width of the building, is replaced by two short HAMMER BEAMS acting as CANTILEVERS and a shorter COLLAR BEAM higher up in the roof.

Helm roof. A kind of blunt STEEPLE with a GABLE on each face of the tower. It occurs most frequently in ROMANESQUE architecture.

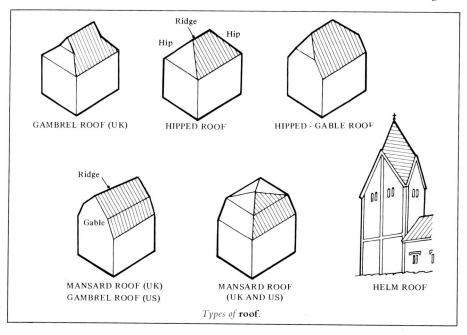

GAMBREL ROOF (UK) HIPPED ROOF HIPPED - GABLE ROOF

MANSARD ROOF (UK) MANSARD ROOF HELM ROOF
GAMBREL ROOF (US) (UK AND US)

Types of **roof**.

Hipped roof. A roof with GABLES sloping back towards the ridge.

King-post roof. A roof with ROOF-TRUSSES containing king posts, vertical timbers standing in the middle of a TIE BEAM and supporting the ridge of the roof.

Mansard roof. A roof with a double slope on two or all sides, the lower one steep, the upper one more gentle. Though the term was in use before his time, it was named after the 17th-c. French architect F. Mansart, who made much use of the design. (In the US, a mansard roof always has the double slope on all four sides.)

Pitched roof. A sloping roof.

Queen-post roof. A roof with ROOF-TRUSSES containing two queen posts, vertical timbers standing on a TIE BEAM and supporting the uppermost PURLIN.

Wagon roof. A timber roof with curved BRACES which are often lined internally with boarding. The whole structure has a fancied resemblance to the canvas hood of a covered wagon. Synonym: cradle roof.

roof comb An extension of the rear wall above roof level in a Mayan building.

roof-truss A frame inserted laterally at intervals under the rafters, to strengthen the structure of a ROOF.★

rosette (Fr. 'little rose') 1. A PATERA of rose shape, used as an architectural ornament. 2. Any small rose-shaped ornament.

Rosicrucians A loose grouping of SYMBOLIST artists led by the Sâr (Joséphin) Péladan, a prolific writer who was a believer in the occult doctrines of the supposed 15th-c. visionary Christian Rosenkreuz. His followers exhibited their work in the SALONS of the Rose + Croix held in Paris from 1892 to 1897. Among the more typical Rosicrucian painters were Charles Filiger (also associated with Gauguin and the PONT-AVEN SCHOOL), Armand Point, Edgard Maxence and Marcellin Desboutin. The chief role of the salons, however, was to draw attention to the work of important Symbolist painters who were not French, such as the Swiss Ferdinand Hodler and the Dutchman Jan Toorop.

rotunda (Lat.) 1. A circular building. 2. A circular interior space, usually one covered by a DOME. See also PANTHEON.

roughcast 1. A granular surface, most usually a mixture of PLASTER and gravel, applied to exterior walls. Synonyms: pebble-dash, harling. 2. The granular coating applied to a wall as the first coat in preparation for painting a FRESCO.

royal doors. The central doors in the ICONO-STASIS of a Russian or GREEK ORTHODOX CHURCH,★ so called because the King of Glory passes through them in the form of consecrated bread and wine.

rubble masonry See STONEWORK.

Rubénisme (Fr.) An 18th-c. artistic tendency in France, which exalted the merits of colour as opposed to line, thus supposedly following the example of Rubens. Watteau and Fragonard were associated with it.

rubrication In medieval and later manuscripts, a system of picking out initials and headings, usually in red, for emphasis. Some printed books, especially early ones, were also treated in this way.

running dog Synonym of VITRUVIAN SCROLL.

rupestrian (Used of paintings.) Done directly on the walls of caves (as with palaeolithic art) or rock-hewn sanctuaries.

rustication See STONEWORK.

S

__s., __sculp., __sculpsit, __sculpebat See F., FE., FEC., FECIT.

S-curve I. The shape formed by figures in GOTHIC sculpture, their hips being thrust forward or to one side. 2. Any serpentine line in art.

sabot (Fr. 'clog, hoof') A metal sheath or cap, often made of ORMOLU and highly ornamented, for the foot of a piece of furniture.

Sacra Conversazione (It. 'Holy Conversation') A representation of the Virgin and Child surrounded by saints, all of whom seem to be engaged in some kind of dialogue, or at least to be aware of one another's presence, in a unified pictorial space. See also MAESTÀ, SACRA FAMIGLIA. (LUNETTE.★)

Sacra Famiglia (It. 'Holy Family') A representation of the Virgin and Child accompanied by St Joseph (and sometimes St John the Baptist and St Anne, the Virgin's mother). See also MAESTÀ, SACRA CONVERSAZIONE.

sacramentary A liturgical book for the use of the celebrant at Mass, and containing his part of the service.

sacred monogram Synonym of CHRISTO-GRAM.

sacristy A store-room attached to a church, used for sacred vessels and for vestments. Synonym: vestry.

saddle bar I. A horizontal wooden bar holding one of the panes of glass in a window. 2. A horizontal iron bar designed to strengthen LEADED GLAZING.

saddle stone The stone which crowns a GABLE.

sadeli (Hindi) A type of MARQUETRY using ivory, horn, wood, silver and tin. It was introduced into India from Iran in the 16th c.

saf (Arabic 'row') A PRAYER RUG designed for more than one person, with several niches represented side by side.

sagger, saggar, seggar A fire-clay casing used to protect objects during FIRING.

St Ives painters A loosely connected group of British painters who lived and worked in the Cornish village of St Ives from the early 1940s. Some of the best known (e.g. Patrick Heron, Terry Frost) produced a British version of ABSTRACT EXPRESSIONISM, often with references to local landscape.

salomónica See COLUMN.

Salon, The (Fr.) An official French exhibition of paintings which was first held in 1667, and thereafter annually, under royal patronage in the Salon d'Apollon in the Louvre. From 1737, the Salon took place biennially, and from the time of the French Revolution (1789–99) once again annually. It continued to be officially administered until 1881, when the government withdrew. In that year a committee of ninety artists, elected by all those who had exhibited in previous Salons, met to set up the Société des Artistes Français, which henceforth took responsibility for the annual show. In 1889, following the International Exhibition of that year, a schism took place and the Société Nationale des Beaux-Arts was founded. This, from 1880 onwards, held an annual exhibition of its own.

salon (Fr.) In France, a general term for an independent group art exhibition.

Salon d'Automne (Fr.) An annual exhibition first held in Paris in 1903, which in its early years was used as a showcase by the FAUVES.

(Left) French 18th-c. writing-table by the ébéniste BVRB, featuring ormolu **sabots**.

(Right) This bust of King Shapur II (?) in silver gilt, 4th c. AD, *shows the* **Sassanian** *interest in precious metalwork.*

Salon des Indépendants (Fr.) An annual exhibition held in Paris from 1884 by artists who were opposed to the official SALON, such as Seurat, Signac and Redon.

Salon des Refusés (Fr.) An exhibition put on in Paris in 1863, to show works rejected that year from the official SALON. It was organized at the orders of Napoleon III, and included works by Manet, Boudin, Fantin-Latour, Pissarro, Whistler and many others.

salon painting Painting in ACADEMIC style, associated with the official SALONS.

sanctuary The part of a church or temple which contains the main altar or image of the deity, and is therefore considered more sacred than the rest. See also PRESBYTERY.

sand blasting A technique for decorating glass, gold or concrete, or for cleaning stone, metal, etc., by directing a stream of sand, crushed flint or iron filings at the surface under pressure. Those parts to be left plain are protected by a stencil or some form of RESIST. The method was first used (for decorating glass) in the US in 1870.

sand-core glass Synonym of CORE GLASS.

sand painting A technique of making designs in different colours of sand, practised by the Navajos and other North American Indians and also in Tibet, in Japan and among the Australian Aborigines, in connection with religious ceremonies. Sand paintings are ephemeral and must be done anew on every occasion – thus being a type of PROCESS ART.

sang de boeuf (Fr. 'ox-blood') An uneven deep red GLAZE derived from copper which is supposed to look like coagulated ox-blood. It was used by the Chinese from the late 17th c., and was revived in Europe in the 19th c. by potters connected with the ARTS AND CRAFTS MOVEMENT.

sanguine Red chalk with a brownish tinge, used for drawing. See also TROIS CRAYONS.

sans serif (Used of TYPEFACES.) Without ornamental cross-lines ('serifs').

san-ts'ai (Chi.), **sancai** (Jap.) ('three-coloured') 1. Pottery made during the T'ang dynasty (AD 618–906) which is streaked and spotted with three colours – usually dark blue, turquoise and aubergine. 2. Pottery made during the Ming and Ch'ing dynasties (1368–1912) with GLAZES of these same colours, kept apart by ridges of clay outlining the pattern. Synonym: three-colour ware.

sarcophagus A coffin or tomb-chest usually made of stone or terracotta.

sarpech (Persian) An Indian jewelled turban ornament.

sash A glazed frame made to slide up and down in grooves; used for WINDOWS★ from the 17th c. onwards.

Sassanian art The art of Iran, Iraq and some neighbouring areas under the Sassanid dynasty (AD 224–651). There was a strong emphasis on precious metalwork, much of it showing ritualized royal hunting scenes in a style ultimately derived from ACHAEMENIAN art.

Satsuma (Jap.) Cream-coloured Japanese POTTERY with a finely CRACKLED GLAZE and elaborate decoration in colours and gilding. It was produced from the end of the 18th c. onwards at Satsuma on the island of Kyushu.

saturation The brilliance of a colour – i.e. the extent to which a particular red, for example, impresses the viewer by its redness.

Sawankhalok Ware produced at Sawankhalok, the old capital of Siam (Thailand) from the 14th c. to the mid 15th c., under the influence of Chinese CERAMICS of the Yüan dynasty (1280–1368). Typically, it is rough, pale grey STONEWARE, with a CELADON GLAZE, the Chinese influence being evident in this glaze, in the shapes of the vessels and in the incised decoartion.

__sc., __sculp., __sculpsit, __sculpebat (Lat. 'engraves, engraved') An abbreviation or word seen on PRINTS, indicating that the name it follows is that of the ENGRAVER of the design.

scagliola (It., fr. *scaglia*, 'scales or chips of marble') Imitation marble made of powdered gypsum, sand and a solution of glue (later isinglass). It is studded while still soft with fragments of stone, concrete, coloured clay, etc., and then smoothed and polished to a high gloss. Its use was known in Ancient Egypt and the technique was rediscovered in the 16th c., when it was used for interior architectural features, especially COLUMNS and PILASTERS, and for ornamental table-tops.

scale Proportion or measurement. Something drawn 'one-third scale' is drawn one third the size of the original.

scale ornament A pattern of overlapping circles, imitating the scales of a fish.

scarab A small Ancient Egyptian amulet in hardstone or FAÏENCE in the form of the scarab, a sacred dung beetle, symbol of resurrection.

schema A form or COMPOSITION reduced to its simplest diagrammatic terms.

Schildersbent (Dutch 'band of painters') The close-knit group of Dutch and Flemish artists working in Rome in the 17th c. They included Pieter van Laer (see also BAMBOCCIATA).

school A group of artists working under the influence of a single master, or possessing a similarity because they come from the same region or practise the same local style.

School of __ By an artist whose identity is unknown but who is nevertheless recognizably influenced by the individual, or practises the style of the region, named.

School of Paris See ÉCOLE DE PARIS.

Schwabacher (Ger.) Rounded, more CALLIGRAPHIC version of BLACK LETTER. (TYPEFACE*).

scraperboard, scratchboard (US) A drawing surface made of fine GESSO covered with ink. When dry, the ink can be scraped away with a sharp point to produce a white line.

screens passage Entrance passage of a medieval or TUDOR house, or of a college at Oxford or Cambridge, with the main hall on one side and the buttery and pantry on the other.

scriptorium (Lat. 'place for writing') The room in a monastery where manuscripts were copied.

__sculpsit See S., SCULP., SCULPSIT, SCULPEBAT.

sculpture 1. Any work of art carried out in three dimensions. 2. With the advent of CONCEPTUAL ART in the 1970s, the word also began to be used for a wide variety of AVANT-GARDE works of art, some consisting only of a series of written statements (e.g. by Lawrence Weiner), and others using the dimension of time as well as space. When the British artist Richard Long made one of his planned walks across country, and recorded what he had done on a map, this ACTION was also labelled 'sculpture'. The word has thus become a label for almost any form of art activity other than painting.

scumbling The uneven working of a thin layer of paint over another of a different colour, so that the under layer shows through. It gives a veiled or broken effect.

sea piece, seascape Synonym of MARINE PAINTING.

seaweed marquetry A type of MARQUETRY consisting of panels of richly FIGURED wood (usually holly or boxwood) set into a background of walnut VENEER. The figure in the wood is thought to resemble seaweed. The technique was popular in the late 17th and early 18th c., but the name is modern.

secco (It. 'dry'), **fresco secco** (It. 'dry fresco) Painting which, unlike true FRESCO, is carried out on PLASTER which has already dried. It can

be done in TEMPERA, or with PIGMENTS in a MEDIUM of lime-water. In the latter case, the surface is dampened before applying the paint. The results are less durable than true fresco.

Secession See SEZESSION.

Second Empire style An eclectic decorative and architectural style, ranging from GOTHIC REVIVAL to LOUIS XVI, popular in France during the period when Napoleon III was President (1848–52) and Emperor (1852–70).

secondary colour A colour produced by mixing equal proportions of two of the PRIMARY COLOURS. Thus blue and yellow produce green; blue and red, violet; and yellow and red, orange. (COLOUR CIRCLE.★)

secrétaire (Fr.) A writing desk with a place to lock away papers and valuables – generally one with a flap which opens to make a writing surface.

section A drawing of a building or object which shows it as if cut through along a specified plane.

Section d'Or (Fr. 'Golden Section') A group of French Cubist painters who first exhibited together in 1912, including Robert Delaunay, but not the two founders of CUBISM, Picasso and Braque. The title was suggested by Jacques Villon, who took it from a 16th-c. treatise on the GOLDEN SECTION (*Divine Proportion*), illustrated by Leonardo da Vinci.

sedilia (Lat. 'seats') A series of stone seats in a church, placed on the south side of the CHOIR for the clergy.

seicento (It. 'six hundred') The period 1600–1700 in Italian art.

semi-precious stones Any natural (as opposed to synthetic) GEMSTONE which is less valuable than a PRECIOUS STONE. The term excludes both organic substances (amber, coral and pearl) and GLASS imitations of gemstones.

sepia A brown PIGMENT made from cuttlefish ink. Also brown CONTÉ.

serial imagery The same image repeated several times, with slight variations, in a painting or sculpture. The image chosen can be FIGURATIVE (Andy Warhol) or ABSTRACT (Don Judd and other MINIMAL sculptors).

serif A small cross-line finishing off the main stroke of a letter. (TYPEFACE.★)

Seaweed marquetry *on a writing-table made by Gerreit Jensen for Kensington Palace, 1690.*

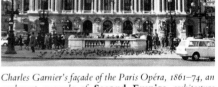

Charles Garnier's façade of the Paris Opéra, 1861–74, an exuberant example of **Second Empire** *architecture deriving chiefly from the Italian Baroque.*

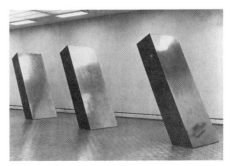

Serial imagery *in minimal sculpture:* 3 Elements, *1965, by the Canadian sculptor Ronald Bladen.*

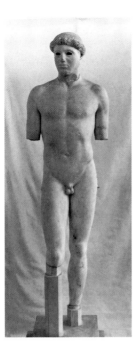

The 'Critian boy', a marble statue in the **Severe style**, *from the Acropolis, Athens, c. 480 BC.*

serigraphy A PRINT-making technique based on STENCILLING. Ink or paint is brushed through a fine screen made of silk, and masks are used to produce the design. These can be made of paper, or from VARNISH applied to the silk itself. Synonym: silk-screen printing. (POP ART.★)

serliano Synonym of Venetian WINDOW.

Seto ware (Jap.) Although a wide variety of different CERAMICS were made in the district round the Japanese city of Seto from the 9th c. AD onwards, those usually referred to by this name are 19th-c. kitchenware – brown or grey STONEWARES freely decorated in black, brown or UNDERGLAZE blue.

settecento (It. 'seven hundred') The period 1700–1800 in Italian art.

Severe style Greek sculpture in a style transitional between the ARCHAIC and the CLASSICAL. The Severe style flourished *c.* 480–450 BC, and was so called because it seemed severe in comparison with the fully developed classical art of the period 450–330 BC.

Sezession, Secession (Ger. 'Secession') Name taken by various groups of German and Austrian artists who rebelled against the SALON system in the last decade of the 19th c. There were Sezessionen in Munich formed by Franz von Stuck in 1892, in Vienna formed by Gustav Klimt in 1897, in Berlin formed by Max Liebermann in 1899, and also in Darmstadt.

sfregazzi (It. 'light rubbing') In oil painting, shadows applied as a GLAZE over flesh tones, using the fingers to rub them on.

sfumato (It. 'softened, vaporous') In painting or drawing, transitions from light to dark which are so gradual as to be almost imperceptible.

sgraffito, sgraffiato (It. 'scratched') The technique of scratching through one layer – of PLASTER on a wall, or of SLIP on a pot – so as to reveal another of contrasting colour.

Shaker furniture Furniture made in North America from the late 18th c. by the Christian communal sect of 'Shaking Quakers' (the United Society of Believers in Christ's Second Appearance), first for their own use and later for sale. It is characterized by an extreme simplicity which reflects Shaker ideals of plain living, but also has a typical attenuated elegance. The forms derive from English 18th-c. rustic patterns.

shakti (Skr. 'female energy') The active or energetic aspect of a Hindu god, sometimes personified as his wife.

shakudo (Jap.) An ALLOY used by Japanese metalworkers, consisting of about 97% copper and about 3% gold. Successive PICKLINGS in acid give the initially grey metal a deep violet-black colour and a glossy surface.

shallow space A characteristic spatial effect found in both CUBIST and ABSTRACT EXPRESSIONIST art where, although there is no genuine PERSPECTIVE, the main forms seem to float in a shallow but undefined area of space behind the surface of the canvas.

shaped canvas Any picture which is not rectangular.

Sharp-focus Realism Synonym of MAGIC REALISM.

shawabti Synonym of USHABTI.

Sheffield plate Objects made, in imitation of solid silver, out of copper rolled between thin sheets of silver. The technique was discovered *c.*1742 and was superseded by ELECTROPLATING from *c.* 1840.

shell keep A wall surrounding a mound to make an unroofed enclosure which serves the same function as a castle KEEP.

Shibayama work Fine incrustation, usually on a LACQUER GROUND, of mother-of-pearl, lacquer, precious metals and other materials. Named after the Shibayama family of craftsmen who perfected the technique in 18th-c. Japan.

shikkara (Skr.) An Indian temple-tower, usually marking the SANCTUARY, which is built to resemble a mountain.

shingle A thin rectangular piece of timber used instead of a tile for roofing and for CLADDING. (In the US metal plates are also used.)

Shingle Style North American version of the QUEEN ANNE STYLE of the late 19th c., which replaced its characteristic TILE-HANGING on exteriors with shingle-hanging. Many houses built in the style, which was popular in the 1870s and 1880s, have open interior planning which now seems to foreshadow 20th-c. domestic architecture.

shishi (Jap. 'lion') A Chinese mythical creature, a combination of lion and dog, which derives from the lions guarding Buddhist altars. See also DOG OF FO.

shōji (Jap.) A Japanese sliding door, made of paper on a wooden frame.

Shonsui (Jap.) 1. The earliest Japanese PORCELAIN, made in the 16th c. by Gorodayu-go Shonsui, who settled near Arita after having learned the secrets of porcelain manufacture in China. 2. Porcelain made in South China in late Ming times, from the reign of Wan Li (1573–1619) onwards, especially for the Japanese market.

Shop Picture Art dealer's term for a painting produced in the workshop of a known master, but not by the master himself (see GUILD).

shunga (Jap. 'spring picture') A Japanese erotic PRINT.

shuttering The wood or metal casing into which concrete is poured for CASTING. Rough shuttering leaves the imprint of the wood grain on the concrete. Synonym: formwork. (BRUTALISM.★)

siccative A substance added to OIL PAINT to make it dry quickly.

A typical **Shaker** *ladder-back chair in maple wood with a cane seat, mid 19th c.*

The **shikkara**, *a major feature of the Rajarajeshvara Temple at Tanjore. Chola, c. 1000.*

Full-length **silhouette** *portrait of Lord Byron, 1824.*

Simultaneous representation: *an Ancient Egyptian drawing of King Tuthmosis III, 18th dynasty, c. 1460 BC. The head and legs are seen in profile, but the eye and shoulders directly from the front.*

significant form A term coined by the English art critic Clive Bell in 1913 to describe what seemed to him the essence of true works of art: the forms, and relationships of forms, which they contain. According to this doctrine FORM itself is the true CONTENT of the work of art, and other kinds of content (e.g. narrative and symbolic elements) are secondary.

silhouette 1. A PROFILE portrait cut out of black paper or painted in solid black. Originally made from a tracing of the shadow cast by a bright light and named after Etienne de Silhouette, an 18th-c. French politician. 2. By extension, any object or scene shown in black with no interior detail.

silk screen See SERIGRAPHY.

silver point A method of drawing with a rod of silver on paper prepared with Chinese white, or else with Chinese white and PIGMENT (giving a coloured GROUND). First used in Italy during the Middle Ages, it was popular in Flanders during the 15th c., but was replaced by the graphite pencil from the 17th c., except for occasional specialized uses such as MINIATURES.

sima recta, sima reversa See CYMA RECTA, CYMA REVERSA.

simultaneity The representation of successive phases of movement, or successive aspects of the same object, on the same canvas. Found in both FUTURIST★ and CUBIST painting.

simultaneous representation 1. Certain 'primitive' forms of representation where each part of a figure or object is shown in what seems to the artist its most characteristic and immediately recognizable aspect, creating an image which differs considerably from the real figure or object. In Ancient Egyptian painting, for example, the head and legs will be shown in profile, but the shoulders will appear as if seen directly from the front. (AMARNA ART.★) 2. Sometimes wrongly used as a synonym of CONTINUOUS REPRESENTATION.

simurgh (Persian) Fabulous bird, gigantic and with a long tail, which appears in Persian painting and as a decoration on CERAMICS.

singeries (fr. Fr. *singe*, 'monkey') A playful form of ROCOCO decoration featuring monkeys in costume playing human roles. It was supposedly invented by Claude Audran and was also practised by Watteau, Gillot and Christophe Huet.

Singeries: *wall decoration by Christophe Huet at the Château of Chantilly, c. 1720.*

Lifeline II, 1963, measuring 7 ft × 6 ft, by Robyn Denny of the **Situation Group**.

sinking in In OIL PAINTING, the dulling of colours that occurs when PIGMENT is absorbed by the GROUND.

sinopia 1. The preparatory drawing used to map out the composition of a FRESCO, 2. The reddish brown chalk used for this purpose.

Situation Group In 1960 an exhibition called 'Situation' was held at the RBA (Royal Society of British Artists) galleries in London, and the name was later transferred to the artists whose work was exhibited. Among them were John Hoyland, Bernard Cohen and Robyn Denny. They were interested in creating large ABSTRACT paintings, influenced by those produced in the US during the 1950s, and chose this name to stress the fact that large-scale abstract painting enveloped the spectator's whole field of vision and thus produced a 'situation' for him.

situla (Lat.) A bucket-shaped liturgical vessel, derived from Roman prototypes and common in the early Middle Ages. It was often made of metal or ivory.

size A weak solution of glue used to stiffen paper or textiles, or to render canvas less absorbent. It is also used over PLASTER as a basis for gilding and as a BINDER for DISTEMPER.

skeleton construction Synonym of FRAME CONSTRUCTION.

sketch A rough preliminary version of a composition.

skyphos (Gk) A shallow drinking bowl on a foot, with a pair of horizontally opposed handles. Sometimes wrongly termed a KOTYLE. (GREEK VASES.★)

skyscraper Term coined in the US in the late 1880s to describe the new multi-storey buildings (then ten to twelve storeys high). What we now recognize as the skyscraper began with Holabird and Roche's Tacoma Building in Chicago of 1890–94 (twenty-two storeys and a complete steel frame). It is dependent on steel FRAME CONSTRUCTION and the electric elevator.

slip A creamy dilution of clay, often in a different colour to the BODY of the vessel, which is used to coat it (often making it waterproof), to decorate it or to join parts together. See also SGRAFFITO, ENGOBE.

soak-stain technique A method of painting which produces soft stains or blots of colour through the use of heavily diluted paint on unsized canvas (see SIZE). The technique is typical of POST-PAINTERLY ABSTRACTION, and especially of the work of Morris Louis.

social realism Art which realistically presents subjects of social concern. To be distinguished from SOCIALIST REALISM.

Socialist Realism The official art of the Soviet Union from *c.* 1925 onwards, in a style which glorifies the State, celebrates manual work and focuses attention on Russian cultural and technological achievement. It has its roots in the ACADEMIC NEO-CLASSICISM of Jacques-Louis David and in the art of the WANDERERS, especially Repin. See also FORMALISM.

socle Synonym of PEDESTAL.

soffit The underside of any architectural surface, especially an ARCH or LINTEL. In the former case, synonymous with INTRADOS.

soft paste porcelain Synonym of PÂTE TENDRE.

soft sculpture Sculpture made of 'soft' materials (canvas, rope, vinyl, latex, etc.) which take on shapes in response to gravity. It began to be made in the 1960s, by POP artists such as Claes Oldenburg, but has since developed more widely in the hands of MINIMAL and PROCESS artists such as Robert Morris.

Soft Style A German version of INTERNATIONAL GOTHIC in painting and sculpture, distinguished particularly by the soft folds of the draperies. It appears from *c.* 1380 to *c.* 1430 (the draperies in the succeeding late Gothic period being much more angular).

soft-ground etching An ETCHING produced by mixing the GROUND with tallow, the design being drawn with a pencil on a piece of paper laid against the PLATE. The ground takes on the grain of the paper, and the resulting PRINT has the soft finish of a drawing made in pencil or chalk.

solar (fr. Lat. *solarium*, 'sunny place') An upper living-room in a castle or large medieval house, reserved for the lord and his immediate family.

solder An ALLOY used to join metal surfaces together, with a melting-point lower than that of the metals to be joined.

solomonic column Synonym of SALOMÓNICA (see COLUMN).

Sondergotik (Ger. 'exceptional Gothic') German late GOTHIC architecture (mid 14th – 16th c.), distinguished by elaborate VAULTING and filigree TRACERY. The term was coined in 1913 by the German art historian Kurt Gerstenberg.

sopraporta (It. 'overdoor') A painting or PEDIMENT over a doorway.

sotto in sù (It. 'up from under') Perspective used in the depiction of architecture and of figures (usually flying), shown from below in extreme foreshortening. Found in BAROQUE★ ceiling decoration.

souk, suq (Arabic) A street (sometimes covered) in an Islamic market.

space-frame A three-dimensional framework designed to resist thrust from any direction.

spandrel 1. The triangular area of stone- or brickwork formed by the outer curve (extrados) of an ARCH, the horizontal from its apex and the vertical continued upwards from the column supporting it. 2. The triangular space between two arches in an ARCADE. 3. The curved surface between two RIBS meeting at an angle in a VAULT. (GOTHIC CATHEDRAL, section.★)

Spasimo (It. 'swooning') A painting of the Virgin Mary collapsing into the arms of attendant women at the Crucifixion or on the road to Calvary.

spire A tall structure, generally found on a church, which rises from a tower or roof and diminishes to a point.

splay A sloping surface, particularly a sloping REVEAL which makes the opening of a window, etc., wider on one side of the wall than the other.

spolvero (It. 'fine dust') A copy of a CARTOON, made so that the original need not be pricked for POUNCING or soiled by the pouncing process, but could be kept in good condition for reference when the final painting was being worked on.

Spozalizio (It. 'betrothed') A painting showing the wedding of Mary and Joseph.

sprezzatura (It. 'nonchalance, ease') 1. The quality of cultivated carelessness which distinguishes a SKETCH. 2. Synonym of SKETCH.

springer The lowest VOUSSOIR of an ARCH.★

springing line The line formed by the undersides of the SPRINGERS, from which the ARCH★ rises.

(Above) **Socialist Realism:** *a typically optimistic depiction of* Collective Farm Threshing, *by A.A. Plastov, 1949.*

(Right) **Soft sculpture:** *Claes Oldenburg's* Soft Ladder, Hammer, Saw and Bucket, *1967, made from canvas filled with foam rubber.*

spur marks Marks found on the back or bottom of a GLAZED CERAMIC object, left by the spurs or stilts which supported it while it was being fired in the kiln.

squaring for transfer A process by which a larger version of a composition can be obtained. The composition is first covered with a grid of horizontal and vertical lines, and the contents of each square are then transferred to a grid of larger squares on a virgin surface.

squinch 1. An ARCH or series of arches placed diagonally at each corner of a square space as a link between it and the round form of the DOME★ above. 2. On a smaller scale, used as the repeating curved unit set at an angle from which Arabic STALACTITE WORK★ is constructed.

squint A small opening, obliquely cut through a wall or PIER, which gives a hidden worshipper in church a view of the main altar.

stabile An ABSTRACT sculpture without moving parts. So called because it is often the work of an artist who normally produces MOBILES.

staffage (Fr.) The small figures used to animate a landscape or architectural composition.

stained glass Window GLASS which has been coloured during manufacture but which is also often painted afterwards to give detail.

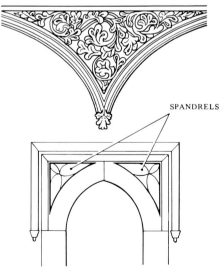

SPANDRELS

Two types of **spandrel**.

Stalactite work *ornaments the arcading in the 14th-c. Court of Lions in the Alhambra, Granada.*

The **stave church** *at Hopperstad, c. 1150, features characteristic upright plank construction.*

stalactite work Islamic ceiling ornament made of numerous CORBELLED SQUINCHES clustered together.

stamnos (Gk) Ancient Greek jar for mixing wine and water at table. It is usually of ovoid form with a short neck and horizontal loop handles attached to a high shoulder. (GREEK VASES. ★)

stancheon, stanchion (fr. Old Fr. *estanchon*) A vertical member in building construction, usually made of steel, and usually supporting a girder.

stand oil Linseed oil boiled away from air. Thinned and used as a MEDIUM for PIGMENT, it gives a particularly smooth, ENAMEL-like effect.

standard The proportion of pure precious metal, as opposed to non-precious metal alloyed with it, in an object made of gold or silver. Used especially of coin.

standard silver Synonym of STERLING SILVER.

state 1. One of several distinguishable stages in the development of an ETCHED or ENGRAVED PLATE, lithographic stone, WOODBLOCK, etc., each showing a deliberate alteration of the design, or fresh evidence of wear. 2. A PRINT from one of these stages.

statuary porcelain Synonym of PARIAN.

stave church (fr. Norwegian *stavkirke*) A medieval Scandinavian church built of upright planks fitted between corner posts.

steel engraving An ENGRAVING made from a plate faced with steel (see below).

steel facing The process of depositing steel, by means of electrolysis, onto the surface of a copper PLATE which is to be used for ENGRAVING. It was invented in the second quarter of the 19th c. and greatly increased the number of IMPRESSIONS which could be taken from the plate before it deteriorated.

steeple A SPIRE, together with the tower supporting it.

stele, stela (Gk 'standing block') An upright slab, usually used as a grave-marker, especially in Ancient Greece. It can be inscribed, carved in RELIEF or painted.

stencilling The process of transfering a design to a surface by applying paint or other colouring through a mask, or stencil, cut to the required shape.

stepped pyramid I. A PYRAMID consisting of several rectangular structures of diminishing size and with sloping, or battered, sides placed on top of one another. 2. In Ancient Egypt, the intervening stage between a MASTABA and a true pyramid.

stereobate The top part of a foundation, appearing above ground-level, on which a building is constructed. (CLASSICAL TEMPLE.★)

stereometric Literally, 'of the science of measuring solids'. Applied to paintings and PERSPECTIVE designs which give a strong impression of three-dimensionality.

sterling silver An ALLOY made up of 92.5% silver to 7.5% copper (UK), or 92.1% silver to 7.9% copper (US). It is used for most silver-smithing and jewellery work. Synonym: standard silver. See also BRITANNIA SILVER, NICKEL SILVER.

Stijl, De (Dutch, 'style') A Dutch art group which took its name from the magazine of the same title founded in 1917 by Theo van Doesburg. Its aim was to evolve a purely ABSTRACT art which would be 'the direct expression of the universal.' The painters Mondrian and Bart van der Leck were closely associated with the group, and so were the architect J.P. Oud and the architect and furniture designer Gerrit Rietveld. Mondrian's NEO-PLASTICISM★ was the most extreme form of De Stijl theorizing, but was not adhered to rigidly by other members of the group.

stile A vertical framing member in wood-work, e.g. in a DOOR,★ chest or cupboard.

Stile Liberty Italian equivalent of ART NOUVEAU.

still-life A painting of inanimate objects.

stipple print A PRINT whose entire design is built up from minute dots.

stippling Paint used in small dots or dabs, so as to produce a dappled effect.

The Pentelic marble **stela** *of Dexileos, engraved and carved in relief. Attic, 394 BC.*

The epitome of **De Stijl** *furniture: the red-blue chair designed by Gerrit Rietveld in 1917, showing almost pedantic visual separation of the constituent elements.*

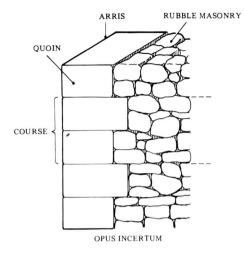

ARRIS · QUOIN · RUBBLE MASONRY · COURSE

OPUS INCERTUM

stoa (Gk) 1. A type of long PORTICO used by the Ancient Greeks as a shaded promenade and public meeting-place. 2. In Byzantine architecture, a hall with one side open, and with its roof supported by one or more rows of COLUMNS parallel to the rear wall.

stoneware Very hard POTTERY made from a mixture of clay and fusible stone. It is fired at a temperature of 1200°–1400° C., which is sufficient to VITRIFY the stone but not the clay.

stonework, elements of
 Arris. The sharp ridge made by the junction of two surfaces of stonework.
 Blocking course. In CLASSICAL and later architecture, a plain band of stonework surmount-

Types of **stonework**.

CHAMFERED RUSTICATION

CYCLOPEAN MASONRY

OPUS ALEXANDRINUM

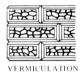

VERMICULATION

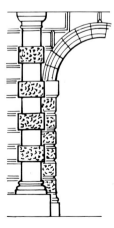
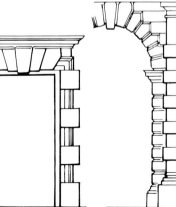
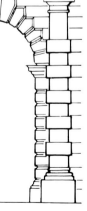

RUSTICATION

ing an external CORNICE, serving to hold it in place. See also BRICKWORK.

Course. A continuous, usually horizontal, layer of stone.

Dressings. Smoothly finished stone blocks used to decorate and strengthen parts of a building, such as corners, windows and doors.

Footing. A course or stepped courses at the base of a wall, used to distribute the weight of the structure.

Quoins. Stones which form the corner of a wall, especially if emphasized or ornamented.

String-course. A decorative horizontal course, usually projecting from the FAÇADE.

Template. 1. A block of stone placed at the top of a brick or rubble wall to distribute the weight of a beam or girder. 2. A pattern, often cut from a sheet of metal, used to ensure accuracy in cutting stone to size.

stonework, types of

Ashlar. Masonry made up of accurately squared stones, laid in regular courses with a smooth face and fine joints. Synonym: dressed stone.

Chamfered rustication. Masonry with the stones CHAMFERED at the joints, so that each joint is marked by a 90° groove.

Chequerwork. Walls or pavements patterned with alternating squares of contrasting materials, e.g. stone with flint or brick.

Cyclopean masonry. Masonry made of huge rough-edged blocks of stone. (NURAGHE.★)

Opus Alexandrinum (Lat. 'Alexandrian work'). Patterned paving made of slabs of marble of various colours.

Opus incertum (Lat. 'uncertain work'). Walling made of stones of random shapes and sizes.

Opus quadratum (Lat. 'square work'). Walling made of regularly squared stones.

Rubble masonry. Masonry built of unhewn stones, laid either at random or in courses.

Rustication. Masonry treated to resemble huge square blocks, often with a deliberately rough surface finish.

Vermiculation (fr. Lat. *vermis*, 'worm'). Masonry ornamented with random grooves supposedly resembling worm tracks.

See also BOASTED WORK, REBATE, REVETMENT.

stop An ornamental projection terminating a DRIP-STONE or other MOULDING.★

stopping out The technique whereby, in ETCHING, the artist covers those parts of the design he does not wish to make any darker with a RESIST of stopping-out varnish before rebiting the plate.

storied (Used of STAINED GLASS.) Containing narrative scenes.

strapwork Ornament common in the 16th c., consisting of intertwining bands supposedly resembling leather straps. Synonym: rollwork.

street art Term current in the 1970s for: 1. PERFORMANCE ART staged in the street, without any kind of formal setting, and often for a political purpose. 2. Non-commercial posters and outdoor MURALS, usually with direct relevance to the local urban community.

stretcher 1. The wooden framework to which a painter's canvas is attached. 2. A horizontal member joining the legs of a piece of furniture, to give additional strength and lateral stability. 3. See BRICKWORK.

striation A pattern of narrow streaks or parallel lines.

striking The process of making a metal object (e.g. a medal or coin) by hammering a heated blank between two dies cut with designs in INTAGLIO.

string-course See BRICKWORK, STONEWORK.

stringing Lines of wood or metal used as decorative INLAY in borders on furniture.

strut A secondary ROOF★ timber, upright or diagonal, used to impart additional strength.

Strapwork *in a late 16th-c. printer's ornament.*

stucco Quick-setting malleable material which hardens when dry. Unlike PLASTER, it is made of gypsum or slaked lime, sand, water and a strengthener such as ground marble. (It sometimes also contains a retarding agent such as wine to slow down the setting time and thus enable a greater area to be worked at one session.) It is used for internal and external decoration, and can be moulded or modelled *in situ*. The technique was known in antiquity, was rediscovered in the 16th c., and thereafter spread from Italy and Austria to the rest of Europe and North America.

studio of __ Indicates that the work of art concerned has been executed under the personal supervision of a particular artist, but that it is at most only partly from his own hand.

study A detailed representation of some part of a figure or COMPOSITION, or of the composition as a whole, made so that the artist can be sure of getting it right in the finished work.

stump A roll of paper, pointed at each end, used to blur drawn lines in chalk and charcoal in order to get gradations of tone.

stupa (Skr.) A hemispherical monument containing sacred relics. Found in both Buddhist and Jain religious architecture. Synonym: tope.

Sturm, Der (Ger. 'The Storm') A magazine founded in Berlin in 1910 by Herwarth Walden, who also founded an art gallery of the same name in 1912. In its first year of operation the gallery showed paintings by members of the BLAUE REITER group from Munich, the Italian FUTURISTS and many other AVANT-GARDE artists. Its main importance, however, was to provide a focus and showcase for the new generation of German EXPRESSIONISTS.

stylobate The upper part of the STEREOBATE in a CLASSICAL TEMPLE★ – i.e. the actual surface on which the columns stand.

stylus (Lat.) Any pointed implement used for making a lightly indented mark or scratch. See DIAMOND-POINT ENGRAVING.

Sublime, the An art term first used in the 18th c., but derived from the Roman philosopher Longinus. It was popularized by Boileau's translation of Longinus into French (1674), and by Burke's *Philosophical Enquiry into the Origin of our Ideas of the Sublime and the Beautiful* (1757). In his final *Discourse* (1790) Sir Joshua Reynolds said: 'The sublime in painting, as in poetry, so

Exuberant 18th-c. **stucco** *decoration in a bedroom at the Palazzo Sagrada in Venice, featuring putti.*

overpowers and takes possession of the whole mind that no room is left for attention to minute criticism.' In the same year Immanuel Kant called the Sublime 'an outrage on the imagination'. Essentially all those who tried to characterize it connected it with ideas of limitlessness, extraordinariness, grandeur and sometimes terror. It is to be distinguished from the PICTURESQUE, which is pleasingly irregular but does not include awe, and also from the Beautiful, which, in 18th-c. art theory, tends to please through absolute harmony of proportion.

sudarium (Lat. 'napkin') The handkerchief offered to Christ by St Veronica, as He passed her on the way to Calvary. He wiped His face with it, and it received the miraculous imprint of His features. It is sometimes used on its own as the subject of a painting. Synonyms: vernicle, veronica.

suiboku (Jap. 'ink painting') A very free style of MONOCHROME painting in ink on silk or paper practised in Japan, often under Zen Buddhist influence, 14th–17th c. It began as an imitation of similarly free Chinese painting of the Sung and Yüan dynasties (960–1368).

suite A number of paintings, drawings or PRINTS linked by a common theme but not necessarily done by the same artist.

Sumerian art Art of the earliest Mesopotamian civilizations, centred on Ur and Sumer, *c.* 3000–2300 BC.

sumi-e (Jap. 'pictures with ink') Painting carried out entirely in black ink, with no

The Sublime: *a heroic retelling of the story of William Tell in an engraving after Henry Fuseli (1741–1825).*

A depiction of St Veronica holding the **sudarium,** *by the Master of the Life of the Virgin. Cologne School, early 15th c.*

additional colour but often giving the impression of colour through manipulation of TONE.

Sunday painter An amateur artist.

Super Realism Art of extreme verisimilitude, associated with the US in the 1970s but to a lesser extent popular also in Western Europe. In painting it is usually, though not always, based on the direct copying of photographs (Photo Realism); in sculpture it makes much use of direct CASTS from the human figure. Synonym: Hyper Realism.

support The material (e.g. canvas, wood, copper, PLASTER) on which a painting is done.

Suprematism (Lat. *supremus*, 'highest') Art movement proclaimed in Suprematist Manifesto (1915) in Petrograd by Kazimir Malevich. A visionary counterpart to CONSTRUCTIVISM, using similar pure ABSTRACT forms in limitless space, but initially without the same reference to their practical use in DESIGN.

suq See SOUK.

surah (Arabic) A chapter of the Koran.

suri–mono (Jap., 'printed thing') A small Japanese colour PRINT (often enriched with gold or silver dust) in UKIYO-E style, designed to commemorate some festival, anniversary or special occasion.

Surrealism (fr. Fr. *surréel*, 'transcending the real') Term coined by Guillaume Apollinaire in 1917, but now used for a movement founded by André Breton in 1924, which absorbed the French DADA movement and made positive

Suprematism: Supremus No. 50, 1915, painted by Kazimir Malevich in the year of the first Suprematist exhibition.

Veristic **Surrealism:** *Salvador Dalí's* Le moment sublime, *1938, features some of his favourite objects, including a snail and a telephone. The plate of fried eggs shows typically deliquescent forms.*

Symbolism: *Ferdinand Hodler's hieratic* The Chosen One, *1893–94, can be interpreted as a metaphor of the relationship between the innocence of youth and the purity of nature in spring.*

claims for methods and processes (defiance of logic, shock tactics) which Dada had used merely as a negation of conventional art. Influenced by Freud, it claimed to liberate the riches of the unconscious through the 'primacy of dream' and the suspension of conscious control (AUTOMATISM). Initially literary, it found artistic expression in COLLAGE and FROTTAGE (Max Ernst), in so-called Veristic Surrealism (fantastic subjects painted in obsessive detail by artists such as Salvador Dalí and Yves Tanguy) and through a freehand ABSTRACTION based on automatism (André Masson) which influenced ABSTRACT EXPRESSIONISM.

sūtra (Skr. 'thread') A Buddhist sacred text.

suzuribako (Jap. 'inkstone case') A Japanese writing box.

swag Synonym of FESTOON.

Swatow ware Chinese export PORCELAIN of the Ming period (1368–1644), both blue-and-white and multicoloured, made in the province of Fukien and Kwangtung and supposedly shipped from the port of Swatow.

Symbolism An influential movement, both in European literature and in the visual arts, from *c.* 1885 to *c.* 1910. Symbolism rejected objectivity in favour of the subjective, and turned away from the direct representation of reality in favour of a synthesis of many different aspects of it, aiming to suggest ideas by means of ambiguous yet powerful symbols. It combined religious mysticism with an interest in the

perverse and the erotic, an interest in what seemed 'primitive' with a sophisticated cult of decadence. Among the artists associated with the movement were Odilon Redon, Gustave Moreau and Puvis de Chavannes in France, Fernand Khnopff in Belgium, Jan Toorop in Holland, Ferdinand Hodler in Switzerland, Gustav Klimt in Austria, and Giovanni Segantini in Italy. See also NABIS, ROSICRUCIANS, SYNTHETISM.

Synagoga See ECCLESIA.

Synchronism An American offshoot of ORPHISM. The painters associated with the movement, which arose just before the First World War, were Stanton MacDonald Wright and Morgan Russell. Their work put stress on the importance of colour, which was enough in itself to provide the CONTENT of the work of art.

Synthetism A term first used to distinguish 'true' IMPRESSIONISM, in which the artist tried to fuse together what he saw in nature, from the analytic approach to appearances favoured by NEO-IMPRESSIONISTS such as Seurat and Signac. It was later adopted by Gauguin and the painters who surrounded him in Pont-Aven during the period 1886–90 (see PONT-AVEN SCHOOL). Emile Bernard, the most eloquent theorist of the group, declared that 'we must simplify in order to disclose.' The group around Gauguin believed that the artist must synthesize his impressions and 'paint from memory', rather than make a direct transcription of the MOTIF. The Pont-Aven artists organized an exhibition under the title 'Syn-

thétisme' at the Café Volpini, during the International Exhibition of 1889, and in 1891 formed a Groupe Synthétiste which included Gauguin, Bernard, Charles Laval, Louis Anquetin and others.

systemic painting A form of ABSTRACT painting which expresses a logical system of some sort, e.g. the repetition and progressive variation of a single MOTIF, either on one canvas or on a series of related canvases.

T

tabernacle 1. A container for relics. 2. A place to reserve the consecrated host. 3. A religious POLYPTYCH. 4. A NICHE for a holy image. 5. A place of worship, often of temporary construction (used, e.g., by Baptists).

table Archaic term for a picture painted on PANEL.

Tachisme (fr. Fr. *tache*, 'blot') A term used from the early 1950s by the French art critic Charles Estienne to characterize ABSTRACT painting where the colour was applied in stains or blots, as for example in the work of Wols or Henri Michaux. It became a generic term for the European equivalent of ABSTRACT EXPRESSIONISM.

tactile values Phrase coined by the art historian and connoisseur Bernard Berenson to explain the painter's attempt to convey sensations of weight, RELIEF and TEXTURE by means of colour and line on a two-dimensional surface.

taenia 1. The band which separates a Doric frieze from its architrave. (ENTABLATURE.★) 2. The FILLET, or hair ribbon, seen in HELLENISTIC ruler portraits, used as an emblem of royalty.

taille d'épargne, en See ENAMEL.

Talbotype Synonym of CALOTYPE. So named after William Henry Fox Talbot.

tambour (Fr. 'drum') 1. A circular embroidery frame. 2. A roll front to a piece of furniture, made of thin strips of wood and running in grooves on either side. 3. The central part of a Corinthian capital, from which the ornamentation springs. (See ORDERS OF ARCHITECTURE.)

Synchronism: Synchrony No. 2 *by Morgan Russell (1886–1953).*

In Henri Michaux's **Tachiste** *drawing* Emergences-Résurgences, *1950, the characteristic blots take on the aspect of small figures.*

tanagra A moulded TERRACOTTA figure, named after those first found in 1874 at Tanagra in Boetia, but manufactured at several sites in Greece and Greek Asia Minor during the late CLASSICAL and HELLENISTIC periods. They represent a wide range of subjects, but elegantly draped women are especially favoured.

tanka (fr. Tibetan *thang-ka*) A Tibetan religious painting on cloth or a piece of embroidery and/or APPLIQUÉ. The subject-matter is drawn from Tantric Buddhism (see TANTRA ART). (MANDALA.★)

Tantra art (Skr. *tantra*, 'loom') Tantra is a Buddhist and Hindu mystical cult focused on a vision of cosmic sexuality. The earliest surviving complete texts relating to it date from AD *c.* 600. In different forms it is found almost throughout Asia – in China, Tibet, Nepal, Mongolia and Cambodia, but perhaps most characteristically in India. In its Hindu form it is based on the worship of Shakti, goddess of power or energy, and aims at an expansion of consciousness through contemplation of appropriate images of the gods (who are usually presented in their most violent and ferocious aspect), objects with a sexual connotation such as the LINGAM, and ABSTRACT diagrams called YANTRAS.

t'ao-t'ieh (Chi.) A stylized dragon mask used in Chinese art and first seen on bronze ritual vessels of the Shang period (1766–1122 BC).

tapa (Polynesian) Fabric made by beating out the inner bark or bast of trees such as the paper mulberry, breadfruit or fig. Tapa is typical of PRIMITIVE societies in Polynesia and Africa. Synonym: bark cloth.

tapestry Hand-woven fabric, usually of silk or wool or a mixture of the two, with a non-repetitive design, usually FIGURATIVE, which is woven in as it is made. Among the numerous places associated with its manufacture from the 14th c. onwards are ARRAS, Tournai and Brussels in the Low Countries, AUBUSSON, BEAUVAIS and the GOBELINS (Paris) in France, and Fulham and Mortlake in England. The two chief methods of manufacture are BASSE LISSE and HAUTE LISSE. Despite its name, the Bayeux Tapestry is not tapestry, but EMBROIDERY.

tarsia See INTARSIA.

tatami (Jap.) A Japanese mat made of rice-straw, the standard floor-covering in a Japanese house. Tatami are made in a standard size, approximately 70 × 35 in. (180 × 90 cm), and the floor area of a dwelling is measured by the number of *tatami* it contains.

tau cross (Gk *tau*, 't') A T-shaped cross.

tazza (It. cup) 1. Strictly speaking, a shallow wine-cup on a foot. 2. Now, more loosely, a shallow dish on a tall stem.

tear-bottle A small glass bottle usually with a globular body and a tall narrow neck, of a kind found in quantity in Roman tombs. So called from the erroneous supposition that they held the tears of the mourners. They are in fact a common type of UNGUENTARIUM.

tectonic Pertaining to building or construction.

telamones (Gk *telamon*, 'support', also the name of a hero) Synonym of ATLANTES.

temenos (Gk) A sacred enclosure.

temmoku, tenmoku (Jap.) Chinese-style STONEWARE with a dark brown GLAZE, sometimes with lighter streaks, which was made in Japan for tea-bowls. Synonym: hare's-fur glaze.

tempera (It., fr. Lat. *temperare*, 'to mix in due proportion') An EMULSION used as a MEDIUM for PIGMENT. Traditionally, tempera is made with whole eggs or egg-yolk, but milk, various kinds of glue or gum, or even dandelion juice or the sap of the fig-tree can be used. The medium is particularly associated with Italian painters of the 14th and 15th c., who used it both for FRESCO and PANEL PAINTINGS. (CASSONE.★)

tempering 1. The mixture of PIGMENTS in painting, so as to produce an intermediate hue. 2. The ANNEALING of steel.

template, templet 1. A pattern, often cut from a sheet of metal, used to ensure accuracy in making parts or repeating dimensions in metal, stone, fabric, etc. 2. See STONEWORK.

tenebrism Art emphasizing night effects and strong shadows.

tenmoku See TEMMOKU.

tenon A tongue of material, such as stone or wood, which projects from one part of an object and fits into a corresponding cavity (or 'mortice') in another, serving to join the two together.

T'ao-t'ieh *from a Chinese bronze vessel.*

term, terminal figure A PILLAR or PILASTER which at its top is transformed into a human half-figure or bust, or the half-figure of an animal. See also HERM.

terra sigillata (Lat. 'stamped clay') 1. Originally, CERAMICS made of grey clay from Samos and Lemnos which were supposed to have medicinal properties. The wares were stamped with a seal to guarantee their authenticity. 2. Later the term was applied to a wide range of moulded wares with a red GLOSS made in Roman times, including ARRETINE POTTERY.

terracotta (It. 'baked earth') 1. Fired clay with no GLAZE, used for building, architectural ornament and sculpture. (ETRUSCAN ART,★ bas-RELIEF.★) 2. A colour resembling fired clay.

terrazzo (It.) A mixture of marble chips and cement, used for flooring. It is laid *in situ*, ground smooth and then polished.

tertiary colour A colour produced by mixing two of the three secondary colours (orange, violet and green), in any proportion. It thus contains some of each PRIMARY COLOUR, and can be any shade of brown, black or grey. (COLOUR CIRCLE.★)

tesselated Covered in TESSERAE.

tessera (Lat., pl. **tesserae**) A small, usually cubic piece of marble, glass, etc., used as the basic unit in making a MOSAIC.

texture 1. In art and architecture, the nature of the surface of a painting, sculpture, building, etc. 2. By extension, the general material qualities of a work of art, such as the rhythm of the brush-strokes in a loosely handled painting (e.g. in the work of Velásquez).

Hellenistic **tanagra**: *a woman with a fan, wearing a sun hat, 3rd c. BC.*

Term *of a child sporting a carved garland, used as a support for a mantelpiece. From Lydiard Tregoze, Wiltshire, 1745–49.*

185

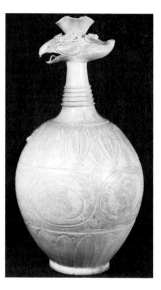

(Above) Maori amuletic pendant in the form of a **tiki**.

(Right) White **Ting ware***: a bird-headed bottle with carved decoration of a lotus scroll. Sung dynasty.*

tholos (Gk) 1. In Greek and Roman architecture, a round building, usually DOMED. 2. A HELLADIC or MYCENAEAN beehive-shaped underground burial chamber.

three-colour ware Synonym of SAN-TS'AI.

throwing The process of making a CERAMIC object on a potter's wheel.

tie-and-dye A method of patterning fabric by knotting it and/or binding portions with thread, before dipping it in dye. The parts so treated do not take the dye.

tie beam A beam used across the width of a timber-framed building to link the lower ends of the RAFTERS and prevent them from spreading. (ROOF.★)

tierceron An intermediate arched RIB in a Gothic VAULT.★

Tiger ware A type of STONEWARE with a mottled brown and yellowish GLAZE. First produced in the Rhineland in the 16th c. and later imitated in England.

tiki (Maori) In Polynesian mythology, either the creator of the first man, the first man himself, or in a more general sense an ancestor. These concepts are represented by amuletic pendants, usually made of nephrite, which show the figure in a contorted pose, and also by large carved figures.

tile-hanging Wall-covering made of overlapping tiles hung on BATTENS fixed to the wall, or on timber framing.

tin glaze An opaque white GLAZE containing tin, developed in Baghdad in the 9th c. to rival Chinese PORCELAIN and transmitted from there to Moorish Spain and thence in the 13th c. to the rest of Europe. MAJOLICA, FAÏENCE and DELFT are all various types of tin-glazed EARTHENWARE.

ting (Chi.) A Chinese Bronze Age vessel, square or circular, on three or four feet.

Ting ware, Ting yao Ivory-white translucent PROTO-PORCELAIN, often with carved designs, produced mostly at Ting Chou in the Hopei province of China in the Sung and Yüan periods (10th–14th c.)

tinsel painting A painting on the reverse side of a piece of glass, which is then backed with crinkled tin foil, so that the painting itself seems to sparkle.

tint The dominant colour in an admixture of colours or in a mixture of colour and white, e.g. 'a bluish tint' or 'a bluish white'.

tintype A photograph on a small PLATE of tinned iron, produced by using a variant of the collodion WET PLATE PROCESS which gives a positive rather than a negative image. The

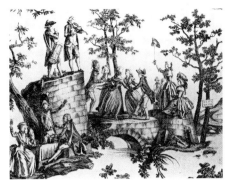

(Above) **Toile de Jouy** *fabric celebrating the French Revolution and showing figures dancing amid the ruins of the Bastille, 1789.*

(Right) Leather bookbinding decorated with gold **tooling***:* Howard's Aphorisms*, Dublin, 1767.*

plates were cheaper and easier to handle than glass negatives or positives, and, if used for portrait photography, the resulting PRINT could be handed to the sitter within a few minutes of the exposure being made. The process was invented in 1853 by the Frenchman Adolphe Alexandre Martin, and became popular in the US from *c.* 1860. Synonym: ferrotype.

toghra (Turkish) The CALLIGRAPHIC CIPHER of an OTTOMAN sultan.

togidashi (Jap 'polished out') A type of LACQUER where the design is first built up above the GROUND with repeated applications of lacquer and gold dust, and then coated with layers of transparent lacquer sufficient to cover the whole design and ground. When these are polished level, the design appears in RELIEF under a transparent coating.

toile de Jouy (Fr. 'cloth of Jouy') Cotton fabric printed with figure scenes in monochrome from ENGRAVED metal plates. So named after the factory at Jouy, near Versailles, where it was first made (1760–1843).

tokonoma (Jap.) An alcove or niche used in Japanese houses and tea-ceremony rooms for the display of works of art.

tole (fr. Fr. *tôle*, 'sheet metal') Tinplate objects painted with decorative designs, of late 18th- and early 19th-c. date.

tonal values The relative lightness or darkness of the various parts of a painting, irrespective of colour. The contrasts so produced are particularly extreme in CHIAROSCURO.

tondo (It. 'round picture') A circular painting or RELIEF sculpture.

tone 1. The prevailing HUE in a picture. 2. Its comparative brightness or dullness.

toning In oil painting, the process of unifying the monochrome underpainting by adding a GLAZE or by SCUMBLING to get rid of extreme contrasts of light and dark before adding LOCAL COLOUR.

tooling 1. Squaring and smoothing a stone block with a broad chisel. 2. Removing roughness and blemishes on metalwork after CASTING. 3. Decorating metalwork in either INTAGLIO or RELIEF using various tools, such as punches and gravers. Synonym: CHASING. 4. Decorating bookbindings and other articles made of leather using heated tools.

tooth The slight roughness of canvas or other SUPPORT, which enables paint to cling to it more firmly.

tope Synonym of STUPA.

torana (Skr.) A gateway in Indian architecture, especially one at the entrance to a Buddhist STUPA.

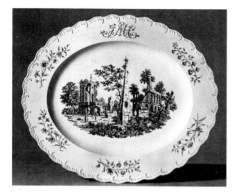

Wedgwood creamware platter, c. 1780, with **transfer-printed** *decoration of an architectural capriccio.*

Transitional style: *part of the nave of Ripon Minster, c. 1180, showing the transition from the Romanesque (round arches) to Early English (pointed arches).*

toreutic (Used especially of metalwork.) Carved, CHASED or EMBOSSED.

torii (Jap.) The formal gateway to a Shintō shrine.

torso A sculptured figure which lacks head or limbs, either by accident or design.

tortillon Synonym of STUMP.

torus (Lat. 'cushion, bulge') A substantial convex MOULDING of semicircular section, often found at the base of a classical column. (ORDERS OF ARCHITECTURE.★)

Tosa School School of Japanese court art founded in the 15th c. and taking its name from the Tosa family. Its members painted in native Japanese YAMATO-E style, as opposed to members of the KANŌ SCHOOL who were heavily influenced by Chinese art.

townscape 1. A painting, drawing or PRINT of a town or part of a town. 2. In current architectural parlance, towns or parts of towns considered as groups of forms analagous to the PICTURESQUE forms found in landscape.

toys Term used in the 18th c. for small ornamental articles in a variety of materials including PORCELAIN and silver. Birmingham silversmiths specializing in small items such as vinaigrettes (miniature boxes in precious metal containing scented sponges) were known as 'toy-makers'.

trabeated Constructed entirely from upright members supporting horizontal ones (as opposed to ARCUATED). Classical Greek and Ancient Egyptian architecture is trabeated. Synonym: beam-and-post.

tracery Ornamental stonework, in more or less elaborate patterns, which is used to fill windows or as a RELIEF ornament on solid walls. (DECORATED STYLE.★)
 Blind tracery, blank tracery. In GOTHIC architecture, tracery used to ornament a flat surface rather than fill a window.
 Drop tracery. A border of pendant tracery ornamenting the SOFFIT of a GOTHIC arch.
 Plate tracery. Tracery in which openings of decorative shapes are cut out of the wall, instead of being formed by MULLIONS.
 See also QUATREFOIL, TREFOIL.

Traditio Legis (Lat. 'the handing over of the law') Christ represented standing between SS. Peter and Paul and handing a scroll to one of

them (usually the former), symbolizing the delegation of spiritual authority.

trailed (Used of both GLASS and POTTERY.) Decorated with freely applied threads of molten glass, or lines of SLIP, respectively.

Transavanguardia (It. 'beyond the avant-garde') Name coined by Achille Bonito Oliva initially for the Italian version of NEO-EXPRESSIONISM.

transept An extension or part of a building, particularly a church, which lies across the main axis. (GOTHIC CATHEDRAL, plan.★)

transfer printing A method of decorating ENAMEL and CERAMICS by printing a design from an ENGRAVED PLATE onto paper, then pressing the result onto the surface to be decorated. In the case of ceramics, this can be done either before or after applying the GLAZE. The process was first used at the Battersea enamel factory in 1753.

transition (Fr.) The intermediary style between ROCOCO and the NEO-CLASSICISM of Louis XVI. It began to establish itself shortly before 1760. It mingled a more disciplined and chastened version of Rococo forms with ornamental details (such as the ACANTHUS) borrowed from the CLASSICAL repertoire.

Transitional art Work produced by modern African artists re-using discarded European materials.

Transitional style The architectural style intervening in Europe between ROMANESQUE and GOTHIC (in England between NORMAN and EARLY ENGLISH.) It applies Gothic details to forms which belong to the earlier epoch.

transom I. The main horizontal cross-bar which spans the width of a WINDOW,★ or part of a window, either at the top or bottom. 2. (US) A small window immediately above a door.

trecento (It. 'three hundred') The period 1200–1300 in Italian art.

Tree of Jesse A diagrammatic representation of the genealogy of Jesus Christ, often found in medieval art. Jesse is recumbent at the bottom, with the tree springing from his loins, bearing other figures on its branches. At the summit is the Virgin in glory with the infant Christ in her arms. The fact that the stem does not extend to Christ signifies His divine incarnation. See also JESSE WINDOW.

Painted and dyed cotton bedspread decorated with a **Tree of Life** *pattern from Palampore, 19th c.*

Trefoil.

Tree of Life A large, vigorously growing asymmetrical tree of indeterminate species, which originated as a MOTIF in England in the 17th c. as a model for Indian calico printers. From India it passed to China, and finally returned to Europe where it was regarded as genuinely Oriental.

treen Household objects made of wood, the majority of them shaped by TURNING.

trefoil (fr. Ancient Fr. *trifoil*, 'three leaves') A decorative design with three lobes, particularly a three-lobed shape in Gothic TRACERY.

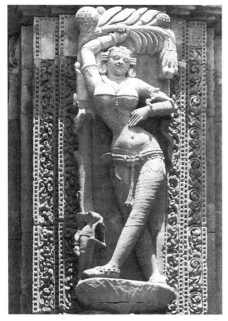

Tribhanga: *a sinuously posed yakshi beneath a palm tree, from the Rajarani Temple, Konarak, c. 1000.*

Trilithon *at Lanyon Quoit, Cornwall.*

tribhanga (Skr. 'three bends') The characteristic sinuous pose found in Hindu sculptures.

tribune 1. A raised platform. 2. A pulpit. 3. A GALLERY in a church. 4. The APSE in a BASILICA,★ generally raised at least one step.

triforium (Lat. 'three openings') An ARCADE on the side wall of a church or cathedral, facing into the interior of the building, below the CLERESTORY and above the arcade of the NAVE. (GOTHIC CATHEDRAL, section.★)

triglyph (Gk 'thrice carved') Part of the FRIEZE in the Doric order, consisting of three parallel grooves or channels with drops ('guttae') underneath, the whole unit placed at regular intervals. In early Doric temples which were made of wood rather than stone, the triglyphs marked the ends of the beams. (ENTABLATURE.★)

trilithon (Gk 'three stones') A prehistoric structure made of one large block of stone supported by two MEGALITHS.

trimurti (Skr.) A representation of the three main Hindu gods, Brahma, Vishnu and Shiva, as one composite figure.

triptych A picture made up of three panels, the two outer ones usually hinged so that they fold like doors in front of the main scene. See also DIPTYCH, POLYPTYCH.

triumphal arch 1. An ornamental gateway, usually free-standing and on a massive scale. Triumphal arches were originally built as permanent versions of the temporary structures erected by the Romans when they celebrated military triumphs. (PERSPECTIVE.★) 2. The choir screen in a church, especially one with a large opening flanked by two smaller ones.

trois crayons (Fr. 'three chalks') Drawing on paper of a middle tone – e.g. mid-blue or buff – made with black, white and red chalks, and typical of early 18th-c. artists such as Watteau. Synonym: trois couleurs.

trompe-l'oeil (Fr. 'deceives the eye') A type of painting, usually STILL-LIFE, which by means of various ILLUSIONIST devices persuades the spectator that he is looking at the actual objects represented. Successful *trompe-l'oeil* occupies a very shallow space behind the PICTURE-PLANE, or actually seems to project beyond the picture surface. (QUADRATURE.★)

trophy 1. A carved or painted representation of a group of arms and armour. It derives from

*Engraved **trophy** of flags, a helmet and weapons. Early Rococo style.*

***Trimurti** with Shiva in the centre. Relief carving from the Adhipuricuara Temple, Tiruvorriyor.*

the real arms taken in battle and set up by the Greeks and Romans in CLASSICAL times as monuments of victory, which were hung from the trunk and branches of an oak. 2. By extension, an object made in commemoration of a victory. 3. By further extension, any decorative group of congruous objects, e.g. musical instruments, or objects associated with stag- or fox-hunting.

Troubadour Style A fanciful French version of GOTHIC REVIVAL. See also CATHEDRAL STYLE.

trumeau (Fr. 'pier, pier-glass') 1. A mirror with a decorative surround, made to go over a chimney-piece. 2. The central PIER supporting the LINTEL of a monumental doorway.

truss See ROOF-TRUSS.

tsuba (Jap.) A Japanese sword-guard.

Tudor 1. Strictly speaking, English art and architecture from the period 1485 (the accession of Henry VII) to 1603 (the death of Elizabeth I). 2. More commonly, that of the first half of the 16th c. only.

tumbaga (Sp.) An ALLOY of copper and gold used for jewellery and other metalwork in several PRE-COLUMBIAN cultures.

türbe (Turkish) A Turkish tomb or MAUSOLEUM often built in the garden of a mosque.

Turkey work Heavy PILE fabric made in Europe and imitating carpets from the Near and Middle East. The term was used, chiefly for upholstery rather than for carpeting, from the 17th c. onwards.

*The façade of the George and Pilgrims Inn, Glastonbury, Somerset, 1457–93, features a flattened **Tudor** arch.*

ABCDEFG

UPPER CASE

SERIF

ASCENDERS 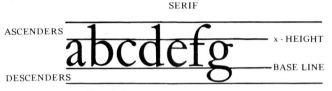 x - HEIGHT

BASE LINE

DESCENDERS

LOWER CASE

(Above) A specimen of Garamond, one of the earliest **typefaces**, *showing some elements of printed letters. (Left) Early styles of type. (For definitions, see individual entries.)*

alſo ſol zürichten. Jr gautze höhe das poſtement hoch ſeyn. Sie ſel ſimps/vnd ein teil das ober geſim: teilen zwen/iſt die breite deß poſte

Schwabacher, *from Froschauer's* Kunstrich Buch, *1567.*

Quod cū audiſſet dauid:deſcendit in preſidiū.Philiſtijm autem venientes diffuſſi ſunt in valle raphaim.Et cō ſuluit dauid dūm dicens.Si aſcendā

Fraktur, *from Gutenberg's 42-line Bible, c. 1455.*

Dann wenn man die Jonica kürtzer da Clotthächtig ſcheÿnen:dann ſÿ nit ſo vile ler ein poſtement iſt/ije breiter vnd dicker ne/habend ſÿ die geſimps am poſtement

Cursive, *from Froschauer's* Kunstrich Buch, *1567.*

TRAGLI altri effetti della p ſtato da alcuni annoverato follevarſi, che fanno quaſi tutti i f nelli ſtrettiſſimi, che in eſſi s'imme

Roman, *from Magalotti's* Saggi, *1691.*

H ic elegos?vm pune diem conſum pferit ingens I elephus?aut ſummi plena iam margine libri S criptus, et in tergo nec dum finitus, Oreſtes? N otæ magis nulli domus eſt ſua, quam mihi lu

Italic, *designed by Aldus Manutius, 1501.*

turning The technique of shaping wood by clamping it in a lathe and using a sharp implement, such as a chisel, to shape it as it rotates. The rotary motion automatically imparts a regular form, which can be hollow – e.g. a bowl or a cup – or of quite elaborate profile – e.g. a spirally turned chair leg or BALUSTER.

turret A small tower, often an addition to the top of a larger structure.

twill Textile woven so as to produce a diagonal, herring-bone or diamond pattern.

tyche (Gk) A representation of the 'Fortune', or presiding spirit, of a city. It is shown in female form, usually wearing a MURAL CROWN.

tympanum (Lat. 'drum') 1. The triangular area enclosed by a CLASSICAL PEDIMENT. (CLASSICAL TEMPLE, portico.★). 2. The area of stone, brickwork, etc., enclosed by an ARCH springing from a LINTEL. 3. The partition filling the area between a ROOD-BEAM or ROOD-LOFT and the chancel arch above. (ROOD-SCREEN.★) 4. The DIE of a PEDESTAL.★

typeface Any of the thousands of letter-forms, often very subtly differentiated, that are used in printing. Each typeface is available in a number of sizes; this book, for example, is set in 9 point Bembo. For the families of typefaces in the Roman alphabet, see BLACK-LETTER, FRAKTUR, LETTRE BÂTARDE, ROMAN, ITALIC, SANS SERIF, SCHWABACHER.

typography 1. The DESIGN of printed texts. 2. Printing considered as an APPLIED ART.

typology The study of types of representation in ICONOGRAPHY, particularly the study of the way in which figures and scenes from the Old Testament were thought to prefigure those found in the New. In the art of the Middle Ages, an Old Testament 'type' was often represented with, but subordinate to, its New Testament equivalent or 'antitype'.

U

Ugly Realism The work produced by a number of artists working in Berlin in the 1970s, among them Johannes Grützke, Mathias Koeppel and Wolfgang Petrick. It was essentially a revival of the NEUE SACHLICHKEIT of the 1920s.

ukiyo-e (Jap. 'pictures of the floating world') The popular art of the 17th to the 19th c. which conjured up the life of the Yoshiwara (brothel) quarter of Edo, now Tokyo. Geishas and Kabuki actors were favourite subjects, but ukiyo-e artists also depicted landscapes and scenes from historical epics, legends and folk-tales. WOODBLOCK PRINTS★ in colour were a major means of expression, and Utamaro, Hokusai and Hiroshige were among the leading artists.

uncial A type of CALLIGRAPHY★ introduced in the 4th c. AD, and widely used in European manuscripts from the 5th to the 7th c. The letter-forms are related to Roman capitals, but many sharp angles are rounded off.

undercroft A vaulted space, often used only for storage, beneath an ecclesiastical or secular building.

underglaze Painted decoration on CERAMIC, applied before the GLAZE, and permanently fixed when the glaze is fired.

underpainting, underdrawing See LAYING IN, SINOPIA.

unguentarium (Lat.) A small container, usually made of GLASS, used in ancient times for toilet preparations of various kinds. See also TEAR-BOTTLE.

uniface (Used of a flat object.) Modelled or ENGRAVED on one side only.

upper case In TYPOGRAPHY, capitals as opposed to small letters (lower case). So called from the

Ugly Realism: *Johannes Grützke's* Three Naked Women, *1973. The ungainly poses recall the work of artists such as Otto Dix.*

One of the most famous **ukiyo-e** *landscapes, Utagawa Hiroshige's* Shower on the Gashi Bridge near Ataka, *1857.*

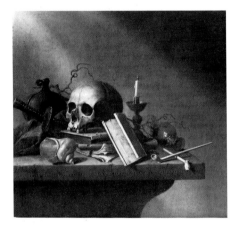

container in which the printer using metal type traditionally keeps these letters. (TYPEFACE.★)

ushabti (Ancient Egyptian, 'answerer') An Egyptian funerary statuette shaped like the usual representation of Osiris (i.e. with a mummiform body) and generally inscribed with the name of the deceased. Such statuettes were buried in large numbers in important tombs, to carry out any tasks the dead man might be called on to perform. Synonym: shawabti.

Utrecht School A group of early 17th-c. Dutch painters from Utrecht who visited Rome and were profoundly influenced by Caravaggio. Among them were Dirck van Baburen, Gerrit van Honthorst and Hendrick Terbrugghen.

V

vāhana (Skr.) In Indian art, the animal mount or vehicle of a Hindu god or goddess.

Valori Plastici (It. 'Plastic Values') The name of a magazine founded in Rome in 1918 by Broglio, Carrà, Severini and De Chirico. It advocated a return to CLASSICISM and the revival of traditional ACADEMIC methods of art teaching and gave its name to a NEO-CLASSICAL tendency in the Italian art of the time.

values The relationship in a painting between: 1. the TONES (ranging from light to dark); 2. the various HUES; or 3. both tones and hues.

vanishing point In PERSPECTIVE,★ the point towards which a set of lines, which are in reality parallel to each other, seem to converge. See also FOCAL POINT. (RENAISSANCE.★)

vanitas (Lat. 'vanity') An allegorical STILL-LIFE, often featuring a skull, in which all the objects depicted are meant to be reminders of the transience of human life. This type of painting was especially popular in 17th-c. Holland, particularly with the artists of the Leyden School. The word derives from the Latin phrase *vanitas vanitatum*, or 'vanity of vanities' (Ecclesiastes 1:2).

vargueño, bargueño (Sp.) A Spanish RENAISSANCE cabinet placed on a separate stand and consisting of a chest with drawers and a DROP-LEAF front.

(Above) **Vanitas** *by Harmen Steenwyck, c. 1640, of the Leiden School. The picture incorporates emblems of the five senses.*

(Left) **Vargueño** *made of various woods and coloured ivory, c. 1520.*

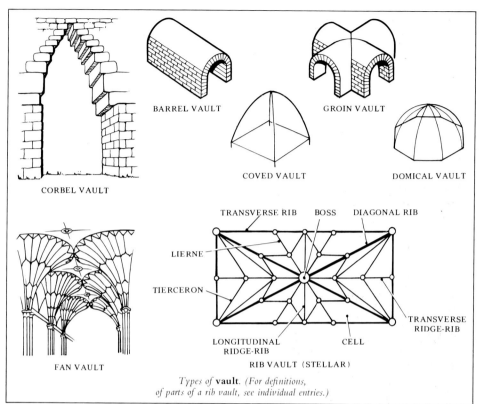

Types of **vault**. (For definitions, of parts of a rib vault, see individual entries.)

Labels: BARREL VAULT, GROIN VAULT, COVED VAULT, DOMICAL VAULT, CORBEL VAULT, FAN VAULT, TRANSVERSE RIB, BOSS, DIAGONAL RIB, LIERNE, TIERCERON, TRANSVERSE RIDGE-RIB, LONGITUDINAL RIDGE-RIB, CELL, RIB VAULT (STELLAR)

variant A version of an original work of art with slight differences. It may be by the same artist or by another hand. See also PASTICHE.

varnish Resin dissolved in a MEDIUM and used either as a protective coating (which can be tinted), or sometimes as a VEHICLE for PIGMENT, and therefore as a kind of paint.

vault A roof based on the structural principle of the ARCH.

Barrel vault. A vault constructed as a continuous semi-circular arch. Synonym: tunnel vault.

Corbel vault. The only exception to the above definition, being constructed by building out a series of CORBELS acting as CANTILEVERS from two or four walls until they meet to complete the span.

Coved vault. A vault made of four quarter-cylindrical surfaces ('coves') which meet at an angle and diminish as they go upward and curve towards the centre.

Cross-vault. Two vaults which intersect at right angles.

Domical vault. A DOME-like vault consisting of segments rising to a point from a base which is a square or a regular polygon.

Fan vault. An elaborate form of vault found only in late GOTHIC architecture in England, and made up of RIBS spreading fan-shaped from a series of CORBELS.

Groin vault. Two barrel vaults crossing at an angle.

Lierne vault. A vault with additional non-structural short RIBS ('liernes') springing from the main ribs and linking BOSS to boss, making a geometrical pattern on the surface. Typical of the DECORATED STYLE in England.

Quadripartite vault. A vault divided into four equal SPANDRELS. (GOTHIC CATHEDRAL, section.★)

Rib vault. A vault divided into four equal SPANDRELS by prominent RIBS, with the spandrels again divided into smaller CELLS.

Stellar vault. A vault in which the LIERNES form a star shape.

Tunnel vault. Synonym of barrel vault.

195

vedutà (It. 'view', pl. **vedute**) A topographically accurate landscape painting, as opposed to a fanciful one (a CAPRICCIO). Associated with 18th-c. Italian art.

vedutà ideata Synonym of CAPRICCIO.

vedutisti (It.) Italian 18th-c. artists who produced VEDUTE. Most, like Canaletto, were Venetian.

vehicle The MEDIUM, or the combination of MEDIUM plus BINDER, which carries PIGMENTS in suspension, and enables them to be applied and adhere to a surface. In distemper the MEDIUM is water and the BINDER is glue – together they make SIZE, which is the VEHICLE.

velatura (It. 'veiling') Synonym of IMPRIMATURA.

vellum Calfskin prepared for writing.

veneer Extremely thin sheets of wood, often chosen for their ornamental figure, used to cover the surface of furniture constructed of coarser and cheaper wood. Veneers can also be made of such materials as ivory, tortoiseshell and brass. See also BOULLE MARQUETRY, MARQUETRY, PARQUETRY.

veranda, verandah An open GALLERY or PORTICO with light wooden or metal supports, and attached to one or more sides of a building.

verdure (Fr. 'greenery') Any TAPESTRY whose design consists mainly of trees or leaves. Those with very large leaves were popular in the 17th c.

verism (fr. It. *verismo*) The attempt to reproduce reality in art with rigorous and unselective accuracy.

vermiculation See STONEWORK.

vernacular architecture Architecture built of local materials to suit particular local needs, usually of unknown authorship and making little reference to the chief styles or theories of architecture (e.g. English thatched cottages in WATTLE-AND-DAUB).

vernicle, veronica Synonym of SUDARIUM.

vernis Martin Imitation LACQUER produced in France during the 18th c., named after Guillaume Martin (d. 1749) and his three brothers. It was basically a fine-textured VARNISH, and as many as forty coats were applied to give the final effect.

verre églomisé (Fr. 'Glomi glass') A sheet of GLASS painted or gilded on the back, with the decoration protected by VARNISH and a sheet of metal or another sheet of glass. The technique has been used since Roman times, this name for it deriving from an 18th-c. picture-framer. See also ZWISCHENGOLDGLAS, TINSEL PAINTING.

verso (fr. Lat. *verso folio*, 'on the turned leaf') The 'wrong' or reverse side of a two-sided object, e.g. a sheet of paper. In a book, the verso is the left-hand page. See also FOLIO, RECTO.

vesica piscis (Lat. 'fish's bladder') Synonym of MANDORLA.

Vesperbild (Ger. 'evening picture') Synonym of PIETÀ.

vestibule 1. A room just within the entrance of a building and leading on to the rest. 2. A small room leading to a larger one.

vestry Synonym of SACRISTY.

vetro di trina (It. 'lace glass') Clear GLASS containing a decoration of interlacing opaque white threads. The technique was much favoured in 16th-c. Venice. See also LATTIMO, LATTICINO.

vial A small container, usually cylindrical and made of GLASS, for potions.

video art Television and video-recording technology used in works of art (e.g. by Nam June Paik).

vignette (Fr. fr. *vigne*, 'vine') 1. Foliage ornament around a capital letter in a manuscript. 2. Similar ornament filling space in a manuscript or printed book. 3. Any design or illustration which fades into the surrounding space without a definite border.

vihara (Skr.) 1. An Indian Buddhist monastery. 2. A hall in such a monastery.

Vingt, Les; Les XX (Fr. 'The Twenty') The Association des Vingt was a group of twenty AVANT-GARDE Belgian painters and sculptors which held a series of annual exhibitions from 1883 to its dissolution in 1893. These exhibitions included the work of numerous leading foreign painters and sculptors then at the beginning of international careers, such as Van Gogh, Gauguin, Toulouse-Lautrec, Manet, Seurat and Cézanne. It was influential in spreading the international reputation of NEO-IMPRESSIONISM and POST-IMPRESSIONISM.

virtù, virtue (fr. Lat. *virtus*, 'excellence') 1. A collective term for art objects or curios. By extension, an *objet de vertu* is a small work of art or decorative object of refined workmanship. 2. The FINE and APPLIED ARTS considered as a subject.

vitreous Of the nature of GLASS.

vitrify To make VITREOUS.

Vitruvian scroll A richly decorated (usually floriated) scroll ornament found in Roman and later architecture, and now named after the Roman architectural writer Vitruvius (active *c.* 46–30 BC). Synonym: running dog.

Volto Santo (It. 'Holy Face') 1. A representation of the head of Christ. 2. A representation of Christ which is supposed to have been miraculously created, and in particular the wooden crucifix in Lucca cathedral which is said to have been carved by angels.

volume 1. The space filled by a three dimensional figure or object. 2. The space which a painted figure or object appears to fill. Synonym: mass.

volute A scroll-shaped architectural ornament, e.g. those found in pairs on Ionic capitals. (ORDERS OF ARCHITECTURE.★)

Vorticism Short-lived English AVANT-GARDE movement founded in 1914 by Wyndham Lewis and others, in the wake of Italian FUTURISM. Ezra Pound later claimed credit for inventing the name, which was taken from the Italian Futurist Boccioni's remark that all creative art emanated from an emotional vortex.

voussoirs (Fr.) The wedge-shaped stones forming an ARCH.★

W

wabi (Jap.) The feeling of detachment and simplicity which Japanese tea masters looked for in objects associated with the tea ceremony.

wainscot Interior panelling in wood.

Waldglas (Ger. 'forest glass') Utilitarian GLASS, usually pale green, made in the late Middle Ages in Germany and Bohemia. The glasshouses were situated in forests which supplied them with fuel, hence the name.

View of the Piazza San Marco, Venice *by Canaletto (1697–1768), a* **vedutà** *possibly made with the aid of a* camera obscura.

The Bride, *1892–93, a mysterious painting by the Dutchman Jan Thorn Prikker, one of the artists who exhibited with* **Les Vingt**.

Vitruvian scroll.

(Above) **Wampum** *belt, made by the Iroquois in the 18th c., which may well have been a mnemonic for the terms of a ceremony or political transaction.*

(Left) **The Wanderers:** *Repin's* They Did Not Expect Him, *1884, shows the unexpected return of a political exile to his family.*

wall plate A beam running along the top of a wall which supports the joists or other timbers of a ROOF.★

wall rib Synonym of FORMERET.

wampum (fr. Algonquin *wampumpeag*, 'white strings') White and purple tubular beads made from sea shells and used by North American Indians for woven beadwork. This had ceremonial, and sometimes mnemonic functions, and the beads were also used as a medium of exchange.

Wanderers, The A group of Russian NATUR-ALIST painters who rebelled against the Imperial Academy of Arts in 1870. They painted SOCIAL REALIST pictures and tried to popularize their work and to extend their sources of patronage by means of travelling exhibitions (hence the name). The best-known of them were Ilya Repin and Vasili Vereshchagin.

ward A courtyard or open space in a castle. Synonym: bailey (see MOTTE-AND-BAILEY).

warm colour A colour which suggests KINAESTHETIC sensations of warmness, such as red or yellow. See also ADVANCING COLOUR.

warp In any woven fabric, the fixed and thicker threads set up on the loom to provide the framework through which the thinner WEFT threads are taken.

wash A HUE or TINT applied in a thin transparent layer.

Washington Color Painters An exhibition under this title was held at the Washington (DC) Gallery of Modern Art in 1965, and the label was subsequently transferred to the artists who exhibited – among whom were Morris Louis, Kenneth Noland and Gene Davis. Their common characteristic was their interest in colour as a thing in itself, expressed by the use of water-soluble ACRYLIC paints on unsized, unprimed canvas – the SOAK-STAIN TECHNIQUE. (See also POST-PAINTERLY ABSTRACTION, PRIMING and SIZE.)

(Above) Morris Louis, leader of the **Washington Color Painters**, *makes use of the soak-stain technique in his* Omicron, *1961, from the 'Unfurleds' series.*

(Left) Tiepolo's drawing, The Banquet of Cleopatra, *c. 1740–50, uses* **wash** *in a particularly free and daring manner.*

watercolour Watersoluble PIGMENTS, combined with watersoluble gum as a BINDER, and water as a MEDIUM, used to make transparent paint. Non-transparent watersoluble paints – e.g. DISTEMPER, GOUACHE – are strictly speaking not watercolours.

wattle-and-daub Woven branches covered with mud or PLASTER. Frequently used for walls, and especially to fill timber-framed construction, in the Middle Ages and in Tudor times.

wax casting Synonym of CIRE PERDUE.

weatherboarding (UK), **clapboard** (US) Boards arranged longitudinally, overlapping one another, and used as CLADDING for a timber-framed building.

weepers Small mourning figures, often with hoods drawn over their heads, round the base of a tomb.

weft Threads thinner than the fixed threads of the WARP, and crossing them at right angles to make a woven fabric. The various ways in which they cross the warp determine the pattern if it is woven in. Synonym: woof.

Weltanschauung (Ger. 'world outlook') Any general idea about the nature of the world, as expressed implicitly or explicitly in a work of art, which is also the vehicle for a system of moral or aesthetic value-judgments.

westwork (fr. Ger. *Westwerk*) A structure to the west of the NAVE of a CAROLINGIAN, OTTONIAN,★ or ROMANESQUE church, generally presenting an impressive many-storied façade with towers on the exterior, and within consisting basically of a VESTIBULE, or species of NARTHEX, and an upper room and GALLERIES opening into the nave.

wet plate process, wet collodion process A photographic process invented by Frederick Scott Archer, published in 1851. It involved the use of a glass PLATE coated with an EMULSION (collodion in a solution of silver iodide and iodide of iron) which was exposed to light and developed while still wet. It was extremely fast, produced great subtlety of tone, and, being unrestricted by patents, led to a general expansion of photography in the 19th c. It was superseded by the DRY PLATE PROCESS.

Whiplash curves *used on a cover for Oscar Wilde's* Poems, *designed by Charles Ricketts, 1892.*

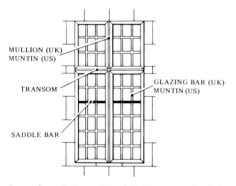

MULLION (UK)
MUNTIN (US)

TRANSOM

GLAZING BAR (UK)
MUNTIN (US)

SADDLE BAR

Parts of a **window**. *(For definitions, see individual entries.)*

whiplash curve An exaggeratedly long and sinuous S-CURVE resembling a plant tendril, typical of many ART NOUVEAU designs.

white line engraving An ENGRAVING made from a hardwood block into which the design has been cut, the ink being applied to the rest of the surface. The image thus appears in white lines on a black GROUND.

white metal Synonym of BRITANNIA METAL.

Wiener Werkstätte (Ger. 'Vienna Workshops') An association of designers and craftsmen established in Vienna in 1903, which was closely associated with the Vienna SEZESSION and with architects such as Josef Hoffmann (1870–1956). It was an attempt to acclimatize English ARTS AND CRAFTS principles in Central Europe, but its products (particularly metalwork, furniture, textiles and leather) also had affinities with French ART NOUVEAU and German JUGENDSTIL. It closed in 1932.

window, types of

Bay window. A window whose PLAN is three-sided or polygonal and which projects from the FAÇADE at ground level, often extending to one or more of the upper stories as well.

Bow window. A window of semicircular or curved PLAN, projecting from a FAÇADE at ground level, and sometimes extending to upper storeys.

Casement window. A window divided vertically into sections, or casements, which swing open along their entire height.

Chicago window. A window stretching across the full width of a BAY, with a large fixed pane in the middle and a smaller movable SASH on each side of it. It is typical of pioneering turn-of-the-century architecture in Chicago, e.g. the work of Louis Sullivan.

Cross-window. A window divided by one MULLION and one TRANSOM. Often found in late 17th-c. buildings.

Dormer window. A vertical window standing up from a sloping roof, and with its own roof.

French window. Two casement windows carried down to floor level, so that they open like a pair of doors. First used at Versailles in the 1680s.

Jesse window. A medieval window designed as a TREE OF JESSE.

Lancet window. A tall narrow window crowned with a steeply pointed ARCH. Found in GOTHIC architecture, especially that of the 13th c.

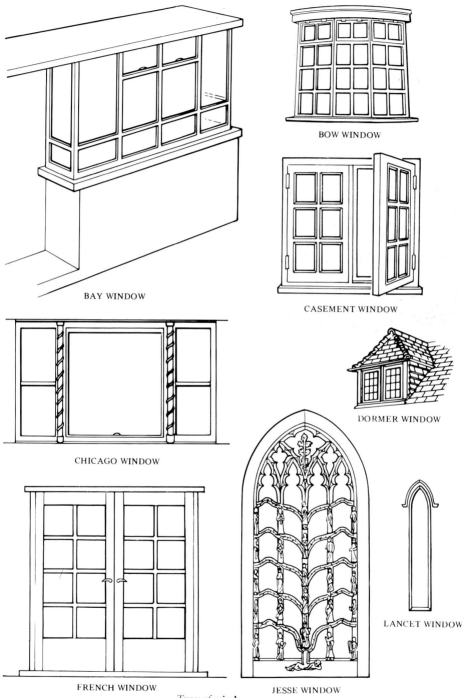

BOW WINDOW

BAY WINDOW

CASEMENT WINDOW

CHICAGO WINDOW

DORMER WINDOW

LANCET WINDOW

FRENCH WINDOW

JESSE WINDOW

Types of **window**.

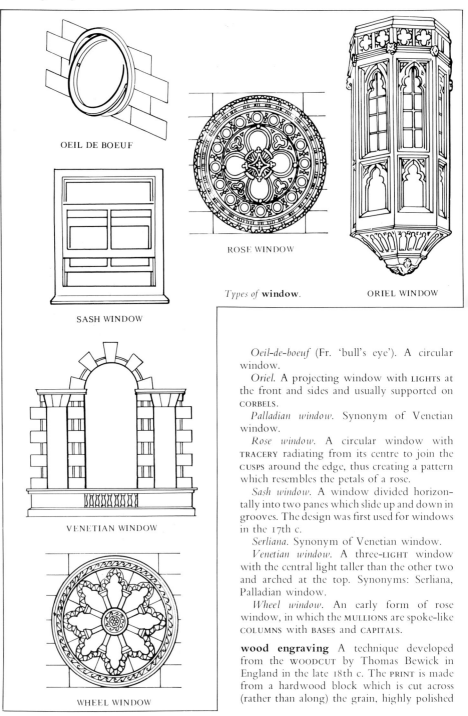

OEIL DE BOEUF

ROSE WINDOW

ORIEL WINDOW

SASH WINDOW

Types of **window**.

VENETIAN WINDOW

WHEEL WINDOW

Oeil-de-boeuf (Fr. 'bull's eye'). A circular window.

Oriel. A projecting window with LIGHTS at the front and sides and usually supported on CORBELS.

Palladian window. Synonym of Venetian window.

Rose window. A circular window with TRACERY radiating from its centre to join the CUSPS around the edge, thus creating a pattern which resembles the petals of a rose.

Sash window. A window divided horizontally into two panes which slide up and down in grooves. The design was first used for windows in the 17th c.

Serliana. Synonym of Venetian window.

Venetian window. A three-LIGHT window with the central light taller than the other two and arched at the top. Synonyms: Serliana, Palladian window.

Wheel window. An early form of rose window, in which the MULLIONS are spoke-like COLUMNS with BASES and CAPITALS.

wood engraving A technique developed from the WOODCUT by Thomas Bewick in England in the late 18th c. The PRINT is made from a hardwood block which is cut across (rather than along) the grain, highly polished

Wood engraving: Poor Mailie, *by Thomas Bewick, an illustration to Robert Burns's* Poems, *1814.*

and engraved with a BURIN and other tools of various sections (rather than a knife and gouges). Parts of the block could also be reduced to a slightly lower level so that they would take less ink and also less pressure when printed. All these developments combined to produce effects of great subtlety. In colour printing, a different block is used for each colour and successive IMPRESSIONS made to create a full colour image. Synonym: xylography. See also WHITE LINE ENGRAVING.

woodblock print A type of WOODCUT printed from separate wooden blocks, each carrying a separate colour and fitted together to make the complete design, with one colour sometimes overlapping another to give still greater variety of HUE. The best examples are UKIYO-E★ prints.

Woodburytype A photo-mechanical printing process introduced in 1864/65 which allowed photographic prints to be produced in massive numbers for the first time and was therefore much used for book illustration in the second half of the 19th c.

woodcut A PRINT made from a block of wood of medium hardness, cut along the grain. Parts of the surface are cut away, leaving the design standing proud to receive the ink. The technique is thought to have been invented in China in the 9th c. AD. See also WOOD ENGRAVING. (DANCE OF DEATH,★ NOVEMBERGRUPPE.★)

woof Synonym of WEFT.

WPA/FAP (Works Progress Administration/ Federal Art Project) A programme established by the US government under the terms of New Deal legislation in 1935, in order to help

Woodblock print: *two Kabuki actors in an* ukiyo-e *print by Sharaku, 1793. Each has a* mon *on his sleeve.*

Woodcut *by Jost Amman, 1568, showing an artist making a woodcut.*

Sandstone **yakshi** *from a Jain stupa at Mathura, 2nd c. AD.*

Yamato-e: *detail of a Kamakura period scroll of the 13th c., showing the artist reading out an Imperial message to his family. Note the strong outlines and the numerous details typical of the style.*

unemployed artists (as well as writers and people in the theatre). It had been preceded by similar but more narrowly based schemes. Under the FAP, artists were hired to produce works of art for tax-supported institutions. Some of the most characteristic products of the scheme were therefore large murals. Both FIGURATIVE and also ABSTRACT artists (such as Arshile Gorky and Adolph Gottlieb) benefited, and the result was a great coming-together of various schools, such as the REGIONALISTS and the members of the AAA (American Abstract Artists) which led to the flowering of American art in the late 1940s.

wu t' sai (Chi. 'five colours') White Chinese PORCELAIN decorated OVERGLAZE (or sometimes directly on the BISCUIT) with ENAMELS, dating from the Ming period (1368–1642) and especially the reign of Wan Li (1573–1619). The term derives from the five colours of the *famille verte* palette – apple green, iron red, yellow, aubergine and violet blue (see FAMILLE JAUNE, NOIRE, ROSE and VERTE) – but the description came to be applied to all types of enamel decoration. Synonym: Five Colours.

Wunderkammer (Ger. 'wonder chamber') Synonym of KUNSTKAMMER.

X

x-height A printing term used to designate the height of the LOWER-CASE letters of a given TYPEFACE. ★

XX, Les See VINGT, LES.

xylography Synonym of WOOD ENGRAVING.

xystus (Lat.) An open colonnade.

Y

yaksha (Skr.) A male nature spirit in Hindu belief, frequently represented as a sculptured image on temples.

yakshi (Skr.) A female nature spirit in Hindu belief, particularly associated with trees. Images of them were often placed at the entrance to sacred places.

yamato-e (Jap. 'Japan painting') The Japanese NATURALISTIC, NARRATIVE style of painting, initiated in the 10th c. when Japanese secular texts such as the *Tale of Genji* began to be illustrated on hand scrolls (*makemono*), previously used by the Chinese largely for landscape. Compositions were based on outline filled in with colour, and contrasted strongly with Chinese styles. It was later revived by the TOSA SCHOOL.

yantra (Skr.) A geometric diagram used by Buddhist mystics to focus concentration while meditating. See also MANDALA. (LINGA.★)

yoni (Skr.) The female genital organs, often represented encircling the base of a LINGA in Indian art.

Zenga: Tan Hsia Burning the Buddha Image, *a typically bold and irreverent painting by Sengai, a leading Japanese Zen master of the 18th c.*

Z

Zeitgeist (Ger. 'time spirit') 1. The spirit of the age. 2. The title of an exhibition of Neo-Expressionist paintings held in Berlin in 1982; hence sometimes used as synonym of NEO-EXPRESSIONISM.

zenana (Persian) The women's quarters in an Indian palace.

zenga (Jap. 'Zen pictures') The extremely bold and spontaneous ink paintings made by Japanese artists under the influence of Zen Buddhism, many of them Buddhist priests. The style became popular in the 15th c. and was still flourishing in the 19th. Among the most famous artists connected with it were Hakuin (1685–1768) and Sengai (1750–1837).

Zero Group A group of KINETIC artists formed in 1957 by Heinz Mack and Otto Piene and based in Düsseldorf. The group disbanded in 1966.

ziggurat (fr. Assyrian *ziqquratu*, 'pinnacle') The platform in the form of a STEPPED PYRAMID on which a Sumerian or Assyrian temple was built.

zoomorphic ornament Ornament, usually linear, based on stylizations of various animal forms. See also ANIMAL STYLE.

Zwischengoldglas (Ger. 'glass with gold between') A type of GLASS formed of two layers sandwiching a decoration in gold leaf. See also VERRE ÉGLOMISÉ, TINSEL PAINTING.

Reconstruction of Ur Nammu's **ziggurat** *at Ur. Early dynastic period.*

Zoomorphic ornament *on the prow of the Oseberg ship from south Norway, c. AD 800.*

Table of Dynasties

Ancient Greece

Geometric	c. 1100–c. 660 BC
Daedalic	c. 660–c. 620 BC
Archaic	c. 620–c. 500 BC
Classical	c. 500–c. 323 BC
Hellenistic	c. 323–c. 100 BC

Ancient Egypt

Predynastic Period

Amratian (Nagada I)	c. 3800–c. 3400 BC
Gerzean (Nagada II)	c. 3400–c. 3000 BC

Early Dynastic Period

Dynasty I	c. 3000–c. 2780 BC
Dynasty II	c. 2780–c. 2635 BC

Old Kingdom

Dynasty III	c. 2635–c. 2570 BC
Dynasty IV	c. 2570–c. 2450 BC
Dynasty V	c. 2450–c. 2290 BC
Dynasty VI	c. 2290–c. 2155 BC

First Intermediate Period

Dynasties VII–X	c. 2155–c. 2040 BC

Middle Kingdom

Dynasty XI	c. 2134–c. 1991 BC
Dynasty XII	c. 1991–c. 1785 BC
Dynasty XIII	c. 1785–c. 1650 BC

Second Intermediate Period

Dynasties XIV–XVII	c. 1715–1554/51 BC

New Kingdom

Dynasty XVIII	c. 1554/51–c. 1305 BC
Hatshepsut	c. 1490–1470/68 BC
Akhenaten	c. 1365–c. 1349/47 BC
Tutankhamun	c. 1347/46–c. 1337/36 BC
Dynasty XIX	c. 1305–c. 1196 BC
Rameses II	c. 1290–c. 1224 BC
Dynasty XX	c. 1196–c. 1080 BC

Third Intermediate Period

Dynasties XXI–XXIV	c. 1080–c. 712 BC

Late Period

Dynasty XXV	c. 745–c. 655 BC
Dynasty XXVI	c. 664–c. 525 BC
Dynasties XXVII–XXXI	c. 525–c. 332 BC

Ptolemaic Period	c. 332–c. 30 BC
Roman Period	30 BC–c. AD 324

China

Hsia dynasty	2205–1766 BC
Shang (Yin) dynasty	1766–1122 BC
Chou dynasty	1122–249 BC
Ch'in dynasty	221–206 BC
Han dynasty	206 BC–AD 220
The Six Dynasties	AD 220–589
Sui dynasty	589–618
T'ang dynasty	618–906
The Five Dynasties	907–60
Sung dynasty	960–1279
Yüan dynasty	1260–1368
Ming dynasty	1368–1644
Ch'ing dynasty	1644–1912

India (Painting)

Pre-Mughal

Jain	11th–16th c. AD
Sultanate	14th–16th c. AD
Early Hindu	16th c. AD

Mughal Painting and its Derivatives

Akbar	1556–1605
Jahangir	1605–27
Shah Jahan	1627–58
Aurangzib to Muhammed Shah	mid 17th–mid 18th c.
Aurangzib	1658–1707

Muhammad Shah	1719–48
Provincial Mughal Style	c. 1750–c. 1800
Company Style	18th–19th c.
The Deccan	c. 1560–1850

Rajasthan and Central India

Ajmer	c. 1630–1800
Amber/Jaipur	c. 1640–1850
Bikaner	c. 1600–1800
Bundi	c. 1590–1800
Kishangarh	c. 1720–1850
Kotah	c. 1630–1850
Malwa	c. 1620–1850
Mewar	c. 1600–1900

Himalayan Foothills

Basholi	c. 1660–1850
Bilaspur	c. 1660–1800
Chamba	c. 1660–1860
Guler	c. 1690–1850
Jammu	c. 1690–1850
Kulu	c. 1690–1800
Mandi	c. 1660–1850
Mankot	c. 1650–1800
Nurpur	c. 1660–1800

India (Sculpture)

Northern and North-western India

Maurya and Shunga	3rd c. BC–1st c. BC
Kushana	1st–4th c. AD
Gandhara	1st–4th c. AD
Kashmir	8th–12th c. AD
Himchal Pradesh	8th–12th c. AD

The Deccan

Sātavāhana and Ikshvāku	1st–4th c. AD
Early Chālukya	6th–8th c. AD
Rāshtrakūta, Late Chālukya and Western Ganga	8th–12th c. AD
Hoysala and Kākatīya	12th–14th c. AD

Central and Western India

Gurjura-Pratihāra	8th–10th c. AD
Maitraka and Solankī	7th–12th c. AD
Chandella and Paramāra	10th–11th c. AD

Eastern India

Pala and Sena	8th–12th c. AD
Eastern Ganga	11th–14th c. AD
Hindu revivalism	17th–19th c. AD

Southern India

Pallava	7th–9th c. AD
Chola	9th–13th c. AD
Vijayanagara and Nāyaka	14th–18th c. AD

Japan

Nara	710–94
Heian	794–1185
Kamakura	1185–1392
Muromachi	1392–1568
Momoyama	1568–1600
Edo	1600–1868
Meiji	1868–1912

Acknowledgments

The publishers are grateful to the following institutions and individuals for permission to reproduce the illustrations on the pages mentioned.

The following abbreviations have been used: a, above; b, below; c, centre; l, left; r, right.

Reproduced by gracious permission of Her Majesty the Queen: 104b, 169a, ACL: 12al, 21b. AGRACI: 51b. Alinari: 85ar, 135ar, 145b, 151a, 159ar. Amsterdam, Stedelijk Museum: 52al, 175ar, 177b, 181b. Anderson: 128al. Archaeological Survey of India: 171b. Architectural Review – de Burgh Galwey: 130b. Athens, Acropolis Museum: 19, 170. Athens, Ceramikos Museum: 177a. Athens, National Museum: 88b. Basel, Offentliche Kunstsammlung: 154ar. Bath, American Museum in Britain: 31ar. Berlin, Staatliche Museen (East): 13c, 144a, 185ar. Berlin, Staatliche Museen (West): 48a, 127b. Bern, Kunstmuseum (extended loan from the Gottfried Keller Foundation): 182ar. Bórd Fáilte (Dublin): 121b. Boston, Museum of Fine Arts: 20 (Gift of Winfield Foundation), 77b, 97al; 145c (Seth K. Sweetser Residuary Funds). Bremen, Kunsthalle:25c. Brogi: 159b. Bulgarian Ministry of Culture: 161ar. Bulloz: 25b, 133ar, 157c, 187al. Chantilly, Musée Condé: 92ar, 173al. Chicago, Art Institute (Collection Friends of American Art): 14a. Christie's: 127ar. Cologne, Wallraf-Richartz Museum: 44. Commissioners of Public Works in Ireland (Dublin): 46ar. Country Life: 145a F.H. Crossley: 188b. DAI (Athens): 88b, 177a. Dept of the Environment: 75b, 90b, 141al. Detroit, Institute of Arts (Purchase, Founders Society): 88a. Gerti Deutsch: 185b. Dresden, Gemäldegalerie: 127c. Dublin, Municipal Gallery of Modern Art: 89ar. Dublin, National Gallery of Ireland: 197a. Dublin, National Museum of Ireland: 46al. Edinburgh, National Gallery of Scotland: 32c. Eindhoven, Stedelijk 'Van Abbe' Museum: 129al. Fototeca Unione: 159al. Frankfurt, Städelsches Kunstinstitut: 85al. Fribourg, Musée d'Art et d'Histoire: 80b. David Gahr: 23b. GFN: 33br, 83a, 194a. Ghent, St Bavon: 12al. Giraudon: 92ar, 103l, 105al, 163ar, 173al. Irmgard Groth: 47ar. Haarlem, Frans Hals Museum: 34b. Hanover, Galerie Brusberg: 193a. Harvard (Mass.), Fruitlands Museum: 171a. Hirmer Fotoarchiv: 19, 27ar, 78ar, 170. Martin Hürlimann: 90a, 149ar. Susan Johnson: 99b. A.F. Kersting: 16al, 40b, 52ar, 144b, 156c, 176al. Kiev, Russian Museum of Art: 175al. Emily Lane: 159c. Richard Lannoy: 89al. Leeds, Art Gallery and Temple Newsam House: 152a. Jonas Lehrman: 47c, 125. Leiden, Museum de Lakenhal: 194c. Leiden, Rijksmuseum voor Volkenkunde: 191ar. London, British Library: 43b. London, British Museum: 13a, 17b, 31b, 33bl, 41ar, 63al, 81c, 83c, 99b, 102, 111a, 113c, 154al, 172b, 186ar, 193b, 203al, 203ar. London, Courtauld Institute Galleries: 45c, 134al (Roger Fry Collection), 149b. London, Courtauld Institute of Art: 64ar. London, Percival David Foundation of Chinese Art: 107c. London, Greater London Council as Trustees of the Iveagh Bequest, Kenwood: 80a. London, National Gallery: 15c, 27al, 43al, 53br, 59b, 63b, 71ar, 113b, 117ar, 161al, 181ar. London, Royal College of Physicians: 10. London, Tate Gallery: 21c, 78al. London, Victoria and Albert Museum: 12ar, 17a, 29al, 33al, 34ar, 41b, 48b, 64al, 65, 78b, 79, 105c, 108, 112, 116, 123b, 135al, 138a, 139ar, 147a, 163b, 187ar, 188a, 189a, 194b, 199al, 204a. London, Wallace Collection: 34al, 162al. London: Worshipful Company of Goldsmiths: 160b. Los Angeles, County Museum of Art (The Nasli and Alice Heermaneneck Collection): 156b. Lübeck Museums:

29ar. Manchester, City Art Gallery: 129ar. Manchester, Whitworth Art Gallery: 132al. Marburg: 43ar, 131al, 139al. Eric de Maré: 93ar. Mas: 49b. Georgina Masson: 155b. Mexico, National Museum of Anthropology: 47ar. Milan. Brera: 85ar. Montpellier, Musée Fabre: 157c. Moscow, Tretyakov Gallery: 37a, 152b, 198b. Munich, Antikensammlungen: 120al. Munich, Bayer. Staatsgemäldesammlungen: 147b, 155c. Münster, Landesmuseum: 111c. Naples, Museo di Capodimonte: 49a. National Monuments Record (London): 71al, 72, 105b, 107al. New York, courtesy Solomon R. Guggenheim Museum: 57a. New York, courtesy Sidney Janis Gallery: 151bl. New York, Metropolitan Museum of Art: 37b (Collection of Irwin Untermyer), 59ar (Gift of Edward S. Harkness, 1931), 99c (Rogers Fund 1917), 101l (Gift of Mrs Russell Sage 1908), 114a (Gift of J.P. Morgan 1916), 120ar The Cloisters Collection (Gift of John D. Rockefeller, Jr., 1937), 158ar (Arthur H. Hearn Fund 1939) 167al (Collection Mr and Mrs Charles B. Wrightsman), 167ar (Fletcher Fund 1965), 180 (Rogers Fund 1906). New York, Museum of Modern Art; 27b; 9a (Gift of Philip Johnson), 56b (Larry Aldrich Foundation Fund), 73c (Sidney and Harriet Janis Collection), 89b (acquired by exchange), 99a (Dr and Mrs Frank Stanton Fund), 107b (Gift of Liberty & Co., London), 128b (Gift of Mrs David M. Levy), 132ar (Gift of Paul J. Sachs), 149al (Gift of David Whitney). New York Public Library (Spencer Collection): 100. New York, Whitney Museum of American Art: 22a, 22b, 151br. Nottingham Museums (Newstead Abbey): 172a. Oslo, Universitets Oldsaksamling:205b. Ottawa, National Gallery of Canada: 73ar. Otterlo, Rijksmuseum Kröller-Müller: 61al, 197c. Oxford, Ashmolean Museum: 30b; 45a (Griffith Institute), 45b. Oxford, Bodleian Library: 200a. Oxford, Governing Body of Christ Church: 69. Paris, Bibliothèque Nationale: 119ar. Paris, Louvre:25b, 63ar, 103r, 133ar, 159ar. Paris, Musée Carnavalet: 187al. Paris, Musée National d'Art Moderne: 51b, 105al. Paris, Petit Palais: 127al. Philadelphia Museum of Art: 123al. Josephine Powell: 121a, 141b, 190a. Private Collections: 54, 62, 68a, 81a, 86al, 86ar, 96, 109, 113a, 114b, 116a, 119b, 121c, 123ar, 128ar, 130a, 131ar, 134b, 138b, 142b, 153al, 157a, 169b, 173ar, 183ar, 183b. Recklinghausen, Icon Museum: 101r. Réunion des Musées Nationaux (Paris): 33ar. Riksantikvaren (Oslo): 176ar. Rome, Museo Borghese: 128al, 159al. Rome, Museo Capitolino: 135ar. Rome, Palazzo Barberini: 194ar. Rome, Palazzo Farnese: 33br, 83a. Rotterdam, Museum Boymans-van Beuningen: 97ar. Helga Schmidt-Glassner: 117br. Tony Schneider: 23a. Shunk-Kender: 33b, 74. Edwin Smith: 30a, 92al, 131b, 143a, 154al, 190b, 191b. Sotheby's Belgravia: 21a. Franz Stoedtner: 105ar. Stuttgart, Staatsgalerie: 182al. Tokyo, Idemitsu Art Gallery: 205a. Toronto, Royal Ontario Museum: 147c. Urbino, Galleria Nazionale: 151a. Urbino, Palazzo Ducale: 104a. Vatican, Sistine Chapel: 145b. Vatican, Stanze: 160a. Venice, Accademia: 41al. Venice, Peggy Guggenheim Collection (The Solomon R. Guggenheim Foundation), copyright Solomon R. Guggenheim Foundation: 29b. Vienna, Kunsthistorisches Museum: 39c, 59al, 103l, 163a. Vienna, Museum für Völkerkunde: 198a. Washington, National Gallery: 77ar, 81b. Washington, Phillips Collection: 53a.

Printed sources

A. Hepplewhite & Co., *Cabinet Makers and Upholsterers Guide* (1788): 142a. T. Hope, *Household Furniture and Interior Decoration* (1807): 73al. L. Kilian, *Neues Gradesco Büchlein* (1607): 95b. C. Percier and P.F.L. Fontaine, *Recueil des Décorations Intérieures* (1812): 75c. Piranesi, *Vedute di Roma* (c. 1748–1778): 141ar. D. Roberts, *Egypt and the Holy Land* (1856): 155a. *The Art of Motion Graphics*, computing report 1969 (photograph by John Stone): 56a.